CW00924345

FLESH AND THE ID.

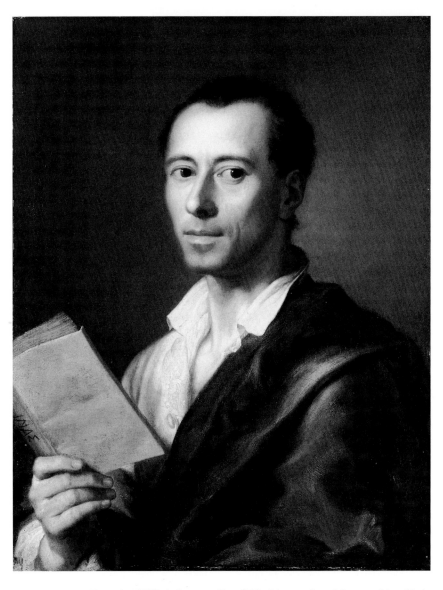

1. A. R. Mengs, Portrait of Winckelmann, oil, *c.* 1758, Metropolitan Museum, New York.

FLESH AND THE IDEAL

Winckelmann
and
the Origins of Art History

ALEX POTTS

YALE UNIVERSITY PRESS
NEW HAVEN AND LONDON

This book is dedicated to the memory of my father, Robert Potts

Copyright © 1994 by Yale University
First paperback edition 2000

All rights reserved. This book may not be reproduced in whole or in part, in any from (beyond that copying permitted by Sections 107 and 108 of the U. S. Copyright Law and except by reviewers for the public press), without written permission from the publishers.

Designed by John Nicoll
Set in Linotron Ehrhardt by Best-set Typesetter Ltd., Hong Kong
Printed in Singapore by C.S. Graphics Ltd

Library of Congress Cataloging-in-Publication Data
Potts, Alex.
 Flesh and the ideal : Winckelmann and the origins of art history /
Alex Potts.
 p. cm.
 Includes bibliographical references (p.) and index.
 ISBN 0-300-05813-6 (hbk.)
 ISBN 0-300-08736-5 (pbk.)
 1. Winckelmann, Johann Joachim, 1717-1768—Aesthetics. 2. Art—
Historiography. 3. Aesthetics, German—18th century. 4. Male nude
in art. 5. Sculture, Greek. 6. Winckelmann, Johann Joachim,
1717-1768—Influence. I. Title.
N7483.W5P68 1994
709'.2—dc20 93-49741
 CIP

9 8 7 6 5 4 3 2

CONTENTS

ACKNOWLEDGEMENTS

I wish to acknowledge a number of people for the role they played, sometimes unwittingly, in the shaping of this book. The names that follow trace important encounters that helped me rethink and give substance to what I was doing— some shedding new light on problems over which I kept stumbling or offering me fresh perspectives when I seemed stuck in a blind alley, others prompting me to spell out my preoccupations and prevent these from becoming merely private obsessions. The stimulus often came from discussions that were quite unconnected with Winckelmann or with the interpretation of eighteenth-century culture.

My warm thanks go to Ernst Gombrich for his help with my early research on Winckelmann and to John Nicoll for his continuing support throughout the long gestation of this book. To Susan Siegfried I am ever grateful for the encouragement she gave and for her insistence on finding ways to clarify my more opaque arguments. I owe a very particular personal debt to Fred Orton and to Michael Podro for the discussions I have had with them over the years.

I also wish to thank Graham Andrews, Caroline Arscott, Sally Alexander, John Barrell, Michael Baxandall, Tony Carter, Tim Clark, Tom Crow, Carol Duncan, Whitney Davis, Wolfgang Ernst, John Gage, Tamar Garb, Nick Green, Tag Gronberg, Francis Haskell, Jutta Held, Andrew Hemmingway, Rasaad Jamie, Elizabeth McGrath, Stanley Mitchell, Hannah Mitchell, Laura Mulvey, Patricia Potts, Adrian Rifkin, Lyndal Roper, Raphael Samuel, Conal Shields, Wendy Smith, David Solkin, Abigail Solomon-Godeau, Martin Thom, Lisa Tickner, William Vaughan, Jeffrey Weeks and Karl Werckmeister.

INTRODUCTION

The middle road is the only one that does not lead to Rome.
Arnold Schönberg[1]

Winckelmann's writing particularly repays a close reading now because of his unusually eloquent account of the imaginative charge of the Greek ideal in art. In his impassioned attempt to reconstitute it, he invoked not just the utopian aspirations but also the darker anxieties that made it so compelling. He showed an unusually acute awareness of the psychic and ideological tensions inherent in its image of an impossibly whole and fully embodied human subjectivity. In other words, he took the Greek ideal so seriously that he could not conceive of it as an abstraction existing beyond the disturbance of bodily desire and ideological conflict. Any moderate middle way to reconstituting the earlier, purer ideal hovering behind the extant ruins of ancient Rome would have been a blind alley for him. No less insistently than Nietzsche's, Winckelmann's image of the Apollonian composure of the antique was one wrested from extremity.

What does the name Johann Joachim Winckelmann usually conjure up? We probably think first of his famous dictum that the essence of the Greek ideal was 'a noble simplicity and a calm grandeur' (*eine edle Einfalt und eine stille Grösse*). The idea of a 'noble simplicity' seems to place him on very traditional ground. A conflation of ethical nobility with formal simplicity had been a long-standing paradigm of classical aesthetics and, partly under the impress of Winckelmann's invocation of it, was endowed with a new lease of life in the late eighteenth century. Yet if 'noble simplicity' represents the inheritance of aristocratic norms of decorum, connoting a world of patrician self-possession and calm, it could also suggest a kind of *tabula rasa* of subjectivity that was at odds with the affectations and excesses of high society, something approaching a proto-revolutionary ideal.

And what of the other words, 'calm grandeur'? If we look again at the German phrase *stille Grösse*, we notice that the conventional translation is somewhat misleadingly tilted towards ideals of poise. The word *stille* also has the idea of stillness, which could simply suggest an absence of signs of life. 'Calm grandeur' projects an image of resonant heroism, the great soul effortlessly in possession of his strength. 'Still grandeur' could be something else— the stillness of an imperturbable calm that might be inanimate or inhuman, perhaps the stillness of death.[2]

The association between Neoclassical aesthetic ideals and death is familiar enough nowadays. It is one of the clichés of our culture that the cold marble forms of the pure classical nude, supposedly embodying an ideal beyond the measure of time and mortal alteration, is redolent of a deathly coldness. In this

crude form, the association is too reductive to explain how and why Neo-classical ideals have cast such a compulsive spell at different moments. Winckelmann's prefiguration of a modern consciousness of the deathly stillness of the Neoclassical nude works because, in his account, the blankness identified with the ideal figure, the stilling of emotion and desire in its perfected marble forms, is coupled with an intense awareness of the kinds of erotic and at times sado–masochistic fantasy that could be woven around such representations of the body beautiful.

His is a very complex reading of the formal purity of the ideal figure, in which a deathly stillness mingles with eruptions of desire and violent conflict. A powerful dialectic is set up between beautiful bodily form and suggestions of extreme psychic and physical disquiet. The image he uses most often to evoke the apparent imperturbability of the ideal figure in repose is the calm expanse of a distant sea. The smoothly modulated surfaces of the finest Greek ideal become like a gently rolling swell, simultaneously calm and redolent of a power that might easily be stirred into raging fury.[3]

Take a specific example. The analysis of the aesthetic, ideological, and stylistic basis of Greek art in Winckelmann's *History of the Art of Antiquity*[4] is headed by the illustration of an antique gem representing a dead or fatally wounded female nude lying prone in the arms of a naked warrior (Plate 2). Right at the outset, ideal Greek beauty is associated with violence and death. In explaining the iconography of the scene, Winckelmann imparts to it a level of disturbance that is noticeably in excess of its immediate connotations. The group most likely represents Achilles holding the body of Penthesilea, the Queen of the Amazons, whom he has just slain, and with whom he has also fallen in love. But Winckelmann makes it refer to a much more vicious and very obscure story in Plutarch:

> The wild sow of Crommyon, which went by the name of Phaea, was no ordinary beast, but a ferocious creature very hard to overcome . . . Theseus went out of his way to find and kill this animal . . . Another account, how-ever, has it that Phaea was a robber, a murderous and depraved women, who lived in Crommyon and was nicknamed the Sow because of her life and habits, and whom Theseus afterwards killed.[5]

The beautiful flowing contours of the female nude and her heroic killer, Theseus, are here charged with suggestions of violence, and even depravity, that are the very antithesis of ethical ideals of nobility and calm. The effect of beauty is produced through an entirely involuntary transfiguration, the bodily stillness that comes with the approach of death. Take another instance, the statue of Niobe (Plate 15), which Winckelmann singled out as the most im-portant surviving example of the austere or sublime style in classic Greek art. Niobe, like Phaea, achieves a transcendant stillness through an excess of violence, in her case a terrifying suffering and fear that, according to

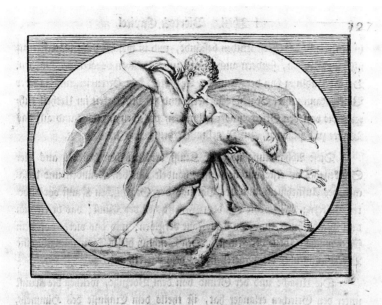

2. Engraving of an antique engraved gem from the 1764 edition of Winckelmann's *History of the Art of Antiquity.*

Winckelmann, had reached such unbearable extremity that all signs of expression on her face were obliterated, leaving her transfixed in the cool forms of a pure, austere, almost absolute beauty. Niobe was witnessing Apollo and Diana slaughtering her children and, according to the legend, her grief was so intense that she was literally frozen into stone.[6]

It is not entirely accidental that these deadly configurations of ideal beauty are female rather than male. They echo a gendering of extreme bodily affect widely current in Western European art. The discomfiting subtexts attributed to these images not only disturb the morally uplifting connotations clustering round eighteenth-century conceptions of antique beauty, but also bring into view anxieties surrounding sexual difference that hover insistently yet largely

hidden on the margins of Winckelmann's very male constitution of the Greek ideal.

The story is not very different when we move to the centre of Winckelmann's recreation of the Greek ideal, those still famous descriptions of the statues in Rome thought at the time to be the most important masterpieces of ancient art.[7] The work already singled out in his early essay *On the Imitation of the Greeks* as the epitome of a 'noble simplicity and still grandeur' is the Laocoön (Plate 16), possibly the least calmly poised of the famous antiques of the period. In his later description of the statue in the *History of the Art of Antiquity*, what comes to the fore is not the poised struggle of a noble soul against adversity so much as a violent juxtaposition of beauty and pain.[8] The state of calm associated with the Greek ideal in his mature writing is also a state of suspended terror. This applies not only to the Laocoön, where the apparent poise is a physical convulsion resulting from his being strangled and bitten to death by snakes, and to the Niobe, whose impassive beauty results from her being overwhelmed by the terror of witnessing the slaughter of her children. The Apollo Belvedere (Plate 19) is seen as expressing his divine authority in a gesture of violence as he advances on and kills the Pythian serpent, while the figure of Hercules that Winckelmann associates with the Belvedere Torso (Plate 36) is imagined in a state of 'transfiguration' after being ravaged by a poisoned cloak and burned alive. The immaculate image of an undisturbed plenitude, the ideal self embodied by the Greek ideal, is framed in Winckelmann's writing by vivid eruptions of physical conflict which at times border on total self-annihilation.

Winckelmann is particularly revealing as to both the political and the homoerotic sexual content of the fantasies that gave the antique male nude its larger resonance within the culture of his time. We confront in Winckelmann, more vividly than in any other writer of the eighteenth century, the question of how the Greek nude could be seen to embody the ideal of subjective and political freedom with which it came to be so closely identified. He does not simply assume, like most writers of the period, that a truly beautiful art, such as that of the ancient Greeks, must have been produced by a free society. Notions of freedom play an integral role in the ideal subjectivity he sees represented by the beautiful figures of antique statuary.

With Winckelmann, then, freedom is not just the condition that makes possible the imaginative creation of an ideal beauty. It is also the subjective state of being figured by that beauty, through its apparent embodiment of a state of unconstrained narcissistic plenitude, which he identifies most immediately with the self-absorbed, free-standing, naked male figure. Here there is an absolute freedom, but also suggestions of a kind of subjective emptiness or, to return to an image already touched upon, a stillness, a sense that such unblemished formal and subjective oneness, so entirely divested of tension and constraint, is not quite alive.

His more dramatic readings of the ideal male nude, such as the Laocoön

(Plate 16) and the Apollo Belvedere (Plate 19), on the other hand, suggest the darker aspect of this fantasy of an absolutely free subjectivity. We see the violence implicit in the idea of an ideally free self once it has to engage with the world around it. Conflict becomes the condition of its existence. Its total autonomy is asserted through a violent struggle that can come to an end only with death or withdrawal into narcissistic isolation. The violent dramas of some of his best-known readings of the Greek ideal thus echo contradictions inherent in the impossible fantasy of an absolutely free sovereign self. Winckelmann seems not unaware of the antinomies lodged in the Enlightenment desire for absolute freedom, which de Sade later wrote about with such disturbing directness.

It would be seriously to misrepresent Winckelmann's projection of the Greek ideal, however, were we to focus only on suggestions of an empty, almost deathly stillness, or his intimations of an uncontrollable violence hovering at its fringes. Then we should be missing what is undeniably the most visibly striking aspect of his writing on Greek art, the unapologetically sensuous homo-eroticism of his reading of the Greek male nude. His projection of the Greek nude as an erotically desirable masculinity is both more immediate and, if anything, more richly invested than his imagining it as the symbolic embodi-ment of freedom. The ideal erotic figure for him is not a feminine object offered up for the delectation and domination of a male gaze. It is rather a finely formed male body. As such it becomes for the male viewer both an object of desire and an ideal subject with which to identify.

The boundary between the homoerotic and what we call the homosexual is one that has long been a subject of repressive anxiety in Western culture, and Winckelmann's intervention in this area has a decidedly double aspect. On the one hand, he voices an unusually explicit erotic enjoyment of the male nude together with a quite passionate apologia for the value of male friendship and love. If, strictly speaking, we should understand this as homosocial rather than overtly homosexual in the modern sense, it comes as close to homosexuality as was allowable in a public context in the eighteenth century. Equally, however, Winckelmann's writing could not but be inflected by his culture's prohibition on associating ideal manhood with sexual desire between men. Homosexual or what were then called sodomitical practices were subject to a taboo that made them almost unmentionable in public except by way of denial and negation.

With his foregrounding of the homoerotic quality of the ideal male nude, Winckelmann exposed a significant fault line in dominant configurations of ideal masculinity within his own culture. The Greek ideal's embodiment of desirable manhood threatened to blur the distinction between an allowable homoerotic feeling and a prohibited sexual desire between men, particularly as ancient Greek culture was widely known to have been favourably disposed to homosexuality. This boundary could not be allowed to remain fluid and open, and had to be policed by an implicit homophobia that Winckelmann himself could not but to some extent internalize. In Winckelmann's writings on the

ideal male nude, the more disturbing sado-masochistic dramas can be seen as charged by the violence of largely unspoken because rarely contested prohibitions framing male same-sex desire in the culture he inhabited. They play out largely disavowed tensions within his culture's eroticized ideal male self-images, tensions that he brought into sharp focus because they impinged so directly upon the public representation of his own sexual desires.

The richness and complexity of Winckelmann's reading of the Greek ideal may be apparent to us nowadays because of an increasing awareness on our part of the contradictions inherent in Enlightenment ideals of rationality. Winckelmann often seems to speak with disturbing directness to our modern sensibility for the darker aspects of the Enlightenment's supposedly ideal symbolic forms—its mostly unspoken homophobia, for example, or the violent ramifications of its fantasies of subjective freedom. At the same time, our understanding of the preoccupations and values that feature in Winckelmann's writing, if they are to mean very much, must have some historical grounding, some basis in what we know would be conceivable for Winckelmann and his milieu. In the case of the fantasy of an ideally desiring free self that is central to Winckelmann's conception of the Greek ideal, we are fortunate to have a body of letters from him that abound in vivid accounts of his social and erotic self, of his 'freedom' and of his desires.

The point is not to trace a causal connection between the images of his life he projected and the ideals of freedom and the dialectics of desire found in his account of Greek art. Rather it is to gain a more precise sense of what the Greek ideal would have meant for someone writing in his particular circumstances. Winckelmann's vision of an ideal political freedom forming the basis of the beauty of Greek art was clearly informed by his own experience of the aspiration for freedom, and of the blockages placed on this, while he was struggling to establish himself as an independent scholar and writer. At the same time, the connections he made between Greek art and freedom were also determined by his culture's larger conception of the antique as an imaginative and ideological construct. Similarly, his notion of the eroticism of the Greek ideal in art must relate to the ideas of male friendship and love that feature so prominently in his letters. In both his more public antiquarian and his more private autobiographical writing, he was one of the period's most impassioned and eloquent proponents of a homosocial ideal. But the image of ideal Greek manhood he conjured up in his *History of the Art of Antiquity* did not reflect in any simple way his particular erotic fantasies and desires. It was a cultural construct with its own logic, imbricated in dominant paradigms of masculinity which at some level marginalized and repressed his own desires.

In exploring the complex dynamic of fantasy in Winckelmann's writing, we are inevitably drawn towards a perspective that mingles the historical with the psychoanalytic. When we try to make sense of the representations of identity in Winckelmann's writings, formed within a social and cultural world very different from our own, we are involved in fundamental confusions between the

psychic and the historical, between ideas of the self and its 'inner' fantasies that structure our own perspective on the world, and ones that seem strange and unfamiliar. Fantasies of the kind we see Winckelmann projecting onto the Greek ideal are defined within particular historical circumstances and inflected by a particular ideology; but our understanding of them is also necessarily ahistorical, part of the very basis we have for conceiving any subjectivity or desire.

Drawing out the contradictory resonances and dialectical reversals of Winckelmann's notion of a 'noble simplicity and calm/still grandeur', as we have been doing here, touches on the most immediately engaging aspect of his writing on Greek art. At the same time, we need to recognize the importance of his activities as a historian and antiquarian scholar. To understand his notion of the Greek ideal, we shall need to involve ourselves in the self-consciously scholarly aspect of his reconstruction of Greek art. After all, technical scholarly detail forms the bulk of his major work, *The History of the Art of Antiquity*. He became an important figure in Enlightenment culture because he was seen quite literally to have invented a new kind of history of art, providing a fuller historical reconstruction of the antique ideal and its rise and decline than anyone before him. He lived on as a major figure in Western European culture as both a historical scholar and an impassioned aesthete, and our perspective on his writing must continue to encompass both terms of this duality.

At the centre of his new history of art were two key constructs, a notion of historical process that construed the larger history of Greek art as a systematic evolution through rise and decline, and a theory of artistic style or modes of visual representation that gave this abstract model a distinctively visual character. The particular pattern of stylistic development he identified in ancient Greek art had very important implications for his picture of the aesthetics of the Greek ideal and its ideological and psychic resonance.

Theoretically speaking, Greek art of the classic period, when the Greek ideal realized itself in all its fullness, should have been styleless, or at least the embodiment of the one true style of the highest reaches of art. But Winckelmann's history did not quite pan out that way. When he constructed a detailed picture of Greek art of the classic period, he saw it as taking two quite distinct, mutually incompatible forms. He opened up a disjunction between the theoretical construction of the Greek ideal as one and whole, and its materialization in history as developing through two generically different modes of visual representation, a high mode and a beautiful mode. This division, this difference introduced into the heart of the classic art of antiquity, articulated a structural tension within the artistic aesthetics of the period that the Greek ideal had to negotiate but could never quite abolish. Indeed, at times it seemed to be made all the more acutely apparent.

In the beautiful mode the Greek ideal revealed itself as sensuous and graceful, in the high mode as austere and pure. The distinction was not just a formal and stylistic one. It articulated a series of ideologically loaded dualities—

between the bodily or erotic and the immaterial or idea-like, between the sensuously pleasurable and the grand or manly, between a cultural ideal of refined hedonism on one hand and one of austere heroics and virtue on the other. In elaborating this stylistic duality between the high and the beautiful, which functioned simultaneously as a formal construct and a richly resonant ideological one, Winckelmann incorporated the sexual and the political into the very foundations of the new history of art he was creating.

The other main feature of Winckelmann's story of art, the systematic pattern of rise and decline, also had important theoretical and ideological implications for the whole conception of the Greek ideal. In defining the formation and disintegration of the art of Greek antiquity so compellingly, Winckelmann effectively made this 'timeless' model of classic excellence into a historical phenomenon. He thereby set in motion a historicizing of the Greek ideal that eventually threw into question its viability as a model for imitation and emulation in the present. At the same time, he was quite explicit that the significance of this ideal could not be recovered simply by way of empirical enquiry. A historical analysis, however painstaking, that sought to piece together the fragments that remained, could not of itself provide a vision of the true essence of the Greek ideal, of what made it so compelling in the present. His history of the Greek ideal both prefigured the more strictly historical understanding that became the norm in the nineteenth century and also undermined its positivist aspirations.

Winckelmann's history of ancient Greek art remains alive to us now precisely because of this unresolvable ambiguity of perspective. He unsettles any easy notion of historical reconstruction that does not recognize the import of the immediate resonance that the 'ideal' being reconstructed has for us in the present, without which we would never even have been motivated to study it in the first place. The sheer extent of Winckelmann's ambition in attempting to create a system that would elucidate the entire history of ancient Greek art and allow us to apprehend its surviving fragments in all their true significance brings into focus problems that are still with us today, in some form or other.

This book originated some years ago in what would now be seen as a somewhat old-fashioned intellectual historical analysis of the structural novelty of Winckelmann's conception of ancient Greek art. Initially it was Winckelmann the antiquarian scholar and historian who was my main focus of interest, the figure who effected a new synthesis of the literary and visual evidence relating to ancient Greek and Roman art, and endowed this art with a new systematic history. In puzzling over the significance of the formal paradigm that enabled him to reconceptualize the larger history of Greek art, I found that his writing on the Greek ideal was rather richer than I had anticipated, in quite unexpected ways. I was increasingly convinced that the contradictions and complexities of Winckelmann's text could not be glossed as weaknesses or lapses in his system, but required close and careful reading. They gave evidence of a charge embedded in his writing that often undermined the very theoretical and historical models it seemed to embody.

Winckelmann's *History of the Art of Antiquity* was designed specifically as an archaeological or antiquarian study of Greek art, yet it was so much more than that as well. I found it impossible to make sense of even the most scholarly aspects of his reconstitution of the Greek ideal without exploring the complex ideologically and psychically charged fantasies evoked by the Greek body beautiful which keep erupting in his text. In making the move from formal structural paradigms of historical scholarship to the antinomies of subjectivity and desire, I was motivated by the internal logic of Winckelmann's writing, and also by changes operating within the modern world of Anglo-American scholarship I myself inhabit. It was important for me, however, not to let my initial priorities slip, and to continue to keep clearly in view the explicitly stated intellectual ambitions of Winckelmann's scholarly work. These frame the more highly invested and potentially subversive passages in his writing, and to insist on them is to resist and complicate too easy a deconstructive reading of his text.

I decided to begin this book with an analysis of Winckelmann's achievements as an antiquarian scholar and historian, the writer who produced the Enlightenment's classic text on the art of Greek and Roman antiquity. Then I proceed to a more symptomatic reading of his lyrical evocations of the essence of the Greek ideal. The notion of style provides a bridge between these two perspectives. His distinction between the high and beautiful styles in Greek art is simultaneously a painstaking analysis of the available verbal and visual evidence and an impassioned evocation of the very different kinds of charge that an ideal nude might have.

While exploring the partially disavowed problems and contradictions inherent in Winckelmann's conception of the Greek ideal, I hold to the dominance of two issues that feature centrally and explicitly in his account of Greek art: the ideal of political and subjective freedom and the sensual eroticism of ancient Greek images of ideal masculinity. That these issues are made problematic in Winckelmann's writings is not just the effect of our retrospective evaluation of the fissures and tensions in his text. The problems are explicit in the structure of his argument. The complexities of his writing are always in excess of the consciously articulated problems his text describes, as we would expect of any worthwhile writer. At the same time, his use of negation and contradiction is also programmatic, and shows a recognition on his part of an unmanageable 'unconscious' that could not be encompassed in a simpler, more visibly consistent presentation. In the coda at the end of my book, where I trace some later echoes of the Winckelmannian Greek ideal, I show how the compulsive interest this ideal continued to have for later writers and artists was informed by ideological tensions already traced out, consciously or unconsciously, in Winckelmann's own writing.

The best tribute I can offer Winckelmann the writer is to acknowledge how worthwhile it has been engaging again and again with his texts over the years, at times fitfully and even reluctantly, yet in the end with something of the obsessiveness I see mirrored in his project. Out of his system I have enjoyed making another system. I had moments when I felt a little uneasy about taking

over Winckelmann in this way, suspecting for one thing that the system I was erecting on the ruins of his was one of which he might radically have disapproved. In allowing myself this liberty of imagining his revisiting one further reconstitution and mutilation of his life's work, I should recall a comment he once made on the first major reprocessing of his *History of the Art of Antiquity*, the French translation that appeared in 1766:

> I have to deplore the fate met by the *History of Art* in the French translation . . . Because of this dismemberment, the continuity is broken up. Each bit is detached from the next, so they are made to appear as limbs existing in their own right.[9]

Inventing a History of Art

The history of the art of antiquity that I have endeavoured to write is no mere narrative of the chronology and alterations of art. Rather I understand the word history in the larger sense that it had in the Greek language, and my aim is to attempt a system.[1]

THE SIGNIFICANCE OF WINCKELMANN'S HISTORY

Winckelmann's *History of the Art of Antiquity* soon acquired an international reputation after it was published in German in 1764. Initially it reached a non-German public by way of extracts and summaries in literary journals such as the *Journal Encyclopédique*,[2] and then by a succession of Italian and French translations, the first of which appeared in French in 1766. The book originated from and spoke eloquently to a cosmopolitan European community for which ancient Rome was a crucial point of reference—Rome being where Winckelmann settled after he left Dresden in 1755. The audience with a special interest in Winckelmann's subject, namely the sculpture and painting of antiquity, which at the time had almost all been excavated in Italy, was a broad one. It included people involved in classical antiquarian studies or the art world, as well as Enlightenment intellectuals who considered classical antiquity a testing ground for their analysis of human culture.

Winckelmann's *History* had a remarkable impact for a scholarly antiquarian publication. It presented a comprehensive synthesis of available knowledge about the visual artefacts of the ancient world, and as such was hardly an easy read. Four main sculptural traditions were discussed in detail—the ancient Egyptian, Etruscan, Greek, and Roman. What particularly caught the imagination of Winckelmann's contemporaries, however, and still assures the book a place among the classics of art history, is what Winckelmann himself envisaged as its core, the eloquent and hugely ambitious attempt to redefine the history and aesthetics of the ancient Greek tradition. In developing a new historical and theoretical framework for reconstructing the antique classical ideal, he was tackling something fundamental. The antique ideal then stood unquestionably as the highest model of art. In several extended, finely wrought lyrical evocations of the beauties of the Greek ideal, which put his book into a category quite apart from the dry antiquarian compilations of his scholarly contemporaries, Winckelmann himself brought this point to the attention of his reader in no uncertain terms.

73/895

Johann Winckelmanns,

Präsidentens der Alterthümer zu Rom, und Scrittore der Vaticanischen Bibliothek,
Mitglieds der Königl. Englischen Societät der Alterthümer zu London, der Maleracademie
von St. Luca zu Rom, und der Hetrurischen zu Cortona,

Geschichte der Kunst

des Alterthums.

Erster Theil.

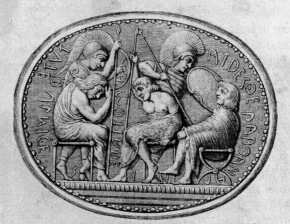

Mit Königl. Pohlnisch- und Churfürstl. Sächs. allergnädigsten Privilegio.

Dresden, 1764.
In der Waltherischen Hof-Buchhandlung.

3. Title-page of the 1764 edition of Winckelmann's *History of the Art of Antiquity*.

Though the original German edition may have failed to make Winckelmann's fortune,[3] it was such a success that he was immediately involved in doing further research and adding to it with a view to republication. In 1767 he produced a supplement, *Remarks on the History of the Art of Antiquity*, and he was putting the finishing touches to a substantially enlarged and revised new edition when he was murdered on his return to Rome from a trip to Vienna in 1768. This new edition eventually came out posthumously in German in 1776, and formed the basis of a series of copiously annotated editions in French and Italian that appeared over the next few decades. The book, swelled by notes and addenda by later scholars, remained for some fifty or so years after his death nothing short of the standard text on the art of antiquity.[4] It was raided for information, as well as for its eloquent celebrations of the antique Greek ideal, by almost anyone writing on ancient art. At one level it was the bible of late eighteenth-century Neoclassicism, and Winckelmann himself was a hero of the classical revival that gripped the art world at the time.

Why did it gain such a hold? It was partly Winckelmann's sheer scholarly achievement in gathering together and imposing a new order on the vast range of textual and visual evidence relating to the art of antiquity. His *History of the Art of Antiquity* also functioned as a more general inspiration for art-historical studies by establishing a model for conceptualizing the entirety of an artistic tradition through a systematically conceived history of its rise, flourishing, and decline. Well into the next century, his work not only functioned as the very embodiment of classical archaeological scholarship. It also became a crucial point of reference for an intellectually ambitious history of modern art. The new histories of art, such as Luigi Lanzi's *History of Italian Painting* published in 1795–6, which by the 1790s began to replace the more traditional compilations of artists' lives, may have leaned heavily on Vasari for their accounts of the Italian tradition through the late Middle Ages and the Renaissance. But Winckelmann's 'classic work', as Lanzi called it, was singled out as the inspiration for establishing a new history of art that would define larger patterns of historical development and seek to explain how and why the visual arts evolved in the way they did, rather than merely provide a chronological survey of biographical facts.[5]

When Winckelmann's revised edition of the *History* finally appeared in 1776, it already needed to be supplemented and corrected on countless points of fact. But for several decades it was not superseded. Even after vital evidence in the form of original early Greek sculpture from Greece and Asia Minor became available in the early nineteenth century and put the study of early Greek art on a new empirical basis, Winckelmann's periodization of ancient Greek and Roman art still retained its hold. His work continued to define the parameters of any larger historical synthesis of the antique tradition. France's most important classical art theorist of the period, Quatremère de Quincy, put this forcefully when in 1820 he was supposedly paying tribute to the antiquar-

ian scholar E. Q. Visconti, who was then seen as Winckelmann's principal successor. More than a half a century after Winckelmann's death, Quatremère made clear, his *History* remained a major presence and inspiration:

> it was precisely the pretension of the work to appear to be what it could not be, and precisely again this title [the history of art] that constituted its success and merit. Yes, the name of history was a grand idea and produced a grand effect. It devalued the narrow methods of the antiquarians, who saw only one fact and object after another, and had no sense of the connection between them. It took the mind into a vaster sphere of observation. If the plan was out of proportion to the means, it was already a lot to have offered to those working in the field the coherence of a regular plan, to have brought back to a common centre all those researches that, endlessly diverted, were losing themselves in the arid deserts of a vain curiosity.[6]

In the period around and just after 1800, when Winckelmann was effectively institutionalized as the father of a new archaeology that replaced the earlier antiquarian study of iconographical motifs and textual sources, Quatremère's was very much the orthodox view. The German classical scholar, Friedrich Wolf, made the point in a tribute to Winckelmann published by Goethe in 1805: 'We are in no way claiming that [Winckelmann's attempt to define a history of Greek art with reference to the surviving monuments of antiquity] was an unqualified success, yet he showed, and was the first to show, how antiquities were to be ordered on the basis of their manifest characteristics in a sequence of rise and decline, regulated according to taste, style and workmanship.' If his *History of Art* needed to be corrected on many points of detail, and Wolf was particularly critical of Winckelmann's speculative attempts to date famous antiquities to the earlier phases of Greek art, it still established the 'larger foundations, which stand immovable and firm'.[7]

It was in these years around 1800 that the conceptual foundations of Winckelmann's new system first came to be examined critically. As we shall see in the next section of this chapter,[8] a counter-current emerged within archaeological studies, which sought to establish a radical alternative to his historical schema. At issue was his insistence that ancient Greek art had only truly flourished for a relatively brief period in the fifth and fourth centuries BC, and since then had gone into inexorable decline. Why was it necessary to assume that the antique tradition had not been able to sustain a level of classic excellence until Roman Imperial times, the period from which most of the best-known antique sculpture derived? However, even one of his more adamant critics, who advocated completely jettisoning his larger pattern of rise and decline, the German scholar Friedrich Thiersch, still presented him as a figure 'from whom the source of the light first went out, that since has illuminated the art of antiquity'.[9] Winckelmann, it seems, was to be credited with setting in train a whole new historical project, even in the view of those who thought he had got it wrong.

Curiously, the move radically to dismantle Winckelmann's historical paradigm proved to be relatively short-lived. After an initial flurry in the first two decades of the nineteenth century, archaeological scholars tended to accept the basic logic of Winckelmann's model, and the attempt to constitute a new history generically different from his was effectively abandoned. The finds of early Greek sculpture that were coming to light in ever larger quantities were simply slotted into his larger schema—an archaic phase, followed by a relatively austere early classic phase identified with the art of Phidias, then a more graceful or sensuously beautiful later classic phase associated with Praxiteles, and finally a long phase of imitation and decline in Hellenistic and Roman Imperial times. By the time Carl Justi came to publish his classic monograph on Winckelmann in 1867–72, this schema had come to be seen as so self-evidently true that Justi no longer perceived Winckelmann as having invented it. He envisaged Winckelmann's *History of the Art of Antiquity* as a great achievement, but one so superseded by subsequent archaeological scholarship that it no longer had any direct bearing on modern understanding of the history of Greek art. He was quite simply blind to the fact that Winckelmann had fabricated a new schematic model because it still underlaid his own picture of how ancient Greek art developed.

Indeed, Winckelmann's speculative history of classical Greek sculpture, though it was based on the evidence of statues that have subsequently come to be regarded as inferior Roman copies or adaptations of earlier Greek work, has stayed around for a remarkably long time. Even now it persists in standard handbooks of Greek art.[10] His larger pattern of rise and decline also provided a very influential model for the more systematically historical understanding of art that was established in the nineteenth century. The idea of conceptualizing an artistic tradition in terms of an evolution through archaic, classic, and decadent phases proved to be hugely influential.[11] This paradigm now comes into view for us as something that needed to be invented because it has been so thoroughly questioned and discredited over the past few decades, along with a whole panoply of related historicist assumptions about the inner logic of history.

In addition to Winckelmann's major scholarly achievement in synthesizing a new historical account of ancient art, a further aspect of his work played an important role in late eighteenth- and early nineteenth-century European culture. Winckelmann gained a reputation among a substantial public that would not even have attempted to tackle the scholarly detail of his *History of the Art of Antiquity*, one that included artists and patrons as well as artistically minded tourists visiting Italy. His eloquent and at times passionate discussion of the beauties of the art of antiquity became a major point of reference for the classical revival of the late eighteenth century. He was the single best-known classical theorist of the period, and in retrospect came to be seen as a forerunner of the Neoclassical taste that emerged in the visual arts after his death. The impact made by his writing had to do with both the canonical status of the

antique in the art theory of the time, and also with the ritual significance for the educated classes of visiting and admiring the antiquities of Rome. What the Sistine Chapel is today for the tourist to Italy, the celebrated masterpieces of antique sculpture in the Vatican Belvedere, namely the Apollo, the so-called Antinous, the Laocoön, and the Torso (Plates 19, 4, 16, 36), were for the artists, patrons, and men and women of letters on their cultural—and often also sexual—pilgrimage to Rome.[12] The lyrical descriptions of these works Winckelmann incorporated in his *History* were easily his best-known pieces of writing, and they were quoted and paraphrased in general guidebooks as well as in publications on the antique. He became the model for defining the admiration, enthusiasm, and depth of response elicited by these masterpieces of art.

Winckelmann's own formation echoed the different strands in the reputation he enjoyed as a writer. While his education, and an early career as a teacher and librarian, gave him a solid background in antiquarian and classical scholarship, he also came into close contact with the art world when, just before leaving Germany, he began to discover his *métier* as a theorist and historian of the visual art of antiquity. In Dresden he was taken up by the court artist, Adam Friedrich Oeser, to whom he dedicated his first publication, the polemical essay *On the Imitation of the Greeks*, a passionate call to imitate a Greek ideal whose sensuous male beauty he knew only at several removes in the form of engravings, casts, and verbal descriptions. After arriving in Rome in the winter of 1755, he established a close relationship with Anton Raphael Mengs, who was then gaining an international reputation as one of the foremost classicizing painters of his time. The two worked together on a treatise on the taste of the ancients in art that was to consist of extended analyses of the most famous sculptures in Rome. This project, though never realized, laid the basis for Winckelmann's descriptions in his *History*.

His formation also played a significant role in the cult that surrounded him as a writer, for reasons that had little to do with his scholarly or artistic interests. His life fascinated his contemporaries because of his almost unparalleled rise from lowly origins, as the son of a cobbler in provincial Prussia, to internationally renowned man of letters with a respected position as Commissioner of Antiquities at the papal court in Rome. Success did not come easily, and was preceded by a long period of obscurity when he immersed himself in an ambitious programme of reading in classical literature and the scholarly and scientific writing of his time.[13]

His first job after completing his university studies in Halle and Jena was as a private tutor and then as a schoolmaster in the small, out of the way town of Seehausen, near his birthplace, Stendhal. It was only at the age of thirty that he acquired something of the status of a professional scholar when he was appointed as a librarian to Count von Bünau, an important figure at the Saxon court. Even here he was working on a project, gathering material for his patron's history of the German Reich, in which he had little interest or affection. Moreover he was based in the small town of Nöthnitz at some remove

from the court in Dresden. Regular commerce with court circles only became possible once he decided to leave his patron's service and settle briefly in Dresden before departing for Italy in 1755. His first publication appeared when he was thirty-seven, just prior to his leaving Germany for good. The circumstances under which he made this move were still far from assuring him a secure future. He was obliged to convert to Catholicism in order to become eligible for patronage by the Catholic establishment in Rome, and in his early days there he lived on a relatively hand-to-mouth basis, helped by a small and irregular stipend from the Saxon court until he entered Cardinal Albani's service in 1758.

It was with the publication of *The History of the Art of Antiquity* early in 1764 that he really arrived professionally. Even then he continued to feel a certain pressure to validate his status as a scholar. In 1767 he produced a rather conventional exercise in scholarly erudition, a two-volume catalogue of antiquities called *Unpublished Antique Monuments*, which was conceived by him in large part as a demonstration to his Italian patrons and the international community that he had fully mastered the standard techniques of antiquarian scholarship. In the end the outward signs of a successful scholarly career came his way only a few years before his early death in 1768 at the age of fifty.

His murder, under circumstances that seemed particularly brutal and senseless, shocked the cultural establishment of Enlightenment Europe, and added further drama to a career that made the man as well as the writing such a source of interest in the later eighteenth century. His death had long-lasting reverberations,[14] and even very recently resurfaced in the popular imagination. When the film director Pier Paolo Pasolini was killed in an incident with a working-class Roman youth, the Italian press drew a parallel with Winckelmann's murder in Trieste. The lure of the mythology associating gay sex with physical violence proved irresistible. A reading of the extensive documentation of the court proceedings, however, suggests that the murder was a violent robbery gone badly wrong.

Whatever happened, it seems unlikely that Winckelmann died for love. He had struck up contact with his murderer, Franceso Arcangeli, because the two were staying in the same hotel in Trieste. Both were waiting for boats, Winckelmann for one that would take him to Ancona on his way back to Rome, Arcangeli for one to Venice, where his wife lived, but he had no money to pay for his passage. Winckelmann showed Arcangeli the gold medals he had received from the Habsburg court, apparently in order to convince him that he was a person of some substance without actually revealing who he was. Later, in a deliberately premeditated act, for which he had equipped himself with a rope and a knife, Arcangeli tried to seize the medals from Winckelmann, who was physically tougher than he had reckoned. In the violent scuffle that broke out he ended up stabbing Winckelmann several times in the abdomen.

Had Arcangeli known about Winckelmann's homosexuality, it would presumably have been in his interests to suggest, when he was giving evidence in

court, that he had assaulted Winckelmann because he had occasion to believe
that Winckelmann was a 'sodomite' or 'pederast'. Equally he may have been
cowed into silence by the high-profile nature of the judicial proceedings that
resulted from Winckelmann being such an important figure. He did make a
point of claiming that he had not deliberately picked on Winckelmann, but that
Winckelmann had been the one initially to seek out his companionship. When
he tried to justify his conduct, he said he had become very suspicious of
Winckelmann because he was so brazenly irreligious and so secretive about his
identity.

In these accusations there could easily be innuendoes of supposed sexual
immorality that we as modern readers are not picking up quite as clearly as a
contemporary might. Winckelmann could conceivably have been the victim of
a gruesome outburst of 'homophobic' prejudice. Arcangeli perhaps reckoned
that Winckelmann's 'sodomitical' tendencies put him beyond the pale, and
gave him a licence to rob and physically threaten him. What he had not counted
on was Winckelmann's status, disguised by the very modest circumstances in
which he was travelling, nor the accidental turn of events that made physical
assault degenerate into full-blown murder.[15]

To return now from the life and death of the man to the afterlife of the work:
the immediate significance of Winckelmann's reconstruction of the Greek ideal
had very much a double aspect. On one hand, his writing enjoyed such success
precisely because it provided a synthesis of received wisdom about the art of
antiquity. It brought together, within the scope of a single book, a vast body of
factual knowledge about the visual artefacts of antiquity, it showed how an-
cient Greek art related to what was known about the political history and
literary culture of the ancient world, and it also offered an unusually eloquent
apologia for the aesthetic significance of the Greek ideal. On the other hand,
Winckelmann's new synthesis did much more than just add further lustre to a
long-standing cult surrounding the art of classical antiquity. By giving this art
a historical specificity it did not have before, he also pointed the way to making
its value as the most appropriate model for emulation in the present appear
problematic.

It was not uncommon, even before Winckelmann, to see the highest and
purest manifestations of the antique ideal as Greek rather than Roman. But this
distinction was only rarely seen as a historical one. Greek art was not necessarily
defined as being early Greek or pre-Roman in origin. Sculptures were Greek if
they were ideal representations of mythological figures, distinguished by their
nudity or by ideal drapery that revealed the forms of the nude. Greekness was
above all a generic category. The more celebrated 'Greek' works, statues such
as the Venus de' Medici or the Apollo Belvedere (Plates 19, 25), are ones we
know to be Graeco-Roman adaptations or copies. There was a tacit recognition
of this in that no clear-cut distinction was made between art that might have
been produced in Greece in the classic age of Greek culture—documented
examples of which only came to the attention of archaeological scholarship
much later—and art in a 'Greek' mode produced in Roman Imperial times.

Winckelmann created a framework in which the distinction between Greek and Roman art took on a more modern significance. He effectively asked a new question of the so-called 'Greek' sculptures excavated in Italy: were they truly Greek in origin, or were they later copies or echoes of a lost early Greek ideal? Though the evidence available at the time he was writing did not allow a categorical answer to this question, nevertheless, as Quatremère pointed out, Winckelmann's analysis made the question one that, in the end, could not be evaded. With Winckelmann, the true Greek ideal was identified with one moment in the history of the ancient world, the so-called classic period of the fifth and fourth centuries BC, and not with some larger Greek and Roman tradition extending from the time of Pericles to the time of Augustus and Hadrian. Winckelmann himself was not in a position to draw out the full implications of this, if only because he did not have to hand the examples of early Greek sculpture that began to enter Western European museums in the early nineteenth century and made possible an empirical comparison between original Greek work and Graeco-Roman copies and adaptations.

Winckelmann's historicizing of antique sculpture had one other very important dimension. His history of art represented the Greek ideal as an integral part of the fabric of early Greek culture. His success in giving so-called Greek sculpture this added resonance for an audience that still saw the antique as a model for imitation in the present depended paradoxically on his analysis not being consistently historical in the sense that we would understand the term. He represented the Greek ideal as simultaneously the product of a long-lost moment in the early development of human culture and a supreme fiction that stood above history. It could only be imagined within the context of a history that was itself in some sense ideal. Winckelmann's analysis is so interesting because he did recognize that he could not entirely abolish the tensions between art as ideal and art as historical phenomenon. Indeed he internalized these tensions within the very structure of his history of Greek art. If classical Greece was a uniquely privileged moment in human history, Greek sculpture as a material reality, as manifest in the actual course of its historical realization, was for Winckelmann always in some sense necessarily incomplete. Over the next few chapters we shall be exploring the complexities of his account of the culmination of the Greek tradition in the classic period, in which he both imagined the coming into being of an ideal art and registered the impossibility of such an ideal ever being fully realized in all its oneness and perfection.

The way Winckelmann represented the Greek ideal as embedded within the larger totality of Greek culture was particularly important for the impact his writing made on German thought of the late Enlightenment and early Romantic periods. A number of the better-known German idealist writers, including Herder, Goethe, the Schlegel brothers, and Hegel, to name but a few, were avid readers of his *History*. They were all inspired by his account of the Greek ideal when they began to imagine a historical divide separating ancient from modern culture. They were the first fully to historicize the antique ideal, defining modern culture as the antithesis of the integrated wholeness of ancient Greek

culture, of its naïve simplicity and centredness, and of its unmediated relation
to itself and nature. Although this is implicit in Winckelmann's account of
ancient Greek art, the idea that the antique was irredeemably alienated from the
present would have been unimaginable for him.

Winckelmann inspired these later thinkers partly because he succeeded in
vividly presenting classic Greek sculpture as the visual embodiment of the
larger values thought to be inherent in Greek culture as a whole. For his more
intellectually adventurous readers, he demonstrated how the ideal Greek nude,
both in its purely visual aspect—the simple white marble forms—and in the
human subjectivity implicit in its image of the human body—that 'first naïve,
unperplexed recognition of man by himself', as Pater put it[16]—could be con-
ceived as the image of some ideal other to the tension-ridden complexity and
self-consciousness of the modern. Indeed Winckelmann's ahistorical perspec-
tive on the Greek ideal continued to live on in these later, apparently more
sophisticated analyses, for it was the very unhistorical integration and whole-
ness attributed to the antique Greek that made the modern appear so alien from
its classic past.

When Hegel looked back in his lectures on aesthetics to define the signifi-
cance of Winckelmann's analysis of ancient Greek art for his generation, it was
above all Winckelmann's larger understanding of the aesthetics of the Greek
ideal that he singled out, the way Winckelmann defined Greek art as not just
important in and for itself, but as symbolic of the 'highest interest of mankind'.
According to Hegel, Winckelmann succeeded in representing art as a phenom-
enon that transcended the narrowly professional concerns of the art world, and
made it the basis for analysing some of the fundamentals of human culture and
philosophic self-awareness:

> Winckelmann was inspired by his contemplation of the ideals of the ancients
> to fashion a new sense for contemplating art, which saved art from perspec-
> tives dictated by common aims and mere imitation of nature, and set up a
> powerful stimulus to discover the [true] idea of art in art works and in the
> history of art. For Winckelmann is to be seen as one of those who managed
> to open up a new organ and a whole new way of looking at things for the
> human spirit.[17]

Hegel concluded this appraisal with the surprising comment, 'Yet his [new]
outlook has had little influence on the theory and scholarly study of art.' In a
sense Hegel was right. Winckelmann's *History* had become the model for
writing a new kind of history of art that seemed to take it outside the narrow
confines of the art world and antiquarian scholarship. Yet no one following in
Winckelmann's footsteps, except perhaps Walter Pater, managed to bring
off what he had done. No one quite succeeded in producing a historical analy-
sis of an artistic tradition that was as resonant as his, that truly functioned, as
his *History* had done, as a point of reference for those engaged in larger

speculation about the present-day significance of the artistic and cultural ideals of the past.

This said, it was above all through the new paradigm he provided for the specialized scholarly study of ancient art that Winckelmann's writing was nevertheless guaranteed a lasting presence. This paradigm had its most significant impact on archaeological studies at the same moment that the intensive engagement with his picture of ancient Greek art as a symbolic cultural ideal took place, the very end of the eighteenth and the early years of the nineteenth century. In the years around 1800 Winckelmann's *History* came to be presented as superseding earlier histories of art. His example was seen as making a new, more systematic, historical study possible. To put it another way, the model established by Vasari, which had served the specialist discussion of both ancient and modern art perfectly well until the Enlightenment period, was now partly displaced by a more systematic conception of the total history of an artistic tradition. It was at this point too that a form of high Neoclassicism was institutionalized that picked up on Winckelmann's representation of the 'Baroque' and 'Rococo' art of the seventeenth and eighteenth centuries as fundamentally corrupt, the product of a tradition in decline. The purer classicism of the late eighteenth century, represented by artists such as Canova and David, was hailed in Winckelmannian terms as a radical renovation or revival of art based on a return to a true classic ideal. Winckelmann's elaborately conceived picture of the rise and decline of the Greek ideal in the ancient world acquired a whole new resonance as it came to be linked in this way to an understanding of art in the present.

Winckelmann's *History* is fascinating now because of its paradoxical status in relation to its appropriation by later art theory and art history. It clearly functions as the origin and foundation of a new kind of history of art based on ideas of systematic historical development, and seems to usher in the new historicizing outlook that took over the understanding of the visual arts in the early nineteenth century. At the same time, however, it resolutely defies being assimilated within this tradition. Winckelmann undoubtedly did invent a highly influential new paradigm. But the larger logic of his history of ancient art became something very different when, forty to fifty years after his death, it was conceived as initiating a break with previous understanding of art and its history. His later inheritors of course saw him as a transitional figure whose conception of art was as yet incompletely historical. Ironically, from our perspective, a careful reading of his *History* exposes some of the epistemological shakiness of subsequent understanding of historical process. Winckelmann's writing both lays the foundations for later art history and the historicizing of the visual arts that went with it, but equally it throws into question the very monument erected on those foundations.

To put it another way: the new ideal of understanding the past entirely on its own terms, which emerged in the early nineteenth century, was seen at the time as making a structural advance on the ahistorical outlook of the Enlighten-

ment. No longer was the rich fabric of history artificially schematized by values and priorities taken from the present. But for all this, the nineteenth-century historicists did not abandon the idea of defining an inner logic that would hold together the disparate empirical details of history. If anything, there was a tendency to insist more strongly than before on the logic of historical development, to see this as having a truth and coherence all its own. But in telling their stories of the rise and decline of past cultures, the historicists imagined they were uncovering the true shape of history, not imposing an abstract pattern on it. The logic of history they 'discovered', despite its remarkable similarity to the schematic constructs of their Enlightenment predecessors, was envisaged by them as a palpable reality embedded in concrete fact, uncovered by the historian who immersed him or herself fully in the rich complexity of the past. The relation between a narrative that gave history a larger significance and the available evidence could thus be seen as unproblematic, at least in theory.

Ruskin, for example, was confident that the decline of Venetian Renaissance culture could be revealed directly to him in the artefacts produced by the Venetian republic in its later years.[18] Winckelmann's account of the rise, flourishing, and decline of Greek art exposes its epistemological problems more openly than Ruskin's history, not because he has any greater powers of critical self-awareness, but rather because, coming at the moment he did, he could not have the same confidence that the system he was erecting was lodged directly in the very nature of things.

Winckelmann is particularly intriguing because he defined a new history of art in terms that are formally remarkably similar to later histories, and at the same time he dramatized the fault lines in the very systematizing of history he effected. How did this come about? In part it was precisely because he pushed his model so far, and indeed took it to its very limits. The deconstructions his history enacted were at one level unconscious effects of his overriding commitment to system. Such a sustained attempt to integrate the disparate bits and pieces of ancient art in a formally and ideologically coherent whole brought to the surface contradictions inherent in a project of this kind which would not have been apparent in less rigorously pursued system-building.

The deconstructive logic reverberating within the ambitious structure of his edifice, however, had a conscious dimension as well. Winckelmann's sense of history, and his particular understanding of system, contained a current of scepticism and ironic self-awareness that was integral to the intellectual world of his more astute Enlightenment contemporaries. His history and pattern-building were lodged in a characteristically Enlightenment epistemology that could not as yet take on faith the belief in the larger logic of history that was internalized in nineteenth-century historical thought. Before proceeding to this issue, however, let us first try and clarify the precise sense in which Winckelmann can be said to have invented a new paradigm when he wrote a history of art that systematically redefined people's understanding of the art of the ancients.

A NEW PARADIGM

If we say that Winckelmann's *History of the Art of Antiquity* lies at the point of origin of a modern art history, does this mean that it marks a transition from an Enlightenment view of art to the more self-consciously historical outlook that emerged in the Romantic period? Did his endowing the Greek ideal with a history reposition it so that it could not continue to exist as a universal model of excellence, valid for all time, but came to be seen as the product of a particular moment in the past, itself subject to historical change? Is it the case that Winckelmann set in motion a historicizing of the antique?[19]

Winckelmann's history of art fulfils such a role only in a deeply paradoxical way. His analysis of the rise and decline of ancient art unequivocally represented the best of this art as emerging at a uniquely privileged historical moment, and would thus seem to represent the prospect of any genuine revival in modern times as highly problematic. In apparent contradiction, however, he was quite explicit that his overriding purpose in defining a new history of ancient art was to prepare the way for a true revival of the Greek ideal in the present.[20] He simultaneously threw into question and reaffirmed the belief, central to traditional aesthetics, that the classic art of antiquity could exist as an integral part of the cultural fabric of modern society. What we seem to have is an intellectual enterprise poised at an acute point of tension between ahistorical and historicizing paradigms that to us are incompatible.

This suggests that we might do best to envisage Winckelmann's history of art in terms of a model of historical rupture, as a project torn between two competing world-views—on one hand, an Enlightenment view of an order of things fixed for all time, to which both the modern and the classical world belonged, and within whose parameters any conceivable historical change could only be cyclical; on the other, a later historicizing view in which historical development was envisaged as open-ended and modernity conceived as structurally different from the classical past.[21] So poised at a moment of rupture, Winckelmann's enterprise would become radically incoherent, with bits of one world-view existing alongside bits of another quite at odds with it.

If Winckelmann's analysis is to be taken seriously, however, he must be seen as having some conscious understanding of these tensions, not entirely at their mercy. He would have to be negotiating them as problems that he could at least begin to articulate within the paradigms of his own culture. Indeed Winckelmann's history of Greek art is best seen, not as effecting a clear departure from traditional ahistorical classical aesthetics, so much as articulating an unease or tension already existing within that aesthetic. There is less of a raw break between the prerogatives of history and the timeless imperatives of the classical involved, than a rethinking of the classical ideal's as yet unquestioned status as a universal model, which exposed an incipient doubt about the possibility of fully emulating it in the present. This ambiguous relation to later historicizing aesthetics is quite consistent with Winckelmann's conceptualizing

of his history of ancient art. His patterning of the rise and decline of art formally looks more like later histories of art than those of his own time. Yet his idea of what a history should be, in other words the ideological underpinning of his analysis, has most in common with Enlightenment thought. His larger outlook on history and culture is closer to Rousseau, Voltaire, and Montesquieu[22] than it is to the German idealists and Romantics, such as Goethe, Friedrich Schlegel, and Hegel, however much their ideas on the irreducible historical difference between ancient and modern culture derived from an intensive engagement with the myth of ancient Greece he traced so vividly.

Nevertheless, Winckelmann did make a major departure from earlier practice when he quite literally invented a new model for conceptualizing the history of ancient Greek and Roman art, and it is important to try and understand precisely in what sense he did so. Where previously there had been vague speculation about the overall rise and decline of art in antiquity, he identified a systematic pattern in which ancient art evolved through a sequence of clearly defined phases. The key moment in this history was a classic period coinciding with the so-called golden age of Greek culture extending from the end of the Persian Wars in the earlier fifth century BC to the time of the Macedonian invasion of Greece in the later fourth century BC. This culminating phase was framed on one hand by a steady progress from stylized archaic origins to a mastery of naturalism and beauty of form, and on the other by a gradual decline through imitation, excess, and outright degeneration. By way of this schema, ancient monuments that previously had been classified almost exclusively on an iconographical basis, according to their subject-matter, began to be categorized stylistically, according to their period of origin. Whether a work dated from the best classic phase of Greek art or whether it was a later imitation began to become an issue some time before 'hard' evidence in the form of certified early Greek work had become available.[23]

In elaborating this new history of ancient art, Winckelmann was engaged quite literally in a scientific problem-solving exercise. He was having to gather together all the disparate bits of evidence that could be culled from ancient literary sources and from the surviving monuments of antiquity, and fit them together into a coherent picture of phased historical development. It would be appropriate to describe Winckelmann as inventing a new paradigm in the strict sense in which that term is used in the history of science, a paradigm that reorganized the evidence relating to the art of antiquity on a new, systematically historical basis.[24] But to what extent did this paradigm have broader implications, which went beyond the confines of the science of archaeological studies? Could it be seen as part of a general shift towards more self-consciously historical ways of thinking about art and culture that emerged in the very late eighteenth and early nineteenth centuries?

Seen from a long-term perspective, the model developed by Winckelmann to define the history of ancient art did have quite radical implications for the

broader conceptualizing of art. He provided a new way of defining an artistic tradition in terms of processes of historical development. He also set a precedent for a novel fusion of history and aesthetics, in which the essence of a tradition would be located historically at a single privileged moment when it supposedly achieved perfection.[25] Winckelmann made the history of art an issue in a way that it had not been before. Yet it was only sometime after the initial publication of his history of art that it came to be seen as throwing into question some of the basic tenets of classical art theory. The terms in which the larger implications of his *History* were understood underwent a major change in the years around 1800, when historicizing aesthetics started gaining ground. The difference is a particularly important one for us, because what we might identify as interesting about Winckelmann's history of art runs very much against the grain of this later appropriation of it. It might be tempting to define the significance of his formalization of the history of art in terms of its uptake in the very late eighteenth and early nineteenth centuries, because it was then that it had its most highly charged ideological reverberations. Only then, not in the immediate aftermath of its publication, did his reconstruction of the art of antiquity, his account of its rise, flourishing, and passing away, start to suggest that the relation between contemporary art and its classic models in the past might be deeply problematic.

Two key issues came to be associated with the new history of art defined by Winckelmann in the period immediately after the 1789 French Revolution, which were not seen to be problems in the same way by Winckelmann and his contemporaries. The first can be defined in terms of a question: was classical art and culture historically alienated from the present, or was it still available as a universally valid model? The second concerned the place of the art of the present within the larger history of modern art since the Renaissance. The parallel Winckelmann drew between the rise and decline of ancient art and modern art would seem to place the art of his own time at the end-point of a long process of decline that had set in after the golden age of the High Renaissance.[26] Yet he continued to look forward to a renovation of art based on a re-engagement with the Greek ideal. Winckelmann thus suggested that modern art was like that of the Roman Imperial period, locked in terminal decline, while at the same time, and without apparent inconsistency, he could project his book as an inspiration to the present to bring alive once again the true art of classical Greece. It was not until the end of the century that it began to seem necessary to force a clear choice between these alternatives, and envisage the situation of the contemporary artist as determined by imperatives of some larger history of rise and decline in which he or she was ineluctably caught.

In the Enlightenment period there was an easy cohabitation of ideas about the state of contemporary art and culture which later came to be seen as contradictory. Art was seen as both totally corrupt and on the point of giving birth to a new flowering. Later cultural theorists of a more historicizing cast of mind worked in a context that forced a choice, often in the direction of a

cultural pessimism that viewed modern culture as radically alienated from the classical past and caught in a long-term process of decline.[27] The opposition between hope for a new cultural awakening and a sense of unavoidable deterioration and decline, between a fascination with the 'modernity' of contemporary culture and a perception of it as worn out and degenerate, became ever more acute, to the point where the contradictory thrust of these alternatives had to be negotiated. This was not yet the case in the period when Winckelmann was working. Just as initially Winckelmann's historical placing of Greek art was not seen as implying problems for contemporary attempts to revive it, so Winckelmannian ideas about the systematic rise and decline of art did not yet seem to condemn contemporary art to being necessarily inferior to the supposedly classic art of the modern period, that of the Italian High Renaissance.

For the shift that occurred to a more historical understanding of the prospects open to modern art, the period of the French Revolution was crucial. It was then that the cultural politics of Winckelmann's history of Greek art really began to take on a different meaning. Political freedom, which Winckelmann saw as one of the main factors encouraging the flourishing of art in Greek antiquity, became a burning public issue in ways unimaginable for an intellectual of his period. Radical Jacobins saw Winckelmann's picture of ancient Greek art as an inspiration for their hopes of reconstituting a free republic on the model of the antique, which would again inspire true art and culture. Conservatives, on the other hand, sought to historicize Winckelmann's notion of freedom and locate it once and for all in the past, as something quite impossible to revive in the modern world, except as an ethical ideal in the mind of the cultivated individual.[28]

In its original context, Winckelmann's history of ancient art was not as yet seen to be articulated by this highly politicized division between 'reactionary' historicism and hopes of 'revolutionary' rebirth. His history could be read as an invitation to strive for a rebirth of true Greek art by looking forward to the return of the free political culture that had fostered it in the first place. Equally it could imply that modern art would never be able to emulate its ancient models and was locked forever into terminal decline and decay. For those writing in the aftermath of the French Revolution, in a politically and culturally different world from Winckelmann's, such implications were the nub of the matter. Winckelmann's account of the rise, flowering, and decay of Greek art became a testing ground for theories about the progress and decline of art, which were now seen, particularly in France and Germany, to be of direct relevance to assessing the future prospects of modern art.

The ideological impetus that Winckelmann's picture of the rise and decline of ancient art had within the context of his own culture was rather different. A deep ambivalence as regards the prospects of progress or decline was an important aspect of Enlightenment thinking.[29] For many Enlightened intellectuals, hopes of improvement, of positive rational change and reform, alternated with anxiety over decline, and a sense of the profound irrationality and corruption of

modern art and culture. It often seemed that a better, more enlightened future was on the horizon. At the same time there was a strong sense of being trapped within an old, tired, and decaying society, where positive impulses for change would inevitably be stifled by the persistence of antique, irrational institutions and customs. There was no consistent basis for imagining a long-term transformation of modern society and culture, and hence little for identifying within present-day culture some clearly defined possibility of future progress or decay. Enough changes were taking place within the social fabric, however, and particularly in the status and self-image of the intellectual, for such people to be fixated by the divergent alternatives of progress and decline. The present invited comparison with, but did not quite fit, those moments in the past when culture and society seemed to be subject to a systematic process of historical change, such as the decline of the ancient world during the period of the later Roman Empire, or the rise of modern art culture in Italy during the Renaissance.[30]

How Winckelmann's new paradigm related to later, more historicizing conceptions of art and culture is best clarified by considering its changing reception and appropriation. When the *History of the Art of Antiquity* first appeared it was greeted with great enthusiasm as by far the fullest and most illuminating account to date of the art of the ancient world. Winckelmann was credited with being the first fully to define the history of ancient art. The new picture he presented was not seen in any way to break with past understanding, but rather to effect a brilliant amplification of earlier ideas on the nature of the classic ideal and its history.[31] There were many criticisms of the details of his scholarly analysis, in part encouraged by Winckelmann's own virulently intolerant attitude towards the factual slips of his predecessors, but almost nothing in the way of a wholesale critique of the conceptual underpinning of his history. The broader pattern of historical development he elaborated was assumed to be self-evidently true. And far from being seen as problematic for the emulation of the Greek ideal in the present, his history was seen as helping to establish the universal validity of this ideal on a more solid basis than before.

The only exceptions to this early pattern of reception were German. Both were given a focus by the competition organized in 1777 by the Academy of Antiquities in Kassel for an essay evaluating Winckelmann's contribution to antiquarian studies. One of them came from the classical scholar, Christian Gottlob Heyne, whose prize-winning essay was soon made widely available in both French and German.[32] The second came from Johann Gottfried Herder, who offered a broader cultural analysis of Winckelmann's approach from an unusually precocious historicizing perspective. Though Herder's contribution to the competition remained unpublished in his lifetime, its basic contents were disseminated in other published commentaries by Herder on Winckelmann.[33]

Heyne was the only early commentator on Winckelmann to argue categorically that Winckelmann's claim that ancient art entered a period of sustained decline after the classic phase of the fifth and fourth centuries BC was not

corroborated by the available evidence, verbal or visual, and was what we would call an ideological assumption. Heyne's own stance was itself no less ideological, for he took issue with Winckelmann's idea that the loss of the Greek city states' political freedom, and the institution of a monarchical system of patronage in the Hellenistic period, necessarily brought with it a decline of art. Nevertheless he was making a methodological point, questioning Winckelmann's application of a simple pattern of rise and decline to define the entire history of the ancient Greek tradition and its continuation under the Roman Empire. He argued that, in the absence of any body of work clearly datable to the earlier phases of Greek art, it remained uncertain whether the very finest products of the Greek tradition necessarily dated from the so-called classic period, and whether work of a later period, from which almost all existing antiquities originated, might not be of equal quality.[34]

Even while making this critique, however, Heyne did not contest the basic validity of the larger pattern of rise and decline presented by Winckelmann. He was arguing that the fit between this pattern and the detailed visual evidence could not, in the present state of knowledge, be as fully defined as Winckelmann wished. In the final analysis, Heyne was not so much expressing opposition to the conceptual underpinning of Winckelmann's history of art as asking for more rigorous scholarly procedures in reconstructing such a history in its earlier phases, where evidence was very thin on the ground.[35]

Herder's critique was of a more general philosophical nature, though he too was particularly troubled by what appeared to be an uncertain fit between the existing evidence and the larger historical pattern Winckelmann conjured up — in other words, between a straight historical chronicling of factual detail, which Herder took to be the essence of empirical history, and an understanding of the larger logic of history. He characterized Winckelmann's project as a *Lehrgebäude* or system rather than a historical chronicle, and at one point even questioned whether it was a history in the strict sense of the word. In the end, Herder was able to accept Winckelmann's basic schema on the grounds that it was based on an understanding of the essence of art and the nature of historical change, and did not therefore depend upon the contingencies of empirical verification for its validity.[36]

The most original aspect of Herder's analysis was the concern he raised about a conflict between representing the Greek ideal as the very model of artistic perfection, an assumption even he never challenged, and the imperatives of a properly historical analysis of the different kinds of art produced by the peoples of the ancient world. Herder raised the important issue that a historical and an aesthetic analysis of art need not necessarily reinforce one another. What principally concerned Herder was the need for the historian to give due credit to distinctive forms of ancient art that differed from the Greek ideal. Historical analysis, he believed, required a certain relativism of perspective, which would allow Egyptian art, say, to be judged in terms of the worldview from which it originated and not according to the rather different norms

of ancient Greek culture. Winckelmann's perspective, which privileged the Greek ideal over the art of other ancient peoples, was aesthetically valid, but not entirely appropriate for a historical study.[37]

Herder made a further important point not as yet explicitly articulated in other contemporary commentary on Winckelmann, namely, that traditional classical doctrine might be rendered problematic by the new history of art invented by Winckelmann. With Herder we see the beginning of that historical understanding of art that came to feature prominently in the nineteenth century.[38] This involved bringing alive the art of the past which seemed particularly compelling to the modern imagination, whether that of classical Greece or the Italian Renaissance or the Northern Gothic, by setting out its history, showing how it came into being and then died out, and how its distinctive excellencies were fostered by conditions peculiar to its particular moment in history. Yet the process of historical reconstruction also gave a vivid sense of the distance separating this art from that of the present, making its direct appropriation or revival as an ideal seem questionable. Herder's response to Winckelmann represents one of the earliest examples of that new conception of the classical tradition in German idealist thought, in which a simple unmediated imitation of the classical ideal was no longer considered possible, only a complex self-conscious engagement with its informing spirit, which recognized that its distinctive forms and conventions were alien to the modern world.

In the new, more ideologically charged engagement with Winckelmann's conception of history that took place in the years around 1800, two distinct schools of thought can be identified. On one hand were the historicists, who insisted that the Greek ideal was locked within a history that made it impossible for modern artists to emulate its highest achievements, just as it had been for the inferior copyists and imitators of Graeco-Roman times. On the other was a small group of polemical anti-historicists. They argued that on the contrary there was no a priori reason to suppose that judicious imitation of the best antique art, combined with the study of nature, would not produce a modern classical art of the highest order, just as there had been no historical fatality in antiquity that prevented artists of a later period from equalling their classic models. With this controversy, Winckelmann's history could be seen as giving rise to a new paradigm that did effect a systematic departure from earlier classic art theory. But it did so precisely because the implications drawn from it ran against the grain of Winckelmann's own consciously articulated theory of art. Issues now came to be raised that would have been inconceivable to someone of Winckelmann's generation—for example, should modern artists be encouraged to stay as close as possible to the Greek ideal, even though they could never hope to rival it, simply in order to keep at bay the corrupting influences of modern culture that were so inimical to true art? It now became possible to speculate whether it might not be better to encourage artists to pursue a different ideal more in tune with modern culture, rather than consign them to

being pale imitators of a past ideal they could never re-endow with the vitality it had possessed in its original context.[39]

Initially, such a debate about the implications of the history of art for assessing the condition of contemporary art was closely bound up with major controversies within classical archaeological studies concerning the historical status of existing examples of antique art. It was in the years around 1800 that Winckelmann's history of ancient art was for the first time seen as seriously threatening the priority accorded to the best known Graeco-Roman master-pieces of ancient sculpture, which were then taken to be the supreme paradigms of artistic excellence. It was becoming increasingly clear that almost all of these dated from the later phases of ancient art, and hence in theory at least should be seen as inferior in quality to the lost art of the earlier classic period. Winckelmann and his immediate contemporaries did not see fit to tackle this issue directly. It was first raised by the painter Anton Raphael Mengs in the 1770s, and remained a largely academic matter until the turn of the century.[40] It began to play a key role in public discussion of antique art once a new, more self-consciously historical perspective began to emerge, and coincidentally, excavations in Greece and Asia Minor made available sculpture that could for the first time be assigned with some certainty to the so-called classic period of Greek art.

These issues came to a head in France in the Napoleonic period during the concerted attempt to formulate a new official government policy toward the visual arts. Post-revolutionary French art and culture was to be represented as the true culmination and continuation of the great classical traditions of the past. The Napoleonic government quite literally appropriated the classical tradition, by seizing all the most famous Graeco-Roman antique sculptures in Italy, which were then seen to be the embodiment of this tradition, and taking them to Paris. Under these circumstances, there was an undeniable pressure to fend off any theory that threatened the exemplary value attaching to these statues and gave greater priority to newly discovered work such as the Parthe-non marbles (Plate 24), which were eventually bought by the British govern-ment.[41] A central figure in the revisionist initiative that sought to protect the status of the Graeco-Roman masterpieces such as the Apollo Belvedere (Plate 19) was E. Q. Visconti, one-time antiquarian to the pope. In 1799 he had fled from Rome to Paris, where he took up a position in the newly opened Louvre, overseeing the collections of antique sculpture.

In the last volume of the catalogue of the antique sculptures in the Vatican, which he published in 1797 just before leaving for Paris, Visconti had already begun to contest Winckelmann's account of the decline of art in the ancient world, arguing against the conclusion Mengs drew from it that the surviving masterpieces of antique sculpture in Rome were necessarily 'inferior' copies or imitations, because the evidence pointed to their being quite late in origin.[42] He began to adumbrate a case for the quality of the ancient tradition being sus-tained well into Roman Imperial times. With his arrival in France, and his

collaboration with the French theorist Eméric-David, this revisionism became more polemical. A systematic alternative to Winckelmann's patterning of the history of art was proposed, in which art was no longer caught in a cycle of rise and decline. The classical tradition was seen as being able to sustain itself almost indefinitely by carefully refining and perfecting the models of excellence produced during its early 'classic' phase. According to this picture, after an initial period of progress to classic perfection, the history of ancient art stood still, protected from cultural and political change, and was maintained by rigorous adherence to a correct doctrine of judicious imitation of early classic masterpieces, enhanced by direct imitation of nature.[43]

This revisionist history deliberately set itself against privileging the earlier phases of a tradition in a way that earlier classical doctrine did not have to. It needed to argue in quite explicit terms that a free imitation of an earlier work could be an improvement on it. This new classicism also had to insist defensively that the quality of the later imitation was not vitiated by its adherence to an earlier model, nor by the historical distance separating its maker from the particular conditions that had brought the earlier masterpiece into being. It now had to be asserted, almost against the odds, that work from a period of republican freedom could be reproduced and improved upon under the enlightened patronage of a Roman despot. In other words, an explicitly ideologically charged point had to be made, that it was possible for a classical tradition to cheat history so long as the art world and its institutions remained faithful to a true artistic doctrine.

Such a theory had obvious attractions as an official ideology in the Napoleonic period, and was also in tune with the academicism fostered by the new Institut de France, which had been founded in the wake of the Revolution to replace the royal academies of the *ancien régime*. It also guaranteed the status of the masterpieces of antique art paraded in the newly opened Louvre museum in Paris.

In the long term, however, the Winckelmannian paradigm, which represented a tradition as always subject to change through a process of rise, flourishing, and decline, and which privileged the supposedly 'purer' earlier moments of its history, did eventually triumph. The alternatives proposed by theorists such as Visconti and Eméric David were very much the product of a period of transition, when a new relationship was being negotiated between the history of art and artistic doctrine, and when antique sculpture still stood at the centre of people's conception of what true art should be.[44] The controversies that surrounded the history of ancient art in the years around 1800 subsided as the so-called masterpieces of Graeco-Roman sculpture began to play a less central role, and the Renaissance and eventually even the Gothic became important as alternative 'classic' moments to that of ancient Greece.

To sum up, Winckelmann's *History of the Art of Antiquity* could be said to represent the art of the ancient world in terms of a new historicizing paradigm, but it also clearly remained within the ideological parameters of an ahistorical

conception of the antique ideal that had prevailed since the Renaissance. In its immediate context, Winckelmann's new systematic history of antique art was not seen to be at odds with the traditional view that the best art of classical antiquity was available in the present for imitation and emulation. Nor was it thought to devalue the exemplary status of the best-known surviving antique sculptures, which were much more likely to have originated from a relatively late, and hence in Winckelmann's terms declining, Graeco-Roman phase than from the classic period. At the same time, it is undeniable that Winckelmann provided later readers with a framework for speculating on these problems, even if only a few of his near contemporaries, such as Herder, began to think through the possible implications of his history in such historicizing terms. Winckelmann's history of art is for us inextricably bound up with the historically conscious outlook on the art of the classical past that began to gain a hold towards the end of the eighteenth century. But since the implications then drawn from his conception of history raised questions about the status of the Greek ideal which Winckelmann himself would not have countenanced, it is perhaps most fruitful to talk of Winckelmann inventing a new paradigm in terms that have specifically to do with the scholarly study of ancient art. He effected a restructuring of the science of archaeological or antiquarian studies that did not of itself necessarily entail a radical shift from prevailing Enlightenment understanding of the history and theory of art.

In putting things this way we are not only avoiding a certain anachronistic projection back onto Winckelmann of cultural constructions of a later period. We are also creating the space for envisaging differences between Winckelmann's understanding of history and the now largely discredited historicizing analysis that took up and built upon his model in the nineteenth century, and viewed the larger pattern of historical development he defined as positivity embedded in the very fabric of historical fact. For us, the important point is not the later amplification of ideas of historical development initiated by Winckelmann but, quite the contrary, the way in which the speculative 'Enlightenment' thrust of his analysis deconstructs the reifying certainties that eventually clustered around his patterning of the history of art.

The paradigm Winckelmann invented, and the new synthesis it provided of the verbal and visual evidence relating to the art of antiquity, persisted for a remarkably long time within classical archaeological studies, and even outlived the controversies surrounding the inevitability of decline after the classic period. From the outset unease had been expressed by the scholarly community over the details of his new synthesis, in particular over his often highly speculative placing of known statues within a schema of historical development. But it was only for a brief time, in the years around 1800, that this unease prompted an attempt to find a systematic alternative to his schema. Ironically, the new direction in archaeological studies that finally eroded the status of Winckelmann's history of ancient art as a classic text was one that took at face value his ideas on the theoretical priority of early Greek art. The increasingly

exclusive focus on early Greek sculpture excavated in the Eastern Mediterranean eventually displaced from view the Graeco-Roman works in Italy that he had so eloquently celebrated.

The publication in 1835 of K. O. Müller's *Handbuch der Archäeologie der Kunst* (*Handbook of the Archaeology of Art*) marks something of a turning-point. Müller's new synthesis signalled that the most up-to-date scholarly analysis of evidence on Greek and Roman art was no longer best achieved by taking over, amplifying, and correcting Winckelmann's picture. Even so, Müller did not throw the basic logic of Winckelmann's schema into question. He still divided the history of ancient Greek sculpture into an archaic phase, a more austere early classical phase, a more refined later classical one, and then a long phase of imitation and decline in the Hellenistic and Roman Imperial periods.[45] Whether this pattern appeared to be credible or not depended more upon the survival of certain assumptions about the historical development of art than on any inductive analysis of the available visual evidence. No such pattern would ever of itself have leapt out of a chronology of the available evidence relating to the art of antiquity.

Where Müller systematically modernized Winckelmann, it was not so much through his empirical knowledge of newly discovered Greek sculpture of the classic period. Rather it was through his ideological insistence that the very best classic art of the age of Phidias could not, as Winckelmann claimed, have preserved vestiges of archaic stylization, but had to embody a true feeling for the rich subtlety of natural form, as, he argued, any fully realized art must. He also represented Winckelmann's history as informed by a sense of the organic wholeness of things, thereby occluding its schematic aspects, which would act as an irritant to his own vitalist conception of historical process. In Müller's words, Winckelmann should be valued for possessing 'a true historical sense, which, basing itself on a feeling for natural and organic life, was able to reconstruct the coherence and the evolution [of ancient art] from isolated traces and remains'.[46]

HISTORY AS SYSTEM

Winckelmann's history of art was, in his own words, 'no mere narrative of the chronology and alterations of art'; rather, it was an attempt 'to provide a system'.[47] The idea of elaborating a system in order to make sense of the empirical diversity of some key aspect of human culture and society was a central Enlightenment project. At this very general level, Winckelmann's *History of the Art of Antiquity* has clear affinities with Montesquieu's earlier *De l'Esprit des lois* (*On the Spirit of Laws*). A system, as Winckelmann conceived it, was both a conceptual construct, deduced from principles that were self-evidently true, and a framework of classification derived inductively from the material evidence relating to the phenomenon under consideration, in his case

the art of antiquity. It was a theoretical model that would make sense of the available empirical facts, the assumption being of course that the constructs of reason would echo a larger logic ordering the empirical world.[48]

What is unusual about Winckelmann's system in the context of its time is not its epistemological underpinning, nor his ambition to define some aspect of culture or society by way of a set of basic types or categories. It is the idea of structuring the history of a culture or a society in these terms. When Winckelmann distinguished between the main artistic traditions of the ancient world, the Egyptian, the Etruscan, and the Greek,[49] as representing generically different styles of art, he was being relatively conventional. His schema was in this respect broadly analogous to Montesquieu's attempt to provide a typology of basic systems of law—tyrannical, republican, and monarchical.[50] Where it differs is in his conceiving the history of the Greek tradition as similarly structured by a systematically conceived pattern. Reversing standard Enlightenment thinking, he saw history as providing the basis for a theoretical ordering of things. His schema defining the evolution of ancient Greek art supplied the conceptual basis for defining generic differences between the art of the different peoples of the ancient world. According to him, Etruscan and Egyptian art differed from developed Greek art in that they had been arrested in their historical development at a moment when art was still marked by archaic stylization. Egyptian art was thus typologically an early archaic art, Etruscan a late archaic or at best transitional art, which had been caught short before it reached the fully developed beauty of classic Greek work.[51]

In the Enlightenment period, the idea of systematically conceived history was usually thought appropriate only to speculation on the origins and early development of culture, as in Vico's *Scienza nuova* (*New Science*), or in Condillac's or Rousseau's reconstructions of the early formation of langauge,[52] or in the summary accounts of how art emerged through various phases of archaic stylization from its rudimentary origins elaborated by Winckelmann's immediate predecessors, Caylus and Barthélemy.[53] The problem to be addressed by such systematic histories as these was how a social or cultural formation came into being. The history concerned was necessarily a speculative one, and could not be narrated as a conventional chronology of fact. It was 'prehistoric' history, concerned with those very early phases in the development of culture that predated the keeping of historical records, a history for which the direct empirical evidence was almost entirely lost.

In the systematic analysis of 'advanced' cultural and social formations, the concern was no longer with historical development, but rather with ahistorical generic typologies that could be used to explain fundamental differences between types of society and their mentalities.[54] Winckelmann's theory, which conceived the history of a tradition even after its early archaic phases in systematic terms, was a new departure. The more ambitious and comprehensive histories of the period that might be set alongside his history of Greek art, Gibbon's *History of the Decline and Fall of the Roman Empire* and

Montesquieu's *Considérations sur les causes de la grandeur des Romains et de leur décadence* (*Thoughts on the Causes of the Greatness of the Romans and their Decadence*), were not conceived as systems. They contain no preliminary analysis of their model of historical development in the way Winckelmann did, and plunged the reader straight into the empirical narrative without a theoretical preamble.

Winckelmann's history of ancient Greek and Roman art, then, is the one truly ambitious attempt from the period to write a systematic history covering a span of time where abundant historical evidence had survived, that is, where a chronology of known facts, or history 'in the narrower sense' as Winckelmann put it, could be written. Why a history of art, as distinct from a history of literature, say, or of civil society or politics? The question is an important one, partly because the schematic pattern of history proposed by Winckelmann set an important precedent for subsequent writing on the history of art. Histories of art have come to depend on a formalization of history in which an artistic tradition is defined by way of a sequence of systematically conceived phases or period styles to an extent that is not found in histories of literature or other cultural phenomena. It was in the study of the visual arts, for example, that the idea of the Renaissance as a moment of structural change in Western European culture came to be represented most systematically through a focus on the 'invention' of naturalistic forms of pictorial representation. More recently, histories of artistic style have provided a similarly simplified model for imagining the break with earlier cultural forms supposedly effected by twentieth-century modernism by envisaging the emergence of purely abstract systems of visual representation as a paradigm of the modernist enterprise.

Did Winckelmann's system effectively aestheticize the history of the ancient world by representing it in terms of a history of the plastic beauty of the visual arts? The way in which Winckelmann put art and aesthetics to the fore, and proposed a pattern for total history through a focus on the development of art should not, however, be equated with what today we might call an aestheticization of history. It is much more interesting than that, and the politics involved are rather different. As Winckelmann conceived it, the history of art did not displace or exclude the political, but rather functioned as a space onto which the logic of a larger history could be mapped out more clearly than in any narrative of political developments.

When Winckelmann began his scholarly career as archivist and librarian to the Saxon nobleman, Count von Bünau, gathering material for a history of the German Reich his patron was preparing, he developed ambitions to make his own original contribution to modern history. This would depart radically from the dry, nit-picking research on the reigns of the early German emperors that he was having to carry out as part of his professional duties. He imagined an expansive project, a freely conceived oral presentation, which would have a larger significance than a traditional chronicle of the deeds of individual rulers and great men:

Knowing about the larger fate of kingdoms and states, their beginning, growth, flowering, and fall, is no less essential a feature of general history than knowing about great princes, talented heroes, and powerful minds. The former should not be recounted in passing, or presented as the effects of the deeds of princes, as in most general histories, which seem to be only histories of individuals.[55]

But this plan never worked out. Easy as it was to identify with the aims and ambitions of the new, enlightened conception of history advanced so eloqeuntly in Voltaire's famous *Essai sur les Moeurs* (*Essay on Customs*), it was another matter actually to fashion a coherent political and cultural history on such a basis.

Voltaire himself never managed it. Once he moved beyond parables about the origins of civil society to write a general history of Western Europe dealing with the vicissitudes of public politics, the history that emerged eluded any rational pattern. If there was any system in his multi-volume history, it had to do, on his own admission, with the disparity between anything that could be conceived as a rational ordering of things, and the spectacle that passed before his eyes of meaningless battles and conquests, of ludicrous and all too rarely enlightened initiatives by those in positions of power, of sequences of events mired in the brute contingencies of material circumstance. A universal history based on a history of the political did not seem amenable to systematic treatment as the latter would have been understood at the time, except in so far as it stood as a satirical inversion of rational process. On one hand, Voltaire sought a 'history that talked to reason', 'the painting of customs (*moeurs*)', which would lead the reader to gain an understanding 'of the extinction, renaissance and progress of the human spirit'.[56] On the other, the actual spectacle of the history of Europe since the fall of the Roman Empire 'is a heap of crimes, follies and misfortunes, among which we have occasionally seen a few virtues, a few happy periods, rather as one catches sight of inhabitants dispersed here and there in wild deserts'. If it was the case that, since the time of Charlemagne, Europe had become 'incomparably more enlightened than it had been then', there seemed to be no sign of any such rational progress in the political history of the period, which presented itself as 'an almost continuous succession of crimes and disasters'.[57]

This disparity in Voltaire's writing, between the desire to fabricate a rational history and any actual history that traced the more significant events marking out the history of modern Europe, does not necessarily explain why Winckelmann's original project to fashion a new form of universal history foundered. Nor is it necessarily the case that Winckelmann, if he had attempted to map out a larger universal history, would have been forced into the ironic or satirical mode of Voltaire. Nevertheless, from a mid-eighteenth-century 'enlightened' perspective, a properly rational history, which sought to define the larger logic of public events and political developments, would seem to have

been a difficult if not impossible project. Winckelmann in effect transferred his ambitions to create a new kind of universal history to the history of art. In making this change, he was able to define a logical history that had no parallel among even the most ambitious attempts by his 'enlightened' contemporaries to write a broadly conceived general history.

Winckelmann picked on a cultural phenomenon, ancient art, whose history could be made amenable to rational analysis—its rise and decline, formation and dismemberment could be conceived as a structured pattern of development, which somehow seemed to override the less tractable pattern of conquests and sudden changes of government that marked out the political history of antiquity. Winckelmann's focus on the aesthetic can be seen as a strategy to go beyond a mere chronology of events and actions, the contingencies of 'history according to external circumstances',[58] and to fashion instead a history conceived on a larger rational pattern. The political re-entered because, in Winckelmann's account, Greek art functioned as an emblem of the totality of Greek culture. He envisaged the destiny of Greek art as a history of Greek freedom, mirroring the rise, flowering, and decline of the free Greek city states, whose detailed political histories would not of themselves have so readily yielded a coherent pattern. What later writers on art, and even some of his contemporaries, such as the classical scholar C. G. Heyne, saw as the crudely schematic relation he set up between political freedom and the flowering of art, is then central to the political thrust of his whole project.[59] His history of art had a broader significance because it was conceived as an allegory of a larger universal history, embracing the complexities and vicissitudes of the political, which sought to make these tractable to reason and logic.

The schematic aspect of Winckelmann's history was also determined to a considerable extent by the distinctive form in which the evidence relating to the history of ancient Greek and Roman art, the core of his project, presented itself to him. Any reconstruction of the early history of Greek sculpture would necessarily have been highly speculative, and was best tackled as a formal problem-solving exercise. A conventional empirical narrative was just not possible because the available visual evidence did not include any works that could be dated with certainty to pre-Roman times. Ancient sculpture existed for him, as for other antiquarian scholars of the eighteenth century, at two generically very different levels which could not easily be correlated. The first level was textual: references in the writings of antiquity to visual art, mostly to the masterpieces and famous artists of the classic age of Greek culture, the fifth and fourth centuries BC. The second was visual: Graeco-Roman statues, mainly excavated in the vicinity of Rome, which by virtue of the admiration they excited and their idealizing form—nudity and abstract classical drapery—were assumed to be equivalents of the masterpieces of ancient Greek sculpture mentioned in the literary sources of antiquity.[60]

To bring together the histories of art adumbrated in the textual sources of antiquity with the remaining fragments of ancient sculpture was in effect to

tackle a complex 'scientific' problem. The connection could not be made on an *ad hoc* empirical basis, as it could later on, when temple sculpture dating from the earlier phases of Greek art, and mentioned in ancient literary sources, was excavated in Greece in Asia Minor, but rather required an analytic model. The continuing attempts to achieve a systematic correlation between the verbal and visual evidence still give the history of ancient Greek sculpture a more schematic character than other histories of art.[61]

The problem Winckelmann confronted had been addressed in a very general way by earlier antiquarian and classical scholars, but not on anything like the same comprehensive basis. Such speculation was either very general—were the best remaining statues of the same artistic quality as the much vaunted masterpieces by artists such as Phidias, Lysippus, and Praxiteles mentioned by writers such as Pliny, or were they inferior—or it concerned isolated points of detail: for example, could any existing statues be matched with the descriptions of statues in ancient literary sources? Only one major sculpture could be securely identified with the many classic early Greek works that Pliny had described as being in ancient Roman collections: that was the Laocoön (Plate 16), and this was a work that Pliny did not assign to a particular period.[62] The disparity between the verbal and visual evidence was heightened by the fact that not even the names on the few surviving signed statues corresponded to names of famous artists recorded by Pliny. At one level, what Winckelmann attempted was to create a conceptual framework where such questions could be asked in a more coherent and cogent way than before.

In making a concerted effort to infer what the art described in ancient literary sources might have looked like by seeking a correlation with known antiquities, Winckelmann was preceded by the French antiquarian Caylus. But Caylus could not see a way to approaching the problem systematically, even if he set an important precedent by treating the interpretation of ancient literary sources on art, not just as a textual philological problem, but as one to which a specialist knowledge of art and visual aesthetics should be brought. He was unable to envisage how he might reconstruct a coherent picture of the development of ancient Greek art from these sources, and indeed expressed considerable scepticism about the value of the insights provided by writers such as Pliny, who in his view did not appear to be connoisseurs.[63] Winckelmann, in contrast, made a concerted attempt to extract from Pliny a consistent picture of the differences between Greek art of different periods.

The schema Winckelmann devised to make sense of Pliny had two main points of reference. First he sought to map out from odd comments in Pliny a pattern of rise and decline centred on a classic period, which he identified as that moment in the fifth and fourth centuries BC to which Pliny assigned almost all the most famous ancient artists. This perspective led Winckelmann to give great weight to one isolated comment in Pliny about the state of art in the period after the age of Alexander the Great: *cessavit deinde ars* (art thereafter was inactive or ceased).[64] On this one thread of empirical evidence hung much

of his claim that Greek art inevitably went into decline after the fourth century BC. Second, Winckelmann sought to construct a picture of the evolution of Greek art in the classic period that would explain an apparent contradiction in Pliny. On one hand, Pliny made it clear that Greek sculpture was seen to have achieved classic perfection at the time of Phidias in the mid-fifth century BC. Equally, however, he highlighted a major refinement, a departure from the apparently restricted 'square canon' of the older masters, brought to the art of sculpture in the fourth century BC by one of the last of the famous classic artists, Lysippus.[65] In solving this problem, Winckelmann proposed that a systematic distinction be made between an austere or high early classical style, associated with artists such as Phidias, and a beautiful or graceful late classical style, associated with later masters such as Praxiteles and Lysippus.

By envisaging the evolution between these two styles as the continuation of a process of stylistic refinement that had previously led to the elaboration of a classic beauty from the hard stylized forms of the archaic, and subsequently produced over-refinement, over-elaboration, and decline, he was able to present an all-embracing system. He brought together in a single coherent picture Pliny's various isolated references to systematic change in Greek art of the fifth and fourth centuries BC. He also integrated a general model of rise and decline on which the speculative universal history of the time was based with a particularized visual pattern of evolution from an earlier austere and grand to a later beautiful and graceful style of art.

The distinction Winckelmann made between a high or austere and a beautiful or graceful style in classic Greek art will be discussed in detail in a later chapter on style. Here our concern will be with the new systematic cast he gave to ideas of historical rise and decline. How was this pattern of development constituted differently by Winckelmann from the discussions of the rise and decline of art that had been part and parcel of writing on the visual arts ever since the Renaissance? The idea that artistic traditions were subject to a general pattern of progress, flowering, and decay was something of a cliché at the time. It usually took the form of some version of the 'great century' theory, in which the larger history of art and culture was envisaged as centred on a few periods of classic excellence framed by archaic underdevelopment and degeneration or decline. But this speculative patterning of history was not seen as providing a framework for organizing an empirical history of art. It might be used on occasion to explain why there often seemed to be a falling off after a period of 'great' artistic achievement, such as the age of Louis XIV or the age of Augustus.[66] Winckelmann, however, was quite exceptional in making a cyclical pattern of rise and decline apply in a systematic way to the empirical details of the entire history of an artistic tradition. He was in effect the first historian of art of the period to insist that all art produced by a tradition after its classic period would normally be inferior, that the logic of a larger historical imperative would inevitably override the efforts of individual artists and individual patrons to revive a flagging tradition, however well intentioned.

The closest precedent for Winckelmann's systematic history of art is to be found in the prefaces to the three parts of Vasari's *Le Vite de' piu eccelenti Architetti, Pittori et Scultori* . . . (*Lives of the most famous Architects, Painters and Sculptors*), first published in 1550. There Vasari had provided a conceptual framework for his empirically based account of the biographies and works of famous artists of the Renaissance. He divided the history of modern Italian art into three main phases, marking a staged progress from archaic beginnings to the refinement and virtuosity of the High Renaissance masters. The schema was in part derived from ancient sources such as Pliny, but was much more systematically elaborated than anything found there. Vasari envisaged the evolution of ancient art as conforming to the same basic pattern, and himself provided a brief outline of the history of ancient Greek and Roman art. The story of the rise of ancient art to classic perfection, which paralleled his 'systematic' history of the progress of modern Italian art, was discussed, however, in a separate section from the brief account he gave of its decline and fall in the later Roman Empire and beyond. The latter functioned as a prelude to his account of the renaissance and flourishing of art in modern Italy.[67] Vasari did not seek to integrate his systematic history of the phased development of art to classic perfection with some larger cyclical pattern of rise and decline. He did not, like Winckelmann, define an overarching logic that spanned both the rise to perfection and the subsequent decline of a whole tradition.

Winckelmann's system had the effect of situating the tradition whose history he was writing very differently in relation to the present from Vasari's schema. One of Vasari's purposes was to present the artistic practice of his time as coming at the culmination of a triumphal progress of art to classic perfection, even if there is an implication that the achievements of the very greatest masters who brought art to this state, such as Michelangelo, might never again be rivalled. Winckelmann's history, on the other hand, locked the antique tradition within a process of rise and decline that separated it definitively from the present, and potentially raised the problem of the relation between the achievements of the golden age of classical Greece and the efforts of contemporary artists. Winckelmann presented a prospect of rebirth and renewal inspired by the epic picture of the rise of art in the ancient world, but he equally, if not more insistently, dramatized the inevitability of its decline. The overriding implication was a sense of loss and alienation from the classic achievement of art's best period in early classical Greece.

Writers on the visual arts after Vasari had tended to dilute the systematic aspect of his history of modern art. The significance of defining the rise to classic perfection seemed to become more and more remote as it literally became more and more distant in time. Vasari's larger schema of historical development was neither significantly extended nor rethought by those writing on ancient or modern art after him, except for a small coda traced by seventeenth-century classicizing theorists, when they represented the Bolognese school as reviving art after a period of degeneration in the aftermath of the High

Renaissance. If anything, the tendency was to fragment the general history of art more and more into separate accounts of the distinctive styles and achievements of individual masters and schools.[68] Thus Winckelmann's *History* could be said to mark a return to a more systematic approach to writing the history of art after a long gap since the late Renaissance. Equally, it could be said to bring to writing on the visual arts a specifically eighteenth-century philosophical interest in defining a cultural phenomenon in term of its origins and early formation; but it did so in a way that resulted in a much more comprehensive and systematic picture of the entire history of a cultural tradition than any of its eighteenth-century models might have supplied.

To find an equivalent to the scope and ambition of Winckelmann's historical system in eighteenth-century writing, you have to look elsewhere than in literature specifically concerned with visual art. The epistemological claims he made, the definition of his project as a scientific one, his attempt to devise a typology of different forms of art from first principles, which would then be used to explain the various forms taken by art in particular places and periods, have certain definite parallels with the project adumbrated in Montesquieu's *On the Spirit of Laws*. Winckelmann explained the scientific basis of his history as follows:

> I have ventured certain thoughts which may not appear to be proved adequately: perhaps, however, they can help others who research into the art of the ancients to go further; and how often has a conjecture become truth through a later discovery. Conjectures, or those that are at least attached by a thread to something solid, are no more to be banished from a work of this kind than hypotheses from natural science. They are like the scaffolding of a building, indeed they become indispensable if, owing to the absence of knowledge about the art of the ancients, you do not wish to make huge leaps over empty spaces. Some of the reasons I have put forward for things that are not as clear as the sun, if taken singly, only yield a probability, but constitute a proof when taken together and united one with the other.[69]

His system, Winckelmann makes clear at the beginning of the preface to the *History*, is based upon general principles about the inevitability of the evolution of art and culture from the necessary to the superfluous. But such a system cannot be elaborated in an entirely deductive fashion, from a priori principles alone. Rather it is composed of hypothetical constructs devised so as to make sense of the empirical material. Any particular aspect of the system cannot be justified by deductive or inductive argument alone, but only by a combination of the two. The system is neither entirely grounded on first principles, nor on inference from empirical data, but acquires credibility because it successfully mobilizes axiomatic truths to give a coherence to the disparate mass of empirical evidence being analysed.[70]

Such a process of system-building was vividly dramatized in Montesquieu's preface to *On the Spirit of Laws*:

Initially I examined men; and I believed that in this infinite diversity of law and custom, they were not led entirely by their fantasy. I posed the principles; and I saw individual cases accommodate to these as of their own volition, the histories of all the nations being no more than the consequences of these principles, with each particular law linked to another law, or depending upon another more general one.

The larger system that eventually fell into place was, however, less the product of abstract speculation than of a long struggle with the complexities of the material he was studying:

I began many times, and many times abandoned this work; a thousand times I threw to the winds the pages I had written . . . I followed my object without forming a plan; I knew neither rules nor exceptions; I only found the truth to lose it, but, when I discovered my principles, everything I had sought came to me.[71]

The form of certainty that this system-building produced was defined in terms almost identical to Winckelmann's:

Here, many of the truths will not be appreciated until you have seen the links that unite them one with the other. The more you reflect on the details, the more you appreciate the certainty of the principles.

With Winckelmann the epistemological basis of the system is defined in more sceptical terms. Its hypothetical character, the continuing possibility of error, can never be banished. His studious evasion of any promise of absolute certainty is very much in tune with the negative cast of his commentary on the accuracy of other scholars' work in his preface.[72] He opens up the prospect of a new science of archaeology, but he does so by way of an extended critique of the multitude of mistakes made by his predecessors. Certainty resides not so much in the positive reinterpretation of the facts as in the certitude with which previous errors of interpretation can be rooted out. The most cogent inference to be drawn from this catalogue of errors is not that the analysis that follows will always be rigorously correct, but rather that it too will be subject to the very kinds of failing detected in the work of earlier antiquarian scholars. The uncertainties of conjecture, then, are of the very essence of what he is doing.[73] Or, as he emphasizes later on, to approach the study of the art of antiquity in a totally dispassionate frame of mind, free of prejudice, is positively injurious:

Some people . . . go wrong because they are too cautious, and wish to set to one side all favourable prejudice in looking at antique works of art. They should however have nourished themselves on such a positive predisposition beforehand: for in the conviction that you are going to find a lot that is beautiful, you will seek this beauty out, and some will actually discover it. You keep on coming back until you have found it; for it is already at hand.[74]

At the bottom line, there is an element of blind faith impelling the historian to make something of value from the raw evidence.

Montesquieu's system in *On the Spirit of Laws* may share quite a lot in its general conception with Winckelmann's. But Montesquieu's system is not a history, nor does he make the same clear-cut distinction found in Winckelmann between a theoretical analysis of the phenomenon being studied and the detailed empirical presentation. *The History of the Art of Antiquity* is divided into two parts, the more conceptual first part exploring the general nature of art as a phenomenon, its 'essence' as Winckelmann says.[75] This includes an analysis of the larger generic differences between the art of different periods and peoples. Part II then spells out the detailed history of the ancient tradition from early Greek times to its demise with the fall of the Roman Empire, what Winckelmann called a history 'according to external circumstances'. This schema finds its clearest analogy in Rousseau's *Discours sur les Origines et les Fondements de l'Inégalité parmi les Hommes* (*Discourse on the Origins and Foundations of Inequality among Men*), published a few years before Winckelmann's *History*. And it is with Rousseau that Winckelmann shares a certain radical scepticism about the essentially conjectural nature of history.[76]

Like Winckelmann's *History*, the first part of Rousseau's *Discourse* sets out an analytic account of the subject; the second then applies this theoretical framework to a more empirical exploration of the contingencies of history. In the conclusion to the first part, Rousseau makes a statement about the epistemological status of the history of inequality he is about to elaborate that shares important features with Winckelmann's methodological commentary:

> I admit that the events that I am about to describe could have happened in several different ways, and I cannot decide between them except by way of conjectures; but besides the fact that these conjectures become reasons when they are the most probable that you can derive from the nature of things and the only means you have available to discover the truth, the consequences that I wish to deduce from them will not for all that be conjectural, because, on the basis of the principles I have just established, you would be unable to fashion another system that did not furnish me with the same results, and from which I could not draw the same conclusions.[77]

For Rousseau, even more than for Winckelmann, the history that he was about to expound could not be presented as a conventional empirical narrative. The evidence for tracing the early origins and formation of civil society was largely lacking. The only possible history was a speculative one, derived from a philosophical analysis that would bridge the huge gaps between the few known facts. Thus Rousseau:

> when two facts given as real are to be linked by a sequence of intermediate facts, either unknown or regarded as such, it is up to history, when one has the latter, to provide the connecting facts; and it is up to philosophy, in

default of this history, to determine similar facts that might tie the known facts together.[78]

Like Winckelmann, Rousseau insisted that much of the history he was reconstructing was necessarily conjectural. He also called the network of hypotheses making up his speculative history a system. But Rousseau had a more radically sceptical view of the validity of his system than Winckelmann, and certainly than Montesquieu, partly on ideological grounds, and partly because the facts around which he was weaving his history were much more scarce. Rousseau took the view that, even if you were sure about your fundamental principles, you could never hope to establish one single valid historical narrative that would best fit the known facts. For any story you might in theory be able to make up, there was always the possibility that another equally valid one could be found that was just as consistent with the known facts and your basic guiding principles. At most, you could assure yourself that you had come up with a probable story, and that this story was as good as you could expect for approaching a truth that could never be determined with absolute certainty.

Winckelmann's epistemology floats somewhere between Montesquieu's assurance that he had produced a fundamentally true synthesis of fact and principle, and Rousseau's scepticism. For Rousseau, the arena of the empirical, and particularly of the empirical historical, was one of fundamental uncertainty, where one might not even be able to find a way of testing a hypothesis to see whether it was false, let alone gain an assurance that it was valid. He talked of the 'impossibility one is in, on the one hand, of destroying certain hypotheses, if, on the other, one finds oneself incapable of being able to give them the certainty of facts'.[79] Time and again, Rousseau carefully examined the standard historical accounts of how important social institutions and cultural practices came into being, such as language and private property, and argued that these were fundamentally lacking or inconsistent. He would show how they simply assumed the very thing they were trying to explain, because they conceived the transition from a state of nature to the early rudiments of civilization as an inevitable process.[80]

For Rousseau a clear distinction had to be made between conceptualizing a development in the history of humankind, which was relatively simple, and determining how such a development actually could have occurred at a particular time and place. The theoretical rationalizing of processes of historical change, and history as it actually happened, were two different things. What determined the occurrence of a major change in the social relations between human beings was not logical principle, but rather a radically contingent conjunction of causes. Here is Rousseau on how he would go about writing a history of inequality:

> After having shown that perfectibility, the social virtues and other faculties that natural man had acquired could never develop of themselves, that in order for them to do so they needed a fortuitous conjunction of several

external causes which may never have arisen, and without which man would have remained forever in his primitive state; it remains for me to consider and bring into relation with one another the different accidents that could have perfected human reason, while worsening the species, making a being wicked while rendering him sociable, and from such a distant starting-point finally bring man and the world to the point where we see them now.[81]

When, in part II of his *History*, Winckelmann represented the detailed empirical history of Greek art as following the systematic pattern set out in part I, he was clearly eliding the logic of a process of development with 'real' history—with, as Rousseau would have put it, the conjunction of circumstances that might have prompted such a development to take place at a particular historical moment. Seen from Rousseau's perspective, this would be the epistemologically questionable aspect of Winckelmann's history, assuming as it did that there was nothing inherently problematic about subsuming the contingencies of the empirical within a systematic framework. It was this assumption that was taken up by later scholars who sought to extend his system to generate histories of art that appeared to be grounded in solid fact at the same time as being logically compelling.

Even from Rousseau's radically sceptical perspective, however, Winckelmann's system could be seen to have a certain justification. Winckelmann conceived his system as the model of an ideal history of art that happened once to have been realized through an unusual conjunction of favourable circumstances, which almost certainly would never be repeated again. All particular histories of art other than that of Greek art were ones in which material constraints blocked the realization of this ideal process of development, and were imperfect or incomplete versions of it.[82] Though the evolution of Greek art through a process of rise, flourishing, and decline was at one level to be seen as historically real, it also represented the ideal type of a history of art. This dual status accurately reflected the position of the Greek ideal in Enlightenment culture as something existing both in and above history.

One particularly distinctive feature of Rousseau's history of inequality was that it refused a simple pattern of progress or decline, and represented each new development in human culture and society as simultaneously a progression and a degeneration.[83] Winckelmann, in contrast, seemed to opt for a more traditional model whereby any particular historical development was to be conceived as part of a larger process of rise and decline. Central to his schema was a moment of flourishing when art as a cultural phenomenon was realized in all its wholeness, whereas for Rousseau such a moment would be a logical impossibility. Rousseau insisted that the perfection of reason, the elaboration of human capacity, was inseparable from a degeneration of man's freedom and 'natural' equality. The institutions of civil society might become ever more elaborate, but always at the cost of the corruption of human subjectivity.

In a way, however, Winckelmann's system offers something of the same

insight. His account of the rise, flowering, and decline of Greek art effects a complex interplay between two contrary impulses that disrupts the apparent closures of a simple historical pattern and of the resigned nostalgia traditionally associated with such a view of history: 'all things have their term and pass away.' In Winckelmann's *History* there is a definite tension between the inspiring story of the unfolding of a truly free and fully realized culture, in which a unique set of circumstances conspires to stimulate the 'highest' and most 'beautiful' endeavours, and the tragic story of inevitable decline, imbued by a powerful sense of the constraints and limitations imposed by material circumstances.

What made Winckelmann's story of the destiny of Greek art so compelling for so long, even in political circumstances very different from his own, was this vivid conflation of ideas of rise and decline, of the realization of an ideal and its loss. The cumulative effect is not to transcend such tensions and reconcile us to them, to make us dispassionate spectators of the grander logic of Greek art's coming into being and passing away. Rather it is to bring the tensions into closer focus, to make history into a hysterical interplay between these two sharply divergent possibilities. The 'hysteria' is lodged in the very process of making history, as well as in the pattern of its unfolding. History recreates Greek art before our eyes, in all its 'original' beauty, from the odd incomplete fragments that remain, and at the same time makes us more vividly aware of its dismemberment, removes it irrevocably into the distant past. It is on this contradictory dynamic that the next chapter focuses.

Fact and Fantasy

Under the grip of deconstructionist thought, we are perhaps inordinately aware of the gap separating the fictional coherence of master narratives and the disparate bits and pieces that make up the facts of history. On this basis, Winckelmann's ambition to create a new systematic history of Greek art, encompassing its fragmentary remains in a single coherent narrative of rise and decline, might seem quite alien. He if anyone is the patriarch of modern art-historical story-telling. But this, as we have already seen, is only part of the picture. For one thing, Winckelmann seems so much more aware than his nineteenth-century successors that his larger pattern of history is a conceptual and literary construct that could not simply be derived from the historical facts.[1]

What makes Winckelmann interesting, however, is not that he in some way manifests an epistemologically 'correct' understanding of the systematic structure underpinning his history. He takes his system utterly seriously, as no Derridean sceptic ever could, and it is in part by virtue of his doing so that his project is so compelling. Perhaps he appeals to our lurking nostalgia for a lost confidence in a coherent historical patterning of the past. Or he may simply make us realize that, however deconstructive we have become, master narratives still have a hold over our sense of history, no less than other deeply embedded linguistic and conceptual structures that involuntarily mould our thinking. The distinctive interest of Winckelmann's history is more particular and more directly political than that, if we take the word political in its 'larger sense', as Winckelmann would say.

He did not see himself as just writing a history, but as reconstituting a lost art, that of the early Greeks, which he believed to have a vital value for the present. For him the Greek ideal embodied an integrity and wholeness that in modern culture could only be experienced as absence. And its ideal 'oneness' was mirrored in his picture of its historical unfolding. His history of Greek art can be read as the very paradigm of a whole and coherent history.

Winckelmann's represents the Greek ideal as perfectly realized at one peculiarly privileged historical moment, which comes as the climax of a long process of evolution sustained by conditions of freedom uniquely favourable to the cultivation of art. In this classic moment all the finest aspects of ancient Greek culture seemed to fuse together to realize the highest ideal of which art was

capable—the beautiful image of perfect manhood. Yet a close reading of Winckelmann shows his history of Greek art to be a rather more complex construct than this, which internalizes the tensions between an ideally desirable history and material constraints it can never quite overcome. Gaps and dislocations open up in the historical unfolding of Greek art whose political overtones are manifest in a repeated failure to realize the fusion between aesthetic beauty and 'manly' political freedom posited by the utopian dynamic of Winckelmann's history.

The disjunctions between an 'ideal' and a 'real' history operate at several levels. If you look closely at the formal pattern of Winckelmann's outline summaries of the rise and decline of Greek art, you will find that the classic phase emerges not so much as the climax of a process of historical change as a moment of hiatus. It seems that the ideal can fully come into being only if the forces of history necessary to its formation are briefly suspended. In his detailed chronicling of the history of Greek art in its classic phase, you notice that the fullest flourishing of art does not quite coincide with the fullest flourishing of its animating principle, political freedom. In the empirical unfolding of history a certain tension manifests itself between the imperatives of beauty and cultural refinement and those of a manly political virtue. There is also an insistent disparity between the imagined ideal of Greek art and the real remains in which this ideal is most vividly embodied for us. Most of the masterpieces of ancient sculpture in Rome, which Winckelmann no less than his contemporaries viewed as the embodiments of the highest ideal in art, are not, as one might expect, directly associated with the moment of flowering of ancient art. Rather his history locates some of the very finest ones after the event, in the so-called period of decline, making them echoes of an ideal already and perhaps always lost.

In the very structuring of his history Winckelmann thus raises the problem of whether the Greek ideal as we imagine it could ever be realized in all its desired wholeness. His history tells the story of how our image of its integrity inevitably encounters resistance when we try to detail the history that brought it into being. The Greek ideal does not simply exist as a stable construct lodged in the past, which might conceivably be recovered in most of its integrity if enough evidence were to become available. It is of its very nature intractable, from the outset an insistent absence and a desired presence. Far from rationalizing this disparity, history only makes our awareness of it more acute.

At the very end of *The History of the Art of Antiquity*, Winckelmann looks back on the historical drama he has traced and stops to reflect on why he has lingered so long on the final demise and destruction of Greek art. At this point he explains how our obsession with the absence and irrecoverable loss of the Greek ideal fuels our compulsion to reconstitute its history. This is the very foundation and essence of the enterprise:

> I have in this history of art already gone far beyond its bounds; and though
> in observing its decline I almost feel like someone who, when describing the

history of his fatherland, has to touch on its destruction, which he himself has experienced, nevertheless I could not restrain myself from gazing after the fate of works of art as far as my eye could see. Just as a woman in love, standing on the shore of the ocean, seeking out with tear-filled eyes her departing lover whom she has no hope of ever seeing again, thinks she can glimpse in the distant sail the image of her beloved; we, like the woman in love, have remaining to us, so to speak, only the shadowy outline of our desires: but this makes the desire for the objects we have lost ever more ardent, and we examine the copies of the original masterpieces with greater attention than we would have done were we to be in full possession of them. We are often like people who want to know about ghosts, and think they can see something where nothing exists: the name of antiquity has become a prejudice: but even this prejudice is not without use. You imagine you are going to find a lot, so that you search hard to catch sight of something.[2]

Here Winckelmann presents the historical re-creation of the Greek ideal as an intensely significant and at the same time impossible task. The impulse that produces history, the projective power that animates the surviving bits and pieces that otherwise would be mere dead fragments, is equally the creator of delusions.[3] It is not just that the historian's task is dogged by error and hallu-cination, but rather that delusion is of the very essence of history. It brings alive what is literally dead, projecting as present what a historical perspective can only make more intensely and evidently absent.

Winckelmann offers his reader two radically divergent possibilities. Either the story that he has told in reconstituting from odd fragments a new picture of the Greek ideal is mere hallucination or it is a vision of a lost truth. His history of ancient art might be the product of a fevered imagination mourning the loss of what can never be recovered and probably never existed; or it could be bringing to life a lost ideal that was once actually realized. The power of Winckelmann's historical analysis is that it internalizes these tensions in the very fabric of its unfolding.

One further point in this passage needs to be addressed. Why does Winckelmann cast himself in the role of a female lover mourning the departure of her beloved when he dramatizes the sense of loss that he sees as the very condition of the kind of history he is writing?[4] Is Winckelmann ventriloquizing female desire so that his male readers can imagine without inhibition an intense eroticized longing for the ideal manhood conjured up by the Greek ideal? Or is he simply evoking a standard figure of emotional loss in Greek and Roman myth, the woman abandoned by her departing lover—Ariadne on Naxos, Dido in Carthage? Or is the female gendering a token of Winckelmann's unconscious recognition that somehow, somewhere in his narrative femininity had a vital role to play? For a moment, the subjectivity of the historian seeking to recap-ture a glimpse of the Greek ideal is not the confident one of a male hero projecting before himself an immaculately formed equivalent of his own self. Rather it is that of a woman constitutionally excluded from identifying with the

image of ideal manhood she has fabricated, able to experience this supreme
fiction only as absence and displacement.

RISE AND DECLINE

Winckelmann was unusually self-conscious for a historian about the ideal
conceptual aspect of his historical narrative. He began his *History of the Art of
Antiquity* with a very bald statement about how the larger pattern of rise and
decline he was invoking was inherent in any understanding of history con-
ceived, as he put it, 'in the broader sense it had in the Greek language':[5]

> The history of art should tell us the origin, the growth, the alteration, and
> the fall of art, together with the various styles of people, periods, and
> artists, and demonstrate this as far as possible from the remaining works of
> antiquity.[6]

Some such narrative pattern is lodged deeply in the whole practice of
historical writing. In one form or other it is implicit in the very idea of defining
a phenomenon in historical terms. The historical analysis of a social, political,
or cultural constellation will always require a story of its appearance and
disappearance, even if this story is only implicit. However sophisticated the
paradigm being invoked, there is no complete abandoning of some such story,
whether it represents the process of appearance and disappearance in terms of
slow, sustained evolution or a sudden discontinuous break. Even with Derrida,
who among present-day thinkers is perhaps the most compulsively sceptical
about our desire to envisage the narratives we construct as representing a reality
that exists beyond the operations of language, identifying a persistent
'logocentrism' in Western European culture cannot evade the implication that
such a constellation of thought did at some point come into being, and might at
some point be displaced, however much he is at pains not to spell out such a
history.[7]

The young Marx made rather well the point that there is a certain banality
to our reliance on narratives of rise and decline, as simply endemic to the
linguistic and conceptual structures we inhabit:

> Now it is indeed a very trivial truth: rise, flowering, and decline are the
> unshakeable circle to which everything human is relegated, which it must
> pass through . . . And then: rise, flowering, and decline are completely gen-
> eral, completely vague ideas, according to which no doubt everything can be
> arranged, but by which nothing can be grasped.[8]

For Winckelmann, the historical pattern of rise and decline was at one level
quite explicitly grounded in the narrative structures through which we define
and give coherence to a story:

For just as every action and event has five parts, and as it were stages, the beginning, the development, the point of stasis, the decrease, and the end, which is the reason for the five scenes or acts in theatrical pieces, so it is the same with the chronological ordering (of Greek art).[9]

Here Winckelmann was asserting that the history of art presents a logical unfolding that conforms to the Aristotelian notion of a whole or complete action in fictional writing. But this was a coherence that Aristotle himself denied to history. According to Aristotle plots in epic or tragedy should be

about one whole or complete action with a beginning, middle parts, and end, so that it produces its proper pleasure like a single whole living creature. Its plots should not be like histories; for in histories it is necessary to give a report of a single period, not of a unified action, that is, one must say whatever was the case in that period about one man or more; and each of these things may have a quite casual interrelation.[10]

Winckelmann's history, then, was not a historical chronicle of the kind envisaged by Aristotle. The rise and decline of Greek art existed both as an actual history and as the ideal type of a complete history of art. At one level, Winckelmann's systematic history of Greek art sought to deny the Aristotelian distinction between poetry and history, and to assert that this one actual history did have the unity and coherence of a fictional construct; or to use Aristotle's terminology again, that the contingencies of history could be represented as having the philosophical coherence of the general statements made in fiction, recounting how things would happen 'in a strictly probable or necessary sequence, not just how things happen to be'.[11]

At the same time, Winckelmann opened up the possibility that the ideal history and the chronicle of historical fact did not necessarily fuse together in a seamless organic whole, as they came to be imagined in much nineteenth-century historical writing. The form of an ideal narrative structure and the telling of the history of art might coincide, but they were not necessarily one and the same thing. Thus Winckelmann made it clear that the history of any tradition other than the ancient Greek one was inadequate or incomplete when measured against a fully realized story of rise and decline. And a certain tension between ideal and empirical history was never quite abolished even in his account of Greek art. The history of Greek art he related was both an ideal construct existing above history, and something played out within the empirical fabric of history, which under the latter aspect could never quite be ideal or whole.

Winckelmann grounded the pattern of rise and decline organizing his historical account of Greek art, not just in the narrative structures of language, but also in the very nature of art as a cultural phenomenon. That this pattern should be seen as derived from his theoretical definition of what art was is emphasized in his introductory comments at the outset of *The History of the Art*

of Antiquity. Here is an axiomatic logical declaration that relies on metaphor to give the bare schema a certain historical density:

> The arts which derive from drawing, like all inventions, began with the necessary: afterwards people sought beauty, and eventually superfluity ensued. These are the three principal stages of art.
>
> The earliest sources tell us that the first figures represent what a man is, not what he looks like, his shape (*dessen Umkreis*), not his appearance. From simplicity of form people proceeded to the investigation of proportion, which taught them correctness, and this gave them the confidence to venture onto a large scale, as a result of which art achieved grandeur. Then at last, stage by stage, it attained its highest beauty among the Greeks. Once all the parts of art had come together, and people sought to embellish them, superfluity took hold. As a result art lost its grandeur, and there followed finally its complete downfall.
>
> This in a few words is the design of this treatise on the history of art.[12]

The first-order dynamic of this history is grounded in an understanding of the nature of any cultural or social phenomenon. Its basic logic is defined as an evolution from mere necessity through progressive stages of refinement until after a certain point superfluity and decline ensue. Midway, in between the constraint of brute necessity and superfluous over-elaboration, a space opens up for the realization of truly beautiful art. Beauty is a kind of necessary superfluity. The schema Winckelmann presents here, like the dramatic progression through a beginning, middle, and end, forms part of a general ontology of human culture, of which art is one aspect.

In Vico's earlier, more wide-ranging attempt at a systematic historical analysis of culture, this commonplace of eighteenth-century speculative thought was similarly given axiomatic status. It articulated an anxiety fundamental in Enlightenment discussions of art and culture, that evolution towards refinement threatened to degenerate into decadent over-elaboration and, above all, into a luxury that sapped the honest values of earlier, simpler times. The preoccupation with superfluity, luxury, and decadence could be seen as a major hallmark of the critical analysis of culture prior to the nineteenth century, together with the assumption that all aspects of human endeavour could only be developed up to certain limits, limits inscribed permanently in the general order of things, or of nature if we use an eighteenth-century term.[13]

Winckelmann's story of the rise and decline of art is primarily driven by a dynamic of development from austere necessity to over-abundant luxury. But it also has a specific inflection given by its being a particular kind of history of culture, a history of artistic representation. As such it draws heavily on theories of the development of language prevalent at the time. The rise of art is defined as a systematic elaboration of forms of representation that allow for a clear, true depiction of the human figure. This replicates the standard eighteenth-century theory of how language gradually developed its resources to the

point where it could articulate a complete and clear knowledge of things. Theories of the history of language, like Winckelmann's history, relied on a model in which the articulation of necessary and useful knowledge came first, then the cultivation of the beauties of style or rhetoric, which eventually result in superfluity and degeneration.[14]

But there is a peculiar paradox here that brings into view a crucial feature of the formal structuring of Winckelmann's narrative and separates it from later, more organic models of rise and decline: the way in which the classic is represented as a hiatus, rather than a culminating moment in which the animating principles of the rise of art would find their most vital embodiment. In Winckelmann's model, though the impulse to a true knowledge of things drives art and language to the point where they achieve perfection and accuracy of representation, the end of art, as Winckelmann presents it, is not knowledge but beauty, a beauty which by its very definition is superfluous to true and correct representation. A similar disjunction is re-enacted in Winckelmann's history between the beauty of a fully realized art and the political freedom he saw as the informing impulse that drove Greek art to its peak of perfection. The beauty that comes as the crowning achievement of the Greek tradition does not coincide with the most dynamic and vigorous phase of Greek freedom. Freedom marks the prelude to an artistic flowering for which it prepares the way, but with which it can never be identical.

In an ideal scheme of things, the classic period of Greek art is a phase of transcendent perfection poised between the drama of a progressive rise from archaic beginnings to perfection and beauty, and the drama of degeneration and decline. In theory, then, the Greek ideal overcomes for a moment the austere crudities of necessity and the decadent over-elaboration of excessive refinement. But it never quite does so, and it can only seem to do so if we imagine its moment of self-realization, not as the culmination of a larger historical narrative of rise and decline, but as a gap opening up in this narrative.

If we look back to Winckelmann's general statements about the rise and decline of art, we find that the moment of 'beauty' is indeed represented not so much as an active moment of flourishing and realization, but as a stilled moment, when the forces of history animating art in its progress to perfection, as well as the disintegrating forces of decay and decline, are both momentarily suspended. The crucial passage in the preface reads: 'the history of art should teach us its origin, growth, alteration and fall.' The classic moment is a kind of non-moment in the historical dynamic of rise and decline, a liminal point of transition between growth and the first alterations of decline. In a similar passage elaborating the 'essence' of the development of art among the Greeks, Winckelmann talks of 'the growth and fall of Greek art' or 'the beginning, the development, the point of transition or stasis (*der Stand*) and the decline and end'.[15]

In terms of Winckelmann's basic schema, then, art's origins and foundations are produced in the struggle with necessity. Subsequently, when the moment

of necessity has passed, a new negative dynamic sets in, producing superfluity and decline. Art can exist most fully only in the empty space between these two opposing historical processes, briefly sustained by the recollection of the force animating its origins and rise. The most supple refinements of beauty can never directly embody the active dynamic that gave rise to them or, in other words, the figure of a harmoniously beautiful self is never identical with the figure of animating struggle that is true political freedom, but without which art sinks into decline. To understand more fully what this means, what its ideological significance is, we now need to look more closely at how Winckelmann conceived the relation between art and freedom.

DICHOTOMIES OF FREEDOM

Freedom, *Freiheit*, had a double inflection within Winckelmann's scheme of things. First it represented the main external stimulus to art, along with climate. Climate, on one hand, and forms of government on the other, were identified by Winckelmann as the key material factors influencing the rise and decline of art through the effects they had on the mentality of a people.[16] This was a standard sociological theory in the period, when discussion of the material determinants of art and culture focused either on the effects of climate —what we would call environment—or types of political rule.[17] But in Winckelmann's analysis of the Greek ideal, freedom did not just have a role as an external stimulus or circumstance. Freedom constituted the mentality of the ancient Greeks and was the animating principle of its art. Greek freedom was not merely a cause of the excellence of Greek art; it was also of its essence:

> Through freedom the thinking of the entire people rose up like a noble branch from a healthy trunk. For just as the mind of a man habituated to thinking tends to raise itself up higher in a wide field, on an open pathway, or at the summit of a building, than in a lowly chamber or in any restricted place, so also must the mentality that prevailed among the free Greeks have been very different from the outlook of subject peoples.[18]

For Winckelmann, this was such an important point that in the posthumous edition of the *History* he elaborated it further:

> The same freedom that was the mother of great occurrences, changes of regime, and emulation among the Greeks, planted as it were at the moment of its birth the seeds of a noble and sublime way of thinking; and just as the sight of the unbounded surface of the sea and the beating of the majestic waves on the cliffs of the shore expands our outlook, and makes the mind indifferent to any lowly considerations, so in the sight of such great occasions and men it was impossible to think ignobly.[19]

Before exploring the complex connection and tension Winckelmann set up between Greek art and Greek freedom, we need to clarify the political conno-

tations of his conception of freedom. Though in Winckelmann's definition the emphasis is on the individual experience of freedom rather than the social and political forms making up this experience, there is still a quite explicit political and civic dimension to his analysis. He explained how the animating power of freedom was felt particularly strongly within a 'democratic regime' such as that of Athens after the overthrow of the tyrants, 'in which the whole people participated' and 'the spirit of every citizen and the state itself was raised up.'[20] Freedom flourished in political conditions where 'it was not the right of one person alone to be great among one's people, and to immortalize oneself to the exclusion of others.' Freedom was the animating principle where individuals were not oppressed or constrained by the power of a monarch or tyrant, where genuine emulation was possible because merit was not decided by wealth or inherited privilege.[21]

Yet Winckelmann was not concerned to elaborate a political theory connecting the ideal of freedom with a particular system of government. Republicanism and democracy were not for him the essence of freedom. Freedom in the strongest sense was a subjective experience, the experience of an expansiveness and elevation of mind made possible by conditions of political liberty. In the more explicitly politicized context of the 1789 Revolution, such notions of an expansively free consciousness did play an important ideological role. Winckelmann shared with the radical republican tradition associated with Rousseau a positive conception of freedom as active self-determination, one that later political theory set in opposition to the negative or passive idea of freedom conceived as absence of constraint or oppression.[22] But in the final analysis, Winckelmann's emphasis on the experience of freedom—freedom as a state of consciousness—links him more with notions of freedom current in German idealist philosophy than it does with the conceptions of political liberty that seized the imagination of the French revolutionaries. Their militantly secular, anti-religious commitments, and their emphasis on freedom as a defining feature of a virtuous republic of active citizens, could hardly be said to be prefigured in Winckelmann, even if the libertarian aspect of his analysis of the Greek ideal did strike a strong chord with the more politically active members of the French art world.[23] Indeed Winckelmann's understanding of freedom has little of the civic public dimension already evident in the more progressive writing of his immediate French contemporaries, who held up antiquity as the model for an art based on republican liberty.[24]

Where Winckelmann's analysis of the freedom enjoyed by the ancient Greeks acquires its most political edge is in his account of the negative effects of its absence on the patronage of the arts in the Hellenistic and Imperial periods. Here he expressed an explicitly anti-court, anti-monarchical ideology, and this is integral to his whole conception of the rise and decline of Greek art. A negative view of courtly or princely patronage is articulated in Winckelmann in a way that it is not in Voltaire and most other progressive earlier Enlightenment historians who speculated about the larger rise and decline of culture. Thus, though Voltaire insisted in theory on the priority of culture and *moeurs*

over the actions of individual kings and princes, he did not, like Winckelmann, separate the notion of a great or classic epoch of art from its traditional association with the patronage of a great ruler. Voltaire's great centuries in the history of human culture were still defined by the reign of a celebrated monarch—the great age of Greece, for example, was for Voltaire the age of Alexander the Great.[25] With Winckelmann art itself, rather than the figure of a great ruler, became the entity defining a classic period.

Winckelmann not only made a distinction between the flourishing of art and the munificent patronage of a court or king. He went so far as to represent the highest efforts of art as being incompatible with court culture. According to him, neither Hadrian nor Augustus, nor even the Greek monarchs of the Hellenistic world, could, for all their efforts and enlightened intentions to cultivate the arts, reanimate them to the level they had reached under the free rule of the early Greek city-states. Of Hadrian's patronage Winckelmann wrote:

> If it had been possible to raise art up to its previous magnificence, Hadrian was the man to do it, as someone lacking in neither knowledge nor initiative. But the spirit of freedom had retreated from the world, and the source of elevated thinking and true fame had disappeared . . . the assistance (*Hülfe*) which Hadrian gave was like the nourishment that a doctor prescribes to patients, which does not allow them to die but at the same time gives them no sustenance.[26]

In mid-eighteenth-century Europe this idea would not have been counted politically subversive in itself, largely because its immediate implications for the present were never fully spelled out. Associating the best culture of ancient Greece and Rome with political freedom was not necessarily seen as being critical of an enlightened monarchy or oligarchy. A republican view of ancient Greek and Roman culture clearly indicated that a writer opposed despotic rule, but would not necessarily imply a critique of aristocratic or monarchical patronage of the arts in the present day. After all, Winckelmann's *History* was dedicated to the Crown Prince of Saxony. Writers of Winckelmann's period often picked up the republican views expressed by Roman critics of imperial tyranny living in the period of the early Roman Empire, who bemoaned the corrupting effects of despotism, rising luxury, and the dulling of emulation that came with the loss of political freedom. Such theoretical republicanism, however, did not necessarily commit a writer to anything more than a favourable view of enlightened reform in the present, that is, to the promotion of freedom within existing frameworks of government.[27]

Still, the modifications made to the text of Winckelmann's *History* after its initial publication in 1764 give evidence that, under certain circumstances, a republican view of the art and culture of the ancient world of the kind he advanced could be seen to have a troublesome critical edge. His more explicit critique of the limitations of enlightened princely patronage in the analysis he

offered of the state of the arts under Hadrian is absent from the summary history of ancient art with which he introduced his *Unpublished Antique Monuments*. It is also excised from the later edition of the *History* published posthumously in Vienna in 1776. The latter omission or censoring may bear testimony to a certain conservatism at the Viennese court, where this edition was prepared. But it is more likely to be connected with the political constraints Winckelmann himself experienced, working amid the reactionary paranoia of the latter part of Clement XIII's term as pope.

The change is consistent with a more general shift of perspective in the Vienna edition. Winckelmann's initial reading of Pliny's passage about the stagnation of the arts in the early Hellenistic period pointing to a fairly straightforward artistic decline is considerably qualified in the later edition. Some new passages testifying to the positive stimulus given to art by the patronage of the early Hellenistic monarchs are also inserted.[28] Even with these modifications, however, the overall rise and decline of Greek art is still seen as identified with the larger rise and decline of Greek freedom.

What is particularly interesting about Winckelmann's history is that it so eloquently projects the idea of a utopian fusion between great art and political freedom and at the same time, almost unconsciously, plays out an incipient rupture between the two. An unease about the possible incompatibility between the aesthetic refinements of a highly developed culture and the austere, 'manly' virtue associated with earlier, more 'primitive' forms of society was as central to Enlightenment ideology as was the impulse to equate true art with political freedom. The complexities of Winckelmann's account of the political aspect of the Greek ideal echo a disquiet about the negative effects of cultural refinement on political virtue that found its most extreme expression in the period in Rousseau's celebrated attack on the corrupting effects of the arts and sciences.[29]

Winckelmann's history of art represents the problems involved more vividly than other accounts of the antique ideal in the period, not just because it is so ambitious and systematic, and thus has to mediate between the disparate value systems projected onto this ideal more explicitly than most. It is also because he insists so strongly on the sensuous refinement and grace of the Greek ideal. In his account, the Greek ideal of beauty has a decidedly voluptuary aspect and is not just a disembodied or abstract ideal form. A tension between the refinements of art and the elevating force of political freedom is most fully played out in the second part of his *History*, where he sets out a detailed chronicle of the development of Greek art. But it is already inherent in his discussion of the external forces stimulating art in the earlier theoretical part of the book.

When Winckelmann sets out to explain how external factors encouraged the formation and flowering of the Greek ideal, in effect he makes a separation between two different facets of this ideal. The sensuous and graceful refinement of form that distinguishes Greek art from that of all other ancient peoples is, in his account, produced by the gently balanced, ideal, Greek climate, while the elevation of mind that sustained this art has its source in the unique

conditions of political freedom enjoyed by the ancient Greeks. Winckelmann attributes the origins of the uniquely graceful sensual beauty of the Greek ideal to the particular environmental conditions of Asia Minor. He then represents the most fully developed Greek ideal as arising from a conjunction between this tendency and the spirit of freedom, bred by the democratic political conditions of ancient Athens.

There is a noticeable disparity of tone between his description of Greek climate and its effects on the mentality of the ancient Greeks, where ideas of musical harmony and graceful suppleness prevail, and his account of the distinctive characteristics of mind fostered by conditions of freedom. In the latter he emphasizes the manly heroic virtue of the fighting warrior.[30] What we have is a certain dichotomy between a sensuous enjoyment of physical beauty on one hand and an active animating force, most vividly embodied in moments of self-assertion and violent struggle, on the other. Winckelmann's history of Greek art, in seeking to imagine how an ideal conjunction between the elevating force of political freedom and the most graceful refinements of culture must once actually have been realized under the uniquely favourable circumstances enjoyed by the ancient Greeks, cannot avoid echoing a structural tension between these two tendencies.

A displacement between the fullest realization of a beautiful art and the most vigorous manifestation of active political freedom first occurs in his historical narrative when he is discussing the final stages of the progress of Greek art to classic perfection. At one level, the transition from the archaic to the classical is represented as an entry into the realm of freedom—art emerges in all its beauty when for a moment Greek culture is freed from the constraints previously imposed by external circumstances. This liberation is echoed in the internal dynamic of artistic development from archaic stylization to the free-flowing forms of classic art. Archaic art had been built on a rigid schema, as a necessary consequence of the need to elaborate a secure framework of representation that would underpin the correct figuration of the human body. The first full flowering of art initiating the classic phase occurred when the constraining severity of this schema could be set to one side. This had its political equivalent in the parallel history of the Greek city-states. This moment, Winckelmann wrote, was one of 'complete enlightenment and freedom in Greece', enjoyed in the aftermath of the violent wars with and final victory over the Persians.[31] But the animating spirit of political freedom had been most active before this point. It had been the driving force behind the progress of Greek art in the archaic period, and had manifested itself most fully in the establishment and defence of Greek democracy. The flourishing of art at the outset of the classic period represented a moment of relaxation after a period of struggle, rather than an active flowering of the animating spirit of freedom.

A more marked displacement between art and freedom takes place in Winckelmann's account of the later classic period, the moment when the very last vestiges of the austere severity of the archaic style disappeared in a free-

flowing gracefulness of form. 'Freedom' at this point had two quite distinct connotations, on one hand an active political freedom, realized in moments of struggle, and on the other a more passive freedom, a free enjoyment of pleasure lived out in the aftermath of such struggles. Whereas until this moment these two freedoms, one political and the other aesthetic, could be seen as distinct but yet closely connected, here a clear historical discontinuity opens up between them. For the most intense refinement of artistic beauty, when style lost the last vestiges of archaic constraint, coincided with a moment when the Greeks first came under foreign domination with their defeat by Philip of Macedon at the battle of Mantinea. According to Winckelmann, this was a kind of interregnum, when political freedom in the fullest sense no longer existed, but its absence was not yet experienced as active oppression. The beauty of Greek art thus achieved its final pitch of refinement, in Winckelmann's scheme of things, when the Greeks 'enjoyed the sweetness of freedom without bitterness', and lived 'in a certain abasement, but in harmony'[32]—when the animating force of political freedom was still remembered but existed only as an illusion.

The complex character of this historical development, in which artistic culture was displaced but not yet, as in later periods, entirely alienated from the experience of an active political freedom, is made particularly explicit in a passage Winckelmann inserted in the posthumous Vienna edition of the *History*:

> After the Greeks, and particularly the Athenians, had completely exhausted themselves through jealous [rivalry] and persistent internal wars among themselves, Philip of Macedon rose up over them, and Alexander and his immediate followers had themselves declared heads and leaders of the Greeks. In reality, however, they were rulers of Greece. As now the system of government of this people took another form, so too did the circumstances of art alter, and art, which until now had been grounded in freedom, took its subsequent nourishment from superfluity and munificence. It is to these factors, together with the fine discernment of Alexander the Great, that Plutarch ascribes the flourishing of the arts under these monarchs.[33]

The best Greek art in its later stages, according to Winckelmann, was sustained by echoes of a political freedom no longer actively manifest in Greek culture. There was still an intimation of freedom in Greek art, but very much at one remove. A similar connection and displacement between the beauty of art and actively asserted freedom is also played out in Winckelmann's descriptions of the classic masterpieces of ancient art. In two of his more celebrated descriptions, the ideal male figure is represented as recollecting or intimating a physical display of its manly capacities, which it could not embody directly without disrupting its harmoniously self-contained beauty of form. Thus the Belvedere Torso (Plate 36) is imagined as representing Hercules after his death and apotheosis, his now beautiful body purged of the marks of the violent struggles in which he realized himself as a hero. The beautifully tranquil

contours of his no longer mortal body suggest the outlines of the legendary strength that once sustained his exploits, but as a distant echo rather than an active presence.[34] The so-called Belvedere Antinous (Plate 4), according to Winckelmann, represented a young Greek hero in a state of perfect tranquillity undisturbed by the slightest passion. The active manly strength associated with his heroic stature could not be represented directly in the beautiful forms of his body, but has to be implied as a potential quality the figure might show in the future.[35]

The tensions between the cultivation of beauty and a more austere or heroic sense of value, which in Winckelmann's analysis of the stimulus to art provided by political freedom centres on worries about over-refinement and luxury, are given a rather different cast in his discussion of the duality between a beautiful and high style in classic Greek art, as we shall see in the next chapter. In the latter a more explicitly sexual dimension enters in. A desired fusion of austere manliness and sensuous beauty is again partially blocked by tensions inherent in the ideological paradigms of Enlightenment culture. But in this case the tensions relate, not to unease about luxury, but to anxiety over the homoerotic fantasies stimulated by images of ideal manhood.

Presences and Absences

In the complex dynamic of Winckelmann's history, the most beautiful Greek art of the classic period both embodied the principle of political freedom and also represented it as not present in all its fullness, whether now or when this art was first created. A classic Greek sculpture thus conjured up the lost freedom of the ancient Greeks, and at the same time also presented this freedom as always displaced from the beauty which absorbed the viewer's attention. But were such a work to be conceived as a purely artistic phenomenon, rather than the symbolic embodiment of political freedom, would it then be seen as entirely whole, as transcending any sense of absence or loss, as being entirely present to the viewer? Not quite. For Winckelmann's narrative sets up an insistent distancing between the imagined fullness of the highest Greek ideal and its existing remains.

At one level this effect of distancing is quite a straightforward matter. As fragments of a once much greater totality, the few statues that survived were inevitably, like ruins, signs of what had been lost as much as surviving presences from the past. But there is a further point that gives this perception a sharper edge, which has to do with a sense of alienation from the highest Greek ideal that Winckelmann identified as already existing in antiquity. In his view, ancient statues produced in Rome were echoes of an ideal already partially lost at the time they were made. In making this point, Winckelmann was drawing on written records relating to ancient Greek sculpture dating from the Roman Imperial period, which looked back to a moment of classic perfection in fifth-

and fourth-century BC Greece, a moment that could only have survived in highly mediated form among the ruins of Imperial Rome available in the eighteenth century. Antiquarian scholars before Winckelmann had already been taxed by the problem as to whether the most admired surviving antique statues were true equivalents of the classic Greek masterpieces mentioned in ancient literature or works of inferior quality.[36]

The problem as it emerges in Winckelmann's analysis is not just one that could be alleviated by the discovery of certified examples of early Greek art. Rather it is one integral to the whole process of historical reconstruction as he conceived it. How this is so becomes apparent if we look closely at the way in which his evocations of the most famous extant antique sculptures are placed within his historical narrative of rise and decline. These masterpieces are described with such unusual vividness that they literally burst into his analysis as apparitions from another sphere. The intensity with which they are evoked effectively marks them out to the reader as unmediated fragments of the true Greek ideal. They stand out graphically in his text as embodied presences quite separate from the surrounding historical chronicle. But if they are the fullest surviving exemplifications of the Greek ideal, they are not necessarily placed historically in the moment of the flowering of Greek art. Most are set in the context of the later decline of art in the ancient world. Statues such as the Apollo Belvedere (Plate 19), which Winckelmann singled out as 'the highest ideal of art among the works of antiquity that have escaped its destruction',[37] thus function not simply as pure embodiments of the Greek ideal but also as signs of its disappearance and loss, marked by a history of successive reappropriations and revivals during a period already distanced in ancient times from the pure Greek ideal.

The Niobe (Plate 15) and the Laocoön (Plate 16) are the only masterpieces of antique sculpture that Winckelmann did place in the classic period. However, they function less as examples of a pure classic Greek sculpture than as vividly dramatized instances of a stylistic polarity within the Greek ideal. The female figure, the Niobe, represents the high or sublime mode, characterized by an austere, partly disembodied beauty, and the male figure, the Laocoön, the gracefully beautiful mode, marked by a greater refinement and sensuality.[38] All the other famous statues singled out by Winckelmann, and conjured up in extended descriptions that interrupt the latter part of his historical narrative, namely the Belvedere Torso, the Apollo Belvedere, and the Belvedere Antinous, are associated with the story of the decline of art in antiquity.

For various contingent reasons, Winckelmann argued that the Belvedere Torso (Plates 36–9) originated in the period when he saw art in ancient Greece as undergoing its last genuine revival, just prior to Greece's total subjugation by the Romans—the product of what he conceptualized as a fragile moment of independence and freedom in the interregnum between Macedonian and Roman domination. 'The Torso of Hercules,' he wrote, 'appears to be one of the last perfect works, which art in Greece brought forth before its loss of

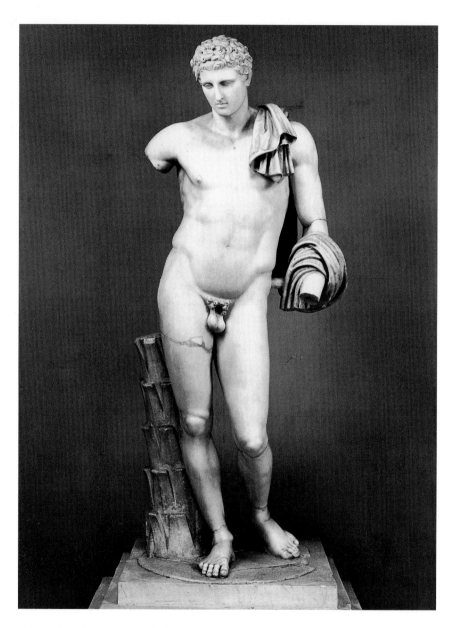

4. Belvedere Antinous, marble, Vatican Museum, Rome.

5. Engraving of the Roman relief with the portrait of Antinous in the Villa Albani from Winckelmann's *Unpublished Antique Monuments*.

freedom.' Its placing within the narrative thus intensifies the drama of the decline of Greek art. It becomes an image conjuring up a brief afterglow of Greek culture just before the very last vestiges of political freedom were lost. The very physical decrepitude of the statue as a fragment enhances the drama of this moment, and in turn re-articulates its status in the present as a sign of the absence of what it so vividly evokes: 'Abused and mutilated to the utmost, deprived of head, arms, and legs, as this statue is, it still shows itself, to those who are capable of seeing into the secrets of art, in the glow of its former beauty.'[39]

The Apollo Belvedere and the Belvedere Antinous were among the two most famous statues of Winckelmann's time, and his hymns to their beauty did a lot to enhance their status as exemplary masterpieces of ancient art. Nevertheless, the position of these works within Winckelmann's historical narrative makes their status somewhat ambiguous. Both are designated as Greek works that had been plundered or imported from Greece to Rome in early Roman Imperial times. They are dated, however, not to the best period of Greek art, but to some unspecified point in its later phase of imitation and decline. In other words, they are not identified as pure examples of the very best period of Greek art, though they stand out as Greek by virtue of being different from the standard run of decadent art being produced in Rome at the time they were brought there. The famous description of the Apollo Belvedere (Plates 19–22) is inserted into Winckelmann's discussion of art during the reign of Nero, an emperor who was known to have appropriated quantities of Greek sculpture to embellish his palaces.[40] It thus enters into the history of the decline of art in ancient Rome as an ideal that by that time could no longer be recreated but had to be pillaged from the past. Its place within the history of ancient art thus prefigures its status as the relic of a lost past within the artistic culture of Winckelmann's own time. This perspective, interestingly, is surprisingly similar to that of present-day archaeologists, who now view the statue as a Graeco-Roman copy or adaptation of an earlier Greek work.[41] In both cases it functions as a sign, lodged in the history of the Roman ruins from which it was excavated, of an earlier, 'purer' Greek conception of art.

The Belvedere Antinous (Plate 4; see also Plates 31–3) occupies an analogous position in Winckelmann's historical narrative. He lodged it at the point where he is recounting the fruitless attempts made by the Emperor Hadrian to revive Greek art under circumstances when 'the spirit of freedom had retreated from the world, and the source of elevated thinking and true fame had disappeared.'[42] This statue had traditionally been identified as a portrait of Hadrian's lover, Antinous (Plate 5). Winckelmann picked up this identification to highlight how its beauty was at odds with work that would have been produced in the Hadrianic period. He argued that it must be an earlier Greek work depicting a mythological hero such as Meleager. But it was not, he hastened to add, an absolutely perfect statue: 'It is placed among statues of the first class, as it deserves to be, more on account of the beauty of individual parts, than because

of the perfection of the whole.'[43] While its beauty stands out in contrast to the decadent state reached by art in the Hadrianic period, it is still only a partial and incomplete embodiment of the pure Greek ideal.

If Winckelmann is to be seen as developing a new, more historical perspective on ancient Greek and Roman art than other writers of his period, it is not only by virtue of his initiating the dating of antique statuary on the basis of a broad historical picture of the rise and decline of ancient art. More significant from our perspective is the complex interplay he set up between the story of the rise and decline of the Greek ideal and the fragments through which this ideal might be made present to us. The exemplary antique statues he evokes so vividly are presented quite literally as powerfully affective material presences. But the very immediacy with which they strike the reader is inseparable from the other function they have in the context of Winckelmann's historical narrative as intimations of the loss of the early Greek ideal.

The Greek ideal in Winckelmann's scheme is historical by virtue of its being at one and the same time a categorical absence and a vivid presence. It is the intensity, and the conceptual and rhetorical complexity, with which this contradiction is played out in Winckelmann's text that makes his a properly historical study, telling a history that is in large part the articulation of its own historical perspective, about 'the very tension of History, its division'. Precisely because Winckelmann is dealing with a history that relates directly to visible fragments, his account projects with peculiar vividness the sense in which, to quote Barthes, 'History is (essentially) hysterical . . . is constituted only if we consider it, only if we look at it—and in order to look at it, we must be excluded from it.'[44] Or, to return to Winckelmann again: 'We have only the shadowy outline of our desires: but this makes the desire for the objects we have lost ever more ardent, and we examine the copies of the original masterpieces with greater attention than we would have done were we to be in full possession of them.'

It is not sentimental nostalgia nor self-indulgent pessimism Winckelmann manifests here, but rather a categorical recognition of the contradictions inherent in his highly invested and systematic reconstruction of the past. To continue with Winckelmann's concluding commentary:

> Had the ancients been poorer, they should have written better about art. We are in relation to them like badly portioned-off heirs; but we turn over every stone, and through inferences drawn from many individual instances, we arrive at least at a hypothetical certainty, which can be more instructive than the surviving accounts of the ancients, which, beyond a few notifications of insight, are merely historical (concerned only with the chronology of factual detail).[45]

In other words, the ancients, who were in possession of an ideal art, had no need to write a full history of it. We feel impelled to write such a history precisely because this art has been destroyed. Loss is the precondition of our larger

historical ambitions. This negative dialectic is not simplified by Winckelmann to the condition of tragedy any more than it is to the upbeat lift of a triumphal progress.

In Winckelmann's historical re-creation of the art of antiquity, the surviving material fragments, for all their immediate palpability, are not just given to be appropriated as the cultural property of his audience, whether gentleman, aristocrat, or sentimental academic, looking back with regret to the passing of a great classic order. As they take on value and interest they are constituted as signs of a radical absence within the culture of his own time, the figurations of an ardently desired but impossible art and freedom. His hugely ambitious project is conceived as a wager very much against the odds, but one in which the stakes are so high that there is every point in staying with it.

The note on which he finally ends is neither one of stoic resignation, nor of knowing irony, nor of willing surrender to a dialectic of absence and displacement. Rather he actively asserts the value of pursuing his impossible task: 'You ought not to be afraid of seeking out truth even to the detriment of your self-esteem, and one person must err, in order that many may go the right way.' The ethical tenor of this injunction to continue to seek out a truth that can only be constituted by way of error and prejudice, the apparent certainty that there is in this intractable process a project of collective value, is a prejudice that engages us now with considerable urgency. It is perhaps our historical loss that we are no longer quite able to sustain Winckelmann's Enlightenment belief in the value of history. He seemed convinced that a solid truth could eventually be attained by simultaneously giving free reign to and sceptically deconstructing the more vivid fantasies evoked by the art of the past. The antinomies inherent in this attempt to recover by way of history what he felt as an insistent lack in the present have hardly gone away, even if his particular obsession with the Greek ideal is no longer one with which we would fully identify. Our history of his project is subject to structural contradictions no less acute than those he faced when writing his history of Greek art.

CHAPTER III

STYLE

The High Style and the Beautiful Style

The novelty of Winckelmann's history of ancient art did not just consist of his representing the entire history of the ancient Greek and Roman tradition in terms of a systematic pattern of rise and decline. He also gave this bare schema a more richly articulated, specifically visual character by tracing the evolution of ancient Greek art through an archaic, a high, a beautiful, and an imitative phase. The crucial distinction he introduced between the high and the beautiful, as two equally valid yet structurally different styles in classic Greek art, had no precedent. It formed the basis for a new kind of history of changing modes of visual representation, which would not immediately be reducible to the history of other cultural phenomena. Through the stylistic duality he opened up within classic Greek art, he was also able to give a new, more vivid inflection to the intractable yet largely disavowed tensions inherent in the notion of the Greek or antique ideal in the period.[1]

Systematic definitions of stylistic differences in modern art history of the kind made by Winckelmann tend to have a very ambiguous foundation. Are they grounded theoretically as a necessary structural distinction between two systematically different modes of visual representation, or are they rather derived empirically through a process of visual analysis of works of art that uncovers a significant difference between the art of two different periods? Winckelmann's *History* offers the prospect of a seamless identity between these irreducibly different bases for determining artistic style.[2] Equally, the ambitious scope and systematic character of his project place such enormous demands on this correlation that it also makes evident the possibility of its breakdown. Winckelmann's 'system' is both a theory of generic differences in modes of visual representation or visual rhetoric, explicitly grounded in conceptions of language and culture current at the time he was writing, and an empirical taxonomy of the different styles of Greek art prevailing at different moments in its history—two distinct orders of necessity that in very different ways override the 'contingencies' of individual works of art and their creators' intentions and desires. He presents us with a not uncommon paradox. While it is clear that these two orders of explanation are of their essence distinct, and need to be recognized as such, it is equally the case that in more fruitful definitions of style they are almost inevitably inextricably bound up with one

another. An epistemological confusion allows history to give empirical weight
to the theoretical definition of artistic style, and theory to give conceptual
rigour to notions of style derived from the disparate facts of history.

The distinction Winckelmann made between the high and the beautiful
styles is not only more novel, but also more fully articulated than other aspects
of his stylistic schema, namely, his definition of the archaic style, and of the
style of imitation and decline. This is partly because the duality between the
high and beautiful involves a paradigm of difference no longer exclusively
defined by models of progressive rise and decline. He grounded the stylistic
difference between the high and the beautiful mode in an understanding of how
ideas might be conveyed differently through the different rhetorical modes in
which the image of an 'ideal' human figure might be represented. It is a theory
of stylistic difference involving not just taste or visual taxonomy, but in its very
essence having to do with the articulation of meaning or what we might call
rhetoric.[3] In elaborating this theory, he invoked models taken from the analysis
of linguistic style to supplement the rather meagre consideration given to the
rhetoric of visual representation in the existing literature on visual art, drawing
in particular on a rich tradition of speculation in ancient Greek and Roman
rhetorical theory.

In his scheme Greek art, as an art that seeks to convey abstract ideas by way
of 'beautiful' figurations of the human body, does so in two complementary
modes, each of their very essence incomplete: a high mode that suggests the
presence of an immaterial idea through a comparative absence of sensual refine-
ment of form, and a beautiful mode, characterized by a fullness of sensuality
and grace, which is more immediately attractive, but can only evoke such an
idea at one remove. The fundamental duality thus opened up within classic
Greek art throws into question the utopian identity between immaterial idea
and beautiful bodily form, which the art theory of the period saw as epitomized
by the antique or Greek ideal.

When Winckelmann makes his case for distinguishing between·a high style
and a beautiful style in Greek art, he does so quite explicitly at two different
levels, one empirical and historical, the other a theoretical one. Essential to his
historical picture of Greek art is a visual taxonomy of a kind that in theory at
least provides him with a basis for identifying existing statues in the two styles.
This taxonomy is closely tied to his schema of evolution from hard necessity
through beauty to over-refinement and decline. The key difference it defines is
one between a certain hardness and angularity of contour in the high style and
a flowing gracefulness of contour in the beautiful style. Such a distinction is
essentially relative, and requires an understanding that the hardness involved
in the high style is not to be confused with the unnaturalistic hardness and
stylization of form that characterized Greek art in the archaic period, before it
achieved classic perfection. In Winckelmann's scheme of things, the relative
hardness of contour in the high style should be the positive manifestation of an
austere kind of beauty, as distinct from the hardness of the archaic style that is

the trace of a lack of mastery of beautiful form.[4] This is the ostensible drift
of Winckelmann's argument but, as we shall see in the subsequent dis-
cussion, the high style exists in a kind of limbo between archaic hardness and
refined beauty, its empirical identity being most readily defined in negative
terms—it is not archaic, but neither is it fully gracefully or sensuously
beautiful. What makes it particularly interesting as a category is indeed the very
difficulty Winckelmann has in defining its embodiment as an empirical
phenomenon.

The potential resonances of the high or beautiful distinction are much more
richly articulated in Winckelmann's theoretical account of the high and beau-
tiful styles. In the chapter where he outlines his schema of the four main period
styles of ancient Greek art, he includes an extended, rather lyrical passage that
is very different in tenor from the more scholarly and factual analysis surround-
ing it. It serves to present vividly to the reader the necessity of envisaging the
Greek ideal as embodied in two different modes or styles. The various images
he invokes to conjure up the different signifying power of the ideal figure in the
high and beautiful modes cluster around one key distinction, that between an
elevated abstract language or mode of image-making, which does not make
itself immediately available to the spectator, and one that presents things in a
refined, sensuous, and appealing form.

He contrasts the high style's strenuous commitment to the 'truly beautiful'
(*wahrhaftig Schöne*) with the beautiful style's cultivation of 'the charming' (*das
Liebliche*). Expression in the high style, he explains, is 'elevated' (*erhaben*),
characterized by a pure harmony and grandeur (*Harmonie und . . . Grossheit*),
and is subject to a strict unity and constancy of form appropriate to an immu-
table elevated ideal of beauty, while the beautiful style shows a greater charm
and a greater variety and diversity of expression (*das Mannigfaltige and die
mehrere Verschiedenheit des Ausdrucks*). The uniformity of images in the high
style makes them like ideas abstracted from nature. Images in the beautiful
style, by contrast, exhibit the varied modulations of natural form and dwell in
the realm of the plurality of nature. The high style is likened to the abstract
purity of an eternally valid system of laws, the beautiful style to the later
elaborations of such a system that mediates its strenuous correctness and makes
it more workable and amenable (*brauchbarer und annehmlicher*).[5]

A work in the high mode is in effect the visible trace of a Platonic form or
idea, but locked in the irreducible contradiction of being simultaneously the
image of a sensuous, beautiful figure and the embodiment of a pure idea. The
high style represents the theoretical essence of the Greek ideal, but is too
rigorously pure to be imagined easily as an empirical phenomenon. The latter
role is fulfilled by the beautiful style. If we take up Winckelmann's analogy
between artistic style and systems of law, the eternal verities of unity and
harmony that constitute the high style are to be likened to the systematic
correctness and rigour of a foundational code of law, while the allure and
refinement of the beautiful style are to be compared to later adaptations and

elaborations of the code, through which it becomes attuned to the variegated realities of things, and in effect becomes embodied.

In Winckelmann's picture of the unfolding of the Greek ideal in two distinct styles or modes, the high style figures both empirically and theoretically as a necessary hiatus or empty space. It is a stylistic category into which almost no extant fragments of antiquity can be placed, and whose distinctive attributes exist in a limbo between the hard austerity of the archaic and the graceful refinement of the beautiful. Theoretically speaking, it is the most elevated yet impossible mode of visual signification, in which the material signifier effaces itself to the point where it becomes transparent to an immaterial signified. The high style is both essence and absence. As such it echoes the utopian status of the Greek ideal within post-Renaissance culture as something that exists more as the theoretical projection of a lost ideal rather than an empirical given.[6]

Let us say that 'bourgeois' aesthetics, in putting pressure on this utopian notion that it did not have to bear before, both gave it a new charge and threatened it with implosion. Winckelmann's invention of the idea of a distinctive high style is thus both a mark of confidence that the Greek ideal could be endowed with a fuller historical reality than before, and a hysterical symptom prompted by the unacknowledged threat of its dissolution or absence.

The terms in which Winckelmann makes his systematic distinction between a high and a beautiful style in Greek art not only echo tensions existing within the post-Renaissance notions of the ideal in art. They also follow the logic of one of the more pervasive stylistic distinctions found in previous discussions of the visual arts. The duality between a form of art that is more austere, conceptual, and disembodied, and one that has more to do with the sensuous fabric of things, is there in some guise or other in the standard distinction between an art based on drawing (the rendering of the essential form of things) and a more superficial art that focuses on colour (the surface appearance and texture of things) in post-Renaissance art theory.

From our perspective, however, Winckelmann's notion of a systematic duality in modes of visual representation seems closer to modern formalist definitions of stylistic difference, which emerged in German art-historical writing of the later nineteenth century.[7] After a phase of reaction against what was taken to be the artificial and schematic nature of his definition of artistic style, Winckelmann's 'larger' understanding of style began to acquire a new importance. It seemed to point the way to establishing a connection between the visual analysis of works of art and cultural history, and it also gave art history a distinctive focus or object of study.[8] Winckelmann soon gained a legendary status within the emerging tradition of professional, university-based, German-speaking art history. As Jacob Burckhardt put it: 'The history of style . . . begins with Winckelmann, who was the first to distinguish between the periods of ancient art and to link the history of style with world history. It was only after him that art history became a branch of cultural history.'[9]

Like Winckelmann's distinction between a high and a beautiful style,

Wölfflin's celebrated formal distinction between a linear Renaissance and a painterly Baroque style, formulated in *Principles of Art History* (1915), served two different functions that could never entirely be disentangled from one another. On one hand, this definition of stylistic difference formed the basis for a historical characterization of visual artefacts from periods supposedly dominated by one or the other style. Equally, it functioned theoretically as a generic distinction between two fundamentally different modes of visual representation, which would be relevant to understanding the structure of any visual image.

These modern formalist definitions of stylistic difference also continue to echo something of Winckelmann's distinction between an art that aspires to the 'immaterial' condition of a purely formal order, and an art that prioritizes sensuous presence. Take, for example, Panofsky's reformulation of Wölfflin's antithesis between the linear and painterly. Panofsky envisaged this underlying duality within visual representation as one between 'form' (the linear or haptic) and 'fullness' (the painterly or the optic), associating form with the unalterable, and hence in some sense ideal, basic structures of spacial configuration, and fullness with the more empirically saturated alterations of the temporal.[10] Or consider the generic distinction made in discussions of avant-garde art in the 1970s between the formal and the literal. Here a conception of art as something whose essence resides in non-palpable formal values (epitomized by colour-field painting) is set against one where the literal sensuous presence of the work of art as physical object is all that counts (minimalist art).[11]

What makes Winckelmann's duality particularly interesting is that, like the formal/literal dichotomy, it shifts attention away from the traditional preoccupation of art theory with painting and the paradoxes involved when its two-dimensional schema of representation appears to make present and palpable a three-dimensional reality. Winckelmann's is a categorization specifically designed to make sense of sculptural or three-dimensional art objects. It highlights a dichotomy between the solid material presence of a visual representation and the immaterial idea that it evokes, embodies, or stands for, which sculpture makes particularly manifest.

Winckelmann, however, did not play out this problem in terms we would recognize as systematically formalist because he still defined the materiality of sculpture in terms of the body being represented rather than in terms of the materiality of the sculptural object as such. His analysis first and foremost concerned the representation of the ideal by way of the image of a beautifully formed body. His preoccupation was with the antinomies particular to this model of representation, a model so central at the time because the ideal nude stood as the paradigm of the fullest and highest artistic endeavour, and also played such a key role in Enlightenment humanist ideology. However much Winckelmann may seem to have made a break with earlier definitions of artistic style and prefigured modern formalist paradigms of stylistic analysis, the more interesting ideological and theoretical loading of his discussion of the high and

beautiful styles still has to do with pre-Romantic understanding of the antique ideal.

PRECEDENTS

Before engaging with the theoretical complexities of Winckelmann's definition of style, we need to understand more precisely how he broke with earlier precedent. In what sense did his duality between the high and the beautiful styles introduce a new feature into the history of ancient art, and more generally, to what extent did it create a different formal paradigm for analysing style in the visual arts? In particular, how did his conception of the change from a high to a beautiful style depart from earlier definitions of stylistic evolution structured around patterns of rise and decline?

The model of a stylistic history of art that prevailed before Winckelmann in both ancient and modern sources was one focused on a systematic progression from crudely archaic beginnings to a fully elaborated beauty and naturalness of form achieved in the work of the classic masters. It offered no model of historical evolution for art after the completion of this development. The systematic definition of the history of art was confined to the story of the early formation of a tradition, and reached its terminus once the basic resources of the tradition had been realized. In this respect, thinking about the stylistic evolution of art had remained largely unchanged since ancient Roman Imperial times, the period from which the earliest surviving histories of ancient art originated. An emphasis on the progress of a tradition from its origins to its moment of classic perfection was as evident in Pliny's detailed chronology of ancient sculpture as it was in the summary outlines of the history of art that cropped up from time to time in ancient rhetorical treatises such as those of Cicero and Quintilian.[12]

Within this paradigm, systematic stylistic development consisted of evolution from an art that was stiff, hard, rigid, and failed to imitate reality, to one that was beautiful, genuinely majestic, and life-like. More specifically, after the progress from archaic origins to the fully developed naturalism and beauty achieved by the great early masters, Phidias and Polycleitus, art ceased to follow any coherent pattern of stylistic development. Different styles emerged, but they simply defined the distinctive character of an individual artist's mode of performance, and did not have a larger status as the defining or dominant artistic language of a period. These styles were seen to coexist within an ahistorical framework of possibility opened up once the last vestiges of archaic imperfection had been overcome. If art was seen to acquire new resources after the initial moment of classic perfection, these were inevitably in the nature of inessential embellishments, not redefinitions of the character and scope of art. From an archaic realm of necessity, art moved into a classic realm of freedom.

It is one of Winckelmann's more clearly definable achievements to have

replaced this paradigm with an apparently more consistent historicizing model in which art, even after entry into the classic phase, continues to follow a systematic, defined pattern of historical development. In his scheme, the later elaboration of the stylistic resources of art continues to bring structural change to the prevailing mode of representation, whether this be the transition from a high to a beautiful mode, or from the most exquisite refinement of the latter to the over-elaboration and imitation of the period of decline. Classic and post-classic art operates within a distinctive visual language or mode of representation just as much as art of the archaic period, and is in no position to rove at will over the stylistic registers of past art. Art never escapes the prison house of a particular language of representation, can never, even at its moment of classic perfection, transcend certain limits inherent in any actual system of representation. All art, even the very finest, is in some sense art in a particular mode.

There are nevertheless certain features of earlier histories of ancient art which could be seen to imply that larger changes in artistic style occurred after the progress from 'inadequate' archaic beginnings to fully realized classic perfection, and these were very important for Winckelmann. Most directly pertinent to his theory of the high and beautiful styles are two passages in Pliny's history of ancient Greek bronze sculpture, much discussed at the time, which would seem to be somewhat at odds with the idea that classic perfection had unequivocally been achieved in the period of Phidias and Polycleitus. First there is a comment at the end of a section on Polycleitus: 'his figures are square (*quadrata*) and almost exactly after the same type.' And then the summary of Lysippus' achievements slightly later on:

> There is no word in Latin for the canon of symmetry which he was so careful to preserve, bringing innovations which had never been thought of before into the square figures (*quadratas staturas*) of the older artists, and he often said that the difference between himself and them was that they represented men as they were, and he as they appeared to be.[13]

The strong implication that Lysippus had brought some fundamental structural improvements to the language of art had puzzled earlier commentators on Pliny. It prompted Caylus, one of the foremost antiquarian scholars of Winckelmann's time, to suggest that Pliny's extravagant praise of the earlier classic masters was not to be taken at face value, and that full classic perfection, comparable to that of the art of the High Renaissance in modern times, had only been achieved at the time of Lysippus. In the commentary on Pliny he published in 1759, he drew a parallel between the 'square' style Pliny attributed to ancient art in the age of Phidias and Polycleitus, and the style of modern art in the period prior to the classic age of Raphael, when, in the eighteenth-century view, art was still dry and somewhat archaic in character.[14] Winckelmann similarly focused on Pliny's 'problematic' comments about the 'squareness' of the work of the older Greek masters, but he came to rather different conclusions. He read Pliny as indicating that these older masters had reached an

equivalent point in the evolution of art to Raphael and the classic masters of the Italian High Renaissance.[15]

Winckelmann's systematic distinction between an early classic high style and a late classic beautiful style was an ingenious solution to problems of textual interpretation posed by these comments in Pliny's history of ancient art. Pliny's point about the 'square' (*quadrata*) character of the work of the older masters played a central role in Winckelmann's definition of the high style,[16] and also in his description of the systematic changes in the style of art that came about with the advent of the beautiful phase.[17] Winckelmann made the (mistaken) assumption, partly on the basis of the meaning attributed to the word *quadratur* by the sixteenth-century Italian theorist Lomazzo, that it was used in antiquity to refer to a certain geometric abstraction of contour, to 'a square manner of drawing' that contrasted with a flowing gracefulness of form, the 'wave-like' rounding of contour, in the beautiful style.

That Winckelmann was motivated in this interpretation more by the force of a theoretical model that he projected onto the text than a philological enquiry into its possible meaning is suggested by the fact that eighteenth-century scholarly opinion tended to the view that *quadrata* had to do with the overall proportion or shape of a figure, not the details of the shaping of its contours.[18] A certain schematic simplicity of outline, which Winckelmann identified as particularly evident in the shaping of the area around the eye and the marking of the eyebrow in Greek statuary, became the closest thing he could find to a visual taxonomic key for distinguishing work in the high style. What we have in effect is a mistranslation of a point of detail overlaid on a highly ingenious 'solution' to the problems of interpretation posed by apparent inconsistencies in Pliny's comments on the styles of the masters of the classic period. This (mis)reading of Pliny brings to bear a theoretical perspective that was not articulated there, nor in any other accounts of the development of art surviving from the ancient world.

There were certain precedents for Winckelmann's distinction between the high and the beautiful styles of ancient Greek art in earlier stylistic analyses of modern art, but these too were not of a kind to provide him with a ready-made model. Even the comparisons he himself made between the stylistic development of ancient and modern art were never entirely consistent. In one context, when trying to give a more vivid idea of what he meant by the 'certain grace' that distinguished the beautiful style from the high style, he suggested that the reader think of the difference between the seventeenth-century master Guido Reni, at the time considered a model of gracefulness in art, and Raphael.[19] But this was not an analogy that Winckelmann chose to work through consistently. In his general outline of the history of modern art, he identified no significant stylistic change in the very brief period of classic perfection achieved by Raphael and Michelangelo, and the art of Reni and his contemporaries was seen to fall firmly in the period of imitation and decline.[20] The duality between the high and beautiful was not in his view fully realized in the less complete pattern of development followed by modern art, and so the latter could hardly have

provided a model for the systematic historical distinction he made between a high and a beautiful phase in ancient art.

Of the histories of modern art on which Winckelmann might have drawn, Vasari's was the one that provided the closest precedent for his distinction between a high and a beautiful phase. Vasari, more than any other historian of modern art, envisaged the development of art in terms of systematically defined phases, and there are certain aspects of his particular distinction between the second or middle phase in the evolution of Italian art and the final or third phase that have affinities with Winckelmann's schema. The art of Vasari's second phase, like the art of Winckelmann's high period, had reached the point where naturalistic form was correctly mastered.[21] Further development in both cases involved stylistic change that could not be assimilated to a simple progress in the conquest of natural appearances. Winckelmann's stress on grace as the main quality distinguishing the beautiful style from the high style also has obvious affinities with Vasari's point about the new sense of grace that artists of his third period brought to the achievements of their predecessors.

Nevertheless Winckelmann parts ways with Vasari's model by insisting that the high style should not in any sense be seen as inadequate in comparison with the later beautiful style, but as an alternative, equally valid mode. The received story of progressive stylistic refinement that still underpins Vasari's account is recast to become an evolution between two differently structured but equally valid styles. Vasari defines the grace of the masters of the third period in terms that deliberately emphasize their comparative superiority—it is not just grace that distinguishes them, but 'superb grace' and 'inspired grace'.[22] Vasari's second period of modern art is in this respect less like the high phase in Winckelmann's schema than the late archaic phase of ancient art, the 'preparatory' period leading up to the perfection of the classic period.

In Vasari's account of Italian art in its later phases, a very careful reader might notice signs of a certain tension between a progressive and a non-progressive model of historical development, and Winckelmann could conceivably have been such a reader. But such a reading would have required the awareness of a paradigm never explicitly elaborated in Vasari, and one at odds with the pattern of development towards ever-increasing mastery and refinement of style that he does invoke. Vasari's schema is in part designed as a celebration of the classic achievements of the famous Italian masters of the earlier sixteenth century, who, according to him, effected a crucial change from mere correctness, and the hardness and rigidity of style that goes with this, to free virtuoso artistry—from diligence to effortless mastery and graceful refinement, from an art that made a display of the work that went into it to one that effaced all obvious signs of effort and constraint. The passage from the second to the third phase is one from the residual constraints of necessity to the open vistas of free artistry. In Winckelmann, the systematic aspect of the history of art is no longer simply mapped out along an axis of progressive development from archaic crudity to perfect beauty and naturalism.

When Winckelmann sought to elaborate a history of ancient art based on an

analysis of the artistic style of surviving artefacts, his most immediate prec-
edent lay in the work of an important group of French antiquarians around
Caylus. In the decade or so prior to the publication of his *History*, they had
pioneered a new approach to the study of antiquities, based on a systematic
comparison and classification of artefacts. In so far as a revolution took place in
antiquarian studies in the eighteenth century, this must be identified with
Caylus and his circle as much as with Winckelmann. What most clearly sets
Winckelmann's work apart, however, is his new distinction between a high and
a beautiful style, for which Vasari's analysis of the styles of Renaissance art
remained one of the few possible inspirations in earlier art-historical writing.
Caylus's history relied on a rather crude model of progressive development
and, like other systematically conceived histories of the period, was concerned
almost exclusively with the origins and early development of art.

The major publications of the new French antiquarian studies included
Caylus's highly influential *Recueil d'Antiquités* (*Collection of Antiquities*), the
first volume of which appeared in 1752, Mariette's *Traité des Pierres Gravées*
(*Treatise on Engraved Gems*) published in 1750, and a series of articles by
Barthélemy on the dating of ancient coins, which appeared between 1757 and
1759. Caylus, the central figure, was very active as a scholar and theorist in both
the Académie Royale de Peinture et de Sculpture and in the Académie Royale
des Inscriptions et Belles-Lettres, and Mariette and Barthélemy also straddled
the world of art and antiquarian scholarship.

These antiquarians proposed a new basis for tracing a history of ancient art,
derived from a visual analysis of extant antiquities rather than from philological
interpretation of ancient texts relating to the visual arts. They saw themselves
as bringing the science of connoisseurship, concerned with distinguishing 'the
spirit and the hand of the artist' as Caylus put it,[23] into the field of antiquarian
studies, where such considerations had been neglected in favour of icono-
graphy and emblematics. Like Winckelmann, they were also committed to
moving away from a history of art conceived as a series of lives and achieve-
ments of individual artists to one defined in terms of larger patterns of stylistic
development.

Unlike Winckelmann, however, they envisaged their method as an entirely
empirical and inductive one. 'Monuments,' Caylus wrote, 'presented according
to this point of view [i.e. observing differences in *dessin* or drawing] distribute
themselves of their own accord in several general classes, relative to the coun-
tries in which they were produced; and in each class they arrange themselves in
an order relative to the period which saw them being born.'[24] Caylus described
this empirical method of visual stylistic comparison as the chief tool of the
antiquary, analogous to the experiments of the physicist.[25] He might equally
have compared it to the empirically based taxonomy being proposed at the time
by Buffon, the famous French writer on natural history, for distinguishing and
classifying animal species. Like Caylus, Buffon presented his major publication
as a series of extended empirical case studies, interleaved with general essays

summarizing the fruits of his investigations, and he set himself against the idea of providing a system deduced from a priori principles.[26]

In Caylus's *Recueil* the general commentary that preceded the catalogue entries in each volume was of great importance, for he had to keep on returning to certain fundamental problems of method. Just as Buffon sought to ground his empirical analysis and classification of natural-history specimens in immutable truths of nature, so Caylus made a point of establishing what he saw as unassailable laws relating to style or taste in the visual arts, which would guarantee the coherence of his studies. These are roughly the same as the assumptions that have been underpinning the empirical pursuit of stylistic analysis ever since, even if not always explicitly recognized as such. These fundamental 'laws of nature', as Caylus called them, were twofold.

One had to do with the uniform pattern of development manifest in the changing look of art as it evolved from rudimentary beginnings. It was the principle

> that in all countries [the arts'] march is uniform, that everywhere they follow the same route . . . that to get from infancy to maturity, they receive the same successive increments. You could say that in this respect, as in so many others, nature always lays down the same law.[27]

An end point to the rule of this law seemed to occur, however, once art had evolved the fullest possible refinements of naturalistic and beautiful form. Beyond this stage, achieved by the Greeks in their best period, Caylus could identify no further systematic development.

The second law had to do with the distinctive character that pervaded all the artistic products of a particular period and place:

> this constancy, or this law that nature seems to impose more or less on all nations, must be seen as an advantage; without it posterity would not be able to distinguish either the period or the place of origin of monuments; and the means of recognition would be confined solely to inscriptions.[28]

The last comment is a clear indication of Caylus's ambitions to establish a new mode of scholarly study, based on visual analysis rather than the traditional antiquarian interpretation of texts and inscriptions.

Caylus had expansive general ambitions as to how monuments could come to serve as 'the proof and expression of the taste that reigned in a period and in a country',[29] but he had no method to offer on this score beyond the intuitive sensitivity of the connoisseur, who could somehow divine the guiding 'taste' of an epoch or a people by simply casting his eye over their artistic productions.

The combination of larger ambitions and the absence of the means to see these through on a systematic basis comes out very clearly in relation to one of Caylus's most sustained theoretical declarations in the introduction to the second volume of his *Recueil*, published in 1756:

By re-examining the precious remains of the ancients, you are able to conceive a sure idea of their taste. The arts carry the character of the nations that have cultivated them; you sort out their beginning, their infancy, and the point of perfection where they have been taken by every people. One is not better able distinguish the taste of these people, their customs, their turn of mind, if it is permitted to speak in this way, in the books that they have left us, than in the works of painting and sculpture that have survived until our time. A glance rapidly cast over one of those cabinets, where such treasures are assembled, embraces in a way the picture of all the centuries.[30]

What this empirical method of comparison and classification could deliver in terms of substantive insights into the stylistic history of ancient art, and the distinctive taste of the art of different periods, was relatively thin. At most Caylus was able to identify differences of style between what were then seen as the main schools of ancient art—the Egyptian, the Etruscan, the Greek, and the Roman. He was also able to give some indication of what archaic Greek art might look like, but this was most securely demonstrated in Barthélemy's numismatic studies, where inscriptions provided important collateral evidence as to place and date of origin.[31]

Caylus's declared aim that series of antiquities arranged chronologically on the basis of their style could be used to build up a picture of the development of art in the ancient world proved rather elusive. On his own admission, it had not proved possible to trace the main phases in the development of early Greek art by using surviving monuments.[32] Too few early monuments could be identified with any certainty. Though the greater abundance of Etruscan antiq-uities in theory made it possible to build up a picture of 'a constant succession' of styles, he largely left this for the reader to do on the basis of the examples provided in his catalogue. When Caylus did briefly indicate how Etruscan art could be seen as having three main phases of development, he was not so much exemplifying a pattern he had derived from a stylistic analysis of Etruscan antiquities as illustrating what he felt to be the determining importance of external influence on stylistic change.[33] He simply assumed that the main turning-points in the history of Etruscan art could be marked out by an initial contact with the Egyptians, which raised their art up from its very crude origins, and subsequent contact with the Greeks, which brought their art to its highest pitch of perfection.

Caylus defined the systematic aspect of the history of ancient art in very simple schematic terms. The main stages of evolution were marked out by the successive achievements of the three principal schools of art in antiquity, starting with the simple grandeur of the Egyptians, moving to the greater elaboration of detail, combined with a lingering dryness of form, in Etruscan art, and culminating in the beauty of the ancient Greeks. In this way he envisaged the history of art as having a larger logic, moving from crude begin-nings to early archaic (Egyptian art), the late archaic (Etruscan art), and culmi-

nating in classic perfection (Greek art). As stated here, the pattern seems to be realized, not so much through a logical process of historical development as through the stimulus of interactions between one ancient people and another. In practice, Caylus did not insist strictly on the literal working of such a model. He never actually described the Greeks taking over art in its late archaic phase from the Etruscans. This was more a concept than a strictly historical truth. Rather he suggested that both peoples' early artistic development probably took off from the ancient Egyptians. In the end, the key development in the latter phases of the history of ancient art was not, as his general schema implied, a transfer of art from the Etruscans to the Greeks, but rather the opposite—a change brought about by the impact of classic Greek art on the still archaic work of the Etruscans. Caylus's theoretical predilection for influence as a dynamic of historical change may in part explain his focus on the Etruscans, whose history of art could most readily be conceived in terms of successive contacts with other ancient peoples.

Though Winckelmann's is a much more elaborate history than Caylus's, partly because it did not rely so exclusively on a purely visual taxonomy, there is no denying his considerable debt to the French antiquarian, particularly in the schema he proposed for the progress of archaic Greek art through an early Egyptian-like phase and a late Etruscan-like one.[34] If, in contrast to Caylus's diffusionist approach, Winckelmann sought to represent the early development of Greek art as more or less autonomous, the basic picture he proposed was quite similar. Winckelmann's schema only departed significantly from Caylus's with the new understanding of style he brought to bear on the history of the Greek tradition after it had reached the point of 'classic' perfection. Indeed, his theory of the high and the beautiful styles threw into question the simple progressive model of his predecessor.

When it came to detail, the empirical method of Caylus and his French contemporaries did less to deliver a new picture of the history of ancient art than bring to light the uncertainties inherent in using antiquities of unknown provenance as historical evidence. Time and again their commentary on individual antiquities demonstrated that visual analysis of itself could not determine with certainty the historical period from which an artefact might date. But visual analysis was very effective for showing up mistakes made when antiquities had been assigned to an early date on the basis of slender epigraphical or iconographical evidence. The new method of stylistic analysis brought to light inconsistencies between the ostensible place and date of origin of a work and the artistic style of the image.[35] It also drew attention to problems raised, not only by modern copies and forgeries, but also by imitations of earlier art dating from ancient times. It soon became clear that there had been a well-established practice in Imperial Rome of imitating earlier styles, such as the archaic Etruscan or the Egyptian.[36] It became clear too that Etruscan art could easily be confused with early Greek art, adding to the difficulties of trying to reconstruct the history of early Greek art on the basis of antiquities dug up in Italy, for

which there was in most cases no circumstantial evidence to indicate whether the work was 'indigenous' Etruscan or imported Greek, or made by Greek settlers working in Italy. The new method, which in theory promised a reconstruction of the early history and progress of art on the basis of systematic stylistic comparison and classification of existing artefacts, immediately became embroiled in new kinds of uncertainty about identifying a work as being early in origin on the grounds that it was archaic-looking in style.

Caylus's theoretical confidence in a method that promised to distinguish the art of different peoples and periods on the basis of visual analysis alone was most justified, judged on its own empirical terms, when it drew attention to the huge pitfalls inherent in such an enterprise. The new method projected the idea of a complete history of art, and in so doing made more vivid the possibility of error attendant upon identifying and ordering the apparently random fragmentary remains on which such a history would have to be based.[37]

Caylus's musings on the possibility of being able to 'judge the culture, the spirit (or mentality), and sometimes even the character of the customs' of a people from 'the number, the taste or the barbarity' of its monuments,[38] rather like the promise he offers of a strictly empirical stylistic history of art, has proved to be considerably closer in spirit to subsequent art-historical practice than Winckelmann's system. In theory Caylus offers the prospect of a visible history that can literally be read from the chronological succession of monuments established by stylistic comparison and classification. However, the mechanism at work here is not so much an act of recognition whereby the mentality of a period is somehow glimpsed in its artistic style, but rather an act of projection. The sight of a visual artefact may set in train ideas about the cultural values and habits of mind associated with its place and date of origin. But these ideas are not a message encoded in the artefact, but ones already implanted from other sources in the viewer's mind. Much social and cultural history of art continues to operate in this way, and as such is more or less interesting depending on the greater or lesser interest of the mind and cultural milieu of the person doing the musing.

Caylus had quite an interesting mind, stocked with some of the less appealing as well as the more intriguing attitudes of the patrician strain of French Enlightenment culture. For him the taste of a people is a strongly socialized quality. Ancient peoples often become metaphors of social types, displaying a greater or lesser degree of urbanity or vulgarity. The Greeks, for example, were revealed in their monuments as 'the most agreeable nation that ever inhabited the world'.[39] The Romans, in contrast, at the point when they start taking an interest in the arts, were

> comparable to those newly arrived men (*hommes nouveaux*) who are surprised to see themselves rich and covered with honours . . . they wish to possess without applying themselves to knowing; and incapable of working

to make the arts flourish by studying them, they made their gold and money shine in the eyes of foreign artists, and the Greeks came running in crowds.[40]

Picking up the Enlightenment belief that genius needed the stimulation of political freedom—in Caylus's case the freedom epitomized by the high-born gentleman of independent means—he engaged at times in 'political' readings of style that seem to look forward to the liberal ethos that prevailed in discussions of art in the nineteenth century. The Romans, he believed, left the execution of their art largely to slaves, so 'Roman taste is in general heavy, flaccid, and lacking in refinement; it is redolent of the state of servitude to which the artists of that nation were reduced.' But he did not go in for the historical determinism of later art historians, including Winckelmann. In his reckoning Roman work could still show 'fine workmanship and grandeur of conception' if it came from the hands of one of the many Greek artists who immigrated to Rome in the Imperial age.[41]

Winckelmann followed Caylus in making loose associations of this kind between artistic style or taste and cultural, social, or political values. The tendency is particularly noticeable in Winckelmann's discussion of the distinctive mentalities of the various ancient peoples as revealed in their art. But the more interesting and systematic connections he makes between art and ideology or culture are articulated within a theoretical analysis of style not found in Caylus. With Winckelmann's novel conception of the high and beautiful styles, the cultural or ideological aspects are as it were implanted in the primary mechanisms of visual representation. Stylistic analysis becomes at one and the same time the formal account of a difference in the mode of visual signification, and a definition of difference which has profound ideological and cultural implications.

Visual Facts

Winckelmann's empirical understanding of the high and beautiful styles in ancient Greek art was based partly on an interpretation of some problematic passages in Pliny, and partly on a visual comparison and classification of antiquities along the lines suggested by Caylus and his French contemporaries. Such stylistic analysis is an important feature of Winckelmann's work, not just because the possibility of dating antiquities it opened up was so central to his own view of the significance of his project. The distinction between a high and a beautiful style in classic Greek art would not have had anything like the same theoretical weight, for him or for us, were it not grounded in an empirical visual analysis of antique statuary. Otherwise it would just have existed as a nice idea floating free above the contingencies of historical fact.

There is a further issue at stake here, which should make us pause if we are

tempted to dismiss Winckelmann's detailed taxonomy of artistic style as not particularly exciting intellectually. A crucially important point about the two styles of classic Greek he defined is that they exemplify the possible material forms in which the Greek ideal could actually take shape, could be embodied as empirical phenomena. The visual analysis of style in ancient art thus provides a basis for Winckelmann's insight into the impossibility of the Greek ideal ever being manifest in all its fullness in one particular form or mode. Moreover, the distinctive status of the high style as a theoretically difficult construct is given further substance by the tenuous and problematic character of its exemplification by known works of antique sculpture. In observing the difficulties Winckelmann had in defining the particular form taken by the high style, we not only witness the more mundane problems he faced in trying to give some body to the verbal accounts of the styles of classic Greek art. We also see him playing out antinomies central to his whole notion of the Greek ideal, which he embedded in his definition of the high style. More precisely how and why this occurred is to be discussed in the last two sections of this chapter. There we shall be exploring his theoretical explanation of the stylistic difference between the high and the beautiful, as well as analysing the distinctive role played in this by conceptions of style drawn from rhetorical theory. But first we need to address how he went about giving his conception of style an empirical basis in existing artefacts.

Winckelmann's definition of the high style, the earlier of the two forms taken by classic Greek art, can be seen as an attempt to conceptualize a certain lack or absence of refinement, a certain archaicism, as a positive value. This did not arise as an issue in the same way in his account of archaic Greek art. The high style was conceived as exemplary, while the archaic was not yet considered, as it came to be later on, a viable alternative to prevailing modern cultural forms. With Winckelmann and Caylus, as with most eighteenth-century theorists of the visual arts, an overriding quality of archaic forms of art was their relative stylistic inadequacy, however much isolated instances of a more positive valuation can be found in their writing.[42] Winckelmann's characterization of the high style in ancient art could be seen to parallel his period's rethinking of Homer as both archaic and a fully realized classic. The high style is a complex, almost paradoxical phenomenon that achieves its austere or sublime perfection through a residue of archaic lack, through a certain resistance to the refined, sensuous plenitude of the beautiful style.

Winckelmann's main visual demonstration of the difference between the high and the beautiful styles is a comparison between two of the most dramatic free-standing statues then surviving from antiquity—the Niobe (Plate 15) and the Laocoön (Plate 16). The emphasis here falls on the contrast between two fundamentally different expressive modes, exemplified by the 'high' drama of the Niobe and the 'beautiful' drama of the Laocoön. The 'frozen' Niobe achieves its austere intensity through an almost death-like obliteration of signs of feeling, which elevates its expression to the realm of an inhuman beauty. The

Laocoön, on the other hand, is shown in the midst of an elaborately modulated struggle, its variegated and beautiful forms, exemplary of the subtle and refined naturalism of the beautiful style, projecting a wide range of changing emotions.[43] The Niobe stands as an abstract disembodied drama in the high mode, the Laocoön as a sensuously embodied drama in the beautiful mode.

From our perspective, we might be tempted to argue that the rather slender circumstantial evidence Winckelmann had for (wrongly) placing these statues historically in the early and late classic periods is in the long run secondary, according to the priorities marked out in his analysis, to the value of these works as embodiments of a theoretically necessary duality within the Greek ideal. But that would be to simplify Winckelmann's project, to iron out the inconvenient material facts of a now apparently outdated antiquarian scholarship. With the evidence at our disposal, which suggests that not only the statues themselves but the earlier prototypes on which they were based long postdate the classic period, it seems that all we can say about Winckelmann's citing these two statues as exemplifications of two different styles of classic Greek art is that he was just plain wrong. But the situation is not quite that simple. While he has been superseded by later archaeological scholarship and we now have examples of clearly dated work from almost all periods of Greek art, our view of free-standing sculpture is still confused historically by late Hellenistic or Graeco-Roman copies and re-creations of earlier work of the kind represented by the Niobe and Laocoön.

Winckelmann's analysis focused on the heads of the figures more than any other feature. What he did deliver empirically was the notion that the rendering of the ideal head in Greek art could not be understood solely in terms of individual variations within a single basic schema or mode of representation, but involved structurally different modes. This kind of preoccupation is still a real element in subsequent studies of Greek sculpture, even if the examples have changed. An emphatically formal approach to analysing Greek sculpture has been sustained by continuing attempts to identify systematic differences in the rendering of the ideal figure, which may at first sight seem relatively small to modern eyes, and which have not necessarily been any less speculative than Winckelmann's.

If Winckelmann's analysis of the high and beautiful styles of classic Greek art were to function as a means of identifying statues in the two modes, he would have to give a more specific visual definition to the general distinction between a certain severity and hardness on one hand and a certain flowing gracefulness on the other. In his readings of the Niobe and Laocoön (Plates 15, 16), he singled out the head as the place where the articulation of different forms of beauty and different modes of expressiveness became most visible, and it was the formation of facial features that he identified as the key to an empirical taxonomy. His analysis of the Athena Farnese (Plates 26, 27), which he (rightly, according to modern opinion) saw as representing a type deriving from the high period, focused on the head as betraying 'a certain hardness'.

Drittes Stück.

Von dem Wachsthume und dem Falle der Griechischen Kunst,

in welcher vier Zeiten und vier Stile können gesetzet werden.

6. Engraving of archaic Greek coins from the 1764 edition of Winckelmann's *History of the Art of Antiquity.*

'One might wish,' he wrote, 'to see a certain grace in the (features of) the face, which it would receive through more roundness and softness, . . . the same grace probably that in the later period of art Praxiteles was the first to give to his figures.' The hardness was not the out and out hardness of the archaic style, but an 'appearance of hardness' (*Schein von Härte*)—one that could better be 'experienced (*empfunden*) than described'.[44]

In his *Unpublished Antique Monuments*, which came out in 1767, four years after the *History*, this point acquired a specificity that almost prefigured the nineteenth-century Italian connoisseur Giovanni Morelli's analysis of artists' distinctive rendering of individual facial detail. Here the basis for distinguishing between statues in the high and the beautiful styles was identified as the formation of the curve of the eyebrow. A 'hard and sharp outline of the bone covering the eyebrow' signalled a work in the high style, such as the Niobe (Plate. 17). Later, when a beautiful gracefulness took precedence over an austere sublime, 'this part was softened, the sharpness was smoothed, so as to suggest a greater gentleness in the eye and in the look,' as in the head of the so-called Belvedere Antinous (Plate. 32).[45]

In the systematic comparisons Winckelmann made between antiquities that he identified with the high and the beautiful styles, this distinctive focus on the

formation of the eyebrow became crucial. In part it loomed so large because of the kinds of antiquity on which he had to draw when developing his taxonomy of visual style in ancient art. In the absence of a significant body of sculpture that could be dated to the archaic period, the one solid empirical starting-point he had for tracing the early stylistic evolution of ancient Greek art was early Greek coinage.[46] A series of coins from Syracuse, carrying the profile of an ideal female head, which he considered significant enough to merit an illustration at the outset of the chapter outlining his theory of the 'four periods and four styles of Greek art', provided the main example on which he based his analysis of the archaic style (Plates 6, 7). The coins could with some assurance be identified as early Greek. Unlike other archaic-looking antiquities, they carried an inscription in Greek that attested their place of origin in the Greek colony of Sicily, and the relatively crude lettering provided epigraphical confirmation that the image on the coin was genuinely archaic. Visible archaicism in the image would not on its own have been sufficient to exclude the possibility that it was an Etruscan, or maybe archaicizing Roman, or simply crude or provincial work of a later period. The key features on which Winckelmann lighted in his analysis of the coin's female head were the formation of the eye, the cut of the mouth, and the particular form of the chin, all of which individual 'parts' in his view showed systematic deviations from the ideal forms of beauty. Profile images of this kind tend to highlight precisely the form of the contour representing the eye and eyebrow to which Winckelmann attached such great significance.

Though he never went on to use coins specifically to demonstrate the distinction between the high and the beautiful styles, they still played a very significant role in his detailed historical description of the beautiful style in part II of the *History*. 'Besides this most beautiful and grand work from the highest period of art,' he wrote, referring to the Laocoön, 'the [beautiful style] lives on in the coins of King Philip of Macedon (Plate 10), Alexander the Great (Plate 11), and his closest followers.'[47] Coins were the only extant Greek antiquities that he could date with some assurance to the period, because they had the name of the ruling monarch inscribed on them, so they gave his empirical exemplification of the beautiful style a much-needed point of reference. However, Greek coins could not be dated precisely in this way before the later phases of the 'beautiful' period. The inscriptions on coins issued by the early Greek city-states only indicated their place of origin, and the inclusion of the name of a ruler did not become standard practice until the Hellenistic period, after the conquest of Greece by the Macedonian monarchy.[48]

In any chronology of ancient Greek coinage Winckelmann might have drawn up, examples of work from the high period would have to be inferred by extrapolation from work in a visually more definable archaic style, and work with a definite historic provenance in the beautiful period. Winckelmann himself suggested the possibility of making such an extrapolation, albeit in terms that stressed the progress to classic perfection rather than his more novel definition of two distinct styles in classic Greek art:

7. Silver tetradrachm from Syracuse with the head of Arethusa, *c.* 485 BC.

8. Silver decadrachm from Syracuse with the head of Arethusa, *c.* 405 BC.

9. Silver tetradrachm from Macedonia with the head of Zeus issued under Philip II, *c.* 359–336 BC.

10. Silver tetradrachm from Macedonia with the head of Hercules issued under Alexander the Great, *c.* 336–323 BC.

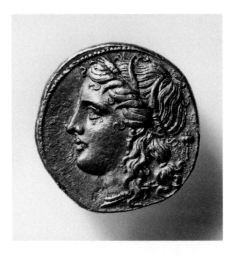

11. Gold drachma from Syracuse with the head of Persephone issued under Hieron II, *c.* 275–215 BC.

That the conception of beauty, or rather that the formation and elaboration of the same, did not, like the gold growing in Peru, originate among Greek artists at the same time as art is proved particularly by [early] Syracuse coins (Plates 7, 8), which in later periods surpassed all others in beauty.[49]

Winckelmann's history of profile heads on Greek coinage had a missing blank between the archaic Syracuse coin he discussed in detail and the coins of Alexander and the early Hellenistic period he cited as examples of the beautiful style. This might have been filled by the magnificent large tetradrachms from Syracuse (Plate 8; now thought to date from the later fifth century BC) which Winckelmann himself cited in another context in the most enthusiastic terms: 'further than these coins human conception (*der menschliche Begriff*) cannot go.'[50] Winckelmann also referred to these coins, along with ones of the beautiful period dating from the time of Philip of Macedon and the very early Hellenistic rulers (Plates 9, 10), as exemplifying the distinctive beauty of the head with which the Greeks endowed their representation of divine figures. But he did not in so many words suggest that a comparison between these coins might illuminate his stylistic duality between work in the high and beautiful styles.[51]

Coinage from Syracuse of the kind Winckelmann cited would certainly have been unusually amenable to being arranged in a continuous sequence of stylistic development. The same basic motif had been retained over the whole period from late archaic to Hellenistic times, and stylistic comparison was further helped by the small size of the coins and their relative abundance. But the only Syracuse coins that Winckelmann specifically assigned to the high period were

relatively incidental to his analysis, and in any case involved a mistaken attribu-
tion. Winckelmann followed Barthélemy in ascribing coinage carrying the
name Gelon to the time of the famous tyrant of that name who ruled Syracuse
in the earlier fifth century BC (see Plate 11 for a similar type of coin). These
coins are now seen to date from the third century BC, from the reign of another,
later ruler of Syracuse who adopted the name Gelon.[52] The larger and more
striking Syracuse coins issued in the fifth century BC could not have been dated
at all precisely by Winckelmann, as they carried no inscription other than their
place of origin. The position of the high style in a sequential history of images
on Syracuse coins, which retrospectively might seem to have provided the
clearest visual exemplification of Winckelmann's taxonomy of the high style—
the pure, sharp, 'abstract' curve of the eyebrow against the softer, more
naturalistic modelling of the area around the eye in comparable heads on the
very early Hellenistic coins he cited—was occupied by a gap and a mistaken
attribution.

Winckelmann's speculative attributions of statues to the high style were very
few in number, and initially included only the so-called Athena Farnese (Plates
26, 27), marked out in rather negative terms, as we have seen, as being in the
high mode, through its lack of a certain grace and suppleness,[53] and the statue
of Niobe (Plates 15, 17), a work now seen as a Roman copy based on a
Hellenistic creation. No doubt Winckelmann felt assured that this statue and
the other Niobids in the group were creations of the classic period because a
marble group representing this unusually dramatic subject was mentioned by
Pliny and attributed to one of two classic masters. Winckelmann put forward an
elaborate argument for attributing the statue specifically to the high phase of
classic Greek art, but in the end the real basis for his doing so was that it looked
to him more high than beautiful in conception. Pliny had said of the Niobe
group in his chapter that he was 'uncertain whether Scopas or Praxiteles made'
it.[54] Winckelmann assigned Scopas to the high period on the basis of what has
been shown to be a mistake in the summary chronology of ancient sculptors in
the surviving version of Pliny's discussion of bronze sculpture, in which Scopas
is classified as a contemporary of Polycleitus.[55] A reading of Pliny's other
references to Scopas would have suggested that Scopas was more likely to be a
near contemporary of Praxiteles, a point that would also have helped to explain
why the sources on which Pliny drew could have been uncertain as to which of
these two sculptors had created the group. Winckelmann argued that Pliny's
uncertainty over the ascription of the group to Scopas or Praxiteles arose
because Pliny had been unable to distinguish between a work in the high style
(Scopas) and one in the beautiful style (Praxiteles). Winckelmann prided him-
self on having discovered the key to solving this dilemma—the Niobe was more
austere in style than gracefully beautiful, and had to be associated with the high
style, and therefore should be attributed to Scopas.

Even so, Winckelmann made it clear that identifying existing examples of
work in the high style was a problematic exercise. There was more scope, he

explained, for exemplifying the characteristics of the beautiful style than of the high style because 'some of the finest figures of antiquity were without doubt made in the period when this [the beautiful] style flourished, and many others, of which this cannot be proved, are at least imitations of these.'[56] There was a greater possibility that examples of work in the later classic style would have survived. Moreover, in his scheme of things, the beautiful style would also have been more pervasive, as it laid the basis for the stylistic refinements cultivated in subsequent phases of the ancient tradition.

Winckelmann's dating of the Laocoön (Plates 16, 18) to the beautiful period has been no less radically revised than his dating of the Niobe. The statue is now seen as characteristically Hellenistic in conception, but whether it is actually late Hellenistic or Graeco-Roman in origin is very much subject to doubt.[57] As in the case of the Niobe, Winckelmann was prompted to assign the statue to the classic period because Pliny gave a special mention to a marble group of this subject that he knew in Rome. Not only that: Pliny singled out the Laocoön as 'a work superior to all the pictures and bronzes of the world'.[58] Winckelmann assumed that the surviving sculpture must have been the one Pliny mentioned, and that because it had such a high reputation in the ancient world, it would have had to originate from the best period of Greek art, even though Pliny did not mention the sculptors of the Laocoön in his chronology of early Greek masters. Winckelmann's assessment of the statue's style gave him the only basis he had for identifying it as being in the beautiful rather than the high mode. His analysis did not focus on the conception of the figure as a whole, but rather on such features as the undulating flow of form in the area around the eyes (Plate 17), which contrasts noticeably with the more schematic and linear rendering of the same area in the Niobe (Plate 18). His highly speculative designations of the Niobe and the Laocoön were thus made to reinforce each other.

Winckelmann did get one thing 'right': the Niobe, particularly its head, is still seen as representing an earlier and very different type from the more naturalistically modulated, less purely ideal Laocoön. Even now his comparison can hardly be dismissed as irrelevant, particularly given the continuing uncertainty over the precise historical pigeon-holing of this kind of statue. The one definite point that does emerge from more recent analysis of the Niobe is that it differs visibly in character from well-known, classic, fourth or fifth century BC prototypes. But, no less than the Laocoön, it continues to hover to and fro within a still highly speculative history of Hellenistic sculptural types. Recent visual analysis of these works certainly tends to be much less revealing than Winckelmann's historically more 'incorrect' one as to the fascination their very different visualized representations of human drama have had for Western artists.

He was on firmer ground identifying work in the beautiful style, partly because he was able to make one fairly secure connection between an existing sculptural type and a famous work Pliny dated to the later classic period. This

is a prototype that Winckelmann knew in several versions, showing a naked boy standing poised to kill a lizard (Plates 12, 13). An unusual subject among surviving works of Graeco-Roman sculpture, and one that was evidently popular with Roman copyists, he could identify it reasonably confidently with a statue of the Apollo Sauroktonos ascribed by Pliny to Praxiteles.[59] The unusually curvaceous pose and flowing outlines of the body, which contrast with the more upright, dangling leg format of most nude male Greek statues, were no doubt factors in Winckelmann's insistence on the 'wave-like' flow of contour in the beautiful style. This identification must also have played a major role in Winckelmann's singling out Praxiteles as the master who ushered in the beautiful style, even though indications in Pliny's history of sculpture would suggest that a systematic modification to the earlier canon of the fifth century BC masters only came later with Lysippus.[60]

The prominence Winckelmann gave to Praxiteles has remained a feature in modern histories of Greek sculpture ever since—Praxiteles the master of a new graceful beauty that departed in a systematic way from the severity of the classic style of the earlier age of Phidias. Indeed, Winckelmann set the stage for a fashion that reached a peak in the period of high Neoclassicism around the turn of the eighteenth century. Not only was there a rash of ascriptions of antique sculptures of beautiful little fauns and satyrs to Praxiteles. Modern artists also became preoccupied with this sculptural ideal, and produced a number of interesting renderings of the boyish gracefulness and supposedly 'innocent' homoeroticism that had come to be associated with this great sculptor of antiquity.[61] Winckelmann's beautiful style, then, proved at several levels to be more fully bodied and more grounded in the material and the empirical than his 'impossible' high style.

He was able to give the Greek ideal a fuller, more substantive identity than a simple schema of rise and decline would have allowed through his novel distinction between a high mode and a beautiful mode in classic Greek art. But this new configuration was still irredeemably caught up in a basic uncertainty about the possibility of distinguishing statues that might have originated in the classic period from the best surviving work of the later so-called period of imitation. Built into Winckelmann's system is an awareness that this was a difficult and deeply problematic issue. Empirical exemplification had to be envisaged, often partly unconsciously, as a process of negating certainty as much as giving body to ideas and hypotheses.

Distinguishing 'original' classic work from later interpretations and imitations could in theory be conceived within Winckelmann's new system in quite straightforward terms. He was adamant that the art of any period, including the classic one, betrayed signs of a distinctive style. The prevailing style of a period was a necessary constraint, the particular historical formation of artistic language an artist had no choice but to inhabit. According to Winckelmann, in Greek art after the high and the beautiful periods, any apparent freedom artists exercised in taking what they wanted from these earlier classic styles was

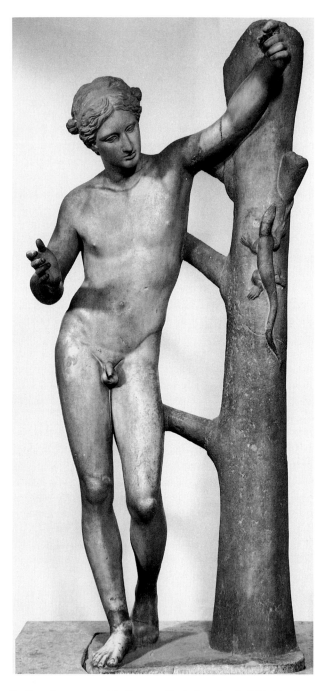

12. Apollo Sauroktonos, marble, Louvre, Paris (previously Villa Borghese, Rome).

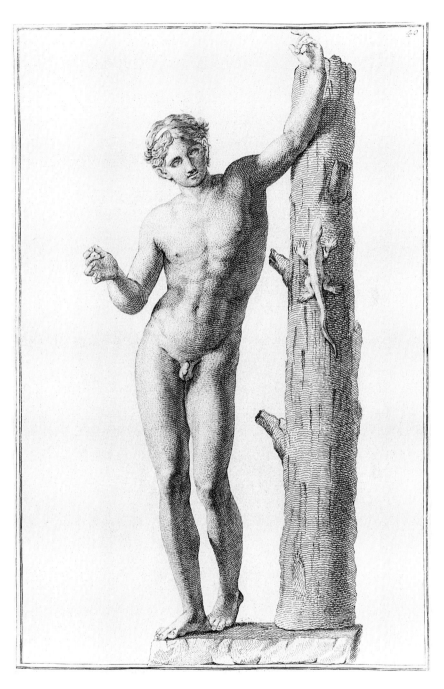

13. Engraving of the Apollo Sauroktonos in the Villa Borghese from Winckelmann's *Unpublished Antique Monuments*.

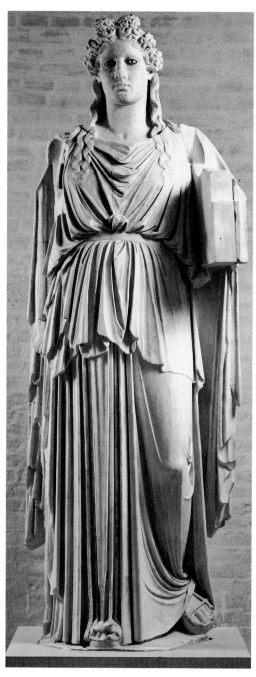

14. Barberini Muse or Apollo Barberini (after removal of restored arms), marble, Glyptothek, Munich (previously Barberini Palace, Rome).

subject to a negative fatality. Later repetitions of the high or beautiful style might reflect the original versions of these styles, but they would always be distinguished by their imitative character[62]—at least in theory. In the absence of any known sculpture whose provenance clearly associated it with the classic period of Greek art, however, any such attempt to distinguish work that was 'high' or 'beautiful' in origin from later reinterpretations or imitations was impossibly speculative.

Winckelmann often addressed the problems involved quite openly, even though, paradoxically, he was also led to disavow them by the prospect he was offering of a complete and totalizing history of art. Thus he would describe a statue such as the Belvedere Antinous (Plates 31–3) in terms that evoked the beautiful style, while carefully not committing himself to placing it in the beautiful period, and indeed indicating that in all likelihood it dated from a much later period.[63] Such were the contradictory parameters within which his speculative system had to operate.

Winckelmann could sometimes be quite explicit that the process of exemplifying his speculative history of style involved radical uncertainties. In the introduction to the supplement to his *History* published in 1767, his description of how he had sought to distinguish work from the earlier periods and traditions of antiquity was hedged around with qualifications and disclaimers:

> With the Etruscan style . . . I do not venture to assert without fear of contradiction that a number of relief sculptures, which appear Etruscan, could not be of the earliest Greek style. With more apparent certainty I discovered various periods in Greek work, but several years went by before some indication of the high antiquity of a muse in the Barberini Palace presented itself to me.[64]

The so-called Barberini Muse (Plate 14) to which Winckelmann referred was a work he cited at another point in his 1767 supplement to the *History* as 'one of the very oldest statues in Rome'.[65] He assumed that it originated from the moment of transition between the late archaic and the high phase of early Greek art, no doubt because it seemed to him to betray lingering signs of archaic stylization combined with a classic simplicity of form (the work is now believed to be a Graeco-Roman adaptation of a late classical type originating from the fourth century BC). His sudden (rather misplaced) outburst of conviction about the great antiquity of this work, however, was projected from within a context of general uncertainty, of what he called merely 'apparent certainty'.

To take one further example, Winckelmann singled out the antique gem he thought to be an image of Theseus and Phaia (Plate 2) as 'one of the most beautiful (designs) from antiquity' which could convey 'a general concept of Greek art'.[66] At the same time, he also made it clear that on his reckoning the work was not strictly speaking Greek in origin, but an Etruscan work of a quality 'that could do honour to a Greek artist'.[67] The gem could function as an empirical-historical exemplification of the beauty of classic Greek work only in

a complex indirect way by appearing to be as close to a pure early Greek style as made no significant difference. Its contradictory status was symptomatic of the speculative complexities of Winckelmann's whole system.

Built into the system was a certain awareness of the theoretical difficulty of establishing a perfect one to one correspondence between the generic stylistic analysis of artefacts and a strictly historical classification. His emphasis on the problems involved undeniably had a lot to do with the meagreness of the evidence he happened to have available. At the same time, his presentation can suggest that the problems might be structural and endemic to the kind of stylistic history he was pioneering. As more and more evidence later came to light, enhancing the illusion of achieving an ever more solid picture of the stylistic evolution of ancient Greek art that was simultaneously systematic and historical in character, the structural disparities between these two perspectives tended to be acknowledged even less than they were by Winckelmann.

It is partly the way in which a radical uncertainty was not entirely repressed in his writing that makes Winckelmann's history more interesting and suggestive than so many subsequent histories of ancient Greek art. This includes even his own later attempts to refine his system, once he became more confident that he had discovered an empirical basis for dating antique sculpture on the basis of its style. One of the more intriguing features of his stylistic analysis of Greek sculpture of the classic period is his 'discovery' of a high style whose very formation seems to be incompatible with its existence as a palpable historical reality. The paradoxes this poses open up an intractable fault line or blank within the history he was tracing of the realization of the Greek ideal.

VERBAL AND VISUAL

Winckelmann's novel definition of the styles of ancient Greek art drew on analogies with linguistic analysis of style in two important ways. Discussion of rhetorical modes in language provided him with a conceptually richer notion of style than was available to him in contemporary discussions of the visual arts, where style tended to function rather mechanically as a visual taxonomy of artistic taste.[68] His use of linguistic models also had another, more concrete, historical basis. The most suggestive analogies he made between verbal and visual style were derived from ancient Greek and Roman studies of rhetoric. From these he had been able to gain a fuller understanding of how style had been conceptualized in the ancient Greek and Roman world than he could from the relatively meagre references to the visual arts. He also drew on the elaborate histories of ancient Greek prose style that these provided in order to bulk out his picture of the styles of early Greek art. The analogies he made between styles of art and writing in ancient Greece were far from being arbitrary. They were grounded in a long-standing practice, originating in antiquity itself, of

drawing parallels between the stylistic evolution of ancient Greek prose writing and that of sculpture.

When modern art-historical study has drawn on literary or linguistic models, the discipline's distinctive preoccupation with the taxonomic analysis of visual form has often resulted in a flattening of the model concerned. At the same time, the stress on formal aspects of style has helped to illuminate certain important aspects of theories of representation. With the advent of non-objective art, for example, visual art came to stand as a limiting case of the modernist understanding of signification—one in which the essential meaning of a work had entirely to do with its internally articulated form, rather than with any reference it might make to things in the 'real world', either by way of naturalistic resemblance or conventional denotation. This may have stimulated some rather crude theorizing about the unmediated expressivity of purely visual form. But it also produced an intensified awareness of the problematic nature of the connections that can be made between the material formalization—or 'style'—of a representation and the meanings ascribed to it.[69] Something of this is evident in Winckelmann's analysis of style.

If we are to talk in semiotic terms, visual art provides a peculiarly vivid case of the disjunction between the mute 'materiality' of the signifier and its 'immaterial' signified. The visual appearance of a lump of stone or a splatter of paint on canvas is obviously different in kind from any significance that might be ascribed to it. Already in antiquity, Pliny reported, the Greek writer Athenagoras was prompted to remark of the venerated early statues of the gods: 'They are but earth and stones and wood and cunning art.' While language is usually assumed to allow an unmediated communication of ideas, the visual image has often been the emblem in Western European culture of a delusive, sensuous form of representation, whose visual allure gets in the way of the transmission of meaning.[70] To put it another way, it is more obviously ludicrous to see meaning as residing in the sensuous forms of a visual image than it is to perceive meaning as somehow inherent in the very fabric of spoken speech or written discourse.

Winckelmann himself touched on this issue when he put forward his own rather rudimentary theory of signification in the treatise, *An Attempt at an Allegory, Particularly for Art*, he published in 1767. In his theoretical commentary on allegory he insisted that visual art must rely on allegorical figures if it is to make reference to ideas, allegory for Winckelmann being by definition 'saying something that is different from what one wishes to refer to'.[71] In other words, ideas could not be conjured up directly by visual images, but only indirectly through the mediation of language and the associations language sets up between ideas and perceptible images. Thus for Winckelmann representations of the gods in Greek art were allegorical personifications of divinities whose immaterial being was of its very nature distinct from their material image.[72] He thereby underlined the discrepancy between a visual image and any idea it is taken to represent. As one might expect, this process whereby an

image signified an idea was far removed from the Romantic notion of symbolism, where meaning and form fuse together. It entailed a substitution spelled out in language, where a seen figure or thing stood for an unseen idea.[73]

Winckelmann's general conception of the Greek or antique ideal, his aesthetics rather than his theory of signification, betrays a very different logic. Here he posits a desired identity between the beautiful form of the Greek nude and its non-material significance, which is more symbolic in character and seeks to transcend the disjunctive mechanisms of allegory. In his theory of the high and the beautiful styles, as well as in his analysis of ideal beauty which we shall be exploring in a subsequent chapter, the theoretical rupture between bodily image and the idea it conjures up becomes redefined as an acute problem. Winckelmann seeks to conceptualize how the art of the ancient Greeks might have achieved the impossible—the unmediated projection of an idea through a perfectly formed visual image. The high style, like the most elevated antique ideal, functions as that necessarily problematic category of representation that would directly body forth a high idea, but in so doing would have to divest itself of its material substance so as to become transparent to its immaterial meaning.

Before exploring Winckelmann's conceptually more elaborate and sophisticated use of rhetorical theory, it is important to appreciate how this analysis was grounded in his historical reconstruction of early Greek art. What precise role did linguistic theory play in the novel distinction he made between a high and a beautiful mode? Clearly a knowledge of the styles of ancient Greek writing was something he was able to bring to bear from his earlier experience as a scholar of classical literature. But classical rhetorical theory did not provide him with any ready-made model for the new distinction he was to make between a high and a beautiful style in Greek art. One significant new feature of his theory, which distinguished it clearly from the assumptions informing the earlier studies of literary style, was his insistence that the styles he identified represented mutually incompatible artistic languages, that they effected a real disjunction at the heart of the Greek ideal, and were not just alternative registers of artistic performance that an accomplished classical artist would have been able to move between at will.[74]

Winckelmann's analogies between literary and artistic style drew on an aspect of ancient rhetorical theory that had already been instrumental in shaping ideas about the stylistic evolution of art in modern art-historical writing. Vasari's pioneering history of modern art was deeply indebted to parallels between the historical development of verbal and visual style elaborated in Cicero's and Quintilian's discussions of the history of rhetoric. Both these writers had compared the staged progression of early Greek prose and visual art through the hard, rigid, and stiff forms of the archaic to the perfectly life-like, majestic, and beautiful forms of the classic.[75]

Winckelmann was entering new territory, however, when he invoked analogies between the verbal and visual in order to elaborate his theory of the dual nature of style in Greek art of the classic period. These analogies took several

forms. They ranged from simple formal associations to more structured rela-
tions between ideas of style in visual art and writing. At their crudest, his
analogies simply identified supposed literary equivalents to the artistic style of
a period for which visual examples were lacking, on the assumption that the
basic tenor of the prevailing style in art and writing at any given moment would
be the same. A key feature of Winckelmann's distinction between a high style
and a beautiful style in classic Greek art was the point that the beautiful style
had a sensuous and refined gracefulness lacking in work of the earlier classic
period. If this could be grounded historically, it was above all in Winckelmann's
perception of a distinctive graceful style that captivated him in the writing of
Xenophon and Plato. This was very much a Winckelmannian view of things,
because standard studies of Greek rhetoric, whether ancient or modern, did
not make a feature of this point. The new form of grace discovered by the artists
of the later classic period, Winckelmann wrote, was the same as the grace that
'made itself known to Plato and Xenophon'. When he characterized the par-
ticularly exquisite refinement achieved by the masters of the beautiful period
who came after Praxiteles, the literary analogy was again crucial. The comedies
of Menander, he explained, 'in the light of the indisputable association between
poetry and art, and the influence of one on the other, can . . . give us an image
of the beauties of the works of art that Apelles and Lysippus clothed with
grace.'[76]

In the outline history of Greek art he published a little later, in *Unpublished
Antique Monuments* in 1767, he drew an extended parallel between the evolution
of ancient Greek art and writing which amplified these comparisons in a more
systematic manner. Art and literature, he explained, followed the same pattern
of development 'in conformity with the spirit of the age'. Just as in the earlier
classic period the art of Phidias shared in the 'sublimity' of Aeschylus and
Pindar and the 'heroic majesty' of Sophocles, so 'the style of Praxiteles was
marked by that same grace and the same purity that we admire in Xenophon
and in Plato.'[77]

Such a conception of two distinct phases in Greek writing of the classic
period had no real antecedents in previous discussions of the stylistic develop-
ment of early Greek writing. At most there were scattered references to the
point that graceful refinement would have been cultivated after the achieve-
ment of grandeur of effect.[78] The distinction Winckelmann made cannot be
seen as arising directly out of his readings in rhetorical theory any more than it
can be seen as deriving from an examination of the available evidence relating
specifically to the visual arts. Neither could have yielded such a distinction
without a framework of interpretation that somehow made the distinction a
'theoretical' necessity.

Had things simply stopped with Winckelmann differentiating between an
earlier and a later classic phase of Greek art on the grounds that later work
displayed a grace and refinement lacking in the more austere beauty of the early
classic masters, his history would not have entailed a radical rethinking of

prevailing models of stylistic analysis. He would only have given a more sys-
tematic air to conventional assumptions, widely current at the time in studies
on both literature and the visual arts, that the later art of a tradition tended
towards a greater refinement and gracefulness. Moreover, the relation posited
between language and art would have consisted of little more than a vague
analogy underpinned by a crude theory of the spirit of the age. It was common
at the time for grandeur and sublimity to be represented as the attributes of an
earlier form of culture, and gracefulness and beauty of a later one.[79]

The more substantive analogy Winckelmann made between verbal and
visual definitions of style in antiquity, which he based on a close consideration
of formal technicalities, sprang from the discussion of two fundamentally dif-
ferent approaches to the arrangement of words and phrases in classical rhetori-
cal theory. When speculating on the style of Greek art in the period leading up
to the achievement of classic perfection in the fifth century BC, Winckelmann
made the point:

> This style could be compared to the style of writing of Herodotus, the oldest
> Greek historian, and that of his contemporaries: Aristotle remarks that the
> latter retained the old form of expression, in which phrases are separated one
> from the other and have no connectives, and hence also the periods lack the
> desired roundness.[80]

Treatises on rhetoric from Aristotle onwards had differentiated between a
disconnected and a connected arrangement of words, between a more austere
style in which the individual elements were clearly and distinctly articulated
and separated from one another, and one in which connectives created a smooth
and flowing transition between parts. Demetrius' treatise on style made a
comparison between verbal and visual forms of this distinction that would have
been directly relevant to Winckelmann's analysis: 'It is this characteristic
[disconnectedness] which gives early style the sharp outlines and neatness of
early statues, when sculptors strove for compactness and spareness, while later
style corresponds to the works of Phidias in the combination of nobility and
finish.'[81]

This analogy was invoked by Winckelmann to clarify the nature of the
residual archaicism in the transitional style that came at the very end of the
archaic period. But it was also directly relevant to his characterization of
the high style. Central to his definition of the latter was the point that it retained
a certain hardness or austerity of form particularly apparent in the sharpness of
transition between forms and contours that contrasted with the flowing and
smooth transitions found in the beautiful style.[82] The distinction in rhetorical
theory between a disconnected and a connected style of word arrangement thus
provided Winckelmann with a more richly articulated stylistic model for envis-
aging that difference than the picture of stylistic development incorporated into
art-historical analysis by Vasari—also derived from rhetorical theory—which

mapped out progressive stages of evolution from archaic hardness to beautiful and graceful lifelikeness.

The definition of types of word arrangement in rhetorical theory operated at two different levels. On one hand it marked out a historical development from an earlier, simpler approach to the composition of words and clauses to a later more refined one. On the other it functioned as a generic distinction between two different rhetorical modes. The disconnected style may have been historically earlier than the connected style. But it was not necessarily an archaic form as a result. In an appropriate context it could function as a perfectly viable alternative to the smooth or periodic style. Its resources were considered particularly appropriate for achieving austerity and grandeur of effect.[83] Such a conception of the disconnected style had important affinities with Winckelmann's view of the high style as historically more 'archaic' in origin, but at the same time just as valid as the beautiful style. Yet there were important differences too.

Winckelmann's distinction between the two styles of classic Greek art was conceived on a more historicizing basis than any parallel it might have in traditional rhetorical theory. In his scheme of things, historical development marked out a necessary disjunction between the two modes. The beautiful style and the high style represented two mutually exclusive possibilities, and the emergence of one meant the disappearance of the other. In traditional rhetorical theory, on the other hand, the elaboration of the periodic or connected style of word arrangement was not seen as redefining the available forms of discourse to the point where a return to earlier forms became impossible, but rather as adding to the range of stylistic possibilities. Disconnected and connected forms of word arrangement were seen as stylistic resources open to any orator working within the developed classical tradition, which could be adapted or not according to the matter in hand, or even blended to form an intermediate style that would exploit features of both modes and combine them. With Winckelmann, on the other hand, the generic definition of stylistic difference was systematically conceived as a historical difference. This promised a new fusion of stylistic analysis and history which was to remain both deeply alluring and highly problematic for subsequent generations of art historians. It also represented a new notion of style as a definition of the empirical limits within which any artistic performance, of its very nature, had to operate, limits inherent in the material operations of a particular language of representation, which were not subject to conscious control.

THE RHETORIC OF THE IMAGE

In the analogies between verbal and visual style discussed in the previous section, style is defined either as a purely formal quality—hard and austere and disconnected on one hand, or smooth and supple and refined and flowingly

connected on the other—or characterized by the expressive effect it might have on the spectator, the hardness and austerity of the high style being seen as grand and majestic, the graceful smoothness of the beautiful style as alluring and seductive. Such definitions of style, though they may be amplified by analogies with linguistic theory, in the end still operate within an established tradition of visual connoisseurship exemplified in the work of Caylus, in which the significance of a style is defined in terms of some mentality or turn of mind. This expressive quality of a style is read in a relatively intuitive manner, which tends to conflate visual taxonomy with content or meaning. A gracefulness of form identified as distinguishing an artistic style, for example, is read in turn as being expressive of some inherent quality of gracefulness in the artist or culture that created it. The mechanisms whereby style might structure the projection of meaning are not at issue here.

Winckelmann's discussion of archaic art provides an intriguing instance of a more complex conception of style, one that does touch on the inter-relationship between the form of a representation and the structuring of its meaning. Winckelmann argued that the clear and emphatic, apparently crude articulation of constituent parts in the archaic style was a necessary prerequisite to the flowingly beautiful merging of one part into another in the art of the classic period. Here he was drawing on a theory common in eighteenth-century specu- lation on the early history of language, according to which the elaboration of a true knowledge of things required in the first instance a sharply defined and emphatic or 'disconnected' mode of representation.[84] It was only when the representational possibilities of language had been fully developed that it be- came possible to cultivate stylistic beauty and embellishment, including grace- ful transitions from one part to another—from word to word and phrase to phrase or, in visual art, between different parts of the body.

When Winckelmann came to analyse the style of Greek art in the classic period, however, the link between style and articulation of knowledge—in the case of Greek art, knowledge of the forms of human anatomy—ceased to be an issue. The distinction between the flowing interconnections of the beautiful style and the comparative disconnections of the high style no longer seemed to have anything to do with the articulation of knowledge. Beauty as distinct from signification took over. In this, he was again picking up theories of language current at the time, in which the epistemological function of language played a central role in its formation only in the earlier phases of its history. The function of stylistic embellishment, or the beauties of style that emerged once a language had reached maturity, had to do with aesthetic pleasure, not with the subtleties of mapping out knowledge of the world, with clarifying the nature of what was being represented. Where style was seen to be relevant to the role of language as a bearer of meaning, however, was in increasing its persuasive or rhetorical power.[85]

In elaborating his distinction between the high and the beautiful styles, Winckelmann again draws on theories of how meaning is conveyed in language,

but here the emphasis is different. He takes over the conception of style as a rhetorical mode, or a vehicle for impressing a message on an audience. Winckelmann explains how the difference between the high and the beautiful styles corresponds to a distinction traditionally made between Demosthenes' and Cicero's oratory: 'the first as it were carries us off violently: the other takes us willingly with him: the former leaves us no time to consider the beauties of execution: and in the latter these appear unstudied, and propagate an even light over the orator's arguments.' Winckelmann is invoking a classic paradigm of rhetorical theory drawn from the famous treatise *On Sublimity* attributed to Longinus:

> Demosthenes has an abrupt sublimity; Cicero spreads himself. Demosthenes burns and ravages: he has violence, rapidity, strength, and force, and shows them in everything; he can be compared to a thunderbolt or a flash of lightning. Cicero, on the other hand, is like a spreading conflagration. He ranges everywhere and rolls majestically on. His huge fires endure; they are renewed in various forms from time to time and repeatedly fed with fresh fuel.[86]

Winckelmann takes directly from Longinus' comparison the contrast between Demosthenes' oratory suddenly overwhelming its audience like a thunderbolt and Cicero's gradually but powerfully taking it over. The former is so forcible and complete in its effect that it suspends time, while the latter develops in a sustained way through time. Winckelmann then adds a new dimension by identifying a difference in the audience's awareness of the rhetoric by which it is being moved. Demosthenes' sublimity does not allow its audience the opportunity to be attentive to the beauties of style. The audience's consciousness of the speech as a phenomenon is instantly effaced by its sudden and irresistible impact. On the other hand, the 'beautiful' grandeur of Cicero's oratory is something that its audience consciously appreciates. Beauty and fineness of style should not appear studied but are integral to the effect being made. The audience knows it is being carried off and moves willingly along. In other words, the sublime works through an apparent obliteration of the means of representation, the beautiful through an awareness of the beauty of the means of representation. Winckelmann also plays out this distinction as an allegory of desire—the sublime is sudden violation, so powerful and overwhelming that there is no opportunity either to resist or to yield; the beautiful is ideal seduction and willing surrender.

The Niobe and the Laocoön (Plates 15–18) function as visual figurations of these rhetorical modes in a distinctly negative and violent register. Niobe with her daughter is a high or sublime representation of the effect of divine wrath. She is frozen in a spasm of terror as she witnesses the killing of her children by the arrows of Diana, punishing her for the sacrilege of daring to vaunt her qualities as a mother over the god's mother, Leto. The catastrophic intensity of divine power has obliterated all signs of emotion on her face. In contrast, the

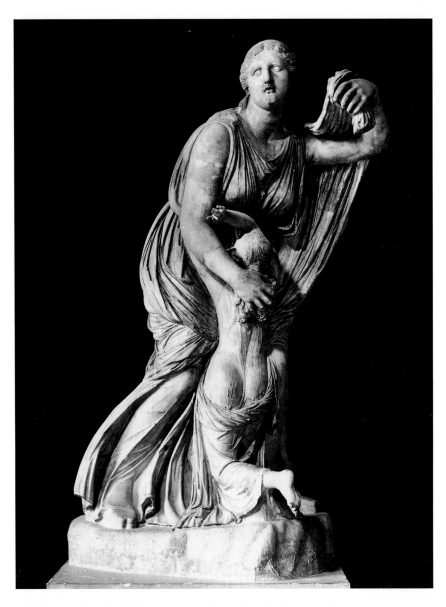

15. Niobe, marble, Uffizi, Florence (previously Villa Medici, Rome).

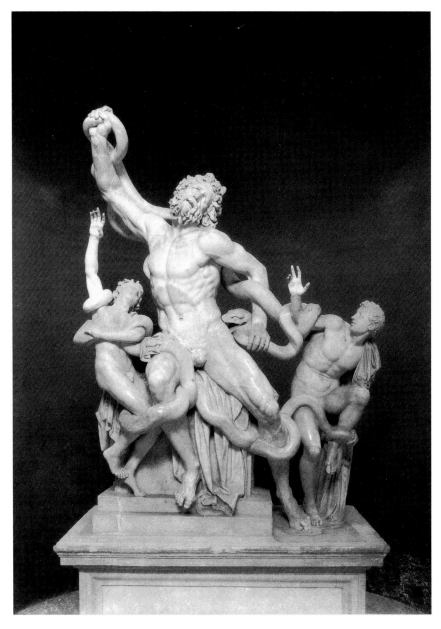

16. Laocoön (prior to the twentieth-century restoration with bent arm), marble, Vatican Museum, Rome.

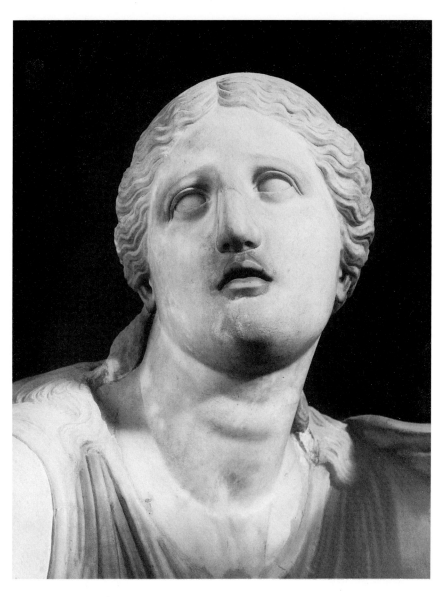

17. Niobe, detail of head.

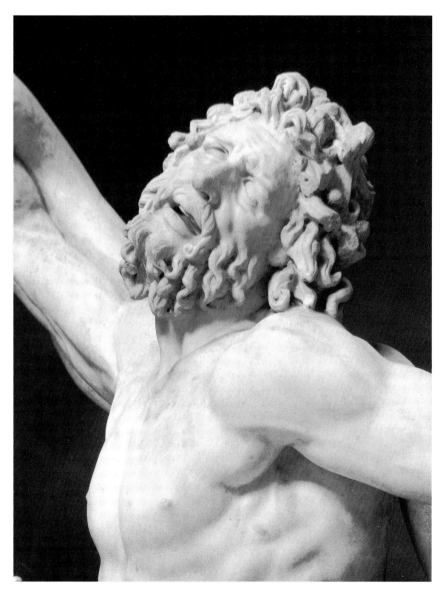

18. Laocoön (prior to the twentieth-century restoration with bent arm), detail of head and shoulders.

Trojan priest Laocoön is shown still actively resisting, even if inexorably falling victim to the attack of two snakes sent by the gods to kill him. According to legend, the violent retribution was prompted by the gods' anger, either at the sacrilege of his having had sex with his wife in front of a sacred image of Apollo, or at his temerity in throwing a spear at the Trojan horse and thereby threatening their plans for the Greeks' entry into Troy.[87]

In both instances, the power of rhetoric is represented as an annihilating intervention of divine power in the lives of mortals, one sudden, the other more gradual but equally irresistible. It is a power that kills, and in killing produces a mirror image of divine calm and beauty. The artist of the Niobe, by 'realizing the secret of unifying the fear of death with the highest beauty', has become 'the creator of pure spirits and heavenly souls'. The sublime indifference of divine power is echoed in the frozen spasm of apparent indifference its violent effect has produced in the face of the figure. With the Laocoön, in a deadly inversion of the willing seduction enacted by beautiful rhetoric, the figure struggles visibly against the divine retribution sent to afflict him, but is caught for a moment in a movement of rhythmic poise and beautifully flowing contours. Thus he paradoxically takes on the attributes of the irresistible beauty of divine power. The Niobe's passions and feelings are suddenly obliterated, literally frozen into the stilled sublime forms of an austerely ideal statue, while the Laocoön is steadily and powerfully and 'beautifully' consumed.[88]

In the context of Winckelmann's representation of the two styles of ancient art as two contrasting rhetorical modes, these statues become figures of figures of speech. One is the 'high' visual figuration of a sublime figure of speech, the other the 'beautiful' visual figuration of a graceful and beautiful one. The power of one mode is shown as suddenly overwhelming its audience, suspending or obliterating any capacity to resist, and the other as steadily overcoming it and inexorably carrying it off. To transpose the contrast into the language of semiotics, one figure is the living sign obliterated and stilled by the unmediated presence of an immaterial idea; the other is the still living sign, refracting or mediating the presence of an immaterial idea in a beautifully and powerfully modulated play of form.

This dialectic of power and desire, and its concomitant semiotic play upon two opposing modes of signification, is elaborated by Winckelmann in an extended allegory of two contrasting forms of grace—a high grace and a beautiful grace:

> One is, like the heavenly Venus, of more elevated birth, and shaped by harmony, and is constant and unchanging, like the latter's eternal laws. The second grace is, like the (earthly) Venus born of Dione, more subject to matter: she is a daughter of time, and only a follower of the first, whom she announces to those who are not devotees of the heavenly grace. The latter allows herself to descend from her loftiness and enters gently into commerce, but without debasing herself, with those who cast an eye on her: she

is not eager to please, but only wishes not to remain unrecognized. The former grace, a companion of the gods, appears self-sufficient, and does not offer herself, but needs to be sought out; she is too sublime to make herself very available to the senses: for 'the highest has,' as Plato says, 'no image.' She communicates only with the wise, and she appears refractory and unapproachable to the rabble; she encloses within herself the movements of the soul, and draws sustenance from the heavenly stillness of divine nature, of which the great artists (of antiquity) . . . sought to fashion an image.[89]

Two key images conclude this allegory. One has rather heavy-handed schoolmasterish overtones and distinguishes between a beauty for the elect, for those whose wisdom puts them in tune with divine self-sufficient calm (a state of mind deeply at odds with the persona cultivated by Winckelmann himself as a letter-writer), and one that will make a more direct appeal to the rabble. The somewhat pedantic élitism evident here is a persistent feature of Winckelmann's shorter essays, where he seeks to provide instruction on the values appropriate to a true appreciation of art.[90] But it is relatively rare in the *History*, and its downgrading of the sensuously beautiful is rather at odds with the balance of values struck between the high and the beautiful elsewhere. The other concluding image is more interesting and more closely integrated into the overall tenor of Winckelmann's analysis: 'the highest has no image.' The high style is the impossible image, the very antithesis of all that a conventional image is, the denial of physical immediacy, accessibility, and sensory appeal, like an eloquence that negates the very substance of eloquence.

The passage from Plato's dialogue *The Statesman* that Winckelmann cites does not have the same problematic implications. In Plato's scheme of things, the vividly sensuous image is not the vital mode of apprehension that it is for Winckelmann: 'but there is no created image through which to convey a clear idea of the highest and most important realities . . . It is necessary therefore to train oneself to give and understand a rational account of everything.'[91] Plato's negation of the image is in the interests of an alternative mode of representation, the strictly rational mode of philosophical enquiry. With Winckelmann the negation has no such issue. The high mode too necessarily operates as an image—a form of image striving to embody what of its very essence is intractable to sensuous representation. The lower style, the equivalent of the earthly Venus, is indeed indispensable—the vivid imaging without which art would be divest of substance. His high grace is at one level an impossible grace, represented by a figure almost totally dematerialized, divested of the obvious, seductive, alluring charms that constitute grace as we know it. Yet its grace is enacted with an unimaginable completeness and purity and immediacy.

Winckelmann's distinction between the two styles of classic Greek art offers a 'critical' theory of visual representation. Characterising these styles as two mutually exclusive modes not only defines a history of the classic ideal, but also opens up a theoretically necessary duality within it. The highest form of art,

traditionally seen as the ideal sign, fully embodying its dematerialized meaning in material form, is split apart. The structural difference between the beautiful mode and the high mode plays out a disjunction within the ideal figure of traditional classical art theory between the body of the representation and its invisible or immaterial referent.[92]

Such a duality is not entirely dissimilar from the one later invoked by Hegel in his philosophical aesthetics. Here it is played out as a grand historical drama, a constantly shifting dialectic between 'idea' and its material representation in language and art.[93] Thus, what in Winckelmann's 'system' is a disjunction lodged within a universally valid Greek ideal becomes in Hegel's 'history' a contradiction that unfolded within Greek culture after the latter achieved for a moment a perfect but inevitably unstable expression of its ideal values in the physically beautiful forms of its art.

Winckelmann's account of the Greek ideal not only divides what was traditionally conceived as a single unified whole into two structurally incompatible styles or modes of visual representation. It also marks out the Greek ideal as never fully present, always partially absent, incomplete. The fullest physical beauty of the signifying figure and the most immediate evocation of the signified idea no longer coincide, and the presence of the one necessarily entails the absence of the other. In the high mode, the immediacy of the signified idea is suggested by an austerity and hardness of form, by a lack in the material presence of the figure supposedly embodying it. The high figure is 'like an idea conceived without the help of the senses . . . it seems not to have been made with any effort, but awoken like a thought, and blown (into existence) with a breath.'[94] At the same time the material trace of this asensual sensuality, this materiality obliterated by the unmediated presence of idea, is an absence of the alluring gracefulness and the fullest refinements of supple naturalism found in the beautiful style. The embodiment of an idea could not be replete with the immediate allure of sensual presence.

In the beautiful mode, in contrast, the sensuous refinement and beauty of the figure is of the very essence, but as a result the idea being represented is necessarily only present at one remove. The idea is now mediated, displaced by the full-bodied sensuality and allure of the signifying figure. The beautiful figure seeks to be 'more appealing and affable', and announces itself as more accessible than the high figure through an 'accommodating gracefulness'.[95] But the presence of its engagingly beautiful body necessarily displaces the idea being signified, making it at some level absent. Winckelmann gives this effect a historical cast when he describes how in the most refined and sensually beautiful work of the late classic period, the original high significance of earlier Greek art could no longer be represented as immediately present.[96]

The duality set up between elevated idea (whether this represents perfection, virtue, freedom, or merely an empty 'Platonic' abstraction) and the most intense, physically beautiful representation of the human figure, though 'deconstructive' of traditional conceptions of the Greek ideal, draws on a

tension already inherent in classical aesthetics and prevalent in post-Renaissance art theory. Traditional art theory took as fundamental a structural distinction between the visual image as a representation of body or brute matter and as a representation of pure idea. The duality, which generally privileged drawing over colour,[97] could be redescribed in terms that make the two alternatives more equivalent in value, and hence more akin to Winckelmann's distinction between the high and the beautiful styles: on one hand an art that impresses through the vivid evocation of the living sensuous presence of the real world, and on the other one that does so through an austerity that signals an affinity with the realm of pure ideas. Winckelmann's analysis is only unusual because it exposes the inherent contradictions in the notion of an ideal art that seeks to achieve a stable mediation between these two extremes. This making problematic the traditional conception of an ideal art, it is important to add, arises in part from the very urgency with which Winckelmann sought to project the Greek ideal as the fullest embodiment of the power and beauty of art.

Winckelmann's high style, then, is poised on an intense contradiction. The most immediate and powerful impact on the spectator is effected by an almost substanceless image that is purged of the very variety, emotive expressiveness, and sensuous appeal conventionally taken to constitute the interest of the visual image. The literary source on which Winckelmann drew characterizes the sublimity of Demosthenes' oratory in a less extreme and paradoxical mode, and still preserves something of the idea that the substance of the sublime sign or word can somehow directly embody the living power of what it signifies.[98] Demosthenes' speech carries us away so completely that we do not register its phenomenal form: it is the speech whose powerful affectivity erases our awareness of its physical presence. But the speech itself is still represented as an active force, a thunderbolt or a flash of lightning or a sudden overwhelming eruption. Winckelmann's conception of the visual sublime is almost the antithesis of the literary rhetorical image of it. As a frozen static figure, the Niobe can in no way be seen as embodying the living power of the sublime, but is at most the negative reflection of the effortless potency that has taken it over and, in Winckelmann's scheme of things, annihilated it.

The figure in the high mode becomes the visual embodiment of the irresistible power of a high idea only by way of a deadly paradox, by being stilled and purified and simplified to the point where it no longer exists as a living being. The figure of Niobe is 'pure spirit' and 'divine soul' in a state of extreme 'fear of death' when total impassivity takes over, and she is no longer capable of being 'awakened by any appetites of the senses'. Characteristically it is a female figure, the Niobe, that is made to enact the self-immolation required to embody the high mode. A female body dramatizes the fatality of the sign that, in becoming the embodiment of pure idea, is emptied of physical being and presence—a fatality mediated in the struggling Laocoön by a shift into the less strenuous beautiful mode, where the immediacy of the signified idea is tem-

pered by the physical identity and presence of its (male) signifier. He can struggle, resist, she cannot. The next chapter will explore this as well as other ideological loadings of the novel distinction Winckelmann made between the high style and the beautiful style.

CHAPTER IV
Beauty and Sublimity

THE SEX OF THE SUBLIME

This chapter takes as its point of departure a puzzle—the apparently paradoxical gendering that occurs when Winckelmann exemplifies the sublime style by a female figure, the Niobe (Plate 15), and the beautiful style by a male one, the Laocoön (Plate 16). At one level he appears to be reversing conventional sexual paradigms. In the aesthetics of the period the sublime, with its intimations of power, elevation, or austerity, was usually associated with the masculine, and the beautiful, with its suggestions of gratifyingly available sensuality, with the feminine. But the dynamic at work in Winckelmann is hardly a simple subversion of dominant paradigms of gendering in favour of the feminine. He invokes the feminine as a figure denied of libidinal charge and consciousness, not as an actively constituted other to the masculine. For at the centre of Winckelmann's conception of the affective power of the antique ideal is the beautiful eroticized male body, around which he weaves his more complex invested fantasies.

Though for Winckelmann the sublime is theoretically the primary category—the sublime grounds the beautiful and emerges before the refinements of the beautiful have been fully elaborated—the priority shifts when he exemplifies these aesthetic ideals through actual statues. The beautiful figure, and for Winckelmann this is above all the beautiful nude male body, provides a sensuous basis for intimating the sublime. The sublime figure, in contrast, is almost a contradiction in terms, and can only exist by way of a categorical, often violent denial of its subjectivity and desire. The elevated inhumanity of the sublime finds its most vivid correlative in a body subjugated by overwhelming forces of destruction, not in weightily resonant affirmative images of bodily presence. With Winckelmann, the sublime involves the viewer in a compulsive engagement with fear of self-annihilation, while the beautiful foregrounds the body's sensuality and invites a more affirmative projection of self and the self's desires.

At issue in Winckelmann is a masculine erotic fantasy and politics of subjectivity exposing complexities in projections of male identity that conventional heterosexist ideology tends to disavow. What he does above all is unsettle a conventional stereotyping of the object of desire as feminine rather than masculine.

How Winckelmann's gendering of aesthetic categories relates to the dominant stereotyping of the time becomes clearer if we look at the most influential

and possibly the most explicitly gendered exploration of the aesthetics of the sublime and the beautiful in the period, Edmund Burke's *A Philosophical Enquiry unto the Origin of our Ideas of the Sublime and Beautiful*, published in 1757, only a few years before Winckelmann's *History*.[1] What we have in Burke is a much more conventional 'bourgeois' gender politics that seeks to establish a simple equation of masculinity with the sublime and femininity with the beautiful—thereby in effect denying the possibility of a 'beautiful' eroticization of the male body so central to Winckelmann's richly invested projection of the Greek ideal. Both Burke and Winckelmann put sex and power at the centre of aesthetics, but to rather different ends. Burke sought a categorical separation between the power of the sublime and the erotic allure of the beautiful. Winckelmann, on the other hand, envisaged them as inextricably intermingled in any powerfully affective image of the human body, even while, like Burke, setting up a theoretical antithesis between the two.

Where Winckelmann seemed most radically to break the bounds of a Burkean gendering of aesthetics in choosing a female rather than a male figure as the image of the sublime unadulterated by suggestions of sensual gratification, the disruption, as we have seen already, was complex and contradictory. His insistent foregrounding of the erotic charge of the male nude made it more beautiful than sublime. This was clearly bound up with his own sexual preferences, however much these had to be mediated, given the taboo operating in Enlightenment culture against any too explicit expression of homosexual or what was then called sodomitical desire.[2] Other factors too worked against the ideal male nude functioning for him as an image of the pure or categorical sublime. In artistic culture of the period, a work of visual art had at some level to be a desirable object, even if it supposedly existed above or apart from ordinary sensual gratification. Thus an ideal nude, whatever its gender, was required at some level to be sensually beautiful. It had to exploit the sensual charge of the naked body, even while not appearing to do so too crudely or literally. A further blockage stood in the way of such an ideal figure being an embodiment of the pure sublime in a strenuous Burkean sense. The sublime object by definition broke the bounds of conventional human understanding and feeling and, as something inhuman or superhuman, was the very antithesis of a clearly circumscribed and centred human form, of the kind epitomized by the classical figure.

At the same time, the category of the sublime as defined in Enlightenment aesthetics came very much to be associated with a masculine rather than a feminine subjectivity. The sublime was the paradigm for a demanding, weighty form of aesthetic experience, one that distinguished itself more evidently from ordinary pleasure and consumption than the beautiful. The sublime object was masculine because it was an image of power, of austere elevation, of something that resisted being appropriated to conventional forms of gratification and consumption. The sublime was something you felt in the presence of the manly and powerful, and thus stood in contrast to the less demanding beautiful object

of desire, stereotypically conceived as a female presence. This ideological coding has in some form or other persisted ever since, though it is also important to recognize an alternative tradition that makes the feminine the locus of the incomprehensible, the incommensurable, something that threatens to invade and break the bounds of a securely centred rational subjectivity, a negative shadow or supplement to Burke's and Kant's masculist sublime—one that manifests itself as a hysterical misogynist nightmare on one hand and female refusal of the logocentric closures and exclusions of patriarchy on the other.[3]

When, in the aesthetics of twentieth-century high modernism, the category of the sublime has been deployed to conjure up the idea of serious, deeply challenging art, questioning common preconceptions about our identity and the world we inhabit, it usually sports a pretty unambiguous masculinity.[4] Barnett Newman's painting *Vir Heroicus Sublimis* clearly proclaims some of the larger ambitions of the new American painting in the period immediately after the Second World War, and does so quite explicitly by identifying the sublime with masculinity. Though the painting itself hardly embodies an aggressively virile presence, and may at some level even be suggestive of a delicate sensuous beauty, it would not, it seems, be appropriate to change the title to *Femina Heroica Sublimis*.[5] At the same time, suggestions of a masculine sublime often depend for their effect upon an unacknowledged elision of sensuous beauty with austere or jagged power, or upon some unstable conflation of vulnerability and aggression. It is one thing for a work of art, existing as a bounded object or image, to evoke the idea of the sublime, another for it to function as the pure embodiment of the sublime—in other word to *be* sublime.[6]

There is then a certain logic to the fact that the objects of aesthetic experience singled out as sublime in Edmund Burke's *Philosophical Enquiry* are almost all natural phenomena or landscapes, not works of art, and above all not ideal representations of the human figure of the kind epitomized by the antique ideal. At the same time, the body is central to Burke's theory. The beautiful he defines as that which arouses ideas of gratification and pleasure, having its origins in the social instincts directed towards the generation of the species. Burke, like most subsequent male theorists of 'female beauty', is at pains to distinguish between the arousal of crude physical desire and a more socialized instinct he calls love.[7] The sublime, in contrast with the beautiful, is that which arouses ideas of pain and terror, and has its origins in the instincts of self-preservation. The beautiful is the simpler category, because the assumed male spectator stands in relation to it as active subject to passive object—the beautiful object is taken over, possessed by the viewing subject's desiring, is cathected (*besetzt*) by it, as Freud would have it.[8] The beautiful is the gratifying object of desire, easy and pleasing to look at, readily appropriated and unthreatening.

The interaction between the spectator and a sublime object is much more complex. The latter is not a safely contained object of contemplation and gratification, but initially faces the spectator as a terrifying or powerful pres-

ence that could overwhelm and destroy him. Then, when the spectator realizes
he has the capacity of mind to master and confront this experience, he is
himself infused by the power that seemed to threaten him. He becomes a
sublime subject.[9] The experience of the sublime thus involves a complex dialec-
tic of identification with and objectification of the aesthetic object that is very
different from the fixed subject–object relation at work in the perception of the
beautiful. The sublime in Burke's scheme of things acquires a masculine gen-
der, both because the powerful presence that threatens and terrorizes is associ-
ated with masculinity rather than femininity, and because the subjectivity
endowed with the inner resources to master this experience and take an expan-
sive pleasure in it is assumed to be male.[10]

Burke's theory of the sublime and the beautiful is unusual in that it plays out
so overtly gendered a duality between 'sublime' potency and 'beautiful' desir-
ability. Thus he insisted that our different responses to the sublime and beau-
tiful are equivalent to the 'wide difference between admiration and love. The
sublime, which is the cause of the former [admiration], always dwells on great
objects, and terrible; the latter on small ones, and pleasing; we submit to what
we admire, but we love what submits to us.'[11] Even in Burke's own terms, there
are unavoidable tensions generated by this categorical gendering. The sublime
subject in its highest form, something that arouses awe through the intimation
of power, is excluded, Burke points out, from the affections and pleasures
associated with beauty: 'The authority of a father, so useful to our well-being,
and so justly venerable on all accounts, hinders us from having that entire love
for him, that we have for our mothers, where the parental authority is almost
melted down into the mother's fondness and indulgence.'[12] At some points
Burke protests so much that his very insistence raises awkward questions about
the stability of his gendering of the sublime and the beautiful:

> if beauty in our own species was annexed to use, men would be much more
> lovely than women; and strength and agility would be considered as the only
> beauties. But to call strength by the name of beauty, to have but one
> denomination for the qualities of a Venus and Hercules, so totally different
> in almost all respects, is surely a strange confusion of ideas, or abuse of
> words.[13]

Our concern here will be precisely with such an 'abuse of words', and its
exposure of the potentially violent exclusions of Burke's 'bourgeois' ideology of
male desire.

Burke's unease indicates that he thought it conceivable that a male viewer
might wish to project onto the male body some of the responses and desires that
his duality confined to the female body. But if the male body should not, in his
view, be beautiful, it could not be equated with the sublime either. His exam-
ples of sublime objects are not only inhuman, but their characteristic aspect in
no way invites association with the image of a heroic male body; the sublime is

'dark, gloomy, . . . solid, and even massive'.[14] A body that displayed these 'sublime' features would be a monster, a Frankenstein rather than a Greek god, terrifying, but utterly destructive of the connotations of powerful and pleasurable mastery that characterize the second, triumphal moment of a sublime experience.

The male body as such could not properly sustain the identification with phallic power, which was best imagined as a dark, obscure landscape, a thing of no clearly defined form or substance. If a man who confronted and came to terms with the awesome power of the sublime himself became infused by the attributes of this sublimity, his body did not thereby become a sublime thing. When Winckelmann elaborated his own systematic distinction between a high or sublime mode and a pleasing or beautiful mode in art, he, like Burke, was never able to identify the categorical sublime with any classical image of the ideal male figure. In both cases the male body itself, however idealized, seemed unequal to the task of embodying the sublime in its full power and elevation. At some level, a human figure was excluded from being a truly sublime object that would set in train the experience of the sublime. In both Burke's and more unequivocally in Kant's definitions of the sublime, the sublime object had to strike the human observer as something beyond her or his capacities, in relation to which she or he felt totally helpless; it had to appear to be something radically unrepresentable.[15]

Burke's characterization of the beautiful, on the other hand, though also based on inanimate objects and landscapes, played very directly on the physical attributes of a 'desirable' female body.[16] A classic female nude like the Venus de' Medici (Plate 25) could thus be seen as an unproblematic embodiment of the category of the beautiful in a way that an ideal male nude could not embody the sublime.[17] Would it be possible to envisage a naked male body that was the very antithesis of a beautiful object, was literally nothing other than a terrifying physical power? An aggressive display of hard steely muscles or brute physical violence could all too easily appear ludicrous or repulsive rather than impressive and compelling. And if a viewer found such an image visually appealing— let's say a publicity image of a body-building star or a classical image of Hercules—would it not thereby become desirable, and in some sense gratifyingly beautiful? The ideal male nude in eighteenth-century artistic culture, no less than the male nude in contemporary advertising, had to straddle aesthetic boundaries between evocations of an erotic desirability conventionally most closely associated with the female body, and suggestions of a powerful defeminized masculine presence. To be historically more specific, the paradigmatic status antique images of ideal manhood enjoyed within the art world of the Enlightenment period required that these be beautiful to function effectively as art, and at the same time sublime so as to satisfy the humanist ethics then associated with the classical ideal. They thus existed as a major point of potential disruption for Burke's attempt to establish a systematically gendered duality among the objects of aesthetic experience.

BEAUTIFUL MASCULINITY

When Winckelmann singled out the Apollo Belvedere (Plates 19–22) as 'the highest ideal of art among the works of antiquity that have escaped its destruction', he envisaged it as a complex intermingling of erotically charged beauty and sublime power and elevation:

> His build is sublimely superhuman, and his stance bears witness to the fullness of his grandeur. An eternal springtime, as if in blissful Elysium, clothes the charming manliness of maturity with graceful youthfulness, and plays with soft tenderness on the proud build of his limbs.[18]

Winckelmann makes this ideal male figure the focus for quite overt fantasies of erotic desire, while still retaining its significance as the model of a manly elevation that precluded it from being seen as a simple object of delectation. In effecting such a confusion of the rigidly gendered separation between sublimity and beauty envisaged by Burke, he was not engaging in some unusual or illicit eroticization of the male nude, but playing out a male fantasy central to the dominant cultural norms of his time.

For the eighteenth-century art world, the image that functioned as the epitome of ideal manhood was not a muscular, solidly virile bruiser like the Farnese Hercules (Plate 23), but the very sculpture singled out by Winckelmann as an ideal conflation of the austerely sublime and sensuously beautiful, namely the Apollo Belvedere.[19] The characterization of this statue published by the British classicist, Joseph Spence, in 1747 is quite typical. On one hand he insisted that it 'gives us the idea of something above human, more strongly than any figure among the great numbers that remain to us'. A sublime power was visualized here, not just implicit or potential, as in the majority of standing male nudes remaining from antiquity, but expansively displayed in a feat of heroic domination. According to received wisdom, the statue showed the god Apollo in his victorious battle with the Pythian serpent, which he had just laid low by discharging an arrow. On the other hand Spence also singled out for attention the figure's bodily beauty. Its face, he maintained, surpassed that of 'his two chief rivals of beauty, among all the deities of his own sex'; Roman poets, when 'speaking of the softer beauties of any prince' would more often make comparison with Apollo than with any other deity.[20]

What becomes clear as you read through the numerous descriptions of the statue from the period is that its unique appeal among the classic masterpieces of ancient sculpture lay partly in its unusually vivid ambiguity, its potential to be the focus of competing fantasies of unyielding domination and exquisite desirability. Within eighteenth-century artistic culture, the ideal type of masculinity could readily be conceived as beautiful, as an erotically charged object of desire. It is Burke's new gender-conscious aesthetics that problematizes the relation between images of masculinity and the category of the beautiful. Thus the poet James Thomson imagined the god Apollo as shown in the moment

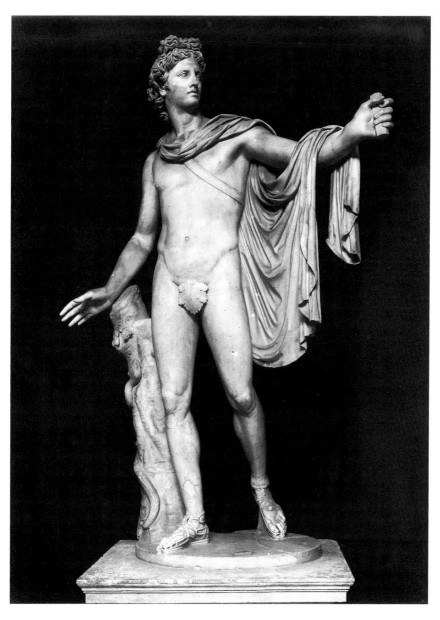

19. Apollo Belvedere (prior to removal of restored hands and forearm), marble, Vatican Museum, Rome.

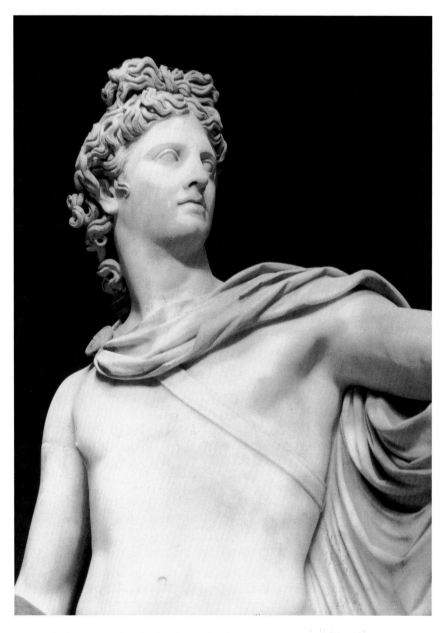

20. Apollo Belvedere, detail of head and shoulders.

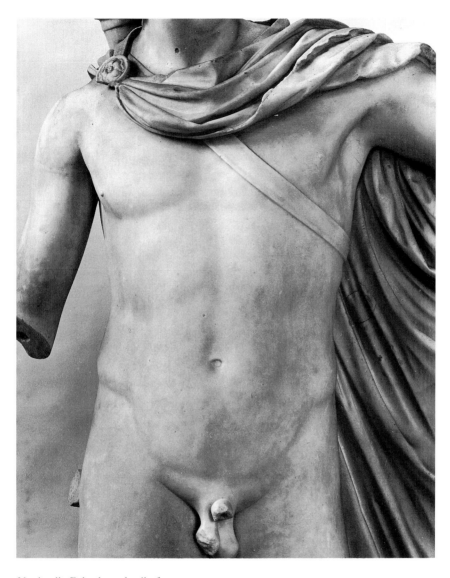

21. Apollo Belvedere, detail of torso.

22. Apollo Belvedere, detail of legs.

after combat, its hard manliness melting into a graceful ease. The whole con-
ception is less than subtly eroticized, the violent release of the deadly arrow
effectively giving way to suggestions of a pleasurable relaxation of tension after
sexual discharge:

> All-conquest-flush'd, from prostrate Python, came
> The Quiver'd God. In graceful Act he stands,
> His Arm extended with the slacken'd Bow.
> Light flows from his easy Robe, and fair displays
> A manly-soften'd Form. The Bloom of Gods
> Seems youthful o'er the beardless Cheek to wave.
> His features yet heroic Ardor warms;
> And sweet subsiding to a native Smile,
> Mixt with Joy elating Conquest gives,
> A scatter'd Frown exalts his matchless Air.[21]

Sometimes the erotic aspect of the figure is projected by shifting the
gendering of the viewer and imagining this person as female rather than male.
In one of the more fulsome descriptions of the Apollo Belvedere, published in
French at the very beginning of the eighteenth century, the speaking voice is at
the outset by implication male and identifies with the god's elevation and
power: Apollo, 'by his air of grandeur, penetrates you, and makes you feel the
traits and splendours of a superhuman majesty that he spreads out, so to speak,
around him.' Even here there is already a hint of 'feminine' surrender to the
god's masculine power, of being taken over by an energy emanating from the
god. Then, to make the sensuous beauty of its body more immediate, an appeal
is made to the putative response of a female viewer: 'Women should come and
see it and say . . . whether all images they have formed of the beauty of men are
not much inferior to what this statue presents to them.' It is as if the imagined
spectator needs to be a woman for the statue to be conceived as an object of
desire, as if male same-sex desire is unrepresentable or can at most be suggested
by way of displacement. But this is not entirely the case. At some level a male
homoerotic reading of the statue is admissible, for the description goes on to
claim that the figure 'is a beauty replete with evidence of divine traits, that
charms men just as much as women'.[22]

The classic reading of the statue by Winckelmann intensifies and elaborates
the tropes of these earlier readings. What is unusual is Winckelmann's sharp-
ening of the conjunctions between violent aggression and graceful beauty,
between austere elevation and exquisite sensuality. Far from dividing the dif-
ferent registers of response between a male and female spectator, he combines
these in a single intensely homoerotic drama acted out by a male spectator, who
both identifies with and submits to the figure before him. The evocations of
bodily form are constantly shifting between vividly contrasting polarities of
beauty and power. Thus you have 'the soft tenderness . . . of an eternal spring-
time' playing upon 'the proud build of his limbs'. The image of the mouth is

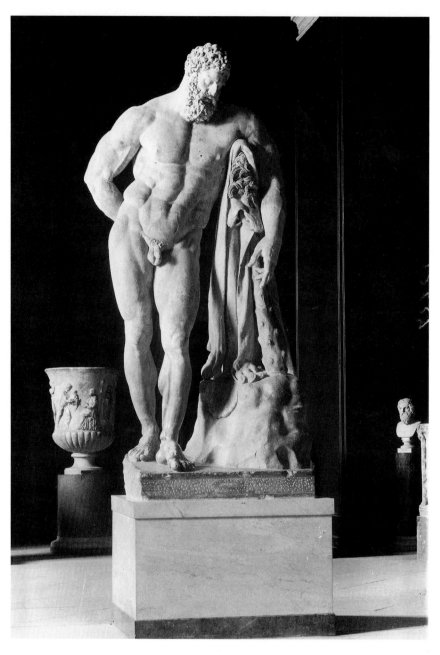

23. Farnese Hercules, marble, National Archaeological Museum, Naples (previously Farnese Palace, Rome).

both that of the angry unyielding god who has effortlessly annihilated his foe—
'disdain sits on his lips'—and 'a mouth shaped as one from which voluptuous
desire flowed to the beloved Branchus' (Plate 20).[23] Branchus incidentally was
one of Apollo's boy lovers who became so obsessed by the god that he became
his oracle, and soon after died, like most of Apollo's mortal male lovers.

The rereading of Winckelmann's description in Byron's *Childe Harold's
Pilgrimage*, published in 1818, again negotiates the potentially dislocating shift
from the sublime to the beautifully sensual aspect of the figure by projecting the
latter through the eyes of a female viewer. This may indicate a certain unease
on Byron's part about too overt a suggestion of homoeroticism:

> The shaft hath just been shot—the arrow bright
> With an immortal's vengeance; in his eye
> And nostril beautiful disdain, and might
>
> And majesty, flash their full lightness by,
> Developing in that one glance the Deity.
> But in his delicate form—a dream of Love
> Shaped by some solitary nymph, whose breast
> Long'd for a deathless lover from above.[24]

It is now, in the early nineteenth century, that you begin to find the first
outright criticisms of the statue. These mark the beginnings of its demotion
from classic status in the face of the rising popularity of newly discovered
fragments of original early Greek sculpture such as the Parthenon marbles. But
when William Hazlitt called the statue a 'theatrical coxcomb', he was not only
registering a change in artistic taste but also in images of ideal masculinity. The
Apollo came to be seen by some cultural pundits as a slightly outdated image.
This figure of regal disdain cloaked in graceful elegance threatened to be more
evocative of a courtly ballet and of rococo taste than a classic embodiment of
manly flesh and blood.[25] More macho images began to come into favour, more
muscular, more immediately resonant of a weighty male presence—even
though responses to these too involved some interplay between powerful manly
strength and beautifully modulated fleshiness.[26]

We might argue that suggestions of a kind of feminine delicacy were no
longer seen as quite appropriate to the serious embodiment of virility. Was it
that Winckelmann's reading played upon a confusion of eroticized gender
stereotypes that ceased to be compelling in the more overtly homophobic
bourgeois culture of the nineteenth century?[27] Any such an explanation would
have to be severely qualified. Homoerotic ideals, like any others, are embedded
in a particular context and subject to modification. The reaction against the
Apollo Belvedere could be linked, not so much to a general de-eroticization of
the male nude, as to changes in conceptions of the perfectly formed male body,
ones that privileged less elegantly poised and smoothly modelled, but in their
different way equally sensual figure types, such as the Ilissus from the Parthe-
non (Plate 24; compare Plate 21). We also have to take into account the

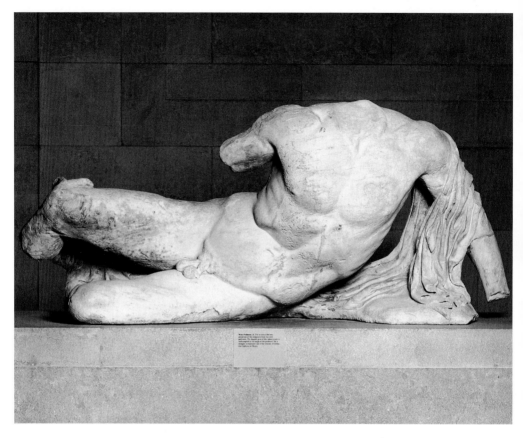

24. Ilissus from the Parthenon, marble, British Museum, London.

phenomenon of uneven development in cultural and artistic fashion, for the Apollo Belvedere continued in many contexts to figure as an ideal image of masculine beauty a long time after it had lost its privileged status in classical archaeology. Thus, for example, we have the male hero of Sacher-Masoch's *Venus in Furs* (1870) saying in terms that are as fully homoerotic as Winckelmann's, and if anything, as one might expect from pornographic fiction, more overtly concerned with male sexual, in particular sado-masochistic fantasy:

> what a beautiful man, by God! I have never seen his like in flesh, only his marble replica in the *Belvedere*: he has the same slender, steely musculature, the delicate features, the wavy locks and the feature that makes him so distinctive: he has no beard. If his hips were less slender, he could be taken

for a woman in disguise. But the strange expression of the mouth, the leonine muzzle and the bared teeth lend a fleeting cruelty to his magnificent face. Apollo flaying Marsyas![28]

What sets Winckelmann's reading of the Apollo Belvedere most evidently apart from other descriptions of the period is his elaborate dramatization of the spectator's response to the work. Here he both echoes and disrupts the shifting position of the viewer in contemporary theories of the experience of the sublime, for he projects an interplay between identification with the figure's power and subjection to it, which is less an affirmation of the self than an orgy of self-obliteration:

> I become oblivious to everything else as I look at this masterwork of art, and I myself take on an elevated stance, so as to be worthy of gazing at it. My chest seems to expand with veneration and to rise and heave, as happens with those I have seen who seem swollen with the spirit of prophecy, and I feel myself taken back to Delos and the Lycean fields, places that Apollo honoured with his presence; for my image seems to take on life and movement, like Pygmalion's beauty . . . I place the idea which I have given of this image at its feet (Plate 22), like the wreaths offered by those who could not reach the head of the divinity that they wished to crown.[29]

Certain features of this narrative are clearly shared with Burke's imagining of the encounter between spectator and object in his theory of the sublime. The spectator, faced with a dominating, overwhelming presence, comes to terms with its sublime aspect by identifying with it and in some sense internalizing its power. But there are significant differences. For one thing, in the initial moment of objectification, when the figure is seen as a presence quite apart from the spectator, the domination of the viewer by this powerful other is overtly eroticized by Winckelmann. It is not just an object of terror or admiration, but commands willing submission—the spectator is both overpowered and seduced by the image of the god. For Burke, in contrast, the sublime object is by definition exclusive of erotic appeal. There is a further major difference. The process of identification with the overpowering other in Winckelmann does not culminate, as it does with Burke or Kant, in self-mastery and self-recuperation. The dominant theory of the sublime imagines the spectator eventually gaining the measure of the force that originally threatened to overwhelm him and emerging empowered. In Winckelmann the spectator's identifying with the irresistibly dominating figure confronting him eventually reaches the point at which his sense of self is effectively annihilated. The spectator is taken over by the all-powerful other: or, to put it in Winckelmann's terms, the god enters and gains possession of the spectator and makes him its mouthpiece. In so far as the spectator can regain a measure of self-possession, it is only by retreating to the role of a distant admirer who can never aspire to a real identity with what he admires.[30]

What Winckelmann describes in his imagined interaction with the Apollo is a process closer to the trauma of mystic experience, or a radical political self-regeneration achieved through self-annihilation, than it is to the gentlemanly self-possession that grounds the dominant experience of the sublime in Enlightenment aesthetics. His is not a narrative in which the self, destabilized for a moment by the imagined threat of something that might overwhelm it, in the end manages to appropriate this within an expanded weightier sense of its own power. The result is more a self-displacement than a self-confirmation. The drama enacted by the viewer who submits to the Apollo is thus no uplifting *Bildungsroman* or aesthetic education. The experience is one of being subjugated and taken over, of being dispossessed rather of than gaining a more developed sense of one's capacities.

The only affirmative selfhood allowed the Winckelmannian viewer is that of the maker of an image of the godhead. The viewer who identifies fully with Winckelmann's elaborate evocation of the Apollo Belvedere enjoys something of Pygmalion's power, bringing alive through the vividness of his response the living conception that once supposedly animated the stilled forms of the marble figure. But he does so as a peculiarly masochistic Pygmalion. If Winckelmann's Apollo exists as the imaginative fabrication of the modern viewer-writer, the image so crafted to the viewer's desire is one that is imagined as taking him over and effectively annihilating him. If he sees himself as the lover offering a tribute to his beloved, he casts himself as the abject lover, who becomes as nothing before the figure he admires. The modern Pygmalion gives birth to a powerful fantasy, but his creative power is exerted in the interests of surrendering to the pleasure of being made insignificant or unconditionally violated by the beautiful presence he creates in his imagination.[31] The Winckelmannian viewer is not quite the Marsyas conjured up by Sacher-Masoch, waiting to be flayed alive by the angry god.[32] But the visage to whose power he imagines himself being captive is suffused as much by the uncompromising violence of a 'sublime' anger and disdain as it is by the charms of a desirable beauty.

It was at some level through his being at odds with a conventionally grounded, upper-class or bourgeois male identity that Winckelmann brought such unusual urgency to the interpretation of this classic image of ideal masculinity. His particular circumstances operated in several important ways to block him from an easy identity with the accepted persona of the gentleman scholar, whose condition he sought to reproduce but also disdained. He was displaced, not only in terms of class origins as the son of a cobbler, but also ethnically and religiously, as a German Protestant having to adopt the trappings of a Catholic cleric so that he could find patronage at the papal court in Rome, and also sexually, as a gay man whose precarious financial position made it impossible for him to acquire the 'normalizing' social attributes of a heterosexual identity, namely a spouse and family.[33] In other words, the extent of his estrangement from dominant models of male selfhood, aside from those allowed to the socially ambiguous persona of a successful writer and antiquarian,

was radically over-determined. In imagining that the most perfect images of ideal manhood available within his culture would have to be a denial or an escape from the viewer's given identity, he broke radically with the protocols of the gentlemanly understanding of the significance of art dominant at the time.

The Apollo Belvedere was rather a special case among the antique statues singled out in the eighteenth century. With most of the other antique sculptures that were looked upon as exemplary images of ideal masculinity the potential for instability and tension was less acute. Almost all were figures in repose, and avoided the active display of physical power that was such an unusual feature of the Apollo (compare Plates 19 and 31). But these male nudes equally disrupted any clear-cut duality between the sublime and the beautiful. On this Winckelmann is particularly instructive because he went as far as any writer of the period was prepared to go in foregrounding the sensual appeal of the naked male body, while still insisting on its heroic elevation or power. In most of his descriptions of antique statues, the figure's immediate presence is seen to be subsumed by the beauty of its physique, while the display of its more sublime aspects is displaced onto its future or its past. It is anchored within aesthetic experience as an object of beauty. At the same time it functions as an image of heroic subjectivity by being seen as possessing the potential to be austerely or powerfully dominating, without imposing itself as such on the spectator.[34]

At times Winckelmann's attenuation of the sublime aspects of the male nude reaches the point where it almost seems to become the equivalent of a desirable female nude, most notably in his account of a statue then taken to be a portrait of the emperor Hadrian's favourite and lover, the Belvedere Antinous (Plates 31–33).[35] Paralleling contemporary accounts of the Venus de' Medici, the beautiful body is presented as sensual, yet not so immediately accessible as to be too overtly an object of erotic desire. Still, there are very important differences. The Antinous is imagined in a state of undisturbed but not quite realized desiring, directly mirroring the simultaneous intimation and suspension of desire in the spectator's response. In most responses to the Venus, only the spectator's desiring is at issue, not that of the figure itself. Winckelmann himself characterized the Venus de' Medici (Plate 25) as no more than a delectable natural object, comparable to a rose opening up before the rising sun, or a firm and still not quite fully ripe fruit.[36] The Belvedere Antinous, in contrast, was not just a thing to be gazed at for delectation, but also a subjectivity with which the spectator would identify, an ideal ego, a mythic image of perfectly integrated manhood that might for a moment project the spectator out of his own troubled and inadequate self.

For Winckelmann, the male figure not only takes precedence over the female figure by being the image of a more complete or elevated subjectivity, as would be commonplace in the unselfconsciously male-dominated culture of the period. The male figure's bodily beauty is so much more richly invested that, even as a point of condensation of the spectator's desire, it marginalizes any libidinal

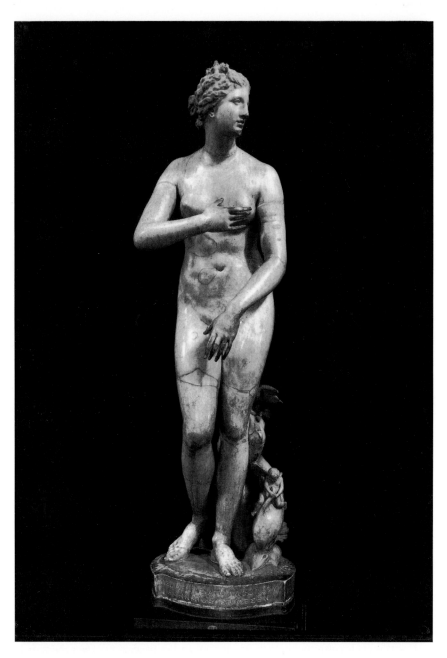

25. Venus de' Medici, marble, Uffizi, Florence.

charge the female figure might offer. The surfaces of the ideal male nude resonate to the full register of power and desire, from the austerely sublime to the sensually beautiful, while the fully unclad female body is more akin to some sensually gratifying object in an ideal still life. In an essay on the feeling for beauty in art, Winckelmann argued quite explicitly against the rococo privileging of the female figure, and of such works as the Venus de' Medici, as the paradigm of the ideal artistic object of desire:

> the person who is only attentive to the beauties of the female sex, and is hardly, or not at all moved by beauties in our sex, will not easily cultivate a feeling for the beauties of art, nor possess it in a lively and universal form. He will have an inadequate grasp of the art of the Greeks, because its greatest beauties come more from our than from the other sex.[37]

How do we read this blanking out of the feminine, which Winckelmann replays in a different register, as we shall see in the next section, when he identifies the austerely and chastely draped female figure as a cipher of the sublime? To read this simply as a measure of Winckelmann's homosexuality would be to show above all a crass misunderstanding of gay identities and desires. It would also misrepresent the cultural economy within which Winckelmann's figurations of the antique ideal operated, an economy in which male narcissism inevitably at times blurred into male same-sex desire. It was not only gay men who, on reading Winckelmann, would take pleasure in imagining, albeit often unconsciously, being seduced, even violated, by the Apollo Belvedere, or being sexually roused by the erotic charge of the Antinous. The significant factor is that this masculine erotic excludes, or we might say represses the feminine. In Winckelmann's reading, the great male ideal nudes, the Apollo Belvedere (Plate 19), the Belvedere Antinous (Plate 31), the Belvedere Torso (Plate 36), and the Laocoon (Plate 16), are not androgynous beings, nor are they the locus for bisexual fantasies breaking down the boundaries between masculinity and femininity. They are male figures that seem to require no female other, obliterating in their self-sufficient plenitude the psychic landscapes of the feminine. Or, if we are to be psychoanalytic, Winckelmann's antique ideal radically represses the feminine. What gives this repression its charge and necessity is not Winckelmann's homosexuality, but a psychic syndrome, a male disavowal of femininity, or a fear of castration as Freud would have it, operating within male subjectivity in the dominantly heterosexual culture of his period.[38]

It may help at this juncture to quote from a modern gay writer in order to make more vivid the lack, the psychic and ideological exclusions produced in this repression of the feminine, as well as to loosen any bonds that might be forming between such repression and homophobic mythologies of a gay male identity. In the following passage from James Baldwin's *Another Country*, the description of the fascination exerted by a gay actor's face becomes the locus for

complex projections of desire in which the categories of masculinity and femininity are simultaneously denied and invoked:

> yet, in precisely the way that great music depends, ultimately, on great silence, this masculinity was defined, and made powerful, by something which was not masculine. But it was not feminine either, and something in Vivaldo resisted the word *androgynous*. It was a quality to which great numbers of people would respond without knowing to what it was they were responding. There was a great force in the face, and great gentleness. But, as most women are not gentle, nor most men strong, it was a face which suggested, resonantly, in the depths, the truth about our natures.[39]

The imaginative configuration here offers no simple liberation from the gendered categories within which the novel's characters lived out their desires—it has its limits, its moments of collusion with the exclusions and repressions of modern masculinity. But in a way that Winckelmann's more exclusively narcissistic images of manhood never could, it can take us to the edge, if not to the beyond of the violently charged denials that haunt masculine identity in modern bourgeois culture.

THE SUBLIME FETISH

Winckelmann's projection of ideas of the sublime and the beautiful onto the ideal male body produces a major structural contradiction in his account of antique art. On one hand, his readings of individual statues play out a constant intermingling of the austerely sublime with the desirably beautiful. But equally, he insists on the necessity of a strict duality between the sublime and the beautiful. The pure sublime is defined as austere, idea-like and elevated, and as such exclusive of the more graceful sensual refinements of the beautiful: the sudden overwhelming transport it produces in the spectator makes irrelevant the latter's allure. But for Winckelmann, as for Burke, no male figure, however high in conception, could be imagined as the literal embodiment of this categorical sublime. What he then substitutes as an appropriate signifier of the pure sublime is the desexualized, austerely draped, female figure.[40] Its role as an image of the sublime is made possible by a double negation—heavily draped, it is removed from the category of an object of desire, and being female, it can better be imagined by the male viewer as entirely untouched by the stirrings of desire. It is absolutely sublime because its delibidinized forms deny the evocative charge that would be carried by a fine male nude.

When Winckelmann singled out a large statue of Athena (Plates 26, 27) as one of the very few existing works in the pure sublime mode, what distinguished it for him from other similar representations had little to do with its suggesting an impressively grand, powerful presence, but rather with the absence in it of attributes that would make it gracefully or sensually beautiful:

26. Athena Farnese, marble, National Archaeological Museum, Naples (previously Villa Albani, Rome).

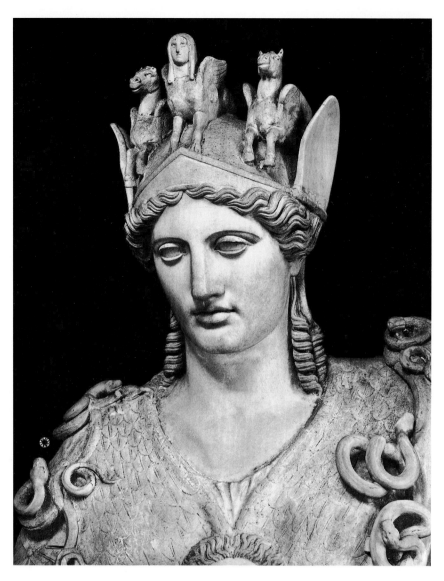

27. Athena Farnese, detail of head.

'you could wish to see a certain grace in the face, with which it would be endowed if it had a greater roundness and suppleness.' In the ideal male figure as envisaged by Winckelmann, the intimation of austere sublimity was always grounded in a sensual fullness of bodily form. Here it was not. According to Winckelmann, the figure of Athena was 'the image of virginal chastity, stripped of all feminine weakness, yes even love vanquished'.[41] In this radically chaste estrangement from desire that constituted her sublimity, she was quite different from other gods. Their divinity may have placed them above the perturbations endemic to merely mortal expressions of desire, but they both aroused and felt the allure of the erotic. The figure of Athena, in her attitude of 'still contemplation' emptied of all libidinal charge, stood for Winckelmann in marked contrast, both to the stereotyped femininity of Venus, with her 'ogling and languishing' air, and to the more masculine Juno, the beauty of whose 'large roundly arched eyes is commanding, as in a queen, who wishes to dominate, be revered, and must arouse love'.[42] It was a radical negation of female subjectivity and desire that allowed the austerely draped Athena to exist as a categorical other to erotically charged beauty of bodily presence in a way that no male figure could.

At the same time, the need to substitute a female figure for the male one as the image of an absolute sublime registered a dislocation in the cultural economy of masculinity. The more powerful symbolic resonances of an ideal masculinity—the pure sublime—could not be identified with the paradigmatic image of the ideal male body. In the context of Burke's philosophical aesthetics, there was no problem in making masculinity the natural home of the sublime. A free interchange took place between the sublimity of some overwhelmingly awesome sublime object and the sublimity of the male subject that would stand up to and encompass such an object. But within the symbolic operations of visual art the situation was not so simple. The image of the ideal male nude, the supposed embodiment of the highest male subjectivity, could not itself be a sublime object, and this on grounds that were strongly over-determined. Any actual male figure, however elevated, could not credibly sustain too direct an association with the full aura of the sublime, which depended for its effect upon the intimation of a power that was not representable, would not be contained by a definable image. The sublime was necessarily rooted in the unconscious of masculinity, and as such could not be encompassed by an image of the male ideal ego. It burst the illusorily bounded confines of the male subject's narcissistic mirror image.

To give this a more historical anchor, it is only necessary to think of attempts made in the wake of Winckelmann to forge a Neoclassical imagery of dominating power with which a wider public might identify. The muscle-bound Hercules chosen to symbolize the triumph of the French people in the more radical populist phase of the French Revolution proved to be more the exception than the rule.[43] Images of state power were more often versions of Athena—large, imposing in scale, but not overwhelming exhibitions of physi-

cal prowess, and insulated from ideas of naked brute force that equivalent images of masculinity might be in danger of bringing into view.[44] If we talk in Freudian terms for a moment, these were images that displaced as far as any powerful human figure could post-Oedipal anxieties over castration. The Athena figure was not a threatening phallic father, and its femininity was played down to the point where its literal lack of a phallus was not a pressing issue either. To take this play upon Freud's allegories of castration to its logical conclusion, we would say that fears of being castrated by the father, and fears prompted by awareness of the mother's 'castration', were displaced by this non–man who was not a woman either. The male spectator could sit in relative ease in the shadow of a figure that traced the outlines of phallic power, but itself did not invite too direct, sexually charged associations. Its formally regulated, chaste austerity also tended to bracket out disturbing regressive fantasies about an infantile surrender to the phallic mother, the mother who was both mother and father. Here you had an imposing yet desexualized figure who was neither father nor mother, but the disembodied trace of both.[45]

The other, rather more vividly dramatized instance Winckelmann gave of a pure female sublime was the statue of Niobe (Plates 15, 17), which he contrasted with one of the period's most widely discussed images of heroic masculinity, the Laocoön (Plates 16, 18). The contrast between these dramatic sculptural groups, as we saw in the previous chapter, served as his central instance of the categorical distinction between a pure de-eroticized sublime and a more sensual, flesh and blood beauty that could only intimate the sublime at one remove.

The statue of the Laocoön played a key role in eighteenth-century discussions of visual art as a model of how a terrifying subject could be presented so as to offer the spectator an uplifting aesthetic experience. It was an exemplar of how a potentially disturbing subject could be made into a beautiful work of art. If Lessing, in his essay *Laokoön* published in 1766, offered a philosophically more sophisticated account of the figure than Winckelmann, he did so by excluding on theoretical grounds a highly charged issue that was central to Winckelmann's account, namely how the figure's beauty might at some level intensify, rather than displace, the psychic resonances of its struggle to the death. In Lessing's distinction between the spheres proper to visual representation and verbal narrative, visual art was envisaged as being concerned above all with the rendering of beautiful form, and hence as excluded a priori from reproducing the powerful or terrifying emotive effects that lay properly in the realm of poetry and drama.[46]

Winckelmann insisted on the central role of the beauty of the figure, but he did not see this as excluding its expressive power. On the contrary, in his readings of both the Laocoön and the Niobe he was concerned to show how an ideal form could become the vehicle for rendering a dramatic intensity pushed to its very limits. In both cases, a sublime power was not an attribute of the figure itself, as in the case of the Apollo Belvedere, but made manifest indirectly

through its violent effects on the figure's body.[47] A sado–masochistic drama was not acted out directly between spectator and image, but displaced, the viewer becoming the spectator of a scene that invited a vicarious psychic identification. The Niobe was sublime rather than beautiful, like the Laocoön, because in Winckelmann's account its suffering had reached such extremes that all traces of human feeling and inner resistance were blanked out.

At this point it is worth quoting in full the contrast Winckelmann himself drew between the Niobe's imaging of the 'fear of death' and the Laocoön's of 'the most intense suffering and pain':

> The daughters of Niobe [note the exclusion of the sons: the statue of Niobe and her youngest daughter forms part of a group that includes statues of her sons, largely nude, and her elder daughters, draped], against whom Diana directs her deadly arrows, are represented in that state of indescribable fear where feeling is numbed and stifled and the present threat of death takes away all capacity to think; in the fable of Niobe an image of this lifeless fear is given by her metamorphosis into stone: it is for this reason that Aeschylus has Niobe appear silent in his tragedy. Such a state of mind, where feeling and thought cease, which is akin to indifference, produces no alteration in the shape or form of facial feature, and so here the great artist was able to fashion as he did the very highest beauty: for Niobe and her daughters are and remain the most elevated ideas of beauty. Laocoön is an image of the most extreme suffering that manifests itself here in all muscles, nerves, and veins; the blood boils from the deadly bite of the serpents, and all parts of the body express strain and pain, allowing the artist to make visible every force of nature, and display his great knowledge and art. In the representation of this most intense pain, however, there emerges the afflicted spirit of a great man, who struggles with extremity, and seeks to quell and stifle the outbreak of feeling.[48]

The contrast between these two statues was most vividly represented in their facial expressions. Niobe's was an empty face transfixed in a stilled expressionless beauty (Plate 17), 'represented in a state of stifled and numbed feeling'.[49] The Laocoön's, in contrast, was veritably convulsed by conflicting expressions of pain and the effort to contain it (Plate 18; see also Plate 28), as Winckelmann explained in his more extended description of the statue:

> Beneath the brow the battle between pain and resistance is fashioned with great wisdom, as if it were brought together at one point: for while pain drives the eyebrows upwards, the flesh on the eyelids is thrust downwards in the struggle against this pain, pressing against the upper eyelid, so that the latter is almost completely covered by the flesh pushing over it.[50]

The contrast between the two statues was further heightened by the heavy drapery enveloping the body of the Niobe and the vivid musculature of the exposed torso of the Laocoön. Niobe's body, largely subordinated to the flow of

the folds of her clothing, appeared almost an abstract cipher in contrast with the vivid flesh and blood presence of the Laocoön.

Niobe in Winckelmann's reading is above all a figure of absolute negativity—she could not be a heroine because she had no self, no volition with which the viewer might identify. While he sees in the Laocoön the signs of a fatherly compassion for his sons, he completely ignores the Niobe's motherly protective gesture towards her daughter, which many viewers might identify as central to the affective power of the statue. Winckelmann's blindness is pretty categorical, because not only does the statue of Niobe dramatize motherly feeling much more fully and explicitly than the Laocoön does fatherly compassion— Laocoön does not turn to his sons in the way that Niobe does to her daughter— but the story of Niobe is so centrally about motherhood, revolving around her hubris in proclaiming herself superior to Leto, the mother of Apollo and Diana. In contrast, the destruction of the sons in the Laocoön story is a secondary affair. Even in the version where Laocoön is being punished for breaking a priestly taboo against procreation, it is in his person as priest rather than as father that destruction is being meted out to him and his family. Winckelmann then is engaged in a very active suppression of femininity in his reading of the Niobe when he represents her as absolutely drained of any inner feeling and any trace of heroic self-possession, and categorically denies her any of the resonances of motherhood she so readily invites. For him her composure is not an expression of some inner strength of self, but on the contrary is quite involuntary, made possible by the total annihilation of her 'feminine' identity and consciousness.

The Laocoön's struggle represents a pervasive trope of male heroism, seen as manifesting itself, not in a moment of triumph, but in a moment of extremity when the hero faces death. Male heroism often seems to be expressed most vividly when its inner resources are almost faltering, but still just holding out. This, anyway, is the ethically improving view. Winckelmann's reading dramatizes the tensions that give this trope its interest—the vigorous display of strength by the struggling body, with which the spectator can identify, on one hand, and the powerful convulsions of pain, on which the spectator may look with horror or pity, but also linger over with a perverse kind of pleasure, on the other.

Winckelmann's reading of the Laocoön in the *History* nevertheless registers a significant shift from a straightforward humanist interpretation of the figure as a hero whose inner strength enables him to maintain a poise, a self-possession, in the midst of unbearable adversity—whose beauty, unlike that of the Niobe, is produced as the expression of a noble inner self. On this point, his reading of the statue departs interestingly from his own earlier characterization of it in the essay *On the Imitation of the Greeks*, published in 1755. In the earlier account, written before he had actually seen the Laocoön, Winckelmann singled it out as the paradigm of a 'noble simplicity and calm (or still) grandeur' of soul that made the antique ethically and aesthetically so superior to the mod-

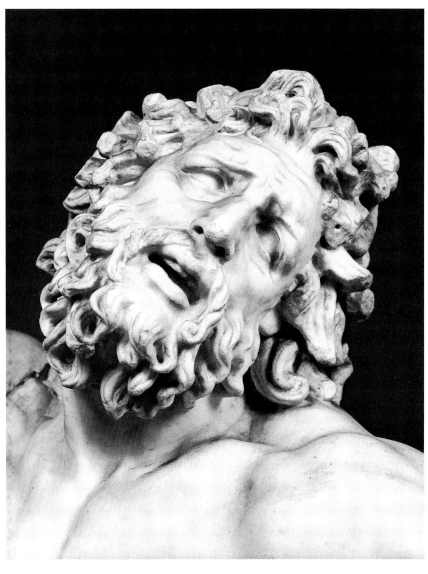

28. Laocoön, marble, detail of head, Vatican, Rome.

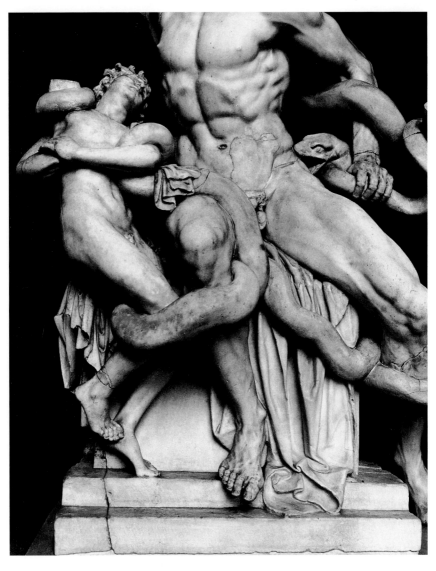

29. Laocoön, detail of lower torso and legs.

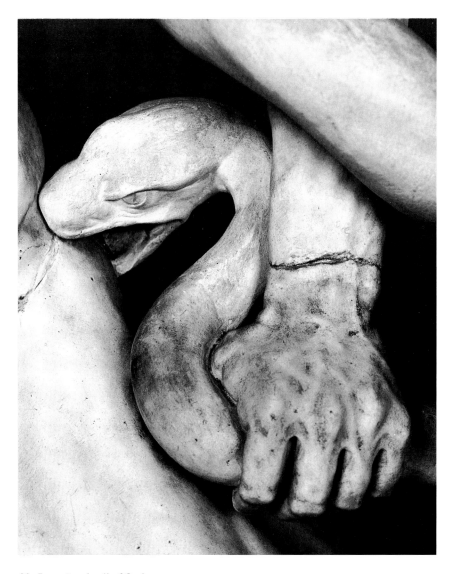

30. Laocoön, detail of flank.

ern.[51] In the much lengthier description in the *History*, his focus on the physical convulsions of the body produces a psychic dynamic that, while it may at one level help to dramatize, also unconsciously subverts the ethical significance of the statue.

The description begins on a high-minded enough note. Winckelmann explains how we see in the statue 'nature in the most intense pain, fashioned in the image of a man, who seeks to gather together the conscious strength of his spirit against this pain'. While his reading of the feelings played out on the face (Plate 28) still has something of this ethical resonance, the latter becomes more and more dissipated once attention is turned to the body (Plates 29, 30):

> while pain swells the muscles, the strongly armed mind manifests itself in the distended brow. The chest rises upwards as the breathing is stifled and the outpouring of feeling suppressed so the pain is contained and locked up within. The alarmed sigh, which he draws into himself with his breath, drains the abdomen, hollowing out its sides, at the same time exposing to our view the movement of his entrails.[52]

Some measure of affirmation is still allowed the spectator in the figure's fine and powerful physique, despite the insistence on brute physical pain and terror. Any suggested expansion of self through heroic struggle ceases, however, when the description focuses on the figure's vulnerably exposed flank (Plate 30), into which the snake is about to sink its fangs. There, according to Winckelmann,

> there where the greatest pain is placed, the greatest beauty also manifests itself. The left side, into which the snake's raging fangs pours forth its poison, is the one that through its close proximity to the heart appears to suffer most intensely, and this part of the body can be called a wonder of art.

The figure's highest beauty thus emerges where the extreme intensity of pain obliterates inner resistance. Around this stillness rages a seething impotent struggle (Plate 29): 'His legs wish to rise up, so he could flee his calamity; no part is at rest; yes even the chisel marks help to conjure up the tightened skin.'

The image of the beautiful flank that Winckelmann thus singles out in the climax of his description instantly resolves the violently alternating readings of the body's seething musculature, flexing in strength and twisting in pain. But it also radically disturbs the conventional ethical significance of the statue. This manifestation of the very highest beauty—the sublime—stills the movements of the body and quenches the perturbations of feeling. As in the Niobe, it is dehumanized, involuntary. A deadly spasm produces the greatest—highest?—pleasure for the viewer, not any display of heroic inner strength.

In Winckelmann the image of the sublime body is not so much what we might think it ought to be—the embodiment of the fullest, most resonant, human subjectivity—but more like a classic Freudian fetish. In the Niobe's face (Plate 17) or the stilled flank of the Laocoön (Plate 30) the outlines of an ideal self freeze into the forms of a dehumanized object, on which fears of

traumatic self-annihilation—or fear of castration as Freud would have it—can simultaneously be projected and disavowed. The stifled, mutely eloquent forms of the sublime are both charged by the violent reverberations of these fears and blank them out. In other words, the sublime object draws the viewer into a compulsive engagement with the idea of self-annihilation, and at another level displaces this threat.

In a modern post-Freudian context, it would be almost disconcertingly easy for us to anatomize the figure of Niobe in terms of a fetishistic structure of response, as a locus for acknowledging and disavowing fears of castration.[53] But leaving aside for the moment the adjustments we should have to make to recast Freud's psychic trauma in terms that made sense in the particular context of Enlightenment culture, Winckelmann's writing is not the place to go to illuminate those aspects of male fantasy woven around a feminine other. The unacknowledged yet insistent disavowal of sexual difference, the systematic bracketing out of any identification with a feminine self, most notably the mother, gives Winckelmann's image of the Niobe too much of the opacity of an actual fetish. The psychic dynamic investing its forms is blindly displaced, compulsively kept at one remove.

Where Winckelmann is more eloquent, indeed unusually eloquent, is in his projection of fantasies surrounding the ideal male nude. In his vividly physical reading of the Laocoön's struggling body, he brings openly into play a dynamic of sado-masochistic pleasure that is erased by the Niobe's purely sublime body—masochism if you as viewer find yourself irresistibly drawn to identifying with the figure, or sadism if you objectify the violent attack on the figure's body and enjoy the spectacle. Either way, the writhing struggle presents the threat of a total annihilation of manhood in the midst of a powerful, erotically charged flexing of beautiful muscles. Here, in this intermingling of erotic pleasure and traumatic self-annihilation, Winckelmann plays out a sado-masochistic dynamic central to the charge of the sublime, to that compulsive mingling of fascination and fear we also saw at work in his reading of the Apollo Belvedere, which Burke's categorically gendered separation of the sublime from the beautiful was designed to disavow.

The Laocoön makes visible what is simultaneously occluded and consummated in the figure of Niobe. Its struggling body lives out the fantasies and nightmares animating the blank—terrifyingly empty and untroubled—spaces of the sublime.

How is it that, in the context of a high-minded analysis of ancient art rather than a piece of erotic fiction, Winckelmann could bring so vividly into view some of the more disturbing psychic dynamics of the sublime that analysis of aesthetic pleasure in the period generally evaded? There can be no simple answer to this question, but in this context too it is important to remind ourselves not only that Winckelmann was gay, but in several other significant respects precluded from living comfortably with the gentlemanly identities available to a man in his position. Though his particular circumstances did not

cause it, they would have played a key role in sustaining his compulsion to work through the traumas that haunted his period's supposedly affirmative images of ideal manhood.[54] In his reading, the Laocoön does not sit entirely easily with the humanist significance that traditionally validated its presentation of physical violence. To focus so intently on the struggling body ineluctably draws the viewer into a blindly orgiastic scene, which can only disturb its recuperation as a self-affirmative object of aesthetic experience.

In so far as Winckelmann's sexuality is an issue in this compulsive projection of libidinally charged self-destructive urges, it is not to some supposed pathology of male homosexual identity that we should be looking, but rather to the violent denials of homosexual desire effected by the dominant norms of Enlightenment culture. To the extent that the destructive aspect of this playing out of sado-masochistic fantasy is bound up with male sexual identity, it is produced by a violent homophobia policing the perimeters of manhood—the 'pathological' imperatives of 'normal' masculine identity in Enlightenment culture, which made great play of the homoerotic while uncompromisingly repressing the public visibility of male same-sex desire.[55] Such tension between affirmation and denial of male desire was inevitably internalized in readings of the ideal male nude, such as Winckelmann's. In a cultural context where the desirability of these bodily images of ideal manhood were simultaneously being affirmed and negated, the more nihilistic syndromes within Winckelmann's readings had an unerring logic. He was having to imagine the enactment of a masculine desire evoked by the beautiful male body on a public stage where such desire was policed by the threat of violent annihilation.

As to Winckelmann's engagement with the psychic resonances of femininity in his reading of the Niobe, we see not an expansive play but a blanking out of male fantasy. Niobe is construed as occupying a territory beyond the reach of desire. Even so, the suppression of the spectator's identification with the figure, and the denial of the pleasure or pain she or he might take in this image of the violation of her motherhood—significantly, Winckelmann has Diana, not Apollo, loose arrows on Niobe and her daughters, thereby bracketing out any overt suggestions of male sadism—is no more extreme in its refusal of femininity than the conventional heterosexual projections of the female figure as gratifying object of desire in the artistic culture of the time. The Rococo conception of Venus allows no more scope for a viewer to identify with a female subjectivity than Winckelmann's Niobe. If anything the Venus is more unequivocally a mere object that fetishistically blocks male anxieties surrounding sexual difference. At least in Winckelmann, it is the mother figure that hovers there as an insistent absence, rather than some mutely malleable erotic plaything, intimating a terror beyond terror, with which the modern male 'bourgeois' subject—whether homosexual or heterosexual—could only identify by annihilating himself.

CHAPTER V
Ideal Bodies

In theory, the Greek ideal should appear entirely whole and centred, its harmoniously poised body the very model of a similarly constituted ideal subjectivity. It still needed, however, to bear some trace of the deep-seated disturbances that motivated the fantasies of ideal oneness it embodied. It had to appear untouched by contradiction and difference even as its affective power drew upon anxieties associated with the 'real' divisions of the self, for only on condition that it did not entirely efface ideological and psychic tension could its potentially bland perfection be of compulsive interest.

We have already seen how, by establishing a duality between the high and the beautiful, Winckelmann opened up an irreducible division within the Greek ideal. This division not only registered the formal impossibility of ever realizing a stable fusion of idea and body in one single image. It also articulated a complex play of fantasy, oscillating between the projection and disavowal of desire, between the assertion and denial, even annihilation, of the active male self. The present chapter addresses such concerns as they emerge in the theory of ideal beauty Winckelmann elaborated in the chapter on the essence of ancient Greek art in the *History*.[1]

Within the conventional humanist ideology that provided the framework for Winckelmann's analysis, the Greek or antique ideal was the very image of a free self, of an ideal sovereign subject, its calm unblemished beauty the sign of its not being in any way disfigured or constrained by the world around it. The simple, clearly circumscribed forms of its body would also seem to preclude suggestions of internal tension and anxiety. Imagined as existing in total isolation, in an empty space defined only by its own presence, such a free-standing figure quite literally bracketed out suggestions of disturbance by a surrounding environment. In many ways Winckelmann takes this ideology at face value, with passionate seriousness in fact. But in playing out these 'male' fantasies of a totally free and unconstrained subjectivity with such single-minded intensity, he exposes the contradictions and repressions involved.

In particular, Winckelmann brings to the fore the erotic dimension of the fantasies of ideal oneness projected onto the ideal male nude. We could say that with him, the male viewer's fascination with the image of a perfectly formed naked male body becomes narcissistic in the fullest sense of the word. But the classical myth of Narcissus, no less than modern psychoanalytic accounts of

narcissism,[2] are not just stories of an undisturbed pleasure taken in an 'ideal' ego. The state of total self-absorption is achieved at a huge cost, and in the end comes closer to self-annihilation than self-affirmation. Such costs emerge unusually vividly in Winckelmann's analysis. The utopian fantasy of a totally unconstrained and undisturbed enjoyment of self, which renders redundant any potentially troubling or frustrating interaction with the outside world, is presented equally as the nightmare of a solipsistic isolation, of a kind of death.

The tensions and contradictions inherent in Winckelmann's projection of the Greek ideal as the image of a free sovereign subjectivity have their strongly ideological dimension too. The fantasy of a freely realized oneness of self, at least in the extreme form found in Winckelmann's account, is above all a modern 'bourgeois' fantasy—modern here being taken to refer to a set of cultural forms that began to be adumbrated in eighteenth-century Enlightenment Europe.[3] The ideological loadings of such a fantasy become explicit in Winckelmann's analysis when he has to confront fundamental class, racial, and sexual differences that the oneness of the Greek ideal seeks to deny or evade. They also surface when the more manly aspect of the idea of freedom, the heroics associated with the Greek ideal, come to the fore. If a state of 'passive' freedom could be represented through an image of narcissistic self-absorption, another quite different form of image was required to figure the active self-realization of a free sovereign subject. When Winckelmann presented an image of ideal masculinity actively asserting itself, he configured it in explicitly violent terms, as in a way the sadistic or masochistic mirror of narcissistic withdrawal. Statues such as the Apollo Belvedere and the Laocoön were imagined in scenes of violent confrontation whose only issue could be a subjugation of the outside world's resistance to the self or the annihilation of the self by the forces confronting it.

The notion of the ideal sovereign subject as something that could only be truly itself when totally autonomous, either through withdrawing from the world or confronting it, is ideological if nothing else. If we say such a notion of the self also seems to haunt modern psychoanalytic accounts of narcissistic fantasy,[4] we are not denying its ideological specificity. Rather we are simply recognizing that our present-day understanding of such fantasy grows out of politically loaded formations of subjectivity that have permeated modern 'bourgeois' culture for some time.

Before proceeding to the more extreme projections of fantasy in Winckelmann's definition of ideal beauty, we shall begin with an analysis he gave of a famous antique statue where he is particularly explicit about its being symbolic of an ideal—or ideally desirable—self. The work in question, the so-called Belvedere Antinous (Plates 31–33), now generally taken to depict the god Mercury, was then designated as a portrait of Hadrian's lover. Winckelmann followed a view already gaining ground in professional antiquarian circles when he challenged this designation, declaring that it must be a figure from Greek religion or mythology. He conjectured that it represented the young Greek

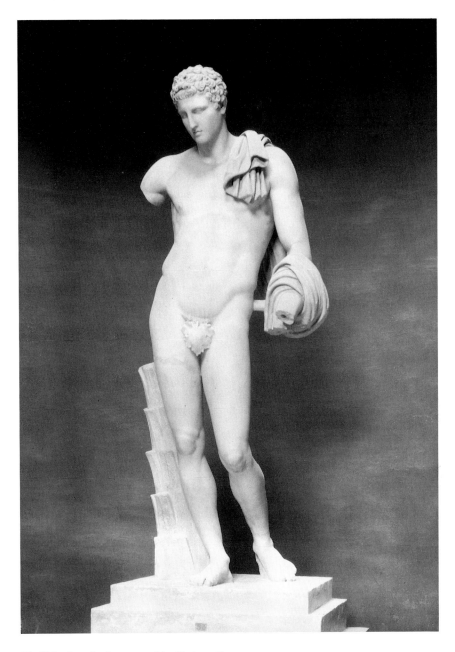

31. Belvedere Antinous, marble, Vatican, Rome.

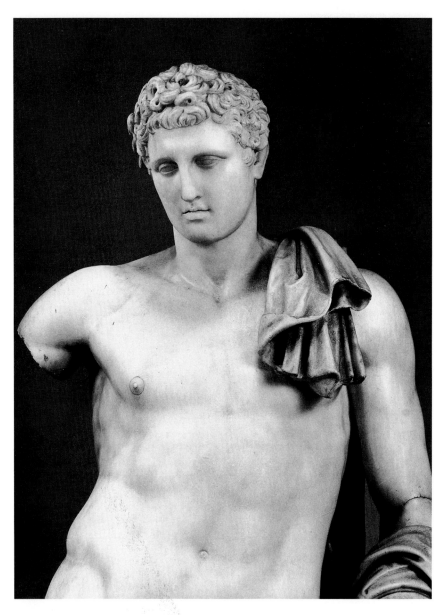

32. Belvedere Antinous, detail of head and shoulders.

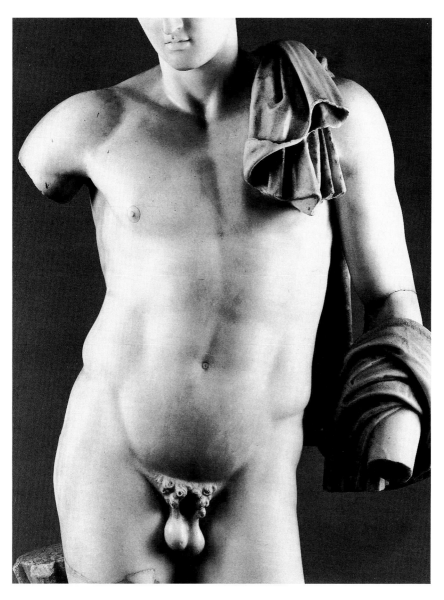

33. Belvedere Antinous, detail of torso.

hero Meleager. It was the best known example at the time of a type very common in Greek sculpture, the free-standing athletic male nude, not totally still but not engaged in any definite action either. Winckelmann read it as a 'narcissistic' figure of self-absorption, turned totally inward on itself:

> The head (Plate 32) is undeniably one of the most beautiful youthful heads from antiquity. In Apollo's [that is the Apollo Belvedere's; Plate 20] face there reign majesty and pride; here however is an image of the lovely gracefulness of youth and the beauty of blooming years, combined with pleasing innocence and soft charm. There is not the slightest hint of passion that might disturb the harmonious unity and youthful stillness of soul represented here. This state of calm, and equally this enjoyment of self in which the senses are gathered inwards and withdrawn from any external object, permeate the whole stance of this noble figure. The eye, which is like that of the goddess of love, but without desire, is moderately curved, and speaks with a captivating innocence. The full yet modestly circumscribed mouth spreads emotions without seeming to feel them. The cheeks in their lovely fullness, together with the arched roundness of the softly raised chin, define the full and noble outline of the head of this noble youth.[5]

The image of the Greek ideal projected here is that of a subjectivity existing in blissful self-sufficiency, undisturbed by any conflict or tension with the world about it or any divisions within itself. In the state of narcissistic plenitude that the figure is imagined as enjoying, there is no barrier to its desires or to its self-realization, on condition that these desires do not fix on potentially disruptive external objects, that the self exists in a state of liminality where it will conjure up no hostile or indifferent other. The fantasy involved is hardly unique to Winckelmann. The image of an essential oneness of being, divested of the tensions inherent in any actual sense of self, and associated with a mythic past where the subject supposedly did not yet feel in any way alienated, is a pervasive one within modern European culture.[6]

Such a mythic constitution of the self and its desires has clear affinities with the fantasy of a 'recovery of the supposedly omnipotent state of infantile narcissism' analysed in Freud.[7] Narcissistic fantasy, according to Freud, projects an ideal whole self by way of an imagined regression to an earlier state of being when there is as yet no awareness of conflict between internal desire and the external world and the self seems to exist in a state of solipsistic plenitude. It is a fantasy activated by potentially overwhelming divisions within the adult psyche. This phantasy of narcissistic oneness is more radically regressive in Freud than in its 'Enlightenment' forms and is set very far back in earliest childhood. A fully undisturbed state of narcissistic self-absorption could only be imagined by Freud as existing prior to the infant's first fixation on the mother or father, which sets in motion the tensions of the Oedipal trajectory. It marks the very beginnings of self-definition when the nascent ego has not yet effected a systematic separation between itself and the world around

it. According to Freud, the first stirrings of a libidinally charged fixation on objects experienced as distinct and hence potentially alien begins with a fixation on the self, with narcissism. The object that the hitherto polymorphous 'isolated sexual instincts' seize upon is not an 'external one, extraneous to the subject, but its own ego'. So the self recognizes in its own image its first object of love—an ideal ego Lacan later defined as the ego's originary object of self-misrecognition.[8]

The fact that the image of narcissistic oneness that Winckelmann conjures up is visibly so much more mature than the ideal ego fantasized by the adult psyche in Freud should give us pause before taking the Freudian analogy too far. Winckelmann's is the more conventional traditional image of a pre-pubertal youth existing in a state of innocence prior to adult perturbations of desire, one that Freud's theories of infantile sexuality explicitly sought to subvert. Winckelmann's youthful narcissistic image also coincides more with ancient Greek conceptions of the pre-adult boy than Freud's infantile one.[9]

But it is nevertheless worth making the comparison with Freud, for it underlines the regressive dynamic of this structure of fantasy pervading modern notions of an ideal self. Freud's more 'infantile' definition of the fantasy is just one case of how the modern 'bourgeois' imagination has constantly had to reinvent ever more archaic or regressive myths of a primal state of being as the imperatives of a monadic individualism become ever more acute.[10] There is in Winckelmann's own fantasizing of the ideal self embodied by the Greek ideal a strongly regressive drift that unconsciously moulds his reading of the so-called Belvedere Antinous. A clear disparity is evident between the very youthful image Winckelmann conjures up and the image of quite mature manhood we ourselves might recognize in the statue. Winckelmann focuses on the head, where the illusion of 'a lovely youth in the beauty of blooming years', suffused with 'innocent and soft charm', is easiest to sustain. His comments on the inferior quality of the lower part of the figure's torso and its legs betray a certain unease that focuses on aspects of the statue insistently resistant to his regressive reading of it as an innocent youth who had not yet emerged from puberty to full-fledged manhood.

The uneasy slippage between manhood and youth registers a certain anxiety about the constitution of the figure's virility. Its more powerfully conceived forms—the forehead, the raised chest—are read by Winckelmann as intimating an emergence into full-scale manhood, but one that has to be projected into the distant future so as not to disrupt the undisturbed youthful calm: 'The brow already announces something more than the youth: in the high splendour with which it rises up, as in Hercules, it announces the future hero.' But its heroic capacities have yet to assert themselves and confront the world. In the specific case of Meleager, the figure Winckelmann saw represented in the statue, his active self-realization as hero resulted in bloody confrontation and death. To preserve the narcissistic illusion, the figure's possession of bodily forms that intimate a virile capacity are countered by its being seen as too young

to feel the stirrings of manly power, just as its erotic beauty intimates a desire
that it cannot yet experience.

The Belvedere Antinous was not for Winckelmann the highest and purest
embodiment of the Greek ideal—only the head came close to that. The pre-
rogatives of ideal beauty as he construed them required a more radically regres-
sive oneness of subjectivity that the signs of virility in this statue would have
disturbed. The more childlike image of the boy that hovers over Winckel-
mann's disquisitions on the essence of beauty do suggest something closer to
the Freudian image of an infantile narcissism. At some moments this fantasy
even reaches a point that is more regressive than that, where any definable sense
of self is lost, and the ideal body's bounded forms dissolve in an unarticulated
flow of delicately modulated contours. We are in effect projected back into a
state which in Freudian theory comes before the constitution of the ideal ego,
a state of absolutely self-sufficient narcissism where the self and the objects
outside it fuse together in unfocused sensations and feelings.[11]

But before moving on to this more absolute, this more regressive figure of
a mythic oneness—an ideal self-projection paradoxically realized, like the sub-
lime figure, in radical self-annihilation—there are some further aspects of
Winckelmann's conception of the Belvedere Antinous that are important. His
readings of antique sculptures are particularly interesting because they involve
a complex interplay between seeing the sculptural figure as an ideal object of
desire and identifying with it as an ideal subject. Much of the more enthusiastic
writing on the beauty of the antique ideal in the eighteenth century, once it
emerges from generalities to focus on particular statues, focuses on the female
nude. The figure is constituted almost exclusively as an object of delectation for
the male viewer, and any possibility of identification with it is necessarily
marginalized for such a viewer. Winckelmann makes the male nude a complex
and potentially disturbing focus of erotic fantasy—which involves not just
objectifying delectation but also narcissistic identification with the figure's
beauty. The visual representation of an ideal male self, which for the human-
ist ideology of the period is the 'highest' value of antique sculpture, is in
Winckelmann inextricably bound up with a vividly eroticized enjoyment of the
male body that is constantly on the verge of becoming a prohibited male same-
sex desire.

Winckelmann's projection of the Belvedere Antinous as the embodiment of
an ideal subjectivity involves the viewer in an imagined reconstitution of his
own subjectivity. In other words, Winckelmann describes how, in responding
to the statue in a particular way, the viewer's own sense of self is redefined.
What is specifically imagined as happening—or not happening—as the viewer
faces this erotically charged and narcissistically self-absorbed figure? For one
thing, a reciprocal dynamic is set up in which the viewer's desire mirrors the
desiring, or the liminal suspension of desiring, imputed to the figure. In this
dynamic, the self-absorption of the figure is very important for it brackets out
tensions that might arise from imagining an explicit erotic interchange between

the viewer and the figure before him. How the viewer desires the figure, or more important, how the figure might react to the viewer's desiring, responding to or rejecting it, is precluded as an issue. The figure is too self-possessed to be imagined as in any way offering itself: far from addressing the viewer, it is completely self-absorbed. The responses most readily invited are ones in which the viewer identifies with the figure's imagined state of narcissistic oneness or admires its beauty from a 'safe' distance.

Such displacement of too explicit an interchange between viewer and figure is an important aspect of the idealizing eroticism associated with the period's conception of the female nude as well, which becomes the more desirable for presenting itself as unavailable. In Winckelmann's reading of the Belvedere Antinous, the displacement has to be more radical because of the unspoken prohibition on presenting a male figure as a seductive object. At the same time, the attitude of narcissistic self-absorption functions as an erotic incitement, heightening the figure's appeal as a displaced or distanced object of desire. As Freud put it in his essay on narcissism,

> it seems very evident that another person's narcissism has a great attraction for those who have renounced part of their own narcissism and are in search of object-love. The charm of a child lies to a great extent in his narcissism, his self-contentment and inaccessibility, just as does the charm of certain animals which do not seem to concern themselves about us . . . It is as if we envied them for maintaining a blissful state of mind—an unassailable libidinal position which we ourselves have since abandoned.[12]

The most powerful dynamic in Winckelmann's reading of the Belvedere Antinous is perhaps the simultaneous incitement and stilling of erotic desire. This can be envisaged as a fantasy of return to narcissistic plenitude, the fantasy of a kind of desiring that would never be frustrated, never be in danger of destabilizing or unsettling the self—a utopian state that could only be imagined as the simultaneous fulfilment and negation of our present desiring. Such a dynamic is very explicitly played out in Winckelmann's general conception of the Belvedere Antinous—his insistence, for example, that in this image of a 'lovely youth' there is no 'hint of any kind of passion which might disturb the harmonious unity and youthful stillness of soul' (Plates 32, 33). The dynamic is compulsively repeated in his detailed reading of the body—'the eye, which is like that of the goddess of love, but without desire . . . the full yet modestly circumscribed mouth accumulates emotions without seeming to feel them.' The interplay between images of erotic repletion, and ones that drain away or deny sexual arousal, is more highly invested than the conventional patterns of avowal and disavowal of desiring, which are played out in other responses to the ideal figure.

This particular investment cannot quite be explained as a straightforward effect of the particular prohibition placed on male same-sex desire at the time. It also echoes something more paradoxical that was inherent in the dominant

paradigms of ideal manhood in the culture of the period. The simultaneous play on and denial of desirability was an important aspect of dominant heterosexual readings of the ideal male nude, as we saw in the last chapter. Here we are made aware of another distinctive aspect of these fantasies played out around the Greek ideal—the narcissistic dynamic projected so vividly by Winckelmann. There is again no simple connection to be made with Winckelmann's homosexuality. The compulsion to 'return' to a state that evades any need to negotiate 'another's' sexual desires has often been associated in psychoanalytic study with homosexuality and construed as its 'pathological' symptom. Without entering here into a discussion of the deeply ingrained ideological assumptions that have made it seem natural for sexual difference to provide the only real basis for the self's experience of difference[13]—in other words, that negotiating a relationship with someone of the same sex somehow involves less of a need to face up to inter-subjective difference than a heterosexual one—there is still the point that the compulsive narcissism of the kind dramatized by Winckelmann are central to male identity within the norms of heterosexuality. A regression to narcissistic self-absorption, a disavowal of sexual difference, a wish to fantasize the object of desire as a mere extension and confirmation of the self, are hardly distinctively homosexual.

For present purposes, what is most important about the particular form of male fantasy projected by Winckelmann is the way in which it exposes, within dominant norms of 'ideal' masculinity, a complex interplay between the mythic self-sufficiency of the ideal subject and the compulsive autoeroticism of narcissism. The latter had to be denied and repressed, even as it was incited so as to give a psychic charge to the antique sculpture's image of ideal manhood—to endow its potentially indifferent marble forms with flesh and blood. In the context of eighteenth-century culture, Winckelmann's foregrounding of the libidinal charge of the male nude made him something of a libertine and a sensualist.[14] But the uneasy position he occupied in relation to that society's dominant sexuality made him particularly sensitive to the 'real' ideological blockages and prohibitions operating on the free play of libertine fantasy.

There was, then, something very real in his so eloquently dramatizing the desires played out on the ideal figure as constituted by lack and displacement, and in his going beyond a simple model of aesthetic gratification and possession. In projecting the male nude as an erotic object that in some repect had to seem to deny the erotic interests it aroused, his identity was on the line. As a result, he was able to give an unusually vivid inflection to the sexual politics inherent in one of the dominant cultural paradigms of his time—the constitution of the ideal male body, the Greek ideal, as the symbol of an ideal subjectivity. When he exposed the disturbingly solipsistic logic inherent in the fantasies woven around this image, the extreme rejection and evasion of difference, and the potentially annihilating denial of flesh and blood in relation to desires that could only be flesh and blood, he was dramatizing syndromes that he knew only too well. He knew them as the potential object rather than subject

of the power they unconsciously exerted in the libidinal economy of the culture he inhabited.

ONENESS AND IDEAL BEAUTY

Winckelmann put the notion of oneness—what he called 'unity' (*Einheit*) or 'simplicity' (*Einfalt*)—very explicitly at the centre of his definition of ideal beauty.[15] There was nothing exceptional about this. Indeed the categorical denials of difference entailed by such a mythic notion of the perfect human figure were central to the conception of the ideal nude in the aesthetics of the period. What he calls 'beauty' (*Schönheit*) in this context, beauty as an ideal of art, is precisely what theorists writing in French at the time would describe in more technical academic terms as *beau idéal* or ideal beauty.[16] What is unusual is the seriousness with which Winckelmann worked through the implications of this theoretical paradigm, exposing the difficulties and disturbances involved in imagining an ideal figure that would really be purged of all marks of physical and cultural difference.

There were several levels at which Winckelmann gave evidence of the impossibility of realizing the ideal beauty supposedly epitomized by Greek art. For one thing, his general definition of beauty failed to single out any known statues that could stand as the full embodiment of the very highest beauty. Here there is some analogy with the way that he defined the highest style of Greek art, the sublime, as virtually impossible to exemplify in a full-bodied way. Ideal oneness always remained a never quite realizable abstract imperative, both implicit in but never quite adequately embodied by any actual beauty.

How, in the face of this difficulty, Winckelmann sought to identify actual images of the most ideal beauty is discussed in the next section. There we examine his suggestion that the most perfect embodiment of the ideal ego might be the figure of a beautiful young boy, a pre-virile ephebe, as yet unmarked by the distinguishing qualities of manhood. We shall also consider his attempts to locate the essence of bodily beauty in the abstract play of softly modulated contours, as if the body were being apprehended close to and any sense of its distinctive shape and form dissolved. The image of flowing contours is, in Winckelmann's analysis, the point where the fetishizing tendencies inherent in the notion of ideal beauty converge. Contour operates as the trace of a number of psychically highly charged disavowals and unconscious recognitions of bodily signs of difference. At the same time it embodies a powerful contradiction operating within the symbolic economy of ideal beauty. His analysis implies that the fantasy of absolute oneness could best be represented by way of a radical paradox. The ideal figure was being imagined in a guise where any disturbing particularity of form, but also any sense of its integrity as clearly circumscribed whole, was dissolved in the undifferentiated flow of surface contours.

Here we shall focus on Winckelmann's theoretical analysis of beauty, and his attempts to negotiate in more general conceptual terms the paradoxes inherent in defining an ideally beautiful human figure from which all marks of subjective division and difference have been effaced. The relative impossibility of this project is registered in the very structuring of Winckelmann's presentation of his theory of beauty. Beauty as an ideal of art, he makes clear, is something that has to be defined by way of paradox and negation, by what it is not. It is much more difficult, indeed impossible, to give a clear general ideal of what beauty actually is. This would require 'knowledge of the essence (of beauty), to see into which we are in few things capable'.[17] His analysis thus begins by emphasizing common misconceptions regarding beauty, drawing attention to qualities commonly associated with it that are perversions of its essence or irrelevant to it. He examines the logic of these dominant misapprehensions of beauty in art, and then goes on to try and refute arguments against the existence of a single ideal of bodily beauty of the kind he wishes to define.

The structural difficulties of giving an adequate definition of beauty are elaborated by him in quite a densely argued passage:

> The wise, who have pondered the origins (or causes) of beauty, exploring its occurrence in the objects of creation, and seeking to reach the source of the highest beauty, have located it in the perfect harmony of a being with its purposes, and of its parts among one another, and with its entirety. But as this is synonymous with perfection, of which humanity is not capable of being the vessel, so our conception of beauty in general remains indefinite, and is built up by us through individual bits of knowledge, which, when they are correct, and collected and brought together, give us the highest idea of human beauty, which we can make the more elevated as we raise ourselves above the material world (*Materie*). What is more, as this perfection was given by the creator to all creatures in the degree appropriate to each, and because every concept derives from a cause that must be located outside this concept in something else, this means that the cause of beauty cannot be found outside itself, existing as it does in all created things. It is for this reason, and because the knowledge we have of things is comparative, and beauty cannot be compared with anything higher than itself, that there is difficulty in producing an explanation of beauty that is both general and clear.[18]

Two key points are made here. In any attempt to give a precise general definition to beauty, the concept necessarily remains indefinite. And second, beauty's distinctive status as an entity mediating between the physical and the ideal is what makes it so elusive. It is neither a purely metaphysical concept that can be defined on a priori grounds, nor can it be defined in purely empirical terms. Winckelmann, we see here, still holds to the traditional notion of ideal beauty as something partly idea-like or conceptual. He was not party to that new empiricist tendency in eighteenth-century aesthetics that sought to explain

ideals of beauty in psychological terms, or in terms of customary practice, or with reference to some empirically definable average or generic type of human form.[19]

The internal logic of Winckelmann's argument may be somewhat opaque to the modern reader, particularly as it derives, not from more familiar forms of Enlightenment thought so much as from the technical concerns and terminology of a more academic tradition of metaphysical speculation inherited from the seventeenth century, which Winckelmann would have encountered in the course of his university education in Prussia. Most notably, cause is not used in the modern sense as a term defined by experimental science. It is not what we could call the cause of something, but more its explanation. Cause relates to the phenomenon being explained on logical grounds, not in ways we would understand as leading from cause to effect. It could be seen as the basis or origin or essence of a phenomenon being explained, provided these terms are taken in a philosophical rather than a purely empirical sense.[20] Winckelmann is in effect saying that, because beauty resides to some degree in everything, there exists nothing within the empirical world distinct from beauty as we commonly perceive it that would help us to explain it. We can never isolate some essence of beauty that would help us to determine what was truly beautiful about the bodies or beings we see around us. Nor can beauty be apprehended in strictly logical or metaphysical terms, because it is of its essence that its attributes and effects are to be found in the sensuous world. It is made manifest to us empirically and thus cannot be deduced on a priori logical grounds, on the model of a geometric demonstration.[21]

The mythic oneness of body and idea, of nature and the ideal, that beauty supposedly embodies, and which makes it so elusive a concept, was absolutely central to the theory of ideal beauty inherited by Winckelmann. On this issue, the closest and also most influential precedent was Bellori's famous essay, 'The Idea of the Painter, Sculptor and Architect, Superior to Nature by Selection from Natural Beauties'.[22] Winckelmann's conceptually and ideologically more strenuous definition of beauty, however, is in one important sense radically different from Bellori's. Winckelmann, in seeking to negotiate the disjunction between the ideal and the sensuous that the conception of an ideal beauty somehow internalizes, recognizes that the force of such a mythic unity lies precisely in the difficulty, almost impossibility, of its realization. His whole analysis reverberates to the disturbances inherent in the attempt to fuse the abstract clarity and unity of an idea with a flesh and blood image of a body.

Bellori, on the other hand, adopts the more fetishistic strategy of defining the ideal precisely as the figure that succeeds in denying the structural difference between idea and body, and effortlessly mediates it. In Bellori, then, the ideal or ideal beauty is posited as being by definition a very un-Platonic fusion of idea and sensual reality in the perfectly formed human body. This perfect form is envisaged as being arrived at quite unproblematically in a process that is neither purely empirical nor purely mental. The best parts of bodies ob-

served in nature are selected and combined to produce a perfectly beautiful ideal whole.[23] As we shall see later, Winckelmann's analysis registers the essentially problematic nature of this enterprise. His projection of the ideal figure alternates almost schizophrenically between the image of an ideal oneness of bodily form and an obsessive focus on the perfect formation of individual bits and pieces. For present purposes, what is most important is that Winckelmann takes on board the Platonic disjunction between an idea and an empirical phenomenon, between the ideal and a sensuous body, in a way that Bellori does not. In doing so, Winckelmann makes the issue of an ideal beauty into a more urgent matter, registering the almost intractable power of the duality it straddles, at the same time seeking against the odds to reaffirm a mythic oneness.

If you were to take the art theory of the period literally, the ideal figure would have to be an abstraction from which all marks of particular identity were effaced. No actual image of a body could of course fulfil this imperative. The mark of difference on which it would most emphatically founder would be that of sex—the fig-leaf might hide but could not efface the suggested presence or absence of the phallus. The notion of a single ideal figure that would stand as the model for all imperfectly particular figures that occur in reality is also a sociocultural phantasm, however much a youthful nude might be an effective visual correlative to the mythic idea of a self unformed or unmarked by history and environment.

The unresolvable tensions between the notion of an ideal oneness of subjective being and bodily form, and the divergences of identity marked out on the body, involved Winckelmann in complex denials and involuntary recognitions of two main kinds of difference. In addressing these differences we now ritually label as those of race and class, he tackled the challenges they posed to the idea of a single immutable ideal of bodily beauty quite directly. At one level, then, he acknowledged that there were powerful factors at work producing radical divergences in people's conceptions of what a beautiful human figure should look like. At the same time he sought to argue that, in the final analysis, these divergences would not stand up to the higher claims of an absolute ideal.

In the case of sexual difference the negotiation was more indirect, and not explicitly acknowledged by him as a problem. That there were significant differences of sexual identity, not just the most evident ones of gender, but also of age—the man versus the boy, for example—marked out in visibly different formations of bodily type, was at one level recognized by Winckelmann. His account of the ideal nude includes a catalogue of different types devised by the ancient Greeks, arranged systematically according to gender and age.[24] But the tensions between this recognition of an irreducible multiplicity of bodily forms and the insistence on a single high ideal of bodily beauty was never explicitly addressed. The ideal of oneness that Winckelmann could only imagine by way of radical negation and sought to associate with the relatively ungendered and undifferentiated figure of the boyish male nude, or with an abstracted image of perfectly flowing contours, existed as a fetishistic denial of irreducible sexual

differences that he could not negotiate directly, but simultaneously had to avow and disavow. Sexual difference was the most visible fault line in the notion of the ideal nude, but also the one whose reverberations gave this erotically charged fantasy of oneness a large part of its resonance.

Signs of class difference were at one level bracketed out by the very conception of the ideal nude. It quite literally removed the particularities of costume through which distinctions of social status were normally marked. But Winckelmann felt it important to acknowledge that the image of the ideal nude, if it did not directly embody the characteristic identity of a particular class or social group, and indeed seemed to make such social distinctions irrelevant, did depend for its appeal and its symbolic value on the class-inflected attitudes brought to it by the spectator. One of the more insistent modern misconceptions of beauty, Winckelmann argued, was fostered by corrupt artists such as Bernini, whose work appealed through a 'plebeian flattering of the coarser senses. Bernini sought so to speak to ennoble forms through exaggeration, and his figures are like common people who have suddenly achieved good fortune.'[25] While the ideally beautiful figure is not itself the symbol of an enlightened middle class, the proper understanding of it is.

If the ideal figure is on the surface a socially and culturally empty image, its forms are supposed to be a denial of the coarsely sensual rhetoric that would appeal to the common people, that is, to the uneducated and labouring classes. It is in effect held up by Winckelmann as an enlightened standard against more marketable modern images of the body that reach out to a larger public through their immediately gratifying and obvious appeal. In the ideal nude, then, you have an image that seems to represent a common humanity lying beneath the clothing of social identity, but so conceived as to exclude those who lack the education and discrimination to appreciate the distinction between mere sensual appeal and a beauty informed by intellectual understanding.[26] In thus giving ideal beauty an explicitly anti-plebeian cast, Winckelmann is very much at one with attitudes deeply ingrained in Enlightenment culture, namely that the social distinction between the educated classes and the common people, between what we might somewhat anachronistically call the middle classes and the working classes, was immutably grounded in the nature of things, and that the latter by the very nature of their role in society were excluded from an active participation in and enjoyment of true culture.[27]

What prompted the most extensive discussion in Winckelmann's preliminary negative definition of beauty was not so much deviant or corrupt notions of beauty, in part, as we have seen, inflected by ideas of class difference. Rather it was a case made against the very idea that there existed a single ideal of bodily beauty based on the evidence of racial difference. Winckelmann's analysis here can be seen as an attempt to situate the Greek ideal of beauty as transcending the particularizing effects of environmental context. It was commonly believed that the different physical types associated with non-European races could be explained by environmental factors, or, to use a term current at the time,

climate.[28] Winckelmann himself embraced these theories, and subscribed to the notion that people's conceptions and ideals depended upon their empirical experience of the particular milieu they inhabited. There was much in Winckelmann's intellectual baggage that would make it logical to see ideals of physical beauty as culturally specific, dependent upon a society's immediate experience of its own ethnic type. Against this, however, he sought to argue that the white European Greek ideal possessed an abstract perfection of form that transcended the relativism of any actual norm of physical beauty.

Elsewhere in the *History*, when seeking a material historical explanation of the peculiar excellence of Greek art compared with that of other ancient peoples, he did appeal to the environmental determinism prevalent in the anthropological and sociological thought of the period. He argued that a prefect balance between hot and cold climates encouraged the formation of beautiful physiques, and provided a uniquely favourable material context for fostering the Greek feeling for beauty.[29] But where the prerogatives of an abstract ideal of beauty were at stake, he had to subordinate these material factors and define a beauty that was totally autonomous, existing in a state of resplendent oneness that evaded any determination by material context.

For Winckelmann, racial difference was visibly more problematic than class difference for the notion of a single norm of ideal beauty, partly for the very obvious reason that racial difference, unlike class difference, was at the time defined so much in terms of different bodily types. There was a growing body of anthropological and travel literature, to some of which Winckelmann himself made reference, which drew attention to the varying ideals of bodily beauty among different peoples.[30] In addition to relying on the Eurocentrism embedded in the culture of his time, Winckelmann also adopted a strategy for negotiating this potential challenge to a single norm of ideal beauty that relates closely to the logic at work in his whole definition of the Greek ideal. In the first instance, the Greek ideal was rescued as a universal paradigm by defining it negatively, as the relatively empty image of the human figure that emerged once the 'inadequate' particularities determined by custom and environment were expunged. It emerged as the negation of all particular ideals, with no definable characteristics of its own that might be seen as distinctive or different.

Accepted without question in Winckelmann's analysis is an assumption common to Enlightenment speculation on racial difference, namely that the Eurocentric white Greek ideal was closest to the original type of humanity, to the ideal human being as it emerged from the hands of God, while other racial types were deviations from this model.[31] Winckelmann, however, frames his argument in abstract aesthetic terms rather than in those of the more explicitly racist anthropological theories current at the time, namely that non-European racial types were literally produced by a degeneration from the original model of humanity. He attempts to argue that such features as the slanted eyes of the Chinese and Japanese, the relatively flatter noses of oriental peoples, the relatively larger lips of negroes, were inadequate because they were not in conform-

ity with the principles of unity and symmetry that should govern the shape of an ideal face.[32] At the same time, he does from time to time draw on fashionable theories of climatic determinism to explain certain supposed 'deformations' of facial features in non-European physical types. At times, particularly when he makes an appeal to the popular physiognomic theory that marked departures from an ideal norm represented a bestializing of the human form, there is more than an incipient racism, particularly in his discussion of black peoples: 'The pouting inflated mouth, which moors have in common with apes, is a superfluous growth and a swelling, produced by the heat of their climate, just as our lips swell up as a result of heat, or sharp salty moisture, or in some people as a result of anger.'[33]

If some of the imagery here recalls the clichés of the biological racism of the nineteenth century, it involves a different, less polemically insistent Eurocentrism. Thus for example, where Winckelmann argues that white skin will make a body appear more beautiful, because white reflects back more light rays and stimulates the senses more vividly, this superiority of whiteness is conceived as a matter of appearances, not of the essence of beauty. And there is more than that. He makes the point that in the end bodies of one colour appear less pleasing to the eye than another, not because of anything inherent in them, but because of the viewer's particular expectations and experience, in other words because of his or her prejudices:

> A Moor can be called beautiful when his facial features are beautifully formed, and a traveller assures us that daily contact with Moors takes away the untoward quality of the colour, and reveals the beauty that they have; just as the colour of a metal, or of black or green basalt, is not detrimental to the beauty of ancient heads.[34]

In his later additions to the *History*, the relativity inherent in preferences for a white skin over other colors is further underlined, even to the point of suggesting that there are good grounds for thinking that a dark skin is in some respects more pleasing than a light one. A white skin, Winckelmann suggests, echoing a common belief of the period, reflects back more light than a dark one because it is thicker and more dense. A brown skin is more transparent, thereby revealing the coloration of the blood, and is softer, and preferable to the sense of touch than a white skin.[35]

Winckelmann is able to countenance a certain relativity as regards colour because he makes a standard distinction between form as the essence of beauty, and colour as a contingent adjunct. But it is not all that simple. He also freely admits that at some level, 'the same holds for divergences in judgements over a beautiful person, as with divergences in preferences over white and brown beauty.'[36] At the level of an empirical analysis that starts from the evident diversities of human experience and value in different cultures, what we might call anthropology, there is in the end no clear-cut distinction to be made between different physical ideals based on form and those apparently more

obviously relative ones based on colour. All aspects of our perception of ideals
of physical beauty, Winckelmann finally concedes, are at some level fashioned
by habit and custom. That significant differences of opinion on ideals of beauty
are somehow endemic is evidenced by their persistence even within our own
culture:

> In these conceptions (of beauty), however, we ourselves are at variance, and
> perhaps more so even than we are in matters of taste and smell where we are
> lacking in clear conceptions, and a hundred people would not find it easy to
> agree over all aspects of the beauty of a face. The most beautiful man that I
> ever saw in Italy was not so in all eyes, including those who prided them-
> selves on being attentive to the beauty of our sex.[37]

It was far easier for Winckelmann to elaborate the significant divergences in
people's sense of what a beautiful figure might be, and to explain these diver-
gences, than to make a case for a basic consensus on the essentials of beauty.
The latter was not amenable to clear and full demonstration, and in the end he
could only assert, almost against the evidence he provided, that such a consen-
sus—a oneness of views on beauty that would echo the oneness of its meta-
physical and ethical essence—did at some level exist. Interestingly, when he
came around to such an assertion after a long excursus through a discussion of
misconceptions and divergences of opinion on the details of beautiful form
among different peoples, he did so in terms that imagined such a consensus as
existing beyond the confines of an explicit Eurocentrism: 'As to form in gen-
eral, the most numerous and the most civilized people of Europe, as well as
those of Asia and Africa, are in agreement; hence conceptions of it are not to be
understood as being adopted arbitrarily, though at the same time we cannot
give the basis for them all.'[38]

Anxiety over cultural and ethnic relativity was common in Enlightenment
thought, and was given a particular edge by the study of non-European cultures
that accompanied the new wave of European colonial expansion in Africa, Asia,
and the South Seas. The terms in which Winckelmann negotiated this anxiety
were more 'Enlightened', less explicitly racist, than equivalent apologias for the
primacy of the Greek ideal among those who took up his Graecomania in the
nineteenth century.[39] Not only did these assert in ways that Winckelmann
could not have conceived that the 'superiority' of the 'white' Greek ideal had a
basis in scientific fact, was a matter of a biologically determined superiority of
the white or Indo-European races. But they had no place for countenancing
the relative validity of non-European perspectives on beauty in the way
Winckelmann occasionally did. Winckelmann, of course, was living in a politi-
cal context where the issue of racial difference was not so immediately urgent
a matter as it was to become for later European intellectuals, for whom the
colonization of Africa and the Near East in particular made contact with non-
European peoples a much more immediately pressing reality. Winckelmann's
'Enlightened' attitudes were in part a factor of the confidence Western Europe-

ans of his time could feel that there was no very visible challenge within their own culture to European norms being seen as universal ideals.

As we have seen, Winckelmann's negotiation of racial difference involved a process of negation, whereby the ideal figure was projected as a largely empty cipher, one in whose abstract clarity of form bodily traces of a distinctive racial identity would be purged. In negotiating sexual difference he followed a similar logic, but it involved a more powerful negation registered at a more unconscious level. That the issue of sexual identity would be so heavily loaded is hardly surprising, not only because of the unavoidable visibility of sexual difference in images of the nude, but also because this imagery functioned so explicitly in the artistic culture of the time as a focus of erotic interest—it was designed to be desirable. The problematics of desire, as distinct from the problematics of inclusion and exclusion from the Greek ideal arising from racial and class differences, were particularly pervasive in Winckelmann's analysis of beauty, and were no doubt too intractable to be addressed directly in his preliminary discussion of misconceptions of ideal beauty. The issues involved here were complex and highly invested, for they had to do both with fantasies of abolishing or evading what is commonly understood as sexual difference—the effacement of any too insistent suggestions of the particularities of masculine or feminine identity—and also with imagining an ideal oneness of being that would abolish all hint of psychic tension, all disturbance to subjective self-sufficiency, produced in the projection of desire. It is where subjectivity and desire come together in this way that Winckelmann offers his most powerfully political projections of the ideal figure.

Before proceeding to examine how extreme an emptying of the ideal figure was required to disavow sexualized anxieties surrounding the body, we need to turn briefly to Winckelmann's own account of the negations inherent in the most perfectly realized beauty. In his so-called positive definition of ideal beauty, he was very insistent that imagining an ideally beautiful figure, from which all disturbing signs of particularity and difference were expunged, entailed a radical denial of anything we might understand as human desire. A figure that embodied the highest beauty should exist in a state of total absence of feeling, particularly any directed outside it that might disturb its state of blissful self-sufficiency—a state of 'absolutely self-sufficient narcissism' as Freud would describe it, a state of complete 'absence of stimulation and avoidance of objects', corresponding to sleep or the impossibly regressive 'blissful isolation of intra-uterine life', in which life itself was on the boundaries of being extinguished.[40]

Any actual human figure we might imagine, Winckelmann explained, would be animated by feelings, and so it would inevitably deviate from this ideal:

> Stillness is the state that is the most proper to beauty, as it is to the sea . . . The concept of a high beauty cannot be produced otherwise than in a still soul distracted from attending to anything in particular. In such

stillness the great poets formed for us the father of the gods . . . the majority of [their] images of the gods are undisturbed by feelings . . . Since, however, the highest indifference cannot be sustained when acting and doing, and divine figures can only be represented in human form, so the most sublime concept of beauty cannot always be striven for and maintained in these [images of the gods.][41]

Similarly in the following passage:

As . . . in human nature there is no middle point between pain and pleasure, even according to Epicurus, and the passions are the winds that drive our ship in the sea of life, and by means of which the poet sets sail and the artist elevates himself, so pure beauty alone cannot be the sole object of our consideration, but we must also place this beauty in a state of acting and feeling, that in art we understand by the word expression.[42]

The most ideally beautiful figure, according to Winckelmann, had quite literally to be divested of its humanity. The very highest beauty would be the image of a god in which 'those parts of the body that are required to nourish it' were entirely absent.[43] The absolute 'contentedness' of a divine state would be represented by a body divested of all physical channels of sustenance and feeling, and would have no veins or nerves.[44] The 'hands of the (Greek) artists brought forth figures that were purged of human need'. When Winckelmann explained how the human body might be remade in the image of an abstract perfect beauty, he conceived this as a process of burning out, of annihilating any recalcitrant flesh and blood signs of its humanity: 'This concept of beauty is like a spirit extracted out of matter by fire, which seeks to create a being conforming to the model of the original rational creature traced in the mind of the god (*Gottheit*).'[45] It is 'matter' purged so it takes on the 'unity' and 'indivisibility' of an abstract idea. It should be so emptied of sensual particularity that it is 'like the purest water taken from the source of a spring, that the less taste it has, the more healthy it is seen to be, because it is cleansed of all foreign elements'.[46] Taken to its extreme, the ideally beautiful human figure is a radical negation of any bodily substance, a crystal-clear nothing, formless and transparent.

It was only then in a totally inhuman figure, from which all signs of flesh and blood existence had been purged, that the oneness of an ideal state of being could be imagined. Yet the Greek ideal was supposed to be the most perfect realization of human subjectivity. The divine figures of the ancient Greeks were seen as exemplary precisely because in them the very highest ideals had taken on a fully sensuous bodily form. We have here a radical contradiction at the heart of the humanist ideology that made the Greek ideal the model of a perfectly integrated humanity, at one with itself and the world. The Enlightenment fantasy of a self-sufficient oneness of being that would be embodied in a single model of the human subject, transcending all material difference, could only, it seems, be fully realized in an image quite divested of its humanity.

THE BODY OF NARCISSUS

In his theoretical analysis of the characteristic forms of ideal beauty, Winckelmann for the most part kept any detailed exemplification deliberately vague. No well-known statues were singled out as perfect realizations of the very highest beauty. This beauty emerged as the imagined end-point of a process of abstraction from any actual human figure, in which all traces of particularized identity, of the disturbances of desire, would be removed. The abstract image of perfect oneness that he conjured up, which defied attachment to any particular image of an ideal nude, was complemented by a catalogue of the different types of ideal figure embodied in images of gods of different ages and genders in Greek sculpture. What mediated between these radically divergent presentations of the Greek ideal, one purely abstract and one more empirical, was the boyish male figure. This had to exist at both levels. It was the particular exemplification of an ideal masculine physique at a certain stage of life, but at the same time it also functioned as the purest imaginable realization of an absolute ideal beauty.

The boyish youth could fill this dual role because it seemed to present an image of manhood prior to its shaping by social or political circumstances, and before too insistent a formation of its sexual identity. It could intimate a subjectivity that was self-sufficient, free and unalienated, because it was as yet to a large extent unformed. It was youthful enough to be imagined in a state prior to the tensions that would result when it had to measure itself against patriarchal power and authority. It is not quite Freud's image of the pre-Oedipal child, but framed psychically and ideologically in a similar way. The image of the boy had a further logic in that it picked up Plato's erotic disquisitions that present the boy as the most worthy and intensely engaging object of (male) love.[47] Though ideologically quite different from Winckelmann's necessarily more problematized image, the distinctive charge of the Greek one also depended on intimating an ideal male subjectivity existing in a state of potential prior to its full formation, before the point where it would have to take on an active role as a man in the social order.

The focus on the image of the boyish youth also clearly connects with Winckelmann's own individual sexual preferences. These no doubt gave a particular impulse to the erotic charge he invested in this image in his writing, by making it both desirable and ideal in an unusually intense way. Moreover, within the cultural and artistic conventions of his time, it was as boy or youth that the male figure could most readily be seen as desirably beautiful, though obviously not in any too explicitly sexualized a way.[48] The force of Winckelmann's own investment in this image for the analysis he was offering lay in its shifting projection of the ideally beautiful figure as both object of desire and desirable being with which to identify. This dialectic, so central to the complexity and force of Winckelmann's investment in the ideal male nude, was one that a homoerotic reflexivity operating between image and spectator would have encouraged much more than a conventional heterosexual eroticism.

In Winckelmann's theoretical schema, the generically different formations of the ideal figure corresponding to sexual difference were secondary to those defined by different ideal types of manhood. His discussion of the female figure presented itself as an appendage to the more heavily invested catalogue of different conceptions of the ideal male nude, from the delicately sensuous youth (beloved?), to the austere and strong mature man (lover?), to the ambiguously feminized androgyne.[49] Even within such an exclusively masculine order of things, however, the image of the ideal could not be fixed in a stable configuration, with let us say a fully formed virile hero or god at the centre. A Zeus or a Hercules (Plate 23) could not function as the universal subject and object of desire that Winckelmann sought in his notion of the very highest ideal. The only image that came near to fulfilling this role was relatively marginal to conventional definitions of masculinity. With the boyish youth, ideal masculinity could be projected while effacing suggestions of any too categorically insistent a masculine identity.

This effacement of masculinity is given quite a literal edge by Winckelmann when he suggests that the imperatives of ideal beauty lead ineluctably to the image of the hermaphrodite or castrated figure[50]—in other words, either to a literal blurring of the particular forms of the male body or to its mutilation. Here we have, not just an attenuation of virility as imagined in the image of the boy, but the most radical destruction conceivable of bodily signs of manliness. The logic of such physical violence is made explicit by Winckelmann when he juxtaposes the differentiation of human types by age and gender with the notion of an all-encompassing single ideal figuration of the human body. After explaining that, on one hand, 'the youthful form of the gods of both sexes has its various stages and ages, in the representation of which art seeks to display all its beauties,' he then points to 'an ideal, partly taken from male beautiful bodies, partly from the natural forms of beautiful castrated youths, and elevated by a sublime superhuman build: for this reason Plato says that divine images are not given real proportions, but those that appear most beautiful to the imagination.'[51]

The perfect 'Platonic' ideal, in other words, has its imaginative and physical equivalent in a sexually ambivalent blurring of the male body with the castrated male body. This castration is not in any way a central, systematically defined feature of Winckelmann's theory of the Greek ideal, but marginal, the symptom of a rift in his system of ideal beauty that cannot be avoided but is not quite fully avowed either. Even without bringing to bear the theoretical panoply of Freud's fear of castration, we would have to admit that anxieties surrounding sexual difference played a not inconsiderable, if largely unconsciously articulated, role in Winckelmann's 'impossible' attempt to define the oneness of beauty through a single image of the ideal figure.

How, according to Winckelmann, is the viewer's subjectivity constituted on experiencing the figure of an ideal youth that is as close as imaginable to an absolute beauty? The figure may be seized upon by the viewer as a centred

image, but its palpable identity then dissolves as it becomes like an apparition in a dream or a disembodied fantasy of sexual ecstasy. The viewer's normal sense of self too is suspended in this encounter, for the divisions operating between subject and object in the 'real' world are effaced in the dream-like or mystic transport of oneness.

Winckelmann writes as follows of a relatively unknown figure that, according to him, gives an idea of 'the highest conception of ideal masculine youth':

> Here I should like to be able to describe a beauty, the likes of which would be difficult to imagine as being of human descent: it is a winged genius in the Villa Borghese (Plates 34, 35), whose size is that of a well-formed youth. If the imagination, filled with the individual beauties of nature, and absorbed in the contemplation of the beauty flowing from and leading to god, conceived in its sleep the vision of an angel, its countenance illuminated by divine light and its stature appearing to emanate from the source of the highest unity—in such a form should the reader envisage this beautiful effigy.[52]

At another point, Winckelmann projects the experience in which such an apparition would involve the spectator as comparable to the transport of mystic ecstasy. His account is infused with a powerful sensuality that recalls the erotic tropes of prayers and hymns by early eighteenth-century Germany Pietists, which he would have known:

> What human conception of divinity in sensuous form could be worthier and more enchanting to the imagination than the state of eternal youth and springtime of life, whose recollection even in our later years can gladden us? This corresponds to the idea of the immutability of divine being, and a beautiful youthful godly physique awakens tenderness and love that can transport the soul into a sweet dream of ecstasy, the state of bliss that is sought in all religions, whether correctly understood or not.[53]

This partly dematerialized experience of the absolute ideal is in an important sense structurally different from the experience Winckelmann conjures up in front of the more virile Belvedere Antinous (Plate 31). There the figure is conceived as a distinct entity, separate from the viewer, while here it is fused into the fabric of the viewer's fantasy world.

There is in Winckelmann's account of the Greek ideal another process of dissolution at work, also bound up with the imperative of ideal beauty to project a purified image of the body as a cipher of ideal oneness. It is a process that is more radically regressive than the one at work in the image of the ideal youth. When Winckelmann focuses on surface contours as the visual embodiment of a purified beauty no apprehension of any actual whole figure can quite sustain, he invites a mode of viewing in which the boundedness and centredness of the figure, the sense of it as a definable object, and of the viewing self as a coherent subject, are in effect dissolved. The image of the body as a centred totality

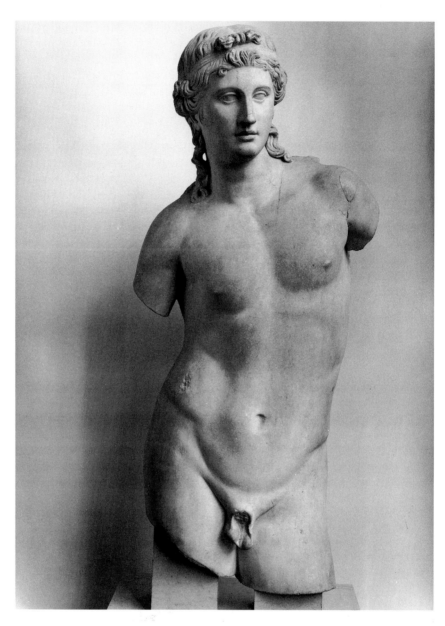

34. Borghese Genius or Cupid (after removal of restored arms and legs), marble, Paris, Louvre (previously Villa Borghese, Rome).

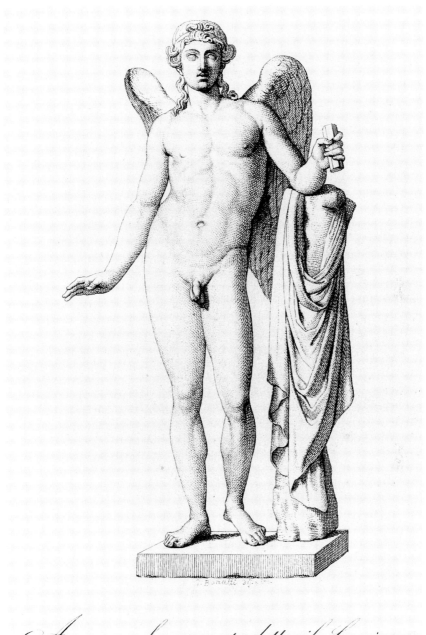

Amore volgarmente detto il Genio.

35. Etching of the Borghese Genius or Cupid from E. Q. Visconti, *Monumenti Scelti Borghesiani* (Milan, 1837).

disappears in the polymorphous experience of flowing contours and undulating surfaces.

The absolute unity, the oneness, of the ideal beauty demands, Winckelmann explains, lack of definition (*Unbezeichnung*) of form:

> From unity derives another characteristic of high beauty, its lack of defini-
> tion, that is, it cannot describe either forms or points, except those alone that
> constitute beauty; consequently, it is an image that is peculiar neither to this
> nor that particular person, nor expressive of any state of mind or movement
> of feeling, for this would mix alien traits with beauty and disturb its unity.[54]

The image of the ideal thus becomes identified with an abstract flow of contour and surface:

> The more unity there is in the connection between forms, and in the flowing
> of the one into the other, the greater is the beauty of the whole . . . A
> beautiful youthful figure is fashioned from forms like the uniform expanse of
> the sea, which from a distance appears flat and still, like a mirror, though it
> is also constantly in motion and rolls in waves.[55]

There is now nothing left but the disembodied perfection of pure line:

> The forms of a youthful body are described by lines that forever change their
> centre, and never trace a circular path, and as a result are both simpler and
> more varied than those of a circle, which, however large or small it is, has the
> same middle point, and encloses others within itself or is itself enclosed.[56]

In this mode of viewing, the differentiated and variegated forms of the body have melted away in a continuously flowing curve. The demand for absolute clarity and definition associated with the highest beauty is realized in a radically contradictory image, an abstract contour that is at one level the figure of geometric precision, but at another a floating, undulating line, dissolving any sense of shape in a free play of form.

If we pursue the psychoanalytic allegories of regressive narcissistic fantasy to their logical conclusion, we would say that we have moved here beyond the kind of narcissism that fixes on the self as an ideal object of love—the fantasy of the ideal ego which, we are told, marks the birth of the ego's sense of itself as a distinct entity. This is a more archaic, polymorphous, and objectless experience that seems to exist prior to any separation between the self and the world around it, in which there is no sense of things as bounded separate entities. It would be a state described by Freud as one where 'the separate instinctual components of sexuality work independently of one another to obtain pleasure and satisfaction in the subject's own body. This stage is known as auto-eroticism and it is succeeded by one in which an object is chosen.'[57]

The ideal contour is fetishistic in a multiple sense—a highly charged yet apparently empty point of condensation for a number of fantasies seeking to expunge anything that might disturb an ideal self's self-sufficiency and unity.

In suspending any definition of shape that might raise questions about the particularities of the body represented, the image of the smoothly undulating contour can function as a site for the simultaneous avowal and disavowal of host of potentially unmanageable anxieties that might be elicited by any 'real' body.

The image of the contour also functions to negotiate a potentially disruptive disjunction between whole and part that exists not just for Winckelmann, but for the whole tradition of speculation on ideal beauty that he inherited. The ideal contour is somehow supposed to fuse together the apprehension of the overall form of the body and that of its individual parts. But the tension between the two can never quite be abolished. In academic theory, you have on one hand a conception of the ideally beautiful figure as a single flawlessly integrated whole. But equally it is seen as a composite figure, an assemblage of individually observed beautiful parts.[58]

With Winckelmann this disjunction is unusually exposed. At one level he projects the image of the ideally beautiful figure as realized in a perfect oneness of outline that in effect obliterates the particular forms of individual parts of the body. On the other hand his obsession with defining the perfect shape of each part of the body produces a contrary dismembering logic. He sets out an elaborate catalogue, almost seven pages long, spelling out the perfect formation of each bit and piece of the perfectly beautiful figure, from the curve of the eyebrow, to the shaping of the navel, to the simple arching of a perfectly formed knee.[59] A sort of convergence is allowed here, only in so far as all these variegated bodily fragments end up looking rather the same as they bend to his insistent delectation of exquisitely modulated contours.

Contour as Winckelmann defines it exists as the cipher for an image of the body as a simple clear bounded totality, but it also represents a floating detail of one of its parts. In effect it seeks to unite two structurally incompatible apprehensions of bodily form, making it seem as if one can blur into the other in a single image. The particularities of the body are effaced in a distanced emblematic image of its overall outline, while the close focus on any one single part also ends up dissipating particularity in a melting play of surface contour. In isolating contour as a formal motif that can stand for the ideal shape of the whole figure or any one of its parts, Winckelmann echoes the logic of Hogarth's famous line of beauty,[60] though his is a more hallucinatory phasing in and out between different modes of apprehension.

The ease with which he can substitute the play of contour for the conception of the figure as a whole emerges in an interesting passage where he characterizes the different formations of the body in the Laocoön, the Belvedere Torso, and the Apollo Belvedere entirely in terms of the surface modulation of their muscles. The Laocoön (Plate 29) is condensed into an image of 'muscles . . . that lie like hills, flowing into one another', the Torso (Plate 36) of ones 'that are like the surge of waves on a calm sea, rising in a flowing relief, and moving in a gently changing swell', and the Apollo (Plate 21) of ones that are 'supple, and blown like molten glass in hardly visible undulations that are more

apparent to the feeling than to the sight'.[61] Seen in this quasi-connoisseurial mode, these complex figures are made into fetishized objects. They are in effect each reduced to an immaculately formed inanimate surface, which shows not the least hint of disjunction or tension, but at the same time might intimate a potentially disturbing suppressed charge, as in the image of the gently swelling sea conjured up by the Belvedere Torso.

Contour as conceived by Winckelmann is not simply inanimate and abstract, but also supple and elastic, suggestive both of the literally hard surfaces of the marble forms of a statue and of the living smoothness of a body. It is through contour that Winckelmann negotiates an interplay between the literally dead materiality of the actual sculpture and the ostensibly live flesh of the body it represents. On one hand contour represents pure stilled 'inhuman' form, drained of flesh and blood. On the other the flow of the contour is a way of imagining a hard marble surface approximating to the feel of softly undulating flesh, abolishing its recalcitrant hardness. Beautiful contour is radically split— simultaneously coldly abstract and vividly sensual, inanimate and living.

This split character of contour is echoed in the viewer's apprehension of it. The imperatives of abstract form—the unity and oneness of the ideal—would seem to objectify the ideal contour and make it impervious to the free play of subjective fantasy. But equally, a focus on contour has the effect of breaking down any hard particularity of shape, the imperceptible flow of one form into the other dissolving any edges or interruptions between different parts of the figure.[62] As such, contour becomes a means of overcoming the material resistance of sculpture to the dematerializing projections of the mind.[63] The suggested dissolution of fixed form in flowing contour fosters a 'narcissistic' fantasy in which the recalcitrant externality of the sculptural object melts away and seems to be modulated to the subtlest stirrings of the viewer's desire. Immersed in the experience of undulating line, the movements of subjective fantasy seem to fuse with the objective materialized forms of the sculptural figure, as in the myth of Pygmalion.

Winckelmann's contour, the central configuration in his visualizing of ideal beauty, is the point of convergence of a number of different fetishizations of the human figure as a beautiful form. Fetishization is meant here in a post-Freudian sense, referring to a process whereby an object is fixed in psychic fantasy as both the disavowal and recognition of a deeply disturbing threat to the integrity of the self. At issue is more the structure of fantasy involved than Freud's particular insistence that such a threat is essentially a fear of castration, and the fetish a more or less literal symbolization of the penis and its threatened absence.[64]

In imagining the ideal body as a free flow of exquisite, but potentially empty, contours, the fantasy image of an immaculate sensuality is forged, which effaces the potential perturbations of physical desire. But the image is at the same time charged by disturbance as Winckelmann exposes the constant expunging or annihilating of flesh and blood vitality that its 'inhuman' purity and simplicity

require. There the ideal figure is poised uneasily, not by Winckelmann himself, but by the ideological imperatives of Enlightenment culture, whose fantasies of ideal oneness played out around bodily beauty he both 'deconstructed' and reanimated with a new charge.

Nightmare and Utopia

If the perfectly formed, unblemished, boyish youth was for Winckelmann the figure that came closest to embodying ideal beauty, it did so by effacing certain qualities associated with heroic manhood which were central to the ideological loading of the Greek ideal. This tension was not explicitly addressed by Winckelmann, but it is registered by default in a disparity between the theoretical precedence he gives to the youthful figure as the purest and most desirable image of beauty, and the manly identity of the masterpieces of ancient sculpture he singles out as the most important existing exemplars of the Greek ideal. The pressures produced by this disparity are evident in his reading of the Belvedere Antinous discussed earlier on, where the youthful identity he initially projects into the figure is quite visibly at odds with the actual statue. Winckelmann himself registers this tension when he gives the figure an appropriately weighty resonance in the concluding passages of the description by suggesting that the sensuous forms of the self-absorbed youth somehow already intimate the powerful physique of a manly hero.

There is, then, an unacknowledged splitting[65] in the ideal subjectivity embodied by the Greek ideal as Winckelmann projects it. On one hand he gives us the image of a youthful narcissistic self, existing in a state of undisturbed self-absorption and sensual plenitude, in effect isolated from any confrontation with the external world. On the other he portrays an active manly self, heroic or divinely powerful, existing in violent confrontation with or domination over what surrounds it, engaging in actions that theoretically speaking can only disturb its beauty. The negativity implied in the ideal subject's relation to its material context—to be fully free, the sovereign subject must imagine itself either as totally self-sufficient or as having to assert itself against external threats and resistances—is one that echoes Winckelmann's understanding of the role of external circumstances in the history of Greek art.

Context in the *History* was often conceived more as a constraint than as a positive stimulus to the full realization of an ideally beautiful art. According to Winckelmann, the Greek ideal was able to emerge because the privileged material circumstances enjoyed by the ancient Greeks did not present the obstacles that stopped short the evolution of art among other ancient peoples. Greek climate, for instance was neither too hot nor too cold.[66] And while the political context of freedom was conceived by Winckelmann as a positive animating force, its role in this respect was very ambiguous. There was a tension within the freedom fostering Greek art that echoed the one in the ideal

subjectivity he saw as embodied by the Greek ideal. On one hand it was an 'active' manly freedom realized in the violent struggles of the early phases of Greek culture, prior to the emergence of beauty in all its plenitude. On the other it was a free sensual enjoyment of things, which reached its apogee at a later time, when the first benign moments of Macedonian rule allowed the Greeks a 'passive' child-like freedom from the disturbances of political struggle.[67]

Winckelmann's most complexly articulated splitting between sensual youth-fulness and heroic manliness occurs in his description of the Belvedere Torso, a statue that played a uniquely privileged role in his writing on antique art. It was the only description he published as an independent essay several years before incorporating it in the *History*. He also republished it later in a revised form in his treatise on allegory, where it featured as an exemplification of the allegorical reading of antique art.[68] Before considering in detail this description of the Torso, however, we shall return for a moment to the more obvious dramatization of a shift from the sensual to the heroic in his analysis of the Apollo Belvedere. Here, unusually, heroic domination is projected directly in the figure's action.

Framing Winckelmann's detailed description of the statue's forms are two very vivid images invoking the contrasting ideals of subjectivity that this 'high-est ideal of art' must encompass. Winckelmann begins by invoking the all-powerful manly god effortlessly dominating and laying waste all around him (Plates 19, 20): 'From the height of his contentedness his sublime glance goes out, as into eternity, far out beyond his victory.' Towards the end of the description, however, we have a very different image of a youthful beauty existing in a state of tranquil withdrawal, away from any conflict: 'His soft hair plays around this divine head like the tender and flowing tendrils of a vine enlivened by a gentle breeze; it seems to be anointed with the oil of the gods, and bound with lovely splendour over his crown by the graces.' In between, the narrative constantly shifts between these two ideals, between a sublime self and a beautiful self, to invoke the stylistic duality discussed in a previous chapter:

> disdain sits on his lips, and the displeasure, which he draws into himself, swells forth in his nostrils, and spreads up over the proud brow. But the tranquillity, which in a heavenly stillness hovers over him, remains undis-turbed, and his eye is full of sweetness, as if he were among the muses, who were seeking to embrace him.[69]

The god Apollo striding forth victorious after slaying the Pythian serpent stands as a kind of inverted mirror image of Winckelmann's ideal, tranquil, as yet unformed youth, even while its more beautiful forms constantly suggest a shifting back to the latter's sensuous narcissism. Here, as Winckelmann imag-ines the ideal figure moving out of a state of solipsistic self-absorption and engaging with the external world, it projects its ideal subjectivity in total, violent domination of the objects around it. We have seen how, in his other

36. Belvedere Torso, marble, Vatican Museum, Rome.

37. Belvedere Torso.

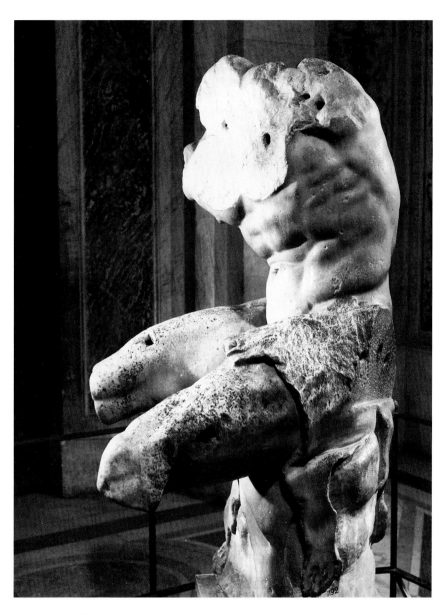

38. Belvedere Torso.

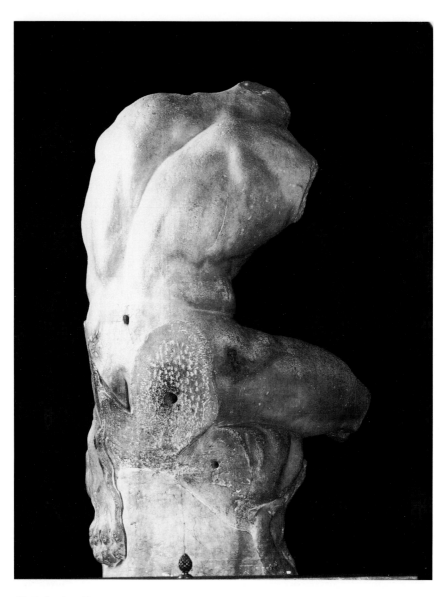

39. Belvedere Torso.

extended readings of figures engaged in dramatic action, the Laocoön and Niobe, a negative mirror image of this logic operates. In these cases, where a less than all-powerful figure engages with the external world, its integrity as a subject is similarly projected as being in violent conflict with outside forces, but the resulting struggle is one that ends in its total annihilation.

Winckelmann's description of the Belvedere Torso (Plates 36–39) is particularly illuminating in the present context because the shifting projections of the figure's subjectivity are not, as with the Apollo Belvedere, in any way suggested by a distinctive dramatic action. Rather they have to be seen as emerging in Winckelmann's reading from a pressure to conceive the finest antique nude as the embodiment of male subjectivity in all its fullness, actively heroic and passively contented. Winckelmann takes this symbolically empty fragment and gives it meaning by presenting it as a hero sunk in contemplation of its past deeds. Like the Belvedere Antinous, it is taken literally to be in a state of narcissistic withdrawal. But its physique is more evidently manly, and more insistently suggests breaking out from these confines to the actively empowered hero.

According to Winckelmann, the statue represents Hercules in the garden of the Hesperides who is enjoying a 'divine' tranquillity after his violent death and transfiguration:

> In this Hercules the artist has figured the high ideal of a body raised above nature, a nature of mature manly years, as it would appear when elevated to a state of divine contentment. He appears here as he became when he had purified himself by fire of the dross of humanity and attained immortality and a place among the gods. For he is represented as without need of human nourishment and further exercise of his strength . . . No blood vessels are visible, and the abdomen is made only to enjoy, not to take anything in, and is full, without being filled out.[70]

Winckelmann traces a violent history on the becalmed beautiful body. Not only are its ideal forms imagined as coming into being through the annihilation and burning of the mortal hero's flesh and blood. These same surfaces had earlier been inflamed by an excruciating pain when Hercules put on the poisoned robe, a pain that could only be stilled by his literally being burned alive. The figure's body is also seen as moulded by earlier violent deeds in which the hero annihilated a quarry or opponent. The beautifully flowing contours of the muscles, which at one level embody a state of 'divine contentment', are also modulated by acts of savage aggression. Thus the 'powerfully raised chest' evokes Hercules' crushing of the giant Geryon, and the strong thighs his pursuit and slaughtering of the iron-footed hind of Cyrenia. The apparent calm and stillness, which recall the blissful self-absorption of the ideal youth, are charged by intimations of the naked physical power of a hero laying waste all that came in his way.

The forms of a seamlessly perfect beauty suggest a fusion between two split conceptions of the ideal male figure. The more immediate suggestions of

undisturbed self-absorption alternate with projections of a state radically at odds with this, in which the figure confronts and destroys whatever resists it in the outside world. The juxtaposition of opposites has a certain fetishistic structure in which the obsessive charge of the fetishized object lies in its capacity both to deny and also to recollect or embody the fear or anxiety 'unconsciously' animating it. Such a structure of fantasy is most vividly visualized in Winckelmann's conception of the Apollo Belvedere. There the immaculately smoothed surfaces of the torso hover in the viewer's imagination beside the piercing arrow the god launches to slay the serpent.

In the conclusion to his description of the Torso, the fantasy of absolute oneness is finally realized by dissolving the formal integrity of the figure—and, by implication, of the viewing subject—in an experience of pure flowing contours. This mode of viewing is invited by the fragmentary state of the work: 'The artist will admire in the contours of this body the ever changing flowing of one form into the other, the floating forms that like waves rise and sink and are engulfed by one another.' Attention then finally comes to rest on the beautiful flesh-like surfaces of the thighs, now disassociated from the heroic deeds that Winckelmann conjured up, and from any too disconcerting suggestions of the figure's once irresistible physical power: 'The legs seem clothed by skin dissolved in oil, the muscles are plump but without superfluity, and such a balanced fleshiness is to be found in no other figure; yes, one could say that this Hercules comes closer to a higher period of art, than even the Apollo [Belvedere].'[71]

In its sheer physical beauty, a beauty that we might wish to admire and also identify with, the figure paradoxically appears to be closer to the very highest beauty of the lost models of Greek art from the classical period than even the Apollo. In the Apollo elevation and power are directly dramatized. In envisaging the Torso to be the fullest surviving embodiment of the Greek ideal, so it encompasses and yet at the same time suspends the violent disturbances of the sovereign subject in action, Winckelmann has to complicate its apparent calm. He has to endow its sensual plenitude with a certain ambivalence by imagining it as the transfigured after-image of a dead hero. The embodiment of an ideal masculinity is effected through the dissolution or destruction of living, acting manhood. The ideal forms of the figure are redolent of a utopian plenitude and calm, their free-flowing contours the physical correlative of a freely harmonious sense of self. Yet the calm of these same forms takes on another aspect as they conjure up a certain deathly stillness, and recall the outlines of a manly strength that has been drained away or suddenly annihilated in violent death.

The antinomies that emerge when Winckelmann imagines the Greek ideal to be the embodiment of an ideal subjectivity have such force because they register larger structural contradictions inherent in the more extreme fantasies of sovereign subjectivity that have haunted the 'bourgeois' imagination ever since his time.[72] We have here a model of ideal self-definition, a mythology of oneness and freedom we associate with European modernity, and 'born', if we

can use such a term, in the Enlightenment. The very real impediments to such a mythic self-projection are registered in the largely disavowed fascination with violent confrontation and self-dissolution that emerges within these fantasies of subjective integrity.[73] The simultaneous obsession with and deconstruction of the 'ideal' ego in modern psychoanalysis could be seen as a twentieth-century equivalent of such forms of psychic fantasy.

The utopian story of the sovereign subject promises a regeneration in which individual subjectivity would be realized as a beautiful and freely unconstrained self. This self is endowed with the harmonious unity and plenitude of a beautiful form from which all sense of internal conflict, or of conflict with other subjects and the material world, is abolished. This is the utopian image Winckelmann conjured up in his discussion of ancient Greek art, an image that had strong echoes in later, more insistently politicized projections of a revolutionary regeneration of self. The nightmare or horror story of a sovereign subject doomed to violent confrontation or solipsistic emptiness is, as it were, the unconscious of such a regenerative utopia. It is in registering the power of this unconscious that Winckelmann's writing differs from the more one-dimensional humanist celebrations of the Greek ideal by his contemporaries and followers.[74] Winckelmann's Greek ideal projects an ideally free sovereign subjectivity, but one surrounded by the violent reverberations of subjectivity's material unfreedom.

This is true, as we have seen, even of Winckelmann's conception of the unformed boyish youth, which was for him the purest embodiment of an autonomous unconstrained self. For the solipsism of this image, which produces an empty echo of the calm, plenitude, and freedom that should be the lot of the ideal subject, is a kind of death. The state of total narcissistic self-absorption may offer a promise of complete liberation from external constraints, but at the cost of liquidating any substantive identity. The latter nihilistic dimension of the fantasy can be seen to echo the death of Narcissus in the legend.

The structures of fantasy discussed here cast quite a spell on Enlightenment thought. Think, for example, of Rousseau's very explicitly politicized essay, the *Discourse on the Origins and Foundations of Inequality among Men*. Here the human subject's emergence from the 'narcissistic' contentment of a state of nature, where it enjoys a total but empty freedom, and its entry into civil society inevitably produce violent tension. Once the human subject ceases to be self-sufficient and starts actively projecting itself in relation to others around it, it is inevitably caught up in struggle and confrontation, and itself becomes divided and alienated. There seems to be no middle way between narcissistic solipsism, with its negative empty freedom, and a state of endemic conflict between the monadic self and the world around it. Diderot may have had a point when he compared Winckelmann's and Rousseau's fanaticism,[75] obsessively preoccupied as they both were with the more extreme fantasies and nightmares animating the Enlightenment ideal of an absolutely free sovereign subjectivity.

Freedom and Desire

A Free Subject

The disjunctions that occur in the utopian projections of freedom and desire in Winckelmann's account of ancient Greek art are of interest precisely because they have a larger logic that cannot be explained in terms of his own particular predicament. The logic is one inherent in the constitution of the Greek ideal in eighteenth-century culture, and also still echoed in conceptions of art current in our own day. Nevertheless, Winckelmann's project, the recovery of an ideal art that would embody an ideal culture, both politically free and freely sensual, was produced in particular circumstances and impelled by particular obsessions, without which it would never have seen the light of day. These obsessions can be inferred from a close reading of the *History* itself. There is a distinctive preoccupation with freedom, which involves both a political fantasy of liberation from the constraints imposed on individual subjectivity in modern society and a psychic fantasy of free enjoyment of the sensuality of the body. These fantasies and desires are accompanied by a powerful articulation of blockages and impediments that forever defer their realization, whether in his own society or historically, in the reconstituted fabric of ancient Greek culture. We might then wish to enquire what in Winckelmann's particular circumstances might have fed the dualities that emerge from his archaeological writing, the intense and at times extreme form in which libertarian fantasies are simultaneously projected and annulled.

If we only had stray bits of circumstantial evidence relating to Winckelmann's life, such speculation would pretty well have to stop here. What is important is not so much the reality of how or in what sense Winckelmann might have been free or frustrated in his desire for freedom, or the truth about what forms of desiring preoccupied him, and to what extent these remained unrealized or unrealizable in his own life. Leaving aside the problem that such matter-of-fact questions can never be answered in a clear-cut way on the basis of historical fact, they are for our present purposes pitched at the wrong level. We are concerned in the first instance with imaginative projections of identity and desire that necessarily have a complex and ambivalent relation to the material circumstances out of which they arise.

In Winckelmann's case we are fortunate to have an extensive surviving correspondence[1] that is itself consciously concerned with definitions of identity, and with the problematics of freedom and sexual desire as Winckelmann

saw these played out in his own life. While his writings on Greek art are concerned with the reconstitution of an ideal subjectivity, with the realization of and the contradictions within any imaginable, ideally free, desiring self, his letters in turn seek to fashion an ideal projection of his own identity as a free subject. It is not as if we have in the letters an explanation of the ideological and psychic formation of Winckelmann's account of the Greek ideal, but rather something that throws light on the particular inflection these had for Winckelmann and for readers within his immediate ambit. The politics of Winckelmann's project can be located in these historical particularities, as well as in larger structural problems concerning art and the antique ideal within eighteenth-century culture. His unusually vivid articulation of the latter was what made, and still makes his writing so compelling. But without the personal necessity, these broader concerns would never have been exposed and drama-tized with such sustained conviction.

Winckelmann's attempts at an ideal self-definition in his letters circulate around two distinct concerns. On one hand there is his public status as a professional man, the fashioning of a kind of freedom within the constraints defined by the networks of patronage on which he depended to sustain himself materially. At issue here was a sense of independence in relation to those who patronized him, which he constantly needed to assert because it was so precari-ous. The problems inherent in such attempts to represent himself as a free agent in the public arena were important for his particular understanding of political freedom. On the other hand there was his self-projection as the free subject of pleasure and desire, constantly haunted by fears of loss and denial. Here the ethics of friendship came into play, through which he defined his more emotionally charged relationships with men whom he could consider equals rather than patrons.

The projection of friendship in Winckelmann's letters is interesting above all when seen as a writing of the self and its desires, not just as a reflection of what was 'really' going on in his life. Necessarily addressed to or about someone who was absent, he was always projecting an imagined or remembered relation-ship, and a sense of himself in that relationship, which was literally being defined in writing it rather than through other forms of what we might wrongly be tempted to call more direct or concrete forms of social intercourse.

To what extent the notion of friendship as used in this context would have been seen at the time as a coded reference to what we would call homosexuality is a question that allows of no simple answer. At a very general level, the problem is that modern conceptions of sexual identity cannot simply be im-posed on an earlier culture where the idea of sexuality as we know it did not yet exist. Homosexuality in its modern usage is so overloaded by the notion that the reality of an erotically charged same-sex relationship is defined in terms of the sexual practices involved. In eighteenth-century Europe, practices we would associate with a gay subculture or gay identity could for the most part only be conceived in negative terms, if allowed any space at all in the language of the

time, because of the powerful, and also necessarily partly internalized, moral and legal prohibitions on what was then anathematized as sodomy. The question of what forms of sexual practice an individual engaged in could hardly be in the forefront of people's avowed conception of sexualized relations between men. But the absence of a publicly defined 'homosexuality' in Enlightenment culture did not entirely operate as repression. The very bracketing out of the idea of sex between men as almost unmentionable or inconceivable allowed a space for publicly acceptable declarations of male same-sex desire that was problematized when such desiring came to be defined through languages of inversion and perversion in the later nineteenth century. 'Friendship' in particular was a relatively 'safe' term, whose use in public discourse would usually be assumed to foreclose the issue of homosexual desire. As a result it could also serve as an acceptable covert vehicle for connoting and celebrating such desire.[2]

Particularly significant for our reading of the often very explicit homoeroticism in Winckelmann's account of Greek art is the prominence accorded to emotionally invested relationships with other men in the accounts he gave of himself in his letters to friends. A passionate and often very public commitment to male friendship was a quite explicitly stated ideal of his life. Few writers of the eighteenth century made such an eloquent case for what we now rather clumsily call a homosocial ideal,[3] to his patrons, to his friends, and even to his reading public. However much many of those male readers whom he addressed, who shared neither his sexual identity nor his lifestyle, responded to his vividly homoerotic projection of the Greek ideal and were able to fantasize their bisexuality, only someone with his own necessarily partly negated 'gay' sexual identity could have endowed this writing with the combination of passionate commitment, deep anxiety, and necessity, which made it so eloquent to his reading public. The particularities of his sexual identity were significant, as were those of his more public social persona, though neither can be seen as the simple cause or explanation of his unusual dramatization of the values and interests at play in the Greek ideal.

It is clear from even the most cursory inspection of Winckelmann's letters that his deliberately crafted self-projection has very little to do with the paradigms of self-cultivation conventionally associated with classical antiquity. There are few signs of measured Stoic self-denial or controlled Epicurean engagement with pleasure. Winckelmann's outburst in his early days as a schoolmaster in the town of Seehausen over the enforced separation between himself and a former pupil called Lamprecht, with whom he had been passionately in love, is one particularly vivid case in point: 'Perhaps this will make a wise man of me and put me in a state where I am impervious to feeling? May such wisdom be damned.'[4] Much later, a year before his death, he used a similar turn of phrase to describe his conduct when planning a trip to Germany, which he called 'one of my last follies [he was fifty at the time] . . . yet one often gets further with folly than with wisdom.' Far from seeing himself as the epitome of Stoic self-control, he described himself as 'an unrestrained man'.[5] When

Goethe celebrated Winckelmann as the very reincarnation of an antique persona, at the same time he emphasized what he saw as Winckelmann's 'inner unrest and discontent',[6] his apparent failure to achieve a stable projection of self, a measured sense of the good life.

In the account Winckelmann gave of himself, there seemed to be no possibility of mediation between an actively projected 'free' self and a negated solipsistic self that sought to preserve a measure of autonomy by circumscribing or denying its desire for anything beyond its immediate control. An empowered utopian self seemed as it were split off from its equally eloquently projected dystopian other. There is some muting of this restless alternation in Winckelmann's later letters, written in the wake of his immense bout of professional creativity in the later 1750s and early 1760s. But this was only achieved by abandoning the more expansive ambitions to which he gave voice during the most creative phase of his career. The relative serenity of this 'late' self is not some perfect mean, but rather defined by the abandonment of the aspirations for an empowered freedom he had expressed earlier, after he left the service of Count Bünau and embarked on a new career in Rome.

An insistent motif in his letters that relates directly to his concerns in the *History* is the idea of freedom—freedom not just as escape from subjection or servitude (*Knechtschaft*), but freedom as an expansive promise, forever being opened up and frustrated. The disparity between the aspiration to autonomy and freedom and the constraints of material circumstances was in Winckelmann's case quite acute. In Rome he moved socially among the great and the good. But the positions that came within his reach were never such as to give him the material independence he sought, that of having the economic means to operate as a free agent, without being tied to a patron, and able to consider himself in social terms securely the equal of those whose friendship he cultivated. Some measure of equality with his patrons could only exist as a momentary illusion in social intercourse with men who had every reason to assume themselves the social superior of a penniless antiquarian scholar whom they knew must always remain their client.[7] Nor was it possible for Winckelmann, in Rome or in Dresden, to see himself as belonging to a community of men of letters or learning that existed in some measure independently of aristocratic or court culture, as was beginning to happen in Paris and London at the time. Least of all was there nascent a political community to which he might feel he belonged that could openly attack the values of court society, and whose members might be able to imagine themselves as potential heroes in a struggle for political freedom. Such fantasies he could enjoy only vicariously, if at all, by projecting them onto figures living in very different circumstances from himself whom he met in Rome, such as the British radical John Wilkes.

The blockages to a desired self-realization were just as acute at the more personal level, in Winckelmann's attempts to imagine himself as the free subject of ideal friendship. Such blockages had their public sociopolitical dimension. The most intensely dramatized relationships played out in his letters were

with younger men who, in strong contrast to Winckelmann, came from upper-class or upper middle-class backgrounds. The desired partner, who as the addressee or subject of Winckelmann's letter-writing was always quite literally absent, was also socially out of reach. Consciousness of class barriers played a significant role in Winckelmann's alternations between an apparently confident self-projection as a 'freely' desiring subject, and a retreat into masochistic self-denial when the almost inevitable rebuff or coolness gave the lie to these fantasies.

A good place to approach Winckelmann's mythologizing of self is the unusual letter he addressed to a patron, Count von Bünau, in September 1754, explaining his reasons for leaving the count's service.[8] He had to negotiate a touchy situation, not so much because he was abandoning the scholarly projects on which he had been engaged in his capacity as private librarian to the count, but because the circumstances of his going to Rome posed an affront to the count's religious convictions. Bünau was a Protestant, and Winckelmann had formally converted, quite cynically, to Catholicism, to open the way for the patronage he would require if he was to support himself in Rome. Goethe, keenly conscious of the apparent lapses of dignity in this strangely self-abasing but also arrogantly confessional and self-justificatory letter, called it a real *Galimathias*, a 'wretchedly confused composition'.[9] It is indeed incoherent to the point of being almost totally incomprehensible on first reading.

Most of the letter is taken up, not with an explanation of the practical reasons for his new departure, but with an ecstatic and at times almost incomprehensibly fragmented hymn to friendship. He presents himself as taking the risky step, of which he knew Bünau would disapprove, because of a deep commitment to this ideal. In his celebration of this 'greatest of all human virtues', there is nevertheless a material politics at play that gives Winckelmann's effusive outpouring a certain hard-edged consistency. On one hand he claims he is seeking a new situation where he will have the financial means to ensure he will never have to be dependent on friends. The ideal of friendship then is bound up with the search for a material position that would enable him to conduct his relations with chosen friends on a basis of equality.

On the other hand, his discourse on friendship involves a deeply fraught and contradictory definition of his relationship to Bünau. At moments he debases himself, begging forgiveness:

> I fall humbly at Your Excellency's feet. I do not presume to present myself to You in person: only I hope nevertheless that your heart, full as it is of a human love that graciously overlooks my many faults, will in the end at least judge me humanely.[10]

The letter ends with a standard formula that underlines the huge formal gap in social status involved: 'Your Excellency's most humble servant (*Knecht*)'. At the same time, Winckelmann deployed his 'philosophy' of friendship to throw out a challenge to the assumed superiority of this noble grandee:

Such happiness is unknown to the great of this world, because it is not to be had other than by renouncing all self-interest and extraneous intentions [*durch Verläugnung alles Eigennutzes und aller fremden Absichten*]. It requires a philosophy of life that does not shy away from poverty and misery, yes even from death itself . . . I account my life as nothing without friend[ship], which for me is a treasure that cannot be bought dearly enough. The change in my life is guided by this great principle.[11]

Winckelmann gave as the rationale for his conduct an ethical ideal from which someone in the position of this wealthy, learned aristocrat was necessarily excluded. Furthermore, in a scarcely veiled reference to Bünau's history of the German Reich on which Winckelmann had been employed, he claimed that it was 'an almost punishable vanity to busy (one's reason) into one's old age almost entirely with things that only activate the memory', instead of putting it to nobler uses.

In this rather disjointed discourse, which often reads more like an exercise in self-justification from a diary than a formal address to a patron, there emerge certain unresolvable anxieties and tensions that recur in later letters. There is an anxiety about social status or 'freedom' growing out of the clash between the social formalities and realities of mid-eighteenth-century court culture, and the status as a free rational agent that an Enlightenment man of letters or a scholar such as Winckelmann might wish to accord himself. Also evident an anxiety about the definition of self in a more private mode as the subject of 'friendship', the desiring self as distinct from the ambitious, actively striving self. The realization of 'political' freedom, the struggle to become a free subject in the public sphere, is often quite explicitly conceived by Winckelmann as bound up with, as being the precondition for, the free enjoyment of 'friendship'. He stressed this point in a letter to a Swiss friend when he characterized Switzerland as a place where 'freedom elevates the spirit and prepares the more capable souls for friendship.'[12]

The promise of such an ideal conjunction was a recurrent motif in Winckelmann's earlier letters, when it still seemed realistic to imagine the prospect of self-realization in both the public and private senses, which would take him beyond the constraints imposed by his immediate circumstances. Thus, after the successful publication of his first work, *On the Imitation of the Greeks*, and just before departing for Rome in 1755, he asserted to the same friend to whom he had once intended to confide his despair over the separation from Lamprecht quoted earlier that 'friendship and freedom have always been the great purpose [*der grosse En[d]zweck*] that has determined [my conduct] in all things.'[13]

Later on, the fantasy of fusing a free enjoyment of friendship with a more politicized striving for social status as a 'free' man in the public sphere came increasingly to appear untenable. Friendship on its own would be designated as the 'greatest human good', existing in a sphere apart from the oppressive

structures of public life, almost as compensation for the sense of social inferiority to which he felt subjected in his interchanges with noble German visitors to Rome. Thus in a letter he sent from Rome in 1766, where he returned to the issues of social rank and friendship he had raised in his letter to Bünau over ten years before:

> though not very conspicuous, [friendship] is one of those counterweights that God has placed in the scales against high rank. He has reserved this great pleasure for the wise not born to high rank; for friendship is only possible between men of the same standing (*Menschen von gleichen Stande*).[14]

The enjoyment of friendship was in the end only imaginable for Winckelmann through renouncing the constantly blocked ambitions to claim for himself the promise of a fully realized freedom that had animated his conception of the Greek ideal, as well as his more intensely invested self-projections, earlier in his career.

POLITICS, PATRONAGE, AND IDENTITY

Winckelmann left Count von Bünau's service as librarian in the autumn of 1754 at the age of thirty-six, first temporarily to live in Dresden, and then the following year to go to Rome. This put him in a position that was simultaneously uncertain and promising. He no longer had the material security he had before, but equally he was released from the regular services he had to perform in his relatively lowly job as librarian and secretary to the Count. The stipend he received from the Saxon court during his first few years in Rome was too small to engage him in any onerous obligations,[15] but also too small and eventually too intermittent to support him, though it was just enough to alleviate the immediate need for a regular paying position. Negotiating a relative independence amid financial insecurity emerges as a pressing concern in the letters he wrote back to his German friends. Thus, when discussing a position he took up in 1757 as librarian to Cardinal Archinto, the former papal nuncio to the Saxon court who had negotiated his conversion to Catholicism, he was at pains to stress that, though it brought the privilege of residence in the Cancelleria, it involved no regular official duties and no stipend. He also claimed that he had been careful not to finalize the arrangement until he could do so from a position of financial independence, once the next instalment of his stipend from Dresden had been secured.[16]

Anxiety over appearing to be an independent agent emerges in Winckelmann's uncertainty as to whether to represent himself as having been a pensioner of the Dresden court,[17] and in his insistently repeated claims to friends in Germany that he was free of obligation in relation to his two main patrons in Rome, Cardinal Archinto and Cardinal Albani. It is very vividly represented in the deep unease he expressed over being seen to have had to

supplement his income by accepting lowly paid employment from the painter, Anton Raphael Mengs, one of his most important professional contacts during his very early years in Rome, and also for a time a close friend. The following passage comes in a letter addressed in 1757 by Mengs to a former pupil, partly dictated to and written out by Winckelmann:

> you have committed quite a gross error in saying to Mr Guibal [another ex-pupil of Mengs] that it was . . . Mr Winckelmann who was now doing the job that you did earlier writing for me and acting as my secretary. What a humiliation it would be for a scholar like him were this to be made public . . . Say rather that Mr Winckelmann is nourishing my mind with literature.[18]

Rome was, in Winckelmann's own mythologizing of his history, the place where he had first discovered and enjoyed freedom. As he put it rather grandiosely to a close friend, Berendis, in 1757: 'as freedom in other states and republics is only a shadow of that in Rome, which probably seems a paradox to you, so quite a different way of thinking exists [here].'[19] A lot hangs on this paradox, though it was not as large a one for someone in Winckelmann's position as we might at first imagine. If the Papal States were politically about as far from being a free republic as one could imagine, Winckelmann's own particular position gave him a different perspective on the matter. As an outsider with access to those in the upper reaches of the papal court—including Cardinal Passionei, a man of enlightened views and a friend of Voltaire's—he enjoyed a freedom and independence he had not had before, which liberated him from the protocols of subordination to which someone of his lowly class origins was subject in Germany. In his former position he had been a kind of servant to Count Bünau.[20]

Still there was an element of his protesting too much in this insistence on the new 'freedom' he enjoyed in Rome. As time went on he was increasingly haunted by uncertainties over the relatively lowly status of the salaried positions available to him there, and the possibility that comparable positions at a German court or university might afford him higher status and more room for manoeuvre. Winckelmann's mention of 'paradox' in relation to the 'freedom' that existed in Rome shows that he was aware that, from the perspective of his North German Protestant friends, Rome would appear a centre of reaction and superstition, rather than the place he painted where a scholar such as himself enjoyed free and easy commerce with art-loving visitors and erudite free-thinking cardinals. The conservative aspect of Roman society was to become a source of considerable concern to him towards the end of his career, during the later years of the reign of the increasingly reactionary Pope Clement XIII, who succeeded in 1758.

Winckelmann's most deliberately crafted attempts to project as 'free' the relations he enjoyed with regard to his social superiors in Rome occur in the accounts he gave of Cardinal Albani. Entering into the latter's service in 1758

was a major departure from the position of independence he had sought to sustain since his arrival in Rome. The change was partly necessitated by the suspension of his pension from the Dresden court, which resulted from the invasion of Saxony during the Seven Years War. He effectively became librarian, to some extent secretary, and also companion to the cardinal. Though any pension he received was very modest,[21] and not sufficient to relieve him from the need to seek other sources of income, his new position did bind him into a system of patronage and obligation from which previously he had managed to keep himself comparatively free. As Winckelmann himself put it, 'Until then I lived outside the bonds of society (*Verhältnisse*).'[22]

One of his most fully articulated attempts to give a positive cast to his position of client in relation to Albani comes in a letter written in 1762 to an old German friend with whom he had just re-established contact. It is worth quoting at length because it shows how Winckelmann's sense of his present status in Rome was so bound up with recollections of what he felt to have been his earlier position of abject servitude in Germany. We see how memories of the identity he had thrust on him, or was denied, in Germany haunt his attempts at a positive self-definition in the ambiguous circumstances of his present situation in Rome:

> I have now been living for eight years; this being the time I have spent in Rome and in other Italian cities. Here I have tried to recall my youth, that I lost partly through wildness and partly through work and misery, and I shall at least die happier. For I have achieved everything I wished for, indeed more than I could imagine, hope, or deserve. I live with the greatest cardinal and grandson of Clement X, not as a servant, but so my master can say that I am a member of his household [*nicht zu dienen, sondern damit mein Herr sagen kann, dass ich ihm angehöre*]. I am his librarian. But his great and magnificent library is entirely at my disposal. I enjoy it on my own account and am spared all work: I do nothing there but make use of it as I wish. No friendship could be truer than my relationship with him, which not even envy, but death alone could sever. I reveal to him the innermost recesses of my heart, and I enjoy this same [confidence] from him. I thus count myself among the luckiest men in the world who are totally content and have nothing else to ask. Find another person who can say this with all his heart.[23]

That relations with Albani were not entirely as equal as he might like to imagine emerges in the verbal contortions of his claim that his position was one where he was not serving the cardinal, but one where Albani could say of him that 'he is attached to me (*dass ich ihm angehöre*).' His day-to-day social traffic with Albani was obviously much more equal than anything he had enjoyed earlier with Count von Bünau, to whom he had been a mere underling. But social protocol still set very visible limits to this apparent equality. On one

occasion, when boasting of the intimacy he enjoyed with Albani, he was still obliged to represent this in highly ambiguous terms: 'He would willingly share a table with me, but this cannot be arranged conveniently because he eats with the prince and two Albani princesses.'[24] Later Winckelmann does seem to have enjoyed this privilege, but it was still something that could not be taken for granted.[25] The special relation with Albani was also purchased at a cost, for if it gave Winckelmann comparative freedom and the security of board and lodging, as well as the privilege of staying at Albani's country residence, it did not give him an adequate income, and he was always having to worry about securing himself financially.

Winckelmann had hoped that his illustrated catalogue of sculpture, *Unpublished Antique Monuments*, would generate sufficient income to make him financially independent, but the costs of production and distribution proved too large. Earnings from his writings were never enough to guarantee him an adequate income.[26] His financial insecurity was compounded at several levels by his efforts to maintain his independence. Thus as a writer, he prided himself on being someone who had made a decision to work entirely on his own initiative, and not undertake written work on commission. Comparing his position to that of Italian scholar contemporaries of his, he once wrote: 'I work as the spirit takes me, and I would not do half as much were I contracted to do it or employed by someone else.'[27] Even though a large portion of *Unpublished Antique Monuments* was a catalogue of the highlights of the Albani collection, Winckelmann was at pains to present the publication as a select catalogue of previously unpublished Roman monuments that he himself considered important. He also indicated clearly on the title-page that the book had been published 'at the author's expense', not on commission from Albani, even if he underlined his debt to Albani in the dedication and was obliged by social protocol to name himself as Albani's 'servant and client'.

Winckelmann's relatively meagre earnings from his writings,[28] and the care he took to avoid official benefices that would demand too much time, meant that, despite the grandness of his surroundings at the Villa Albani, he was in no position materially to live anything resembling the life of a gentleman. As he commented to a Swiss friend about how hard he was having to work seeing through the last stages of the publication of the *Unedited Antique Monuments*, 'I am my own maid, servant, clerk and messenger.'[29] The architect Erdmannsdorf, who met Winckelmann on a visit to Rome in 1766, remarked on how small his income was: 'He had no one to serve him.'[30] How precarious he could feel his position to be, despite frequent protestations that he had everything he really needed, emerges in a letter he wrote to Mengs in 1765 about the difficult situation he would be in should Albani die: 'All the philosophy in the world is no proof in our century against poverty. I should not be able to fend it off were I to lose the cardinal (Albani) and remain with 200 scudi on my own in Rome.'[31]

Winckelmann's letters often dwell on hesitations and anxieties over negotia-

tions to find a suitable permanent benefice or post in Rome that would guarantee him a stable income without infringing excessively on his 'freedom'. The problem was exacerbated by his irregular position as someone with strong anti-Catholic convictions working within the system of ecclesiastical patronage at the papal court. What particularly exercised him was the prospect of being forced for financial reasons to accept a benefice that brought with it religious duties. When in 1758, delay and the possibility of the permanent suspension of his pension from the Saxon court made his financial position look precarious, and his new patron Cardinal Albani offered him a canonry, Winckelmann wrote: 'I am wedded to poverty, mother of liberty, and I hope that this matrimony will last without giving grounds for displeasure.'[32] Later he dramatized his turning down this post as something done 'in order to affirm the noble freedom that I have been pursuing tirelessly'.[33] His conversion to Catholicism had been entirely pragmatic, and he was apprehensive about the prospect of being forced to play the charade of saying Mass. He seemed particularly worried by the impression this would make on his Protestant friends and acquaintances. As he put it to Francke, an erstwhile colleague in Bünau's library, 'I rejected the canonry because I could not accept the tonsure. I was born free and intend to die so.'[34]

His sensitivity over appearing to be a Catholic is evident in the way he insisted to Protestant acquaintances and dignitaries that his being called 'Abbate (Abbé)' was purely titular, and did not involve his performing religious duties. He made it clear that he did not want them to use this term of address in their letters to him. He also sought to provide evidence that he was in no way a devout Catholic, talking, for example, of how he would secretly sing Lutheran hymns in the morning.[35] This was hardly an expression of Protestant religious conviction, but rather an assertion of his independent identity in Catholic Rome. Religious matters did not seem to interest him, and what he did say on the subject was pretty negative about any institutionalized religion, as when he referred disparagingly to the 'theological trivia . . . that, thanks be to God, I have renounced entirely, short of the true faith'.[36]

The ambiguous status of patronage from the papal court was something that preoccupied Winckelmann throughout his later years in Rome. When he published the original edition of the *History* in 1764, he described himself as 'President der Alterthümer zu Rom, und Scrittore des Vaticanischen Bibliotheks (President of the Antiquities of Rome and Scriptor of the Vatican Library)'. Later, in the *Unpublished Antique Monuments* of 1767, his titular status at the papal court had been contracted to 'Prefetto delle Antichita' di Roma (Prefect of the Antiquities of Rome)'.[37] The apparently only minor change from one appellation to the other, relinquishing the title of 'Scrittore' at the Vatican library, erupted as a veritable drama of professional status in his letters. Both the positions flagged in the 1764 *History* were papal benefices that Winckelmann had been granted in 1763, just prior to the book appearing. On 16 April 1763 he was made 'Commissionario delle Antichita' della Camera

Apostolica (Commissioner of the Antiquities of the Apostolic Chamber)' by Clement XIII, and then on 2 May 1763 'Scriptor linguae Teutonicae (Scriptor of Teutonic languages)'. Being commissioner of antiquities provided him with only a modest pension, but the work did not involve him in any menial tasks that might threaten his status in the eyes of those visiting Rome, and was on his own account not particularly onerous. Addressing a Danish sculptor friend of his with whom he had lodged in his early days in Rome, he described the post, in one of his more upbeat and enthusiastic moments, as 'agreeable and conven-ient', a secure position that he could have as long as he desired, which left him 'freer and happier than a king'.[38]

But the position as 'Scrittore' in Teutonic languages was another matter. Very soon after his appointment was finalized, he was writing: 'I sometimes feel ashamed when friends pass through who recognize me. But what can I do? I have no other means here to earn my meagre daily bread.'[39] Less than four years after taking up the appointment, he was finding it so irksome that he gave it up: 'May God however always remind me of the freedom that I enjoy here, and now more than ever before, particularly as I have resigned without fuss from the Vatican library.'[40] What Winckelmann had hoped for was the much more desirable post of Keeper (Custode) of the library, 'that brings in 400 scudi without requiring the least work',[41] and would not oblige him to be in attend-ance for visitors as he had to be in his more menial job as 'Scrittore'. He had hoped for the Keepership as a means to provide him with security of income into his old age. But though the post was partly in Cardinal Albani's gift, it never came to Winckelmann, because the incumbent outlived him.[42] Albani apparently tried to create a second keepership for Winckelmann 'that would not oblige him to go to the library', but this did not work out. The alternative offered was considerably less lucrative and would have required him to be in attendance at the library, and on these grounds he turned it down.[43] The situation was such that when in 1765 a close German friend suggested that the publication of *Unpublished Antique Monuments* would gain him 'a permanent position', Winckelmann could reply 'here in Rome there is nothing more for me to hope for.'[44]

Part of his unease over his professional status in Rome had to do with worries over how it would compare with the kind of position to which he might aspire in Germany as a professor at a university or a chief librarian. This emerges in his letters to Christian Gottlob Heyne, a classical scholar who had followed a parallel career to Winckelmann's. He had been a librarian in another of the large Dresden libraries when Winckelmann was working for Count Bünau, and then moved on to become a professor at Göttingen University. When Winckelmann entered into correspondence with Heyne after being in-vited to become an associate of the Göttingen Academy of Sciences in 1764, he was rather too eager to insist on the high status and complete independence he enjoyed in Albani's service: 'as I have not submitted to the least obligation . . . so I live according to my own wishes.' When he made a great

show of being so well off that he could not imagine now being a mere professor in a provincial place like Göttingen, the stridency with which he did so betrayed a certain unease about assuming a position of superiority in relation to Heyne:

> It seems to me that one would grow old leading this way of life, and before one's time, whether one wanted it or not. [Such circumstances] would be even harder for someone who, over a long period, had enjoyed a good climate and beautiful country where all of nature smiles.[45]

But the status of the job as 'Scrittore' open to him in Rome when seen in relation to that of a German professorship was still for Winckelmann a source of concern. Even as he was describing how he had turned down the post of 'Scrittore' of Greek languages at the Vatican, offered to him as compensation for the custodianship that never materialized, he felt he needed to insist that the person who at present occupied the post be called 'Professor (or as one says here), Scrittore'.[46]

His concern over outsiders' views of the status of the post of 'Scrittore' of Greek languages he was offered in the Vatican library emerges particularly clearly in a letter to the French architect Clérisseau. He recalled his reasons for turning down this job in the wake of his unsuccessful negotiations for a post at the Prussian court as librarian and keeper of the king's cabinet of antiquities. Though it was 'one of the highest positions at the Vatican library', he had not accepted it, 'feeling that after having refused a post as first librarian to a king with the title of Privy Counsellor (*conseiller privé*), it would not be appropriate for me to be Scrittore in the [Vatican] library'.[47] The lengths to which he went in negotiating a position in Prussia in 1765, which according to him foundered because the income he was initially promised failed to materialize in the final offer, is itself an indication that his institutional position in Rome was far from being entirely satisfactory.[48]

At the same time, he was uncertain as to how to weigh the prospects of a better paid and higher position in Germany against the relative independence he knew he enjoyed in Rome. As he put it to his close friend Stosch just before leaving for Germany in 1768, he would probably find it hard to be tempted by any position he might be offered in Berlin: 'I am happier to make my own bed here than if I were to be called Privy Counsellor (*Geheimes Rath*), and have a couple of servants standing behind me.'[49] Acquiring a position that would assure him a good income as well as tangible status in the eyes of those who counted in the world of learning was going to be at odds with his desire to minimize the bonds of patronage and be able to continue to operate as a relatively free agent. To become a man of standing with secure economic means and remain free in the fullest active sense of the word was proving increasingly impossible.

In trying to project himself as a free subject, Winckelmann was involved in deeply contradictory perceptions of what it meant for someone in his position

to be working in the social ambience of a court. Court culture provided the one public arena in which someone from his background could gain recognition and status. But it also quite explicitly denied him any formal political equality with his patrons. His letters make frequent play upon the servility, the denial of freedom, endemic to German court life. To his friend Stosch, after the latter had recently taken up an official position in the Prussian court, he disparaged the 'crawling' attitude and lack of independence of mind of those who worked at German courts, and denied that he had sought to impress Frederick the Great when he sent him a presentation copy of *Unpublished Antique Monuments*, 'for I have no need of the grace and favour of princes'. And then he added: 'Yet you are now a courtier (*Höfling*), and this is no sustenance for you, my dearest friend.'[50] Prussia, the place of his birth and his early professional life teaching at a school—the 'despotic land of slavery' that 'is my fatherland'[51]—was particularly singled out in his attacks on the suffocating restriction of freedom in Germany.

It is hardly surprisingly that his anathematizing of the Prussian court reached a peak after his pension from the Saxon court was discontinued as a result of the invasion of Saxony by Frederick the Great in the Seven Years War. To Swiss correspondents he was most vividly eloquent on this subject, referring at one point to Prussia as 'My fatherland—but one weighed down by the greatest despotism ever conceived. I shudder when I think of this country; at least I experienced slavery more than others.'[52] A couple of months later, in February 1763, when he was having to contemplate the prospect of a taking up a job in Berlin before he managed to secure his paid benefices from the Vatican court, he seemed to anticipate the political rhetoric of the more radical French revolutionaries. The main reason for his aversion to Prussia, he claimed, was

> love of freedom; for I have grown up like a weed following my own inclinations, and I believed that I had been in a position to sacrifice another person and myself, were monuments to have been erected commemorating the murderers of tyrants [Winckelmann here is referring to the story of the two close friends and tyrant slayers, Harmodius and Aristogiton, who had a monument erected to them in Athens].[53]

It was then far from the atmosphere of the court that a man's free self was to be nurtured. As he wrote to Friedrich von Berg, the young nobleman to whom he dedicated his essay *On the Capacity for the Feeling for Beauty*, someone in Berg's position could best realize himself by resolving 'to flee the court, particularly [the Prussian one], and try and enjoy your fair life on your own and for your own sake.'[54] He wrote in similar terms of the 'noble youth',[55] Heinrich Füssli, whom he had guided around Rome, when setting out the young man's prospects for developing a healthy feeling for art. As the free subject of a free country, he would be able to realize himself, Winckelmann explained to a Swiss friend, in a way that no subject of princely patronage could:

Your fatherland [Switzerland] will soon be able to pride itself on possessing the greatest art expert who will be discriminating and judicious. No prince to my knowledge has succeeded in attracting such a man: moreover the princely scum is not worthy of such an asset.[56]

In a moment of eloquent republicanism, he wrote to another Swiss acquaintance: 'Ten princely offspring, I told him, would count for nothing against a single worthy free burgher of Basel.'[57]

The need to present himself as a 'free' man while he was in fact a client of an important Roman cardinal, and his understanding that he had only been able to realize himself in these circumstances, forced another perspective on him that was radically at odds with his utopian celebration of the ideal free life far from the social pressures of court society. Simply imagining how to present himself to others as a free and independent agent, let alone trying to live out such a role, involved him in very contradictory perceptions of court life and culture: the court was for him simultaneously an instrument of oppression and an agent of liberation. On one hand, it was only once he came to Rome that he began to feel himself free. This freedom he experienced as an escape from the relative lack of opportunities for self-realization in his earlier situation, first as schoolteacher, and then as librarian. Looking back on that phase of his life, he saw himself as cut off from the larger-minded public world that in his experience could only be found in and around a major court. The contrast between the atmosphere of court life and life outside it was thus in part inflected for him by the retrospective contrast he drew between the relatively isolated and provincial world of his early professional career in Germany, and the new life he forged for himself after leaving the service of Count Bünau and going to Rome.

This perspective on the court as a realm of freedom rather than of oppression is presented very explicitly in a letter that at one point he seems to have intended for publication and which he wrote to Francke, his former colleague at Bünau's library, in 1762. Here the ambience of court life is set against the narrow pedantry and impoverishment of the life of the provincial scholar in what is a scarcely disguised apologia for the benefits of the situation in which he found himself in Rome:

> Life in places far away from courts where very little happens (*ohne grosse Veränderungen*), where one is in contact only with one's peers or young people, stunts the mind. The circumstances in which one is placed prevent one from enjoying youthful high spirits.[58]

At issue here was a certain amount of special pleading for the superior circumstances he enjoyed over colleagues in Germany, and a certain paranoia about how they might judge his capacities as a scholar. As he wrote from Rome a few years later, 'Here there is no professorial and schoolmasterly envy. The court decides on the merit of scholars' and the judgements made on people's work are more open and generous.[59] To his publisher Walther he could rationalize the

advantages of having his treatise on allegory proof-read in Dresden rather than Leipzig in terms that seemed to place his loyalties clearly with the men of court rather than the men of learning. In Dresden, he felt, 'where at least a shadow of a court remains, you still likely to find people whose knowledge is certainly not acquired at a university.'[60]

Yet Winckelmann did not often project the court as the most favourable environment for true learning. The main issue as regards his perception of the narrow circumstances of German scholarship was its isolation from the public ambience of the court, compared with the open interchange between the two spheres he had experienced in Rome. Outside Italy, according to Winckelmann, men of learning had only two options, either to teach at an educational institution, a school or a university, or to make a living by producing educative writings. Italy, or more specifically Rome, provided an opportunity for the scholar to be free of this narrowly pedagogic perspective. In Winckelmann's view the Roman court was very special, for it included men of the highest rank who were also considerable scholars, such as his friend Cardinal Passionei. It was a court that 'more than any other insists on learning', in contrast with most others where learning and scholarship subsisted as narrow pedantry: 'Among princes the terms scholar and pedant are generally synonymous, and both give off the same odour at worldly courts.'[61]

Rome then could be celebrated as an escape from the narrow confinement of learning by German court culture. Yet it too was a court, with its own petty privileges and hierarchies, and Winckelmann's utterances about it were inevitably shifting and unresolved. Rome could only work for him as an arena of freedom because so much of its cultural life, particularly that associated with art and antiquities, was sustained by an international community living and visiting there, rather than the papal court alone. Thus it was that he could say to an artist friend that giving up an official post in France or Germany and coming to live in Rome was 'to get away from all the pomp of the court'.[62] As there was for him no public arena completely away from a court where an individual of his class could aspire to represent himself as a personality of note, the best available situation was the anomalous no man's land in and around the papal court in Rome. Here, better than anywhere else, he could perhaps enjoy some equivalent to the free public sphere he imagined had been realized in the republican city-states of ancient Greece.

The material circumstances of Winckelmann's life could not, however, allow him to sustain a utopian projection of life in Rome. In the end he was frustrated in his attempts to secure an official position there that properly corresponded to his self-image as a free scholar and man of letters. It was not only his status in relation to his patron, Cardinal Albani, and to the papal court that he came to see as problematic, but also to high-ranking foreign visitors to whom he would act as companion and cicerone. An interesting case in point comes in his account of the visit of the Prince of Braunschweig to Rome in the winter of 1766. Writing to his friend Stosch, he tried to give the impression that he had

taught the taciturn young prince a thing or two, and had come quite openly to despise him after he found he remained unresponsive to his blandishments about true art or friendship. He was, according to Winckelmann, one of those men of high rank about whom it was not worth bothering because he was incapable of appreciating the 'greatest human good', true friendship, and quite lacked 'the most elementary skill in the world . . . to make himself likeable'.[63] But at the same time Winckelmann also made it clear that he could not afford to be seen thus to despise someone of this prominence. He asked Stosch to keep quiet about the opinions he had expressed, and wondered whether, even in personal letters, he should not be 'more cautious in writing'. For all his private reservations, he still felt he needed to cultivate this potentially important contact, and expressed some anxiety when the prince did not reply to a letter he sent. When finally he did receive an acknowledgement a year and a half afterwards, he wrote to Stosch: 'Now that the exchange of letters has been established on a friendly basis, I shall make every effort to keep it up.'[64] Still, he did reserve the right to declare privately that the man, rather than the magnate, was someone he could only despise: 'He is a petty, if not base, unbalanced (*ungleiches*) and indeterminate (*unbestimmtes*) being . . . I am shortly awaiting a letter from him.'[65]

In his commerce with important German visitors, advising them on their sightseeing of classical antiquities, Winckelmann played the ambivalent role of both servant and internationally renowned man of learning. Such activity was seen formally by the papal court as a task that would justify remission from his duties as 'Scrittore' at the Vatican library during the few years he worked there.[66] But it was also something he could negotiate to suit his own personal and professional interests. The relationship he forged with Friedrich Franz of Anhalt Dessau on the latter's visit to Rome in 1766 was close enough that, when he was planning his aborted visit to Germany a few years later, he could count on using the count's residence in Dessau as a place to meet with his Prussian friends.[67] The ambivalence with which he viewed most encounters with visiting German noblemen emerged in a letter he wrote to his friend Stosch some time after he met the Prince of Braunschweig and Friedrich Franz of Anhalt Dessau. At one level he described it as a blessing that he was no longer being bothered by foreigners wanting to be shown around Rome. At the same time he saw his life as much less exciting than it had been at the high point of such visits.[68]

How he represented his commerce with people of standing as a high-class cicerone would vary depending on his audience. To the 'free' Swiss, he would assert that 'Conversing with princes . . . should not have to be the occupation of a free man.'[69] To an acquaintance who Winckelmann felt was assuming he could be contacted as a mere cicerone by any visiting German, on the other hand, he did not stop short of outright snobbery: 'I am unable to act as guide to anyone who is not of high rank, because it is on account of the latter that I am released from work at the Vatican.'[70]

As time went on Rome became for Winckelmann less and less the city of freedom, not just because he was becoming more conscious of inequalities and constraints that had not been fully apparent to him as a newcomer from 'provincial' Germany. We also find in his later letters a concern about the ever increasing political limits to freedom being imposed by papal rule. In his early years in Rome, he could boast to potentially sceptical correspondents that, despite appearances to the contrary, he was at liberty to express free-thinking views even on religious matters:

> In Rome I have become so accustomed to telling the truth without having to worry that I would not hold it back from a cardinal. With the exception of religion you can talk as ill as you like, even of the Pope, whether you have reason to or not. No one takes offence.[71]

This was in the early days of Clement XIII's reign, when the tone of the papal court was still set in part by enlightened cardinals such as Passionei.

Later his perception of the situation changed, even if he could still write to John Wilkes that Rome might be seen as bearing some traces of its ancient republican liberty: 'for at Rome there are many who give orders, and no one obeys, and for my part I breathe a liberty that I could not have found elsewhere.'[72] By the time he addressed this letter in the summer of 1767, he was presenting a very different picture to his closer friends, more in line with how we might imagine a Protestant North German would view political life in Rome. By now, the reactionary policies pursued by Pope Clement XIII were even affecting the life of the charmed inner circle of high-ranking churchmen to which Winckelmann's patron Albani belonged, while the more progressive and free-thinking figures with whom he previously had been in contact, such as Archinto and Passionei, had died. For the first time he felt himself being watched and coming under suspicion for his opinions. In July 1767 things reached a point when he seriously suspected that the Inquisition might start investigating him, but the threat never materialized. Eventually he tracked down the source of his problems to some off-the-cuff comments he made at dinner with Cardinal Albani and the Albani princesses.[73]

Judging from the way he recollected the occasion and could assure himself that he had not let slip anything particularly incriminating, it would seem that he had always been mindful of the need to be careful about expressing his (ir)religious opinions publicly in Roman society. But the situation was evidently getting more difficult. He complained to Stosch that Albani was now becoming 'extremely fanatical and bigoted', and announced that in future he would have to withdraw from formal social intercourse with his patron and his circle, 'which anyway is something very easy and at the same time very advantageous for me'.[74] He was now seeing Rome as a foreign 'Catholic' world, and no longer so free at that. Albani increasingly figured in his letters to close friends, not as friend and companion, but as a troublesome aging patron, prone

to raising difficulties over travel plans,[75] in addition to having a mistress who stoked up suspicions about Winckelmann's irreligion.

The political tenor of life in Rome now presented itself to him in a rather negative light. Just before departing on his trip to Germany in 1768, he reported to Stosch: 'The whole apparatus . . . is going to rack and ruin; I am talking of that of the priests; in fifty years there will probably be neither Pope nor priests.' The only hope now was for a new pope who would bring about a change in 'the whole system of relations between the states [*Staaten*—presumably the Papal States] and the Roman court, particularly in matters of religion'. He was far from alone in perceiving things this way, and the next pope, Clement XIV, elected one year after Winckelmann's death, was obliged to reverse some of his predecessor's more reactionary initiatives.[76] In his last years in Rome, Winckelmann started emphasizing the split between the spirit of ancient Rome and the present-day Rome of priests and pope. This was a common Protestant perception that until now he had largely suppressed, keeping alive a myth of Rome as a place of liberty. In a letter he wrote in 1767 to the Hanoverian minister Münchhausen, he not only underlined the decline of classical scholarship in Rome, which his German contemporaries were beginning to comment on, but also explained this state of affairs in pointedly political terms as 'the fruit of the education that is in the hands of clerics and will remain so'.[77] Education, the field in which he had begun his career, was precisely the one from which a person such as himself, who refused to play the part of an observant Catholic, was excluded in Rome. He had commented on this earlier when he was considering going to Berlin, thinking that there he might be able to pursue his 'inner natural calling . . . which is to be a teacher of youth . . . Here education is in the hands of priests and thus out of my reach.'[78]

Two descriptions of Winckelmann by travellers who encountered him in Rome make a particularly fitting conclusion to this account of his complex attempts to project himself as a free and independent public personality. The first comes from a report by one of the Prince of Anhalt Dessau's companions in April 1766. It describes a dinner conversation in which Winckelmann, animated by drink,

> came to talk about the King of Naples. He did not measure his words and said quite plainly: he is a beast. Monsieur l'Abbé, the Prince of Mecklenburg said to him, perhaps remembering at this point that he had a king for brother-in-law, just think that you are talking about a crowned head, and that in a few days the majority of this young king will be declared [*ce jeune Roi sera déclaré majeur*]. Good God yes, Winckelmann exclaimed, he will then be a major beast [*une bête majeure*].[79]

From a quite other perspective, we have the radical politician John Wilkes's recollection from his unfinished autobiography, based on a meeting with Winckelmann in 1764 and subsequent correspondence. If in part derived from Winckelmann's own self-mythologizing, this portrait is interesting because,

from a point of view quite outside the world Winckelmann inhabited, it can envisage him as living out an ideal of freedom that had definite political overtones:

> he was born a subject of the tyrant of Prussia, and had pass'd the greatest part of his life under the despotism of the Roman Pontifs, yet he has a heart glowing with the love of liberty, and sentiments worthy of the freest republicks of antiquity, for, if I do not mistake, most of the modern republicks are degenerated into corrupt aristocracies.[80]

A similar political sympathy flowed in the other direction, with Winckelmann writing to Wilkes in 1767 concerning the latter's *Letter to . . . the Duke of Grafton*: 'I have read and reread it, animated by the very spirit of liberty that I feel keenly, without having tasted it.'[81] The filiation from Winckelmann's freedom to the revolutionary liberty of 1789 is not then entirely a retroactive projection—its possibility was traced out by Winckelmann himself.

FRIENDSHIP AND DESIRE

The dedications Winckelmann made in his publications were very carefully considered gestures, with the more conventional ones functioning as tokens for important patrons. The *History* was dedicated to the Elector of Saxony, Friedrich Christian, who as crown prince had arranged Winckelmann's stipend from the Saxon court. In the circumstances, this dedication was not quite as effective at is might have been. It ended up being a sign of gratitude for favours rendered in the past, as Friedrich Christian died just before its publication.[82] Winckelmann dedicated his other major work, *Unpublished Antique Monuments*, to Cardinal Albani. This made sense since a high proportion of the items in the catalogue were taken from Albani's collection. But the dedication also registered Winckelmann's continuing dependence on the Cardinal's patronage. These official dedications were complemented by more unusual ones to friends. Indeed, in the *History* itself, Winckelmann supplemented the official dedication with an informal one inserted at the end of the preface to 'my friend Anton Raphael Mengs'.[83] Both kinds of dedication were public projections of identity, albeit in very different modes. With one Winckelmann was confirming his standing through association with a prestigious patron, and with the other presenting himself as a 'free' man choosing to offer a token of friendship to an equal—a token of friendship, and also a token of desire.

Winckelmann's most modest declaration of friendship was to a young Swiss in *Reports on the Most Recent Discoveries at Herculaneum*, published in 1764. The dedication consisted of a short and fairly conventional quotation from Lucretius. The dedicatee, Heinrich Füssli (not the famous painter), was the son of a Zürich publisher and writer on art. He had just spent a year in Rome, where he had been tutored by Winckelmann. In letters to Swiss friends re-

porting on his progress Winckelmann represented the young man in glowing terms: 'I have never encountered a more innocent child, with such great talent and wit. He seems to me a picture of virtue incarnate and the very first man of the golden age.'[84] Though Heinrich Füssli recollected with considerable warmth the time he spent with Winckelmann in Rome, he only acknowledged the dedication perfunctorily,[85] and made no effort to keep up the correspondence that Winckelmann initiated after he returned to Switzerland.

This was a minor version of a much more traumatic episode surrounding Winckelmann's highly charged dedication in the essay *Treatise on the Capacity for the Feeling for Beauty*, published in 1763, to a young Latvian nobleman, Friedrich Rheinhold von Berg, with whom he fell in love. Disappointment over Berg's failure to return his gesture drove Winckelmann to complain that 'this thanklessness and the scarcely grateful conduct of our Germans' has made him resolve 'not to waste a thing on anyone [*mit niemanden ein Stück zu verliehren*]'.[86] Another similarly intense but more measured tribute to friendship is found in the dedication of his *Remarks on the History of the Art of Antiquity*, published in 1767, to Heinrich Wilhelm Musel Stosch. This dedication, unlike the other two to 'friends', did not carry with it the danger of a rebuff, for it was addressed to an older man with whom Winckelmann had long maintained a close and intimate correspondence. Wilhelm Stosch was the nephew and inheritor of Baron Philip von Stosch. Winckelmann had got to know him when working on the catalogue of the latter's antique engraved gem collection in 1759.[87]

The dedication to Berg was at several levels a crucial one. First, it represented an important new departure in the politics of self-presentation. Winckelmann had chosen to dedicate an important essay on aesthetic principle to a friend and an admired young man, rather than to a grandee whose patronage he was trying to cultivate or offer thanks for. In the past, Winckelmann had expressed some unease over the honour supposedly accruing to an author through a dedication to an important patron. In connection with his plan to dedicate a treatise on architecture to the Crown Prince of Saxony, he would write: 'One must never allow princes to feel that, when one dedicates a work to them, it bestows more honour on us than on them.'[88] In contrast, the dedication to Berg was to be a freely given token of esteem and affection, not a formal tribute to a '*Herr* (lord)' to whom he felt politically bound.

The dedication had more of a charge to it than that, though. It was almost a love poem. Winckelmann cited Pindar and likened Berg to the 'beautiful' youth of Locri to whom Pindar had dedicated an ode. He also proclaimed in very direct personal terms that his disquisition on beauty had in large part been inspired by Berg:

> The contents are taken from your very self. Your form [*Bildung*] allowed me to complete what I desired; I found in a beautiful body a soul made for virtue which was endowed with the feeling for beauty.

The essay was presented by Winckelmann as both a memorial to their encounter and something with which to alleviate the absence that had intensified his feelings:

> the parting from you was one of the most painful of my life . . . May this essay be a monument to our friendship, which for my part is free of any ulterior motive, and always remains dedicated to you for you to use as you like.[89]

The dedication was saturated by recollection, memory, and absence. Winckelmann was projecting himself as the subject of an ideal friendship, defined by inevitably fantasized recollections of the brief contact he had with the twenty-six-year-old young nobleman over a period of little more than a month's stay in Rome.[90] In its self-absorption, this declaration of 'true love' by Winckelmann was hardly exceptional.

The extensive surviving correspondence from Winckelmann to Berg, most of which was made available for publication by Berg soon after Winckelmann's death,[91] suggests that much of the emotional charge of the affair between the two men was generated through letter-writing. Letters about or between absent lovers functioned in eighteenth-century literature as a very important medium for defining and playing out a passionate relationship. Winckelmann almost appeared to be projecting his unrequitable desire for an absent friend by imagining himself as a character in an epistolary novel, such as Rousseau's *La Nouvelle Héloïse* or Richardson's *Clarissa*. No doubt the conventions of these novels partly informed the expectations of the late eighteenth-century reading public that had such an insatiable appetite for published collections of Winckelmann's letters.[92]

After Berg left Rome, Winckelmann seems to have expected their acquaintance to end there. A letter from Berg appears to have motivated him to make something more of the encounter, and not let it drift into the oblivion he had come to expect from earlier contacts with young Englishmen passing through Rome.[93] The first surviving letter from Winckelmann to Berg is rather reticent, and the tone of address only warms up as the correspondence gets going. By early 1763 he was informing Berg of his proposed dedication, promising that 'I shall take pains to attract a certain amount of attention to your name, my sweet friend.'[94] The climax comes in the next surviving letter early the following year. Here Winckelmann sets to one side any conventional dedicatory talk about how his fame as a writer might add lustre to the young man's reputation, and launches into a hymn to love and friendship:

> No name I might give you is sweet enough and adequate to my love, and whatever I could tell you is quite insufficient to convey what my heart and soul would like to say. Friendship arose from heaven and not from human feelings [*nicht aus menschlichen Regungen*]. It was with a certain awe that I

approached you; and as a result I was deprived of the highest good by your departure. What should I have had to write were a single one among a hundred of my readers to understand this sublime secret. My dearest friend, I love you more than any other creature, and no passage of time, no accident, no old age, can diminish this love.[95]

Maybe at some more or less subliminal level Winckelmann gave this declaration an intensity that he knew had to be or that he even wanted to be unanswerable. In the event, Berg chose not to reply, nor even to acknowledge the dedication. The remaining letters are quite cool and business-like, save for one last reference Winckelmann made to this earlier intimacy after hearing of Berg's marriage, when he imagined the possibility of the couple visiting Rome: 'as I have loved you more than anything else on earth, and would willingly have accompanied you as your shadow, the desire to see you in the arms of your beautiful wife would for myself be a lovely pleasure'.[96] The rising passion, the climax, and the separation, had all been enacted by letter, inspired by a fairly brief encounter between Winckelmann and, from what one can gather, a none too receptive pupil, which might easily have passed without trace, had not an exchange of letters re-enacted and given it a new significance.

His affair with Berg came to be seen by Winckelmann as one of the two great passions of his life, the earlier being with a young man called Lamprecht, whom he was tutoring when he took up his teaching in Seehausen in 1743—'my first love and friendship' as he recalled twelve years later.[97] Memories of the emotionally traumatic end to the earlier friendship seem to have been revived by Berg's rebuff. In letters he wrote in 1765, in the immediate aftermath of his interchange with Berg, the two names were often connected by Winckelmann.[98] Bound up with both these passions were issues of class difference that could only have intensified the particular significance they had for Winckelmann.

Both were relationships between Winckelmann in his role as pedagogue, and a younger upper middle-class or upper-class gentleman[99] from a background to which Winckelmann himself could lay no claim, either by birth or lifestyle, but to which at some level he aspired. When he proffered his 'friendship' to Berg, there was an unavoidable class barrier to be crossed which would have made it impossible to realize an attachment on any permanent basis—over and above the block social taboo placed on a homosexual affair being lived out publicly. Throughout his correspondence, Winckelmann kept to the formal *Sie* when addressing Berg, as distinct from the more intimate *du* he used to old German friends. He signed one of his more passionate letters your 'ever dedicated friend and obedient servant'.[100] At the same time, some of the imaginative resonance this friendship had for him almost certainly lay in the social distinction, accentuated by geographical separation, which made it almost inconceivable for his passionate declarations to be fully reciprocated. In other words, the potential barriers and denials hovering over any declaration of love to another man were over-determined by his position of social inferiority to his lover.

The strong and, it seems, reciprocated friendship he had with an Italian of similar status to himself, a Roman librarian called Ruggieri, did not play anything like the same role in his self-representation to friends as did his affairs with Lamprecht and Berg. Something of an imagined social identity he wished to claim—as well as a passionate love—was bound up in his relationships with social superiors that was not at issue in his friendship with Ruggieri, even while he did remember him as his very closest friend in Rome. Just after Ruggieri's tragic death by suicide, Winckelmann wrote: 'My friendship towards him was a truly intense passion, and I do not believe that anyone could be more of a friend than I was to him.'[101]

Winckelmann concluded his dedication to Berg with a vision of Berg returning home to cultivate himself in circumstances quite alien from those the writer could ever hope to claim as his own: 'enjoy your fair youth in noble diversion [in einer edlen Belustigung], far away from all the folly of the courts, in order to fulfil yourself as you clearly can, and raise sons and grandsons in your image.'[102] Here we have the voice of the tutor, imagining his pupil living the ideal life of an independent landed gentleman, from which his own social and professional circumstances excluded him. When Winckelmann remembered his time with Berg as one in which 'I recalled my unspent youth in your company,'[103] he was underlining how the two were separated not just by age, but by a youth of deprivation that had been Winckelmann's lot as a lowly scholar and schoolteacher in Prussia.

The essay dedicated to Berg, *Treatise on the Capacity for the Feeling for Beauty* was at one level a more personal work than *The History of the Art of Antiquity*—a discussion of a subject close to Winckelmann's particular passions as a man and scholar, on how a true feeling for beauty was to be cultivated through the education of the young, and addressed as a token of friendship to one who had enjoyed such an education from Winckelmann at first hand.[104] But it was also a work where what we would construe as repressive articulations of class identity surface more than elsewhere in Winckelmann's writings. As in most eighteenth-century discussions of taste, it openly gave the lie to enlightened ideals of equality, and was quite explicit in its association of aesthetic discrimination with social superiority. The libertarian politics and the more vividly expansive discussions of beauty in the *History* were absent. The discussion explicitly excluded anyone of the lowly class origins of Winckelmann himself from seeking to approach an understanding of beauty. It was a vision of the privileged educational opportunities Winckelmann never had. While, like all his writings, it assumed a separation between a true conception of beauty and court culture, or at least did not collapse the two into one another, its idea of how a feeling for beauty was to be acquired made no secret of Winckelmann's identification with the privileges that separated the man of means from the common man, whose lowly lot he had managed to escape.

Persons incapable of distinguishing between the beautiful and the mediocre, Winckelmann wrote, are like those men of 'excessive politeness' who are indis-

criminately receptive to a 'man of standing (*Verdienst*)' and a 'common man (*Pöbel*)'. The feeling for beauty, he insisted, could only be cultivated by people who had the leisure to do so, and were not obliged to work for a living, 'which is self-evident'.[105] As the last phrase indicates, Winckelmann was expressing a common-sense view of the Enlightenment culture he inhabited. At the same time he was identifying with the superior social standing of his dedicatee by making it explicit that only men of reasonably high class standing could participate in the cultural accomplishments he had to offer as a teacher. When, as here, Winckelmann publicly declared his values outside a framework of client patronage, he was still obliged to present himself as caught in an insistent, if necessarily largely unacknowledged, contradiction. The ideal social identity he was projecting, one that allowed a free and easy commerce with classical culture, was also one from which his unprivileged class origins should theoretically have excluded him.

To friends, Winckelmann was quite explicit about his emotional investment in the dedication to Berg:

> I fell in love, and how, with a young Latvian and promised him the best of all letters. That is, I wanted to offer him very possible token of my affection (*Neigung*); and I might even have promised him the dedication of the *History* if I could have changed it.[106]

At one point, he claimed that in the essay he had written for Berg he had been able to declare himself with a freedom that he would not have been allowed in a work dedicated in a more conventional manner: 'I have written then somewhat freely, in the confidence that no great lord or minister will read it.'[107] In what way might this essay on beauty not have been seen as entirely to the taste of the great and the good? Certainly there is nothing at all contentious in it that we might call its class politics. If something was potentially problematic, most likely it would have been the homoerotic element, though this could not have been seen as too overt, for the essay did after all enter the public sphere as a book published in the normal way. More than anything, the form of the dedication was at issue, because its intense declaration of friendship would have been socially unacceptable had Winckelmann addressed it to an obvious superior. It seems that Winckelmann could envisage this dedication to a relatively unknown individual as one that would at some level be read as a private matter between himself and Berg, not bound by the protocols governing a dedication to a known public figure. As such, it need not have been read by a larger public as contentious. Moreover, its highly charged rhetoric is not so unusual when seen within the context of the emotive apostrophes to friends common in eighteenth-century literature. Its evocations of homoerotic desire would have been allowable on another score too, because they were framed within the classicizing paradigms of Socratic or Platonic friendship.[108] Conventional 'Platonic' ideas on the correlation between a fine mind and a beautiful body, of the kind Winckelmann evoked in the dedication to Berg, provided a relatively safe medium for imagining male same-sex desire.

That Winckelmann, however, still felt the need to be sensitive as to the constructions that people might place on his dedication is evident from the change he made to the introductory epigraph, partly it seems on the insistence of Berg. For the passage from Pindar, 'Oh Muse, tell me where he lies in my heart' he substituted less explicit one from the same ode, describing its dedicatee as 'beautiful of build and endowed with grace'.[109] The most explicit indication of concern on Winckelmann's part is the formula he used to conclude the dedication. His 'friendship', he insisted, was 'free of any ulterior motive [*rein von ersinnlichen Absichten*]'.[110] The dedication as a whole is inflected by an internalized tension between the anathema on what then would have been seen as sodomitical sexual relations between men, still legally punishable by death in most European countries, and a relative freedom to declare what we would now read as homoerotic desire within the paradigms of male friendship. There are a number of points in Winckelmann's letters that betray a certain anxiety on this score.

In a letter to a Swiss friend, written just as the essay *Treatise on the Capacity for the Feeling for Beauty* was being published, where he develops his argument about the male figure being a truer yardstick of beauty than the female one, he shows an awareness that his relatively openly declared preoccupation with male beauty could be cause for comment. Recalling his interest in a beautiful youth whom he had admired at a distance in Florence some years before, he wrote: 'No feeling (*Neigung*) was as pure as this. Besides, I am not particularly anxious about what they might think of me on this score in Germany. In the *History* I may have given the stern moralists far more cause for concern.'[111]

In the revised edition of the *History* he was preparing at his death, he did indeed insert a disclaimer at the beginning of his hymn to Greek beauty, which also registered a certain concern about people's interpretation of his essay to Berg. There were, it seems, moments when visible limits had to be seen to be imposed on the projection of homoerotic desire in his published writings if the latter were not to be accused of sliding into sodomistic innuendo. It is significant that this disclaimer was inserted in the same revised edition in which he felt he had to retract some of his more overt disparagement of the unfree patronage of an 'enlightened despot' such as Hadrian:

> Whatever might give rise to misinterpretation in the following observations on beauty should not trouble those who teach: for just as Plato and Aristotle, the master and pupil, asserted the complete opposite about the ultimate aim of tragedy . . . so the most innocent intention [*unschuldigsten Absicht*] can give rise to an adverse judgement [*ungeneigtes Urtheil*], even on the part of those who think correctly. I am particularly reminded of this in connection with my publication, *Treatise on the Capacity for the Feeling for Beauty in Art*, which elicited views from some people that were quite remote from my original intention.[112]

One key issue on which attacks on sexual relations between men in the eighteenth century focused was the supposed threat this posed to the 'natural'

male desire for women. Charges of misogyny were an important component of public expressions of homophobia, and Winckelmann was quite sensitive on this issue, partly because he was not in a position to marry and present a conventionally acceptable domestic face to the outside world. The intensity of his very negative response to an account of his early life, published by an erstwhile colleague from the school in Seehausen,[113] is partly explained by its passing accusation that Winckelmann was 'an enemy of the opposite sex'.[114] Winckelmann would protest to friends that he was not ill-disposed towards the female sex, and that it was only the material constraints imposed by his way of life that had kept him from contact with women.[115]

His surviving letters are indeed pretty well entirely concerned with male friendships, and contain almost no references to even casual encounters with women. But there is one major exception. This concerns Margherita Mengs, the wife of the painter Anton Raphael Mengs. Winckelmann had a close but difficult friendship with Mengs, whom at one point he counted with his lovers Berg and Lamprecht as among the three really important friends who had failed him.[116] When early in 1765 Margherita Mengs returned on her own to Rome from Madrid, where her husband was court painter, Winckelmann was charged by Mengs to act as proxy for him, which he apparently did all too conscientiously. Winckelmann described the affair that developed between himself and Margherita Mengs in the following rather apologetic terms to an old Prussian friend, Berendis: 'I fell in love then for the very first time with someone of the female sex. How could I have resisted so high a beauty as that of my friend, who was so earnestly commended to me alone (*die mir allein auf meine Seele anbefohlen war*).'[117] The claim that this was the first time he had felt strongly attracted to a woman should not perhaps be taken too much at face value. There is an off-the-cuff comment in a letter from Rome in December 1758 about how he had taken a fancy to a beautiful twelve-year-old female dancer, qualified, however, by the proviso that 'yet I shall not be untrue.'[118]

Winckelmann's representation of the relationship with Margherita Mengs to Stosch has an interesting double edge to it. On one hand he described in some detail how there had developed between them a 'an intimacy . . . which, failing the ultimate pleasure, could not have been greater'. On the other, the confession was framed by a celebration of male friendship, as if to reassure Stosch that his almost being taken over by 'the image of the beloved' had not eclipsed his lifelong commitment to 'friendship'. It was, he assured his friend, to the 'origin' and 'summit and throne of friendship' that his soul would always return when in a state of rapture, that it was in friendship that his soul's 'highest pleasure consists'.[119]

Though publicly there was a very firm line to be drawn between a way of life that revolved around highly charged male friendship, and one that embraced sexual relations between men, it is clear from Winckelmann's correspondence that, within the social circles in which he moved in Rome and among his more intimate German and Swiss correspondents, little taboo was attached to talking

privately about sexual relations with young men. These Winckelmann himself kept in a strictly separate category from his more highly invested male friend-ships. To Bianconi, the doctor at the Saxon court who had been instrumental in enabling him to get to Rome, Winckelmann was quite explicit about his sexual encounters with youths during his stay in Florence in 1758–9, where, as he put it, he advanced beyond the 'surface of Platonism . . . I bent my head and submitted to an act analogous to b . . . [buggery?]. I am reduced to taking enemas and had to avail myself of one again this morning. Thus have I paid the genius of Florence the tribute of my virginity.'[120] Both to an old friend from Prussia, Berendis, and to a young Swiss man, Leonhard Usteri, whom he had shown around Rome in 1761, he freely made reference to his sexual affairs. In one case it was an involvement with a 'beautiful young Roman sixteen years old, half a head taller than I', and in another with a fourteen-year-old castrato, whose portrait he was having painted. 'Sometimes I fall in love,' he wrote, 'which is even more annoying' than having to entertain unwanted visitors from the Saxon court.[121]

Living with Albani seems to have allowed him considerable freedom to conduct his sexual affairs as he wished. In 1761 he wrote to Berendis about how 'I am freer than I ever have been in my life, and I am in a manner of speaking master of my master [Albani] and of his country residences . . . I often entertain him with my "Amours"; the nobility here is without pretension and the great lords (*Herren*) without pedantry.'[122] In 1763 he announced his intention to spend August on his own in Albani's summer villa outside Rome 'in the company of a good-looking individual . . . because I want to write about beauty after a living beauty'.[123] In the autumn of the same year, he was writing to a close friend about how he had his eye on a 'finely built boy' whom he was thinking of educating to accompany him on a trip to Germany he hoped to take once the new edition of the *History* was completed, 'so as to make of him a companion for myself'.[124] Albani's own way of life was apparently free and easy enough to cause him some anxiety when he was connected with a scandal that broke in 1764, relating to the separation between a couple six months married, where the women involved had taken up with a castrato.[125] Judging from the absence of references to amorous affairs in Winckelmann's letters dating from his very last years in Rome, when he was remarking on the oppressive bigotry seizing public life in the city, the freedom about which he had once boasted to his German friends seems to have been curtailed on several fronts.[126] Relations with Albani had become far from free and easy; it was at this point that Albani let it be known that he disapproved of the liberties Winckelmann took in talking about religion.[127]

During the eighteenth century Italy, and Rome and Florence in particular, had a reputation as places where sodomitical practices were more widespread than elsewhere.[128] This perception tells us less about tolerance of gay sexual practices in Italian society, or even about the possible prominence there of a gay subculture, than it does about the relative freedom enjoyed by upper-class

tourists in Italy, who no longer felt bound by the norms and prohibitions
operating in their own societies. As someone closely involved with the traffic in
antiquities, who acted as cicerone to foreign visitors, Winckelmann quite liter-
ally continued to inhabit Rome's 'bohemian' world of tourists and artists even
after settling in the city. His position attached to the top aristocracy at the papal
court also insulated him from the rules governing most Italian society. He
inhabited an exclusive male sphere, where, according to a comment he made to
Casanova, it was safer to engage in 'pederasty' than to be known to have a
mistress.[129]

When Winckelmann was being courted for a job in Berlin in 1765, Christian
Felix Weisse, the editor of the journal that published Winckelmann's early
essays, wrote to Christian Klotz, one of the foremost classical scholars in
Germany, that Winckelmann was better off not going to Berlin. He had fared
better in Rome than anywhere else, he claimed, adding rather preciously, 'his
little vanity [*Eitelkeit*] finds more nourishment there.'[130] The particular circum-
stances in Rome, which tolerated a marginalized sexual permissiveness, may
have been a significant factor in the new freedom Winckelmann said he had
come to enjoy there, as when he announced to a Swiss correspondent with
characteristic bravado: 'I am healthy and healthier than I ever was in Germany,
free and contented, and I can say that I have begun to live for the very first time
in Italy.'[131] This stands in marked contrast to his earlier negative prognosis in
a letter to his close friend Berendis, written while he was still trying to decide
whether or not he should go to Rome: 'I should prefer it were I to die all of a
sudden. I have never enjoyed my life, and the compulsion of my feelings [*der
Zwang meiner Sentiments*] will make things very bitter for me in Rome.'[132]

In the cult of the self in Winckelmann's letters, there is a certain Epicurean-
ism as well as self-denial. The frequent projections of himself as a freely
enjoying subject, his apparent embrace of erotic and sensual pleasure, might
even be seen as manifestations of the libertine culture of his period. His literary
tastes certainly inclined in that direction. When he had the run of the Stosch
library in Florence in 1758–9, he took the opportunity to read the erotic
literature in which the library abounded. His readings included *Alcibiade
Fanciullo*, a rare pro-sodomitical diary published in the seventeenth century.
But what particularly caught his fancy was Cleland's *Memoirs of a Woman of
Pleasure*, now usually known as *Fanny Hill*, which he described to an erstwhile
colleague in Bünau's library as 'the most obscene book, that the world has ever
seen . . . but it is by a master of the art, by a man of delicate feelings and high
ideas, and written in a sublime Pindaric style'.[133] Pindar's homoerotic poetry
was particularly important to Winckelmann. Passages from one of Pindar's
odes to a young athlete were to play a key role in his dedicatory declaration of
love to Berg.

Cleland's book could easily be read as one of the masterpieces of homoerotic
literature, for almost all the eroticized descriptions are of male bodies. The
author's obvious delight in lingering over the sexually desirable features of

beautifully formed men is ingeniously displaced as issuing from the mouth of a female narrator. Here we find many of Winckelmann's erotic tropes of the male body: 'a face, on which all the roseate bloom of youth, and all the manly graces, conspired to fix my eyes, . . . a body . . . in which all the strength of manhood was concealed and softened to appearance by the delicacy of his complexion, the smoothness of his skin, and the plumpness of his flesh'. A young man's 'instrument' almost becomes the very epitome of Winckelmann's attempt to fuse the sublime and the beautiful in one single image. It is imagined as 'an object of terror and delight', its 'proud stiffness' modulated by a 'velvet softness'.[134]

The terms of Cleland's celebration of the beautiful male body are, however, necessarily deeply ambivalent. The pornographic images of male bodily beauty are heterosexually framed not only by the manifest content of the story-line, but also by a moralizing diatribe against sodomitical acts after the 'innocent' heroine witnesses two handsome boys engaging in sex with one another. At the same time we know that Cleland himself later ran into trouble because of accusations of sodomy against his own person.[135]

Libertine culture in the eighteenth century did leave some space, at least in the mid-years of the century, for a positive apologia for the pleasures to be had from sexual acts between men. But this space was small and constantly under threat from the violent opprobrium attaching to sodomy in society at large. In one of the rare public apologias for sexual acts between men and youths in La Mettrie's *L'Art de Jouir* (*The Art of Enjoyment*) of 1744, these were defended as a guard against 'the boring uniformity of pleasures'. But in the final analysis such sex with an 'amiable child' had to be conceived as a stimulating diversion in a sexual economy where the primary sexual act remained that between men and women. La Mettrie's avowed ethos is that of the enthusiastic libertine who wishes to see no limit placed on the 'empire' of 'beauty', save lesbian sex, which was seen as a threat to the empire of masculinity.[136] La Mettrie also shows a sensitivity to accusations that he might be seeking to represent the male body as more desirable and beautiful than the female body—a 'misogyny' probably seen as explicitly and hence indefensibly homosexual. In La Mettrie's narrative, the man who engaged in 'pederasty', to use eighteenth-century terminology, must prove himself by returning from the homosexual to the heterosexual bed with renewed desire and libidinal energy.[137] In other words, a 'homosexual' economy of desire of the kind found in Winckelmann was still blocked and dislocated by violent social taboos that made his 'libertinism' different from the relatively unproblematic effusions of La Mettrie. If we are now accustomed to talk theoretically about displacement and absence as the very conditions of desire, we need to remember that the literal necessity for such displacement has been, and in many circumstances still continues to be, much more insistent for some than for others.

We are fortunate to have one particularly fascinating text in which Winckelmann directly confronted the problems he had in defining himself as a

'homosexual' subject within the paradigms allowed by eighteenth-century cul-
ture. The text is characterized by a very compelling and subtle interplay
between the negation of the present-day practice of 'pederastry' as something
almost unmentionable, and the affirmation of sex between men as integral to
the reality and value of ancient Greek culture. The text comes from a thor-
oughly libertine context, the diary of the legendary lover Giacomo Casanova,
who met Winckelmann in Rome in 1761. If it does not necessarily exactly
reproduce Winckelmann's own words, particularly at moments towards the
end where the pleasures of heterosexual sex become an issue,[138] it remains none
the less an extremely illuminating cultural document of the period.

Casanova described how he accidentally came across Winckelmann in his
cabinet 'where normally he was always alone engrossed in deciphering antique
characters, and I saw him withdrawing quickly from a young boy'. He dis-
cretely gave Winckelmann the opportunity to pretend that nothing had hap-
pened, but Winckelmann felt impelled to give an account of himself, which
Casanova recalled as follows:

> You know, he said to me, that not only am I not a pederast, but that all my
> life I have said that it is inconceivable that this taste had so seduced the
> human species. If I said that after what you have just seen, you would judge
> me to be a hypocrite. But this is how things are. In the course of my long
> studies, I became at first the admirer, then the adorer of the ancients, who as
> you know were almost all b . . . without hiding it, and several among them
> immortalized the pretty objects of their tenderness in their poems and even
> with superb monuments. They went so far as to allege their taste [in this
> matter] as testimony to the purity of their morals [*moeurs*], as Horace did,
> when he wished to prove . . . that slander could not take a hold on
> him . . . and defied his enemies to prove that he had ever sullied himself with
> adultery. In the evident knowledge of this truth, I cast an eye over myself
> and I felt a disdain, a kind of shame that I did not in the least resemble my
> hero in this respect. I found myself, to the cost of my self-esteem, in a certain
> manner despicable, and being unable to convince myself of my stupidity
> with cold theory, I decided to enlighten myself through practice, hoping that
> by analysing the matter my mind would acquire the enlightenment neces-
> sary to distinguish the true from the false. Having resolved to do this, it is
> now four years that I am working on the matter, choosing the prettiest
> Smerdias [the youth Smerdias was one of the legendary favourites of the
> Greek poet Anacreon]; but it is useless. When I set myself to the task, I do
> not come [*non arrivo*]. I see always to my confusion that a woman is prefer-
> able in every respect, but besides the fact that I don't care about this, I fear
> a bad reputation, for what would they say in Rome, and anywhere else I'm
> known, if they could say that I had a mistress?[139]

The model that validates talk about homosexual practices, and above all
enables these to be presented as possibly desirable, is the example of the

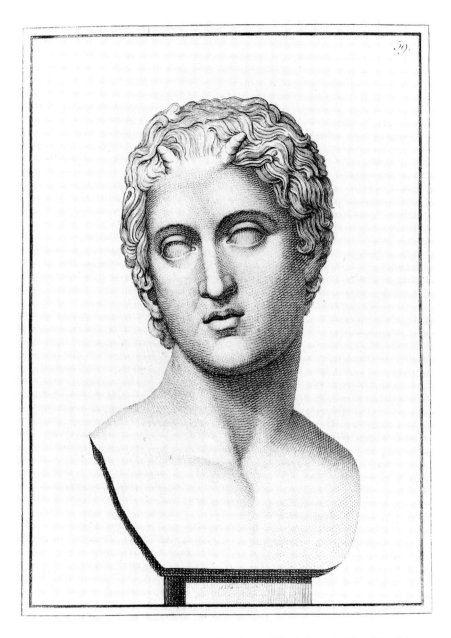

40. Engraving of a faun's head in the Villa Albani from Winckelmann's *Unpublished Antique Monuments*.

ancients. It was widely recognized at the time that sexual relations between men had been much more socially acceptable in ancient Greece and Rome than in modern Europe. This raised the vexed question as to what sense to make of much-admired classical texts, such as the *Symposium* by Plato, which represented erotic relationships between men in unashamedly positive terms. Most commentators sought to 'rescue' these texts from what they saw as the stain of sodomy or pederasty by reading their evocations of male same-sex desire as involving a purely 'Platonic' or non-physical attachment.[140] Winckelmann then was taking up a position as close as his culture would allow to an open defence of homosexual practices when he turned this reading on its head and talked about how the ancients 'went so far as to allege this taste [for buggery] as testimony to the purity of their morals'.

All the same, denial or displacement remains the condition of his talking about the status of such practices in the present. It is as if the negative loading of sodomy set up a linguistic block that precluded the possibility of any direct positive affirmation of erotic relations between men, except indirectly, by way of imagining the radically different world of the ancients. Winckelmann made effective ironic use of the injunction to imitate the ancients to bridge the gap with his own deeply problematic situation. Only a skilled manipulation of denials and displacements could give him the space to account for his 'homosexuality' in terms not totally over-determined by the prohibitions his society placed on pederasty or sodomy. The note of decided ambivalence on which he ended, the claim that '*non arrivo* (I do not come, or I do not get there)', could be interpreted either as a disclaimer or as a literal statement about non-realized desire. But its force hardly lies in either of these alternatives. We can take the statement at another level, as articulating the impossibility of his 'arriving at' anything other than a negative or ambivalent account of his desires within the language available to him, which is not to say that the blockages and the necessity of displacement existed entirely at the level of language. They did, after all, define the world and the self that Winckelmann could inhabit.

Voyeurism and visual delectation provided Winckelmann with one arena where a libertine freedom of choice of the object of desire could be played out publicly without risk of his being seen to transgress public taboos. This entailed looking at real bodies as if they were marble bodies, as if they were the form without the possibly troubling content of erotic desire. One such instance, briefly mentioned earlier, which looms large in Winckelmann's letters concerns a Florentine youth of the noble class, called Castellani, whose beauty had captivated him when he saw him in Florence during his stay there in 1758–9. Perhaps partly because of the class divide that would have made any appearance of advances from Winckelmann seem socially questionable, Winckelmann was at pains to assert that this had been a purely 'platonic' encounter, the delectation of an admired object of desire from a distance.[141]

At the time, Winckelmann's friend Stosch felt the need to advise him not to pursue his interest in Castellani. When several years later he nevertheless

reported back to Winckelmann how Castellani had lost much of his beauty, this prompted from Winckelmann some disturbed reflections on the apparent advantages of marble form over real bodies for the true connoisseur:

> I am truly saddened by the transitoriness of so high a good and by the speed with which the springtime of our life runs its course, the latter being short-lived for those of exceptionally fine physique. One is thus able to proceed with greater certainty and more lasting ideas in the case of beauties in marble, among which [I count] a young faun with two small horns (Plate 40) . . . [This] surpasses any beauty that I have been able to observe until now.[142]

The statue, which he kept in his study, he once described as 'my Ganymede, which I can kiss without causing scandal in the presence of all the saints'.[143]

At play is the appearance of a relatively detached visual delectation, whose abstractly defined sensuality made an affirmation of the desirability of the male body for men relatively acceptable. The limits imposed by such a connoisseur's eroticism allowed Winckelmann to assert quite publicly in the essay he dedicated to Berg 'that those who only attend to the beauties of the female sex and are little, if at all moved by beauties in our sex . . . do not easily acquire a lively feeling for beauty in art . . . The greatest beauties [in the art of the Greeks] come more from our own than the other sex.'[144] As he explained in a letter to the Saxon court doctor, Bianconi, he did not wish to be seen as asserting an illegitimate preference for the beauty of the male body to the exclusion of the female body, but rather to protest against a narrowly limiting identification of beauty with the feminine. On the face of it, he was like La Mettrie in advocating a more open libertine attitude, that of the true connoisseur, responsive to beauty in all its forms. In opposition to Bianconi's insistence on a 'feminine genius', Winckelmann argued: 'I cannot limit myself only to the beauty of the other sex. The eye, taste and passion of the connoisseur do not wish to be partial and restricted but to go everywhere that beauty is to be found.'[145]

We are approaching territory close to the eroticized celebrations of bodily beauty in the *History*. Nevertheless, what makes the latter's analysis of beauty so compelling is precisely its highly charged investment of the apparently abstract ideal of Greek beauty to which this free and easy connoisseurial eye is blind—an eye that only sees the beautiful forms of the body as an object to be deleted, and brackets out the more potentially disturbing projections of identity and desire that eventually enter into any obsessional focus on the body.[146] A connoisseur's delectation is then hardly the nodal point of Winckelmann's concerns, even in his disquisitions on beauty in art, more a moment of escape from the possible dislocation and negation that representations of a desirable male body might provoke.

This detachment is marginal in the context of Winckelmann's more powerful projections of desire in his letters. His writing becomes most compelling, particularly later on, where desire is integral to his self-representation as a

friend to another man. The bonding of friendship is animated by desire in a social and sexual discourse where the question of whether this friendship did, or might in the future, involve a sexual relation could not be articulated explicitly—could not be affirmed, but could not be excluded either.

Winckelmann's declarations of friendship in his letters produced some of his more finely tuned and carefully crafted writing. Defining himself as the subject of male friendship became for him every bit as important, if not more so, than defining the nature of Greek beauty. Take, for example, the following apostrophe to an old friend from university days with whom he had just re-established contact:

> You, who have remained the only one to whom I write as brother [Winckelmann uses *du*, the informal mode of address]! As we were separated by mountains and rivers, I thought that I had been forgotten by you when your letter that gave me [such] pleasure was delivered to me. I pressed it to my heart and lips, because it came from the hands of one to whom a secret attraction drew me in the first bloom of our years [*zu dem mich eine geheime Neigung zog*]. As in a picture, I conjure up our entire youthful history.[147]

Another more 'public' panegyric to male friendship, addressed to someone with whom Winckelmann had a less close involvement, occurs in a letter to John Wilkes. Winckelmann had met Wilkes in Rome in 1765 at Carnival time, and their encounter was only very brief. But it established a relationship, developed in a subsequent exchange of letters, of which Winckelmann would claim 'I can call [it] friendship.'[148] Winckelmann's declaration is particularly interesting, not only because it presents the cultivation of friendship as such an important ethical ideal for him, and sets up a complex interplay between 'friendship' and 'love'. Here he projects the ideal of Greek friendship as a utopian fusion of the enjoyment of a passionately invested bonding with another man and dedication to the public cause of liberty. Winckelmann invoked in this context the memory of the celebrated friendship between the two Athenian tyrant-slayers, Harmodius and Aristogiton. Thinking of Wilkes, he saw how manly desire and the politics of freedom might also come together in the modern world, but as something that he himself would probably only be able to experience as absence:

> A long solitude, when I was left abandoned to my own devices, has given me means to study this virtue, of which all the world speaks without knowing about it. I studied it, as one should study a science, and friendship takes the place of love for me, that is, it becomes passionate, delicate, and like love grows through being distant from the object to which I have dedicated myself. I ventured to make this declaration to you, knowing that in the olden days liberty was often brought about through friendship.[149]

Endings

In Winckelmann's last few years in Rome, after he had published the *History of the Art of Antiquity*, and after his failed dedication to Berg, a different self-projection begins to emerge in his letters. With hindsight we can too easily read this as a kind of retreat from his powerfully articulated, if continually frustrated, claims to self-realization in his earlier years. Yet the 'late' self is if anything a more sustained and richly evocative creation than his earlier attempts at self-definition. In a sense the literary creation of a persona had now become his central project. It was at this point that he turned to Stosch, representing a new mythology of friendship that he quite explicitly conceived as a reaction against the more powerfully charged failed friendships of his earlier years—with Berg, with Lamprecht, and also with the painter Anton Raphael Mengs.[150] To Stosch he wrote in December 1764:

> I am becoming ever more convinced that you of all my friends, including those whom I have praised in public to the whole world, are the truest and most reliable. Since I had been unlucky until then with three friendships, I had the greatest reason in the world . . . to decide to stifle all my feelings, were it possible to do so, and my mind and soul were in this upheaval [*in dieser Gährung*] when you arrived in Ancona.[151]

The dedication to Stosch in his *Remarks on the History of Art* then read as follows:

> I place your name at the front of this work, less with a view to providing a dedication than to take the opportunity of making a public declaration of our well-tried friendship, which is of a higher nature. If the strength with which friendship grows through absence can be proof of its truth, then ours has this rare advantage that . . . the more distant you are, the greater my longing and love have become. In the relations that I have sought to establish with other people, I believe I have been the more active party. In our case I concede this priority to you. There is one single desire, however, that both of us have not been able to realize in our friendship, namely that enjoyed by the painter and sculptor during the making of a work: which is to shape and create our friend. For we were already made for one another, and became friends in the same way that the very first man was created, like a high and sublime image, achieving greatness and fullness not bit by bit, but all at once.[152]

Winckelmann insists that he is offering something quite different from a conventional dedication, for he makes it clear that this one is to be seen as a gesture of friendship that breaks with formality. It is written in the form of a personal address to the dedicatee, almost as if it were a letter. The conception of friendship it presents reiterates a number of important themes in his writing,

such as the claim that the more intense feelings of friendship are produced through absence, and that love is to be associated with living out something of 'a higher nature'. This dedication, however, has nothing like the erotic charge of the dedication to Berg. The one explicit mention of 'desire' is not erotic, and the affinity between himself and Stosch is represented in terms of the disembodied, asensual 'high' style. There is also a note not in evidence in the earlier dedication, a new self-consciousness and distancing, which produces split between the phantasized image of the beloved as a pure projection of the speaking self, and the image of the friend as an entity existing independently of and prior to the self's desires. The dedication to Berg presented 'an image of the friend' that was Winckelmann's own highly wrought ideal creation. It was the fantasy of a lover totally transported by falling in love and it projected much more intense expectations, in which more was at stake, more was being risked.

In the dedication to Stosch, friendship was something of a compromise with that intense projection of the self's desires. It was as if Winckelmann had moved beyond the point where he could any longer envisage the simultaneously ideal and erotically charged images conjured up in his recreation of Greek art as the model for a friendship he himself might be able to enjoy. Circumstances were such that he could not hope to fabricate the private world he lived in anew in the form of the Greek ideal, he could not 'imitate the Greeks'. In this failure he elaborated a less emotionally charged ideal of friendship, and one that was more reciprocal, less exclusively sustained by his own desires, where he no longer had to take 'the more effective part'. The conclusion to the dedication to Stosch, conjuring up his planned but never realized return to Prussia 'in order to see my most worthy of friends face to face, so I can bring back [to Rome] his image renewed within me', reinforces the active role of the dedicatee.[153]

Winckelmann's aborted trip to Germany, on which he set out in April 1768, never to arrive, should have been the culmination of his successful career, a triumphal return to his homeland as one of Europe's most successful writers and scholars. It should also have been the realization of a more private desire to enjoy the company of several close friends from whom he had long been separated. But in the more emotive letters that he wrote in anticipation of the visit, these positive expectations are less in evidence than the hope for some mitigation of his present desperately circumscribed life in Rome. This is how he described the situation to Friedrich Wilhelm von Schlabbrendorf, a young German aristocrat, who knew Stosch, and with whom he had developed an increasingly warm correspondence ever since their meeting in Rome:

As far as you can you need to plug or hack off entirely all channels of displeasure, for the latter finds unsuspected hidden passages through which it can penetrate to us. On my journey I should at least place no furrow on my brow that has not been etched there already. I shall be like a field that has long lain fallow, and shall be giving vent to a gaiety and foolishness which

have been dormant within watched by one healthy and one sick pair of eyes [Stosch had just been ill]. At present I often feel like a person who would like to bring up something and cannot [*der sich übergeben wollte und nicht kann*]. With my old friend [Albani] the year has no springtime and is like a tree that gives out no blossom; and I am quite cut off from other Italians. I have to be happy on my own, and I am that, for I can pride myself on being one of the very human beings who are content with their lot.[154]

The self he projected at the very end is still a 'free' self, but one that enjoys freedom only by stifling any desire that might take it beyond its immediate desolate self-containment, a freedom achieved in self-dispossession, that precludes the active enjoyment and perturbations of what Winckelmann called friendship. This stands in marked contrast to the expansive and Epicurean self-image projected in his earlier letters from Rome, 'a constant cheerful spirit and an indifference towards life, only relishing it cheerfully'.[155] It was as if his earlier 'extreme' ambitions and impulses to self-realization, and the inevitable pain and disappointment they brought, had to be 'hacked off', as he put it, if he were to survive. And though Germany offered a different prospect, it was above all a place where warmth of friendship was being realized as a kind of fiction in letter-writing. The real Germany did not necessarily hold out much promise, particularly given its painful associations for Winckelmann with a past of material dispossession and what he called 'servitude [*Knechtschaft*]'. His self-projection had reached a point of radical negation, and the only free self-sufficiency of which he felt he could be sure was one enacted within that negation.

There were still circumstances in which Winckelmann would fantasize about a free and active enjoyment of friendship, but these were where the possibilities of encounter were forever deferred. To Riedesel, a young Prussian who had become one of his more intimate correspondents in his later years, he wrote in the summer of 1767, savouring the still as yet open and undecided prospects of either going with Riedesel to Greece or visiting Stosch in Prussia:

> full of good wishes, love and warm friendship, but at the same time not without great confusion [*Verwirrung*], I answer you: for I am torn between Greece and my fatherland. In this great conflict, where thousands of enchanting images pass through me in quick succession, leaving my heart and feelings wavering, my greatest consolation is the sweet hope of enjoying you soon in body and mind, and with total freedom and unlimited devotion [*in aller Freiheit und mit unumschränkter Eregebenheit*], and also the idea that I am free and not tied down and able to follow you.[156]

The trip to Greece never took place, nor the visit to Stosch in Prussia. In a sense, Winckelmann chose not to realize either of these projected meetings with friends. Why he curtailed his trip to Germany, suddenly stopping short in Vienna to return to Rome, he could not explain even to his closest friends

waiting to meet him in Prussia. His only excuse was that a severe and uncontrollable depression had seized him.[157] The enjoyment of a free and easy friendship, which offered an escape from the retrenched self-denial in which he increasingly felt himself trapped in Rome, was something whose fictional status he almost seemed to want to preserve. Or perhaps he was in the grip of such a deep depression that it was impossible for him to imagine how an intimacy could be realized that would provide any real relief. As he wrote to Stosch about his decision to break off his trip: 'the enjoyment of peace and quiet with you would only be of short duration, my sweetheart, and I should have to stop in a hundred cites on my way back, and as many times start life over again.' For all its negativity, the measure of self-possession he had achieved in Rome was something he seemed to be afraid of losing. I am convinced, he said, 'that outside Rome I have no hope of any true pleasure, as I should have to buy this with a thousand inconveniences.'[158]

In a letter he wrote to a former colleague at the Bünau library, Francke, with whom he was not normally in the habit of being enthusiastically affectionate, the poignant fantasy of connecting with his lost past in Germany mingles strangely with an eerie image almost anticipating his impending death:

> At last I shall have peace in the place where we hope to see and enjoy one another's company, a place I cannot recollect without the innermost stirrings and tears of friendship. There I wish to leave the world as I entered it like a light-footed traveller. I consecrate these tears that I shed here to the elevated friendship that comes from the womb of eternal love, which I have achieved and found in you.[159]

The image of his leaving life as he 'entered it, like a light-footed traveller [*leichter Fussgänger*]' echoes directly what he had written the previous month to another librarian-scholar whom he had known in Dresden, Christian Gottlob Heyne: 'I step out of the world like a light-footed traveller, with cheerful mien, and poor as I entered it.'[160]

This was not just a figure of speech. From his present social vantage point he had, as the son of a cobbler, quite literally entered into the world with nothing. But in a sense he was also leaving it with nothing—for all his fame, he did not enjoy anything approaching the material security of a gentleman of means.[161] He literally had no home to which to return, and this in a double sense. He became alienated irreparably from his immediate background once he went to university, and particularly once he started moving in court circles. Enlightenment culture provided no paradigm for a successful scholar and man of letters such as he became to represent his working-class origins in positive terms, even to an intimate circle. Winckelmann was only able to project his background as a nothing from which he had emerged to become something. There was the added factor that all his known relatives were dead, something he saw as putting him in an unusual position of isolation. In April 1767 he wrote

to Stosch: 'I have no relatives left in the world, which probably makes me an exceptional case.'[162]

If Winckelmann had wished to fantasize about retreating from the pressures of public life, and to imagine taking to heart Voltaire's dictum in *Candide*—'il faut cultiver son jardin (you must cultivate your garden)'—he would quite literally have had no refuge, no garden of his own to which to retreat. At most he had an imagined community of friends, fashioned in their absence through an exchange of letters. And the particular circumstances under which he was able to return to Prussia hardly provided an opportunity to realize such a community. He had to arrange to meet Stosch and Schlabbrendorf at the Prince of Anhalt Dessau's residence in Dessau, a context defined by the grace and favour of a patron, and not one in which he could be assured of enjoying a free and easy intimacy on his own terms. There was then a radical contradiction inherent in Winckelmann's fantasies about a 'return' to Prussia, about which his letters show a powerful self-awareness. On one hand there was an expectation that the warmth projected in his writing might now be lived out in an actual communion with friends. Equally there was an awareness that perhaps no imaginable space existed for such a fantasy to be realized.

Winckelmann's image of 'a light-footed traveller'—both light of step and lightly laden—offered a mythic yet dispossessed kind of freedom. Though he was the author of several major books, and an internationally renowned scholar, these achievements seem to be detached from any substantive identity that he could claim as his own. In his self-perception there was now both a total freedom and a radical alienation. Quite literally not having a home, nor any close relatives, not seeming to belong by right to a community of social equals, nor enjoying the privileges and material security of an independent man of means, and effectively precluded by social convention from publicly affirming a definite sexual persona, he was unusually unencumbered, save by the anxiety aroused by this lightness of being. To see himself as a 'light-footed traveller' was to represent himself in the impossible 'high' mode, through an image that was very clear and simple yet insubstantial. He had construed a fantasy of self divested of any weighting from the fabric of the culture he inhabited. Was he now the shadow of some mythic Greek hero, or was he no more than a common pilgrim or tramp without any possessions to his name?[163]

CHAPTER VII

Afterlife

JACOBIN POLITICS AND VICTORIAN AESTHETICISM

Among many ways in which I might have defined the historical afterlife of
Winckelmann's work, I have deliberately singled out two very loaded engage-
ments with his image of the Greek ideal, the first connected with the politics of
the 1789 French Revolution and the second with late nineteenth-century aes-
theticism and definitions of homosexual identity. In each instance, a distinctive
combination of historical circumstances made Winckelmann's conception of
Greek art particularly compelling as the model of a utopian freedom and de-
sire. Equally, these apparently conjunctural encounters were mediated by
eroticized and politicized ideals of beauty and of self pervasive in modern
Western European culture, which gave Winckelmann's writing and persona
such resonance even to those who began to be aware of a historical distance
separating their own world from his.

My choice is hardly objective, but neither is it arbitrary. It is informed by my
own interests, and unapologetically brings to the fore issues of political ideol-
ogy and sexual identity that I consider crucial. At the same time, my particular
perspective is determined by the larger cultural afterlife of Winckelmann's
writing. My view of his work has been moulded by my encounters with earlier
evaluations of his project, and the more urgent and persistent issues these have
raised are inevitably echoed in what I have chosen to emphasize. There is at
work here what a Freudian would call a certain *Nachträglichkeit* or 'deferred
action'.[1] Winckelmann's text acquires much of its present-day resonance from
traumatic redefinitions of ideological formations of the self and ideal self-
images that historically postdate Winckelmann, but which nevertheless cannot
now but inform our reading of his work.

In one case I explore the French painter Jacques Louis David's attempts to
represent a republican revolutionary ideal by way of the image of a beauti-
ful, sensually charged, male body. This highly politicized projection of a
Winckelmannian ideal is located at the heart of radical Jacobin utopian images
of a politically free and regenerated subjectivity. We shall see how repressions
modulating the apparently immaculate forms of this image of an ideal mascu-
line ego echo tensions and contradictions inherent in Jacobin political ideology.
In the other case I shall be looking at Walter Pater's richly invested identifica-
tion with and slight distancing from the model of a 'gay' male identity pre-
sented by Winckelmann. Pater both celebrated the image of an aestheticized

sensual manhood he discovered in Winckelmann's writing, seeing it as the model of a self unencumbered by the prohibitions and complexities of modern sexuality, and yet could not quite embrace this model wholeheartedly. I shall be exploring his unease over the active political aspect of Winckelmann's Greek ideal, as well as his intense yet ambivalent engagement with the eroticized 'narcissistic' aspect of this ideal as it emerges in Winckelmann's writing. In each case, we shall see how the Greek ideal's apparent simplicity and wholeness was moulded by tensions, often violent, that it was seeking to displace.

REVOLUTIONARY HEROES[2]

The narratives that unwittingly grip our imagination today are rarely those of renovation, of progress and triumph, but more of dislocation and dismemberment, of irreducible disparities of interest and desire. When, in the later eighteenth century, the call to renew modern art through a return to the pure and simple forms of the antique combined with the demand for political rebirth through a revival of the elevated public values of ancient Greece and Rome, an ideology emerged that seemed to promise a new fusion of desire and virtue. It was as if a radical alternative to the worn-out and corrupt *ancien régime* were being glimpsed in the mythic unities of a rejuvenated classical ideal. What is most striking from our perspective, however, is not so much the utopian aspiration to abolish the excesses and corruption of modern culture by reviving a simpler and truer art and politics. We are probably more aware of the modern stresses and anxieties inflecting the clear outlines of this intensely imagined classical past.

Here we shall be exploring a highly charged engagement with the classical ideal associated with the radical Jacobin phase of the French Revolution, which reconnects with Winckelmann's attempt to represent the beauty of the Greek ideal as the embodiment of political freedom.[3] In particular, we shall be concerned with the work of David as an artist who, unusually, managed to bring to bear on his artistic practice a very active engagement with revolutionary politics. His work in the 1790s effected a particularly fascinating conjunction between the aesthetic resonances of the classical ideal and the political ones of the new republicanism. At issue is not just a general association between the antique and republican freedom, but something more complex and demanding, a loading of the distinctive beauty of the ideal nude with highly politicized notions of a truly free subject—a synthesis constantly threatened with destabilization. Looking closely at the tenor of David's engagement with the antique in the immediate aftermath of the 1789 Revolution, no less than exploring the resonances of Winckelmann's earlier identification with the Greek ideal, is to be made acutely aware of radical disjunctions within the apparently purified unities of Neoclassical imagery, disjunctions that are not just circumstantial and contingent, but central to its rhetorical power.

In the earlier work by David designed to be loaded with ethical or political significance, there is a fairly obvious way in which the resonances of style and message fit together. Ideas of heroic austerity, of virile nobility, could apply equally to the message or to the formal conception of such works as the *Oath of the Horatii*, the *Death of Socrates*, and the *Brutus*. As spectators, we might wish to identify with and admire the Horatii, but we are not invited to desire them. This changes in a number of works that were produced or had their origins in the 1790s. The rendering of the male figure is more sensuously graceful and beautiful, and the relation between its now nude rather than austerely draped forms and the political ideal supposedly embodied by it no longer seems so direct. This new phase in David's classical history painting was seen by contemporaries as marking a turn to a formal preoccupation with ideal Greek beauty, which, according to Delécluze, David's biographer and student, David himself felt to be a programmatic departure from the less aesthetically pure 'Roman' artistic vocabulary he had used before.[4]

The change is not necessarily to be seen as a retreat from politics into aestheticism. It is particularly in evidence in *The Death of Bara* (Plate 42), a work like the austere and manly *Death of Marat* produced at the height of the most radical phase of the French Revolution, in which David was so closely involved. With the *Bara*, which has often been singled out as peculiarly Winckelmannian in conception, and also to some extent with *The Intervention of the Sabine Women* (Plate 41) and the *Leonidas* (Plate 43), there is a fairly straightforward, if not particularly compelling formal connection between a noble political message and an artistic style. Elevated subject-matter requires the most elevated possible artistic vocabulary, the pure forms of the antique ideal nude. But the rhetorical power of the latter derives from an erotic engagement with the body, with bodily beauty, which is not conventionally associated with ideas of austere virtue. Indeed in the late Enlightenment, the elevation of thought informing political virtue was if anything seen to be at odds with the erotic and the voluptuary. What is going on, then, when a 'manly' politics of freedom is being invoked by way of an intensely sensual bodily beauty? It is here that the conjunction between a beautiful art and a high ideal projected in Winckelmann's *History of the Art of Antiquity* becomes relevant.

In the immediate aftermath of the 1789 Revolution, the aesthetic ideal cultivated by politically committed artists would seem to relate quite closely to David's earlier 'manly' Roman style, and not to the more voluptuary Winckelmannian Greek ideal. Take the attempts made in the early 1790s to define a revolutionary artistic practice, as recorded in Détournelle's *Journal de la Société Populaire et Républicaine des Arts*. A much quoted entry dating from 1794 talks about how the art of the new republican order, which would inspire love of virtue and hatred of despotism, would be characterized by 'masculine contours, an energetic drawing'. But this entry comes close after another in which Winckelmann is invoked as 'the only one to have described with some dignity the beauties of the antique',[5] that is, as the best guide to understanding

the vocabulary of a truly regenerated classical art. It is just at this point that David's own art gives evidence of a re-engagement with the antique in which bodily beauty and sensuality start taking precedence over the austere muscularity of his earlier, more obviously heroic, or should one say stoically virile style.

Before analysing this turn in David's work, we need to look at the evidence that Winckelmann's writings, and in particular his Greek ideal, were a significant presence in French artistic culture of the period. The years around 1790 do indeed mark something of an upturn in French engagement with Winckelmann's *History of the Art of Antiquity*. The new translation by H. J. Jansen, which first appeared between 1790 and 1794, re-established Winckelmann's text as the fullest compendium in French of information on the art of antiquity, bringing it up to date with a vast scholarly apparatus of notes and supplementary articles. At this point the text ceased to be purely Winckelmann's, and functioned as an encyclopaedia of the art of antiquity. Together with turning Winckelmann's book into a monument, his conceptual framework came to be examined in a much more thoroughgoing way than before. His analysis of the aesthetics of the antique ideal, and of the political and cultural context that fostered the flourishing of Greek art, became a major point of focus for the ideologically charged debates on the history and aesthetics of art taking place at the time.[6]

Central to the reputation Winckelmann enjoyed among the more politically radical artists and theorists was his eloquent formulation of the widely held view that 'freedom' was the 'principal cause of the pre-eminence of Greek art', and that art had inevitably gone into decline once this political freedom had been lost, particularly under the Roman Empire.[7] For obvious reasons, a theory that there existed an intimate connection between a purified classical aesthetic and the politics of liberty enjoyed an unprecedented vogue in France in the years immediately after 1789. Winckelmann could readily be assimilated to the view that a true revival and flourishing of art would be directed against the accepted values of French *ancien régime* court culture, and would emerge from a revival of the republican freedom of early Greek and Roman antiquity. But it was then no longer simply a matter of looking back to early Greek antiquity as a utopia, when art was free from the repressions and corruptions of the modern court. Now the concerns were much more immediately political: how would artistic practice respond to the conditions of liberty produced by the overthrow of the French monarchy?

After the first flush of libertarian enthusiasm, when middle-class radicals looked forward to a spontaneous efflorescence of art and culture stimulated by the newly reactivated spirit of liberty[8]—when Winckelmann's ancient Greece seemed to provide a model for a regenerated republican France—we begin to notice a tension developing between overtly political talk about the function of art, and aesthetic talk about the Greek ideal and the fostering of a purified artistic practice based upon it. A combination of a desire for a fusion between political freedom and aesthetic beauty, and an anxiety over a potential split

between the two, was already an issue in Winckelmann's writings, even if it did not have the same direct political urgency, nor was explicitly debated, as it was to be in French artistic circles in the 1790s. The deliberations of the Société Populaire et Républicaine des Arts indicate that, already by 1794, a concern was mounting among the more politically aware members of the artistic community that aesthetic standards might have to be artificially encouraged even under the new conditions of republican freedom.[9]

This implicit questioning of the utopian desire for an integrated unity between the aesthetic and the political, between great art and republican freedom, marks a prelude to the re-institutionalization of artistic education and doctrine with the foundation of the Institut under the Directoire. Eventually what emerged was what we might call a post-revolutionary academicism, which was quite sceptical of the libertarian expectations of artistic renewal through political change that made Winckelmann's projection of the connection between art and freedom such an important point of reference in the years just after 1789. If we look ahead to the essays produced for the competition sponsored by the Institut in 1801 on the causes of the perfection of antique sculpture, we notice not only a new stress on correct artistic doctrine and a certain disillusionment with the idea that good art and political freedom necessarily went hand in hand. There was also a quite un-Winckelmannian tendency to mark out a separation between the artistic and political spheres. The influential apostle of a bureaucratic *juste milieu*, Eméric-David, for example, cited the precedent of Greek antiquity as an example of how a classical perfection in art could be sustained despite political change and turmoil. Fostering a modern equivalent of the Greek ideal was projected as purely a matter of artistic policy, which could operate in safe isolation from the more disturbing vicissitudes and confusions of political life.[10]

Even in the early 1790s, when classical aesthetics and a republican political idealism did seem naturally to go together, one central issue tended to be evaded rather than addressed directly—how precisely did the sensual forms of the ideal nude actually symbolize or embody the elevated ethical and political values associated with political freedom? It was in this context that another aspect of Winckelmann's writing was of particular importance for French revolutionary artistic culture, namely his famous descriptions or close readings of the best-known masterpieces of antique sculpture. These were widely quoted and paraphrased at the time. Not only do they feature prominently in Détournelle's *Journal de la Société Populaire et Républicaine des Arts*, but Détournelle relied on extensive quotations from Winckelmann to suggest a correlation between the beauty of antique statuary and ideals of political freedom.[11]

It is because Winckelmann's descriptions project both the erotic charge and the elevated meaning of these works with such intensity that they reveal so much more than other writings on the antique in the period about how the sensual forms of the ideal nude might be read as embodiments of the high

values associated with the antique. This also means that Winckelmann exposes the problems involved. We encounter directly, within Winckelmann's descriptions, a usually unacknowledged disparity between images that are redolent of the pleasure associated with either looking at a beautiful body or fantasizing that one inhabits such a body, and the more abstract conception of ideal beauty as a signifier of an elevated free subjectivity. Can the body that gives the most intense pleasure also be the one that most powerfully evokes a free expansive subjectivity produced by political freedom? As we have seen, Winckelmann's readings answer both yes and no. And this unstable correlation is played out again in interesting ways in David's overtly politicized attempts to project an aesthetically purified 'Greek' image of the male body as the emblem of an ideal heroic self.

The gendering operating in both Winckelmann's and David's time made the male body the only possible focus for such an unstable and highly charged conjunction. This is a simple factor of the casual exclusion of the feminine from most radical eighteenth-century discourse about the free subject. Moreover, the ideal female body in art conventionally had a relatively simple function as a signifier of sensuous beauty, as the object of desire, uncomplicated by association with more austere ideas of freedom and heroism. It was only in the representation of an ideally beautiful male body that tensions between the body as the locus of pleasure and desire, and an ethical investment of the body as the sign of an ideal subjectivity, the ideal subjectivity of the virtuous and free republican subject, could be played out. This gendered distinction between the ideal male and female nude is quite explicit in the differential responses to the most widely celebrated male and female figures surviving from antiquity, the Apollo Belvedere and the Venus de Medici.[12] Thus a French writer on art and champion of Davidian Neoclassicism, Vivant Denon, cited Winckelmann's characterization of the Apollo (Plate 19) when posing this antithesis between it and the Venus de' Medici (Plate 25): 'it has been said "that one has never looked at the Apollo without oneself adopting a prouder attitude". I believe that one can say that one has never talked about the Venus without attaching to its name a caressing epithet.'[13]

The complex investment of the ideal male nude in Winckelmann found increasingly fewer echoes in the new wave of art theory produced in France after the fall of Robespierre, when the idea of an institutionalized art academy again began to gain a hold. The later discussion of the antique ideal tended to exclude explicit evocations of the erotic and the body, as it did the contentiously political. In this high aesthetic domain, pleasure was allowable only in so far as it could be conceived as categorically different from bodily lusts or desires, just as the ethical significance of art came increasingly to be severed from the supposedly 'prosaic' realities of politics. In Quatremère de Quincy's unbendingly abstract definitions of ideal beauty, or Eméric David's unremittingly bureaucratic analysis, such issues are almost hysterically repressed. Winckelmann's 'over-enthusiastic' prose began to elicit a certain amount of

41. J. L. David, *The Intervention of the Sabine Women*, oil, 1799, Louvre, Paris.

sceptical commentary,[14] even while his descriptions remained an indispensable point of reference for those seeking to convince their audience that the Greek ideal could be intensely evocative of sensual interests and desires without their having to spell this out themselves.

Here we shall focus on two works by David, *The Intervention of the Sabine Women*, conceived in 1795 and completed in 1799, and *The Death of Bara*, produced in 1794. The *Sabines* (Plate 41) is the less problematic and strenuous work, and could be seen as operating in a mode comparable to Winckelmann's conception of the beautiful style. A graceful and sensuous beauty is very much to the fore, and high or austere value intimated at one remove. That the picture invites a new kind of reading, in which the bodily beauty of the male figures plays a central role, as distinct from some austerely virile presence more conventionally associated with the figure of the hero, is evident in Chaussard's classic analysis of the work published in 1800.

When Chaussard defines the relative significance of two main protagonists

in the drama, Romulus, on the right, is singled out as the dominant figure for being the most intensely beautiful, while Tatius, his foil, on the left, is seen as more prosaically virile. Romulus is 'in the attitude of a demi-god, calm, elevated, above humanity, *beautiful in his youth and heroism*'. Tatius, on the other hand, is 'closer to a mortal (form) in the sharpness of his contours, and in the expression of his face, where ferocity mingles with courage'.[15] Beauty rather than character or action has become the primary signifier of heroic virtue. The imposing yet supply graceful figure of Romulus has certain affinities with the image of the Apollo Belvedere (Plate 19) as projected by Winckelmann. Its powerful expansiveness is represented, less as calmly noble than as *both* violently dominating and irresistibly seductive. It is through a potentially unstable conjunction of heroic strength and exquisite sensuality that the figure acquires its charge. There is though one very significant difference between Romulus and Apollo. With Romulus the gesture of violent domination is forever blocked. Heroic self-realization in an act of unthinking destructiveness is stalled by the intervention of the female figures. The warrior ethic is both projected as compellingly beautiful and held in check. As in almost all David's more ambitious canvases, a tension charged by an ethical value visibly ruptures the apparent classic unity of the picture.

Significantly, Chaussard's reading puts the figure of Hersilia, who at one level is the central motif, the activating force suspending the imminent cataclysm, in a secondary role. In his reading, this draped female figure functions as the vehicle of dramatic sentiment and expression, and as such does not have the same highly charged presence as the beautiful, heroic male nudes. Here we have echoes of Winckelmann's theory that what is most essential and highest about a figure is made manifest in a state of repose, and can only be veiled or distorted by action.[16] The naked male bodies are the embodiment of an ideal subjectivity, while the draped female body acts as the organ of feeling and expression, as in some sense a cipher in a drama grounded in the male figures' presence.

The unspoken assumption at work in the masculine gendering of the figure that is ethically exemplary as well as physically desirable is quite clear. The ideal subject, the exemplary subject of freedom, is assumed to be a man. The beautiful male figure can thus function as both an ideal object of desire and an ideal subjectivity with which the male spectator can identify. In this ideological and sexual economy, the female body is either a marginalized erotic image, denied the ethical and political investment given to the male body; or it functions in a quite different mode. Clothed, austere, maternal, it becomes, as in Winckelmann's scheme of things, a de-eroticized and hence partly disembodied signifier.[17]

It is in the interest he shows in a relatively marginal figure in the picture, however, that Chaussard makes most apparent a Winckelmannian preoccupation with the sensually charged beauty of the male nude. At first sight, his singling out of Tatius' exquisite young equerry might seem rather arbitrary.

42. J. L. David, *The Death of Bara*, oil, 1794, Musée Calvet, Avignon.

But the figure is not just enjoyed for its formal perfection. Rather it is assigned a value that derives precisely from its apparently gratuitous youthful beauty. According to Chaussard, 'this figure is perhaps the most beautiful of the painting, at least it is the one that best recalls the beautiful antique.' As such, it cannot participate in the action, the artist fearing 'to dilute its beauty by giving it any expression other than that of ingenuousness'. Its role in the picture is to embody 'those youthful and admirable forms that are redolent of the ideal'.[18] At one level, the figure is an exercise in formal perfection; at another, its presence as 'pure' self-absorbed body, detached from the drama, enables it to act as a signifier of an ideal world that is more immediate, less encumbered than the whole complex drama. As in modernism later on, the signification of some higher value becomes more direct and intense by virtue of its self-referentiality. But what value?

This is the point to turn to the earlier painting of Bara (Plate 42), where the issue takes on a special urgency. For here there is no obvious signifier other

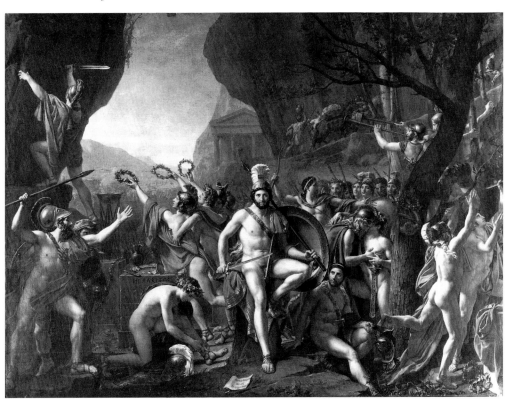

43. J. L. David, *Leonidas at the Pass of Thermopylae*, oil, 1814, Louvre, Paris.

than an erotically charged, naked, youthful body. At least this is how David left the incomplete painting, whose destiny as a public image was frustrated by the fall of the Jacobins and the suspension of the revolutionary martyr cult for which it had been conceived. Though the painting's power is integrally bound up with the nudity of the figure of Bara, it has been argued that David might at some point have intended the figure to be partly draped. But he left it nude, and displayed it prominently in this form in his studio as a work that had a special talismanic status for him. A largely nude format would be consistent with David's other famous, completed, martyr image, *The Death of Marat.* Nudity also makes sense in relation to the figure's symbolic function as a timeless exemplary icon, rather than a particularizing dramatization of a historical event.[19]

The work has a fascinating and unusually fully documented history as a political image, some details of which are worth recalling here. Its political genesis located it quite explicitly in the realm of ideal imagery. The story of the

boy martyr Bara was a carefully fabricated myth created by the Jacobin govern-
ment when it was trying to mobilize popular support for an ideology of purified
revolutionary virtue in the months before its overthrow in July 1794. The
mythic aspect of the story of Bara is already in evidence from the very moment
when a report was read to the Convention in December 1793 about a boy called
Bara, attached to the Republican army fighting in the Vendée, who had been
killed by counter-revolutionary insurgents. Robespierre exploited the interest
aroused by the incident, skilfully reinventing the somewhat prosaic circum-
stances of Bara's reported death. In a speech to the Convention a few days later,
he refashioned the story of Bara's dying moments to make of it an exemplary
drama of virtuous self-sacrifice, in which the youth expired proclaiming '*Vive
la République*' in defiance of his murderers' demand that he capitulate and
repeat '*Vive le roi*.' In the following months, David brought to bear his own
highly charged visual and verbal rhetoric to amplify further this mythic apothe-
osis as he took charge of the official commemoration of Bara and another boy
hero called Viala.[20]

Some of the more carefully thought out recent interpretations of the picture
seek to make it less problematic it by pointing out that the apparent strangeness
of its depiction of a naked youth clutching the tricolour to his heart arises from
our tendency to read such works naturalistically, rather than allegorically, as
they were originally intended. To see the figure's exposure as intimating viola-
tion, as did some critics writing after David's death, when they envisaged Bara
as brutally unclothed by the brigands who killed him, would be to betray an
anachronistic romanticism. The beautiful and graceful nudity is to be seen as a
formal idealizing device that makes the figure into a more effective signifier of
heroic virtue than a naturalistic clothed image of the boy hero. Any disjunction
we might see between ideas of virtue and the eroticized presence of this
seemingly helpless naked body is not integral to the image's public or political
signifying power. Its message would be in tune with the comments David made
in his famous discourse to the Convention, when he called for a commemora-
tion of Bara and the other boy hero, Viala, 'that bears, following their example,
the character of republican simplicity, and the august imprint of virtue'.[21]

If we leave things here, however, we are in danger of falling into a kind of
formalism that mirrors the earlier academic appropriation of David's work as
the embodiment of a purified classicism. We are bracketing out the rhetorical
power of the image, and its invitation to erotically charged and violent readings,
on the grounds that these seem to be irrelevant to the public political meanings
it was intended to convey. But this rhetoric is not just something that has to do
with private, romanticized responses to the work, but rather with its potential
public significance. There is no denying that, at a certain level, the image had
to be open to a simple reading. It must have been conceived as a vehicle for a
clear political message of the kind envisaged by David and Robespierre in their
speeches to the Convention.[22] But some rather intense and potentially disturb-
ing complexities are inevitably introduced when, as here, ideas of virtue, of

political heroism and freedom, are being projected onto and through images redolent of desire. Some overloading of David's apparently simple image of Bara is intrinsic to its historical condition. It lies at a conjunction of extreme ambitions, both political and aesthetic, and still interests us today as being caught up in the over-determined failure of these ambitions. So much is invested and repressed in this conception of an unblemished yet damaged subject of a pure yet violated freedom and virtue.

If we are to see the conjunction of psychic and political fantasy in the Bara as echoing aspects of Winckelmann's conception of the ideal youth, we should still of course have to recognize the major ideological shift between Winckelmann's investment of the Greek ideal and such 'Jacobin' images of revolutionary heroes. In Winckelmann, a fairly abstract notion of elevated value is projected onto the erotically charged, beautiful male body, however explicitly it is associated with political freedom. In the early 1790s in France, not only had the idea of freedom become a site of violent political contention, but the function and evocative power of a public art, the ideological investment in art, had itself become extremely politicized in a way it had not been before. The ideal subjectivity signified by the ideal body, the virtue embodied in its beauty, was a public political issue in a way that it could not have been for Winckelmann. Nevertheless the tensions inherent in the utopian image of a free male subject found in revolutionary culture are not totally distinct from those that surface in the more radical moments of the late Enlightenment. Also shared are the rhetorical devices through which the image of the ideal male body is made into such a powerfully invested motif, devices that work by associating heroic values, or virtue as Robespierre would say, with largely disavowed stirrings of sado-masochistic desire.

In exploring how David's *Bara* might play upon some of the complex tropes of the ideal nude found in Winckelmann, we shall take as read that its ideal nudity functioned as a conventional sign of ideal political value. The point here will be to consider its excessive aspects, which may even appear to be at odds with the first-order reading of the boy as an image that associates the ideal of the beautiful classical nude with the ideal of the politically virtuous subject. It is a matter of trying to understand how the particular formation, the particular aesthetic charge of the figure, heightens and gives body to its political charge. In doing so, we shall see how the conception of the picture both plays upon rhetorical devices developed by Winckelmann in his readings of antique statuary, but also in certain important ways moves beyond the ideological and psychic parameters of Winckelmann's writing. Like his image of the absolutely ideal youth, the *Bara* is both empty and complex, everything and nothing, posited on a simultaneous disavowal and incitement of potentially disturbing fantasies that are only partially displaced, but not expunged, by its 'innocent' youthfulness.

Displacement operates in the very way the figure is presented in a state of rest, as an almost beautiful object of desire, existing beyond the violent drama that is essential to its meaning. The mechanism is akin to that in

Winckelmann's reading of the ideal nude that associates a figure's beautiful, eroticized presence with its self-realization in violent action by way of displacement. At times this can take an intensely violent turn. In Winckelmann's descriptions of the Belvedere Antinous (Plate 31) and the Belvedere Torso (Plate 36), the figure is first and foremost a beautiful being absorbed in its own bodily presence, but it is also possessed of a heroic subjectivity whose unfolding is projected onto either its past or its future. The exquisitely modulated flesh, the supple flowing contours, both efface, while still conjuring up at one remove, the hero's violent trials of strength.[23]

A displacement of this kind operates in the image of Bara, at the same time that it takes a rather different, more destabilizing form. Bara is represented as still just living through the very last moments of an intense drama, dying and clutching the tricolour, not yet entirely transfigured in death—nor, for all his youthful grace and integrity of form, existing entirely beyond the reach of violent threats from the world around. It is in this respect different too from David's Marat, whose transfiguration is more resolved, comparable to that of a dead Christ in a Pietà. The fusion of blissful transfiguration and painful ecstasy achieved on the verge of death puts one in mind of more feminized Christian imagery, such as Bernini's *Ecstasy of St Teresa*. There a female saint is shown in a spasm of bliss and pain as she surrenders to a mystic self-annihilation. The figure of Bara is more suggestive of such a passive surrender to a power greater than itself than it is of a manly feat of heroic resistance.

Bara's body is not just beautiful. It is also violated, shown at the moment of release as death is expunging the boy's pain. Such a trope of the heroic subject, as one who achieves his moment of transcendence in an encounter with death, is deeply ingrained in the cultural politics of Robespierrian Jacobinism. As the Commission d'Instruction Publique put it in an announcement published on the 12 July 1794, the message that the dead heroes of the Revolution have to convey to the people of France is 'How beautiful it is to die for one's country.'[24] The most intensely moving heroic body is a damaged body, one that has the pathos of a vulnerable yet indomitable subject facing annihilation. In Winckelmann, this trope of heroism is very vividly played out in the reading of the Laocoön (Plate 16). The figure's beauty—and its heroics—are made more interesting and elevated by way of its violent struggle against death. The virile body becomes powerfully moving by being represented as threatened or damaged.

Winckelmann's description of the Laocoön, though, is even more illuminating in relation to the Bara with its suggestion that the viewer's experience of the figure climaxes in a conjunction of intensely engaging bodily beauty and violent pain. An unease and fascination provoked by 'beautiful violence', more than the admiration excited by a heroic struggle, is what seems to make this ideal male body interesting. But if the fascination aroused by the *Bara* is also in part derived from projections of sado-masochistic fantasy, these have a rather different inflection because of the suggestions of a feminized pathos and vulner-

ability that simply do not feature in Winckelmann's world—even where, as in his description of the Niobe (Plate 15), he imagines a female figure threatened by deadly violence. It is as if in order to give the boy hero Bara the most intense emotional charge possible, David has to move outside the sphere of masculinity and draw upon the apparently more vivid imagery of a violated femininity. The figure of Bara allows a certain narcissistic identification from the male viewer. But it is also the object of a sentimentalized pity and sadistic pleasure conventionally associated in male fantasy with the female body.

The most Winckelmannian aspect of David's painting of Bara was the way it envisaged a pre-pubertal youth as the purest—perhaps also most elevated—embodiment of an ideal subjectivity. In parallel with Winckelmann, the very highest ideal came to be represented through the image of a boyish youth rather than a mature hero because of the relative absence in the youth of marks of a formed sexual or cultural identity. Bara was conceived as a pre-sexual ephebe, almost hermaphroditic, emptied of the particularities and imperfections of the mature male subject. It was his emptiness or innocence that made him the perfect vehicle for personifying an untainted republican virtue. As Barère explained in a speech delivered to the Convention on 28 December 1793, just after Robespierre 'invented' Bara as a national hero fit for the honours of the Panthéon: 'Generals, representatives, philosophers, may be excited by pride or by some ambition or other; here it is virtue in its integrity, simple and modest, as it left the hands of nature.'[25]

Among the great unspoken distinctions being effaced in this speech, and by implication too in David's painting, are of course those highly contentious ones of class and gender. The image of a young boy displaces questions about social identity much more effectively than that of a man. He can be defined as not having a history, as coming straight from the arms of nature. Yet the ideality of David's figure of Bara is, ideologically speaking, highly specific. He is the Bara of a radical middle-class imagination, besieged by contending populist and revisionist pressures. He is Robespierre's virtuous Bara, who died uttering the words '*Vive la République*', not the plebeian Bara imagined by his protector, General Desmarres, whose dying words would make a travesty of David's image—or should we say whose confused yet vigorous words David's image could only travesty: 'Up yours you useless crook . . .'[26] Similarly we could read the class repressions inherent in David's *Leonidas at the Pass of Thermopylae* (Plate 43), his most comprehensive and ambitious projection of a heroic masculinity, using the words deployed by Robespierre just after liquidating the Hébertists: 'It is a long way . . . from Leonidas to Père Duchesne.'[27]

Again, there is a crucial distinction between David's and Winckelmann's conceptions of the ideal youth that has to do with the implicit femininity of the *Bara*. In David's painting, the 'unvirile' youth was characterized, not just as a presexual male, but as in some sense endowed with a feminine identity. There are intimations of the figure's undergoing some intense erotic experience that produces a quite unmasculine trope of desire. In this attempt to fashion an

image of the ideal self as both hero and martyr, which was as intensely moving
and beautiful as possible, both the forms of the body and the emotional charge
with which these forms were endowed had to be partly feminized.

The painting of Bara was conceived in a context where the issue of feminin-
ity was a particularly contentious one at a number of levels, in ways that had a
direct bearing on the martyr cult of which the painting formed part. Who had
the right to become an exemplary revolutionary subject? In theory, potentially
everyone. But in reality women were partially excluded from this role because,
though they could be victims, there was an injunction against their acting as
public heroes. Male anxieties over the new visibility of women in the public
sphere led to legislation being passed that categorically excluded women from
political life, in a way that had not been necessary before. At the same time, in
the symbolic economy of revolutionary culture, the image of the ideal woman
played a crucial role. The charge attached to the female figure was widely
exploited in the new imagery of the republic. Liberty in particular was repre-
sented exclusively as female. At the level of allegory and symbol, the female
figure functioned as the embodiment of male political desire. David's Bara
might be seen as straddling the differently gendered roles of female symbolic
ideal and male public hero. He was both the feminine embodiment of liberty
and republic and the masculine embodiment of heroic endeavour. He simulta-
neously played the role of passive female victim or helpless martyr and of active
male hero struggling against all odds. S/he was an impossible figure represent-
ing the ideal revolutionary subject as both masculine and feminine, in a situa-
tion where in reality gender distinctions made this confluence quite illegitimate
and the feminine was excluded from self-presentation on the stage of political
life.

In Jacobin ideology, how was the female subject co-opted into the project of
political regeneration and at the same time excluded from it? David's speech to
the Convention on the commemoration of Bara is an interesting case in point
because it is so explicit about the gendered division in an ideal revolutionary
order between male heroics and its female complement. The feminine becomes
the embodiment of pleasure and comfort, set against the violent struggles and
trials of strength of a heroic masculinity. The duality could be seen as both
blurred and reaffirmed in David's *Bara*, whose feminized heroic body seeks to
encompass violent male struggle and the balm of a feminized aftermath in one
image.

David's speech begins with a celebration of the struggle against despotism,
and then turns at the end from the pathos of the dead hero to the rewards await-
ing the battle-scarred heroes who survive. Wounded yet purged in the struggle,
they are imagined as returning to enjoy a life of peace and pleasure, prepared by
the chaste yet fertile women who await them. However, the most intense
beauty achieved in the aftermath of heroic struggle is still in the final analysis
located in the damaged male body. Here is David's address to the young women
of France:

Victory will bring back to you friends worthy of you . . . be careful not to despise these illustrious defenders of liberty covered with honourable scars. The scars of the heroes of liberty are the richest dowry and the most durable ornament. After having served their country in the most glorious war, may they taste with you the sweetness of a peaceful life. May your virtues, may your chaste fecundity, increase a hundredfold the resources of the fatherland.[28]

From a present-day perspective, this hardly sounds like a revolutionary utopia, not least because it seems so unconsciously complicit in the crudest bourgeois repressions and myths of femininity. The pathologies we see operating in such an ideology of rigidly defined sexual difference are nakedly dramatized here in a way that they are not in Robespierre's more abstract, closely argued political speeches, for example. In so far as we can talk about pathology in this context, it is not simply to be ascribed to David as an individual. Given the public context of his speech, it is quite clear that the images and myths he invoked were part of a broader symbolic currency. At their most positive, they could be seen as peculiarly vivid projections of antinomies within a desired revolutionary self, antinomies over-determined by pressures on the Montagnard revolutionaries who were having to distance themselves from, while at the same time still seeking to represent, the forces of popular revolution. David's discourse on revolutionary heroism was caught up in acute political contradictions that later radicals were no more able to resolve than the Jacobin revolutionaries. That his heavily invested images of the ideal revolutionary hero could only be imagined as male was one of its more insistent pathologies, which has continued to haunt subsequent libertarian projections of political regeneration and renewal.[29]

The rhetoric of David's speech, with its insistent yet unconscious intermingling of pathos and desire, of physical violence and sexualized pleasure, with its celebration of the heightened erotic charge of a male body that was simultaneously heroic and damaged, could be seen as having certain affinities with the tropes we identified in his image of Bara. There are significant differences, though, not least because the visual image blurs and perhaps even disturbs the rigidly gendered dualities the speech tries to reaffirm. The world of male heroics David tried to conjure up is perhaps closer to a somewhat later painting by him, *Leonidas at the Pass of Thermopylae* (Plate 43). This representation of an exclusively masculine imaginary world is one that categorically excludes the female figure from the arena of action of the 'free' male hero. The ideal male body takes over the whole panorama of ideal selfhood. He needs no female supplement, or only one that exists quite apart from the heroic male subject's testing ground. In its quasi-totalitarian monism, in its repressive projection of an exclusive masculinity, it might best be seen as the complement to another equally rigid masculine monism, the fantasy of an easeful world of female bodies available only as objects of desire. Ingres's *Turkish Bath* could be seen as

the other side of the coin carrying David's *Leonidas*, equally charged by the libidinal and political economy of an extreme male bourgeois fantasy. On one hand there is a sensuous paradise of flawless eroticized passive female bodies, in which the presence of a virile figure would be a disturbing intrusion, and on the other the ideal world of a heroic and undivided self-sufficient manhood, from which femininity was by definition excluded. If the extreme gendering of these complementary male fantasies about enjoying and identifying with a finely formed body is symptomatic of a dislocation in definitions of male subjectivity in post-revolutionary society, it is one lodged at the centre of the tradition that made the two images possible.

After the massive coherence of the *Leonidas*, its overbearing celebration of a heroic male subjectivity formed in violent struggle, we may wish to return to the relative ambivalence and incompletion of the *Bara* (Plate 42). It is in a way the freer image, leaving more space for varying projections of identity, anxiety, and desire, and it may not be entirely irrelevant that, in strictly historical terms, it is the product of a much more truly revolutionary moment.

It is also the more radically disturbing image, not just because its damaged body is so compelling a representation of the intractable tensions within the libertarian aspirations it seeks to embody. It also raises discomfiting questions about the pleasure we might take in the violence done to a beautifully desirable body. Years later, Oscar Wilde was to put this more nakedly, and with a new depth of self-awareness, when he said 'Yet each man kills the thing he loves.'[30]

Modernity and its Discontents

Walter Pater's important early essay on Winckelmann dating from 1867 offers a curiously ambivalent image of the Greek ideal.

> The beauty of the Greek statues was a sexless beauty: the statues of the gods had the least trace of sex. Here there is a moral sexlessness, a kind of in-effectual wholeness of nature, yet with a true beauty and significance of its own.[32]

The slippage between ideas of 'wholeness of nature' and phrases suggesting lack—'ineffectual' and 'moral sexlessness'—reverberates throughout Pater's analysis of the Winckelmannian Greek ideal, an ideal that was for Pater simultaneously an icon of male self-fulfilment and a denial of the fuller resonances of the self. Exploring the workings of such paradoxes, however rooted they are in the particularities of British Victorian culture, do help to illuminate Winckelmann's project, for Pater was an unusually close and careful reader of *The History of the Art of Antiquity*. Like any good reader, Pater was also extremely partial, and his analysis was driven by preoccupations and disavowals that made him blind to important aspects of Winckelmann's writing, in particular to the eruptions of violent physical struggle that are supposedly tran-

scended by the most purified forms of the Greek ideal. These very blindnesses will help us to clarify precisely what it is that we now find so compelling in Winckelmann's work.

Pater's essay on Winckelmann initially presents itself as the portrait of some supposedly simple other to the turbulent paradoxes of the modern. The epigraph *Et ego in arcadia fui* (I too was in Arcadia)[33] which introduces it, suggests the recreation of a lost utopian world, the whole youthful world of the ancient Greeks. But a troubling unease over a persistent threat of death is also intimated. The Greek Arcadia that Pater evokes is not just framed by death and dissolution. It is of itself insistently imbued with a disturbing absence, with what he calls 'a negative quality'.[34] Pater locates this both in Greek sculpture's 'colourless unclassified purity of life',[35] and in the absence of 'intoxication produced by shame or loss' with which Winckelmann handled 'the sensuous element in Greek art'.[36] While at one level the sensuous plenitude of the antique is being set against its absence in the modern world, lack, loss, and absence are also seen to reside within the very ideal being conjured up. Pater's Arcadian antiquity is not in any commonly accepted sense a culture replete with the wholeness of nature; rather it already contains 'a premonition of the fleshless, consumptive refinements of the pale, medieval artists'.[37]

The supposedly unperplexed realm of self-realization and freedom embodied in the Greek ideal thus reveals a disconcerting absence. Far from effecting a clear separation between classical, medieval, and modern apprehensions of the self, which might allow a stable perspective of the destabilizing dynamic of modernity, the distinguishing features of these different configurations bleed into one another in a disconcerting way. There is no clearly defined other to the anxieties and disturbances of the modern, nor to the denials of sensuous plenitude supposedly epitomized by the dark medieval world, from which the Hellenic ideal was traditionally seen as offering total liberation.

Pater's engagement with Winckelmann's Greek ideal is very different from the Davidian one, not only because the political dimension so important for the French revolutionaries is more or less absent. The politics in Pater is very much a politics of identity, which relates to an individual contemplative self rather than an active public one. But the whole nature of his involvement with Winckelmann is very different. Pater was concerned, not just with the Greek ideal, but also with the persona of Winckelmann as scholar and writer. Pater takes his place in a tradition of writers' and scholars' self-projections through Winckelmann, based on a reading of his letters and biography as well as his archaeological writings, which flourished among German writers in the generation or so after Winckelmann. The most famous and interesting instances are Herder's and Goethe's celebrations of Winckelmann, the latter being the starting-point for Pater's essay.[38] In these eulogies Winckelmann emerges as a peculiarly paradoxical figure—at one level, the new model of a man of letters who fashioned for his time a refurbished classical ideal, on the other the scholar who had been able to bring alive again the lost ideal of the ancient Greeks

because he was so unmodern, because at some level he embodied himself the very essence of the Hellenic ideal from which the modern world had become alienated. As Pater said, Winckelmann 'made himself a pagan for the purpose of penetrating antiquity'.[39]

In the later nineteenth century there was another surge of re-identification with Winckelmann, which coincided with the major expansion of art-historical and archaeological studies in universities in Germany,[40] where Winckelmann functioned as heroic model and founding father. Justi's still famous intellectual biography of Winckelmann came out at almost the same time as Pater's.[41] It is more comprehensive and complete than Pater's, but it is in the end a simpler portrait, presenting Winckelmann as the exemplar of an admirable scholarly life and achievement, with which any respectable academic or man of letters could identify, not the site of vexed and vexing questions about art, subjectivity, and sexuality, as in Pater's essay. Pater also made a more intensely focused identification that gives his essay an urgency lacking in the more conventional humanist Winckelmann cult that flourished in the German-speaking world.

In contrast with his German contemporaries, Pater, as a British writer, was making in Winckelmann a very unusual choice of intellectual hero. Winckelmann's *History* first became available in English in a rather inaccessible American edition some ninety years after its initial publication, and only appeared in full in 1873, after Pater had written his essay, in the year when he republished it in *The Renaissance*.[42] Winckelmann was no cultural icon of British literary or scholarly life, unlike Goethe, who was something of a hero figure among British Victorian intellectuals.[43] Goethe's famous essay on Winckelmann was indeed one very important stimulus for Pater. To some extent, Pater's analysis can be seen as a commentary on the image of Winckelmann fashioned by Goethe, in which Winckelmann's antique spirit had already been projected as a radical other to modernity. Pater sought to negotiate the complexities of Goethe's involvement with Winckelmann's supposedly ideal antique self—a distancing identification that both recognized the alienation of the antique from modern culture, while striving to incorporate it so as to give some centredness to the complexities and instabilities of the modern self.

But there is another more important point of engagement with Winckelmann that Pater makes quite explicit, the projection of Winckelmann as the ideal of a personal and intellectual identity based on male same-sex desire.[44] The Winckelmann essay was part of a larger project, which included an essay on Leonardo, and which 'begins to theorize a place for perverse sexual self-awareness in cultural formation and critique'.[45] If it would be somewhat anachronistic to envisage Pater as exploring what we would call a gay identity, we are with him nevertheless on the boundaries of a new modern consciousness of sexuality as playing a constitutive role in definitions of the self.

At several points in the essay Pater insists that the intensity of Winckelmann's engagement with the antique arose out of his erotically charged

relations with younger men, if in terms that are quite wilfully paradoxical: 'These friendships [with young men], bringing him into contact with the pride of human form, and staining the thoughts with its bloom, perfected his reconciliation to the spirit of Greek sculpture.'[46] Also evident are the limits to this projection of what we would call homosexual desire. With Pater, the question of male sexuality becomes an issue in a way that it could not have been in the eighteenth century, and so these limits have to be made more visible than in Winckelmann. In Pater's text there is an elision between suggestions of a limitation to the forms of desiring inherent in the Greek ideal—a 'moral sexlessness'—and references to the supposed 'sexlessness' of the erotically charged involvement with men cultivated by Winckelmann.

One key passage makes these ambiguities and tensions particularly apparent, the more so for being channelled through the highly wrought cadences of Pater's prose:

> Certainly of that beauty of living form which regulated Winckelmann's friendships, it could not be said that it gave no pain. One notable friendship, the fortune of which we may trace through his letters, begins with an antique, chivalrous letter in French, and ends noisily in a burst of angry fire. Far from reaching the quietism, the bland indifference of art, such attachments are nevertheless more susceptible than any other of equal strength of a purely intellectual culture. Of passion, of physical excitement, they contain only just so much as stimulates the eye to the finest delicacies of colour and form. These friendships, often caprices of a moment, make Winckelmann's letters, with their troubled colouring, an instructive but bizarre addition to the *History of Art*, that shrine of grave and mellow light around the mute Olympian family.[47]

Winckelmann's male friendships are presented as a passionate and turbulent other to the 'quietism', 'the bland indifference' of the ideal art to which he devoted his intellectual life. But like the sensuality of the Greek ideal, the sensuality at play in these friendships in turn folds in on itself to become abstractly dematerialized. The connection Pater makes between Winckelmann's emotionally charged male friendships and the desexualized beauty of Greek art is not just by way of contrast, in which the turbulent passions of 'real life' frame the colourless indifference of a lost Apollonian ideal. In Pater's reading, these friendships were themselves characterized by a comparative absence of 'passion' and 'physical excitement'. Pater sets up a contrast between life and intellectual project, only to insist in the end on a continuity between the blockages to desire played out within the Greek ideal—that youthful beauty that 'gives no pain, is without life'—and those blockages operating within the desexed sexualized persona he constructed around Winckelmann.

But Pater also talks about the passionate concentration of energy that fuelled Winckelmann's definition of the antique Greek ideal. This 'passion, this temperament' is seen as 'nurtured and invigorated by friendships which kept him

always in direct contact with the spirit of youth'.[48] Then the very next sentence effects a sudden and unconditional blocking of such desire: 'The beauty of the Greek statues was a sexless beauty.' The transition is too highly charged to be mediated. In other words, an imagined sensuous plenitude realized in male same-sex desire and an internalized social prohibition on living out such desire in Victorian England are incompatible, but nevertheless exist alongside one another as the very condition of the male subjectivity Pater was defining. As a vehicle for both imagining the fulfilment of a fantasy and registering the reality of the threats and fears blocking this fantasy, the Greek ideal is caught up in a psychic dynamic we might describe in Freud's words as a 'splitting of the ego in the process of defence'.[49]

The moment of rupture in Pater's text results in a reassessment of Winckelmann's Hellenic ideal which almost overturns his earlier celebrations of the 'force and glow' and 'enthusiasm', the 'unexpressed pulsation of life' in Winckelmann's writing, and the 'emancipation' it provided from the 'repression' of the dark barbarous world Winckelmann inhabited.[50] Now the very quality that Goethe had identified as the ethical essence of Winckelmann's Hellenism is seen by Pater as imbued with lack. The 'serenity (*Heiterkeit*) which characterizes Winckelmann's handling of the sensuous side of Greek art . . . is, perhaps, in great measure, a negative quality.' Negative in that desire as we know it in the modern world, desire in all its disturbing complexity has no place. There is none of the 'intoxication' inextricably bound up with a modern 'sense of shame or loss'. There is harmony, but it is achieved through excluding or ignoring the psychic 'conflict' whose intensity 'makes the blood turbid, and frets the flesh, and discredits the world about us'.[51] The Hellenic ideal cultivated by Winckelmann, which seemed to promise a wholeness of self integrated with its desires, could only in Pater's view do this at the cost of excluding the fullest, if painfully contradictory, resonances of modern desire.

Winckelmann's Greek ideal is not only innocent of the richer, more disturbing antinomies of desiring. It is so constituted as to exclude 'an intoxication' of passion. At this point Pater's most negative image of Winckelmann's project emerges, an image that exists uneasily alongside his libertarian projection of Winckelmann's ideal as one where again 'the lost proportions of life right themselves':[52]

> his insight into the typical unity and repose of the highest sort of sculpture seems to have involved limitation in another direction. His conception of art excludes that bolder type of it which deals confidently and serenely with life, conflict, evil. Living in a world of exquisite but abstract and colourless form, he could hardly have conceived of the subtle and penetrative, yet somewhat grotesque art of the modern world.[53]

For Pater, Winckelmann's world lacks a (burdening) consciousness of the antinomies of the desire it speaks. In his reading, it is our modern consciousness that invests Winckelmann's discourse on the erotic charge of the youthful male

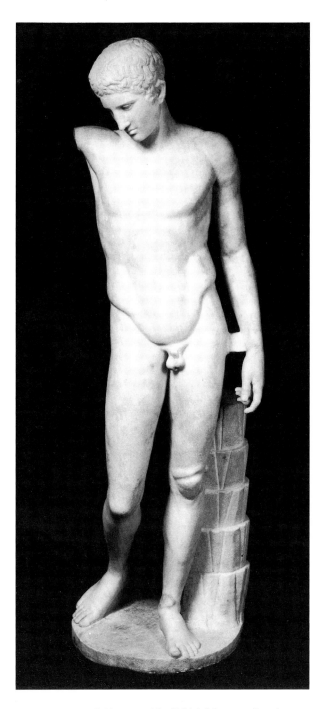

44. Westmacott Athlete, marble, British Museum, London.

body with a richness that was not to be had in Winckelmann's pre-modern intellectual and imaginative world. We are the ones who discover the 'joy of finding the ideal of that youth still red with life in the grave', not Winckelmann.[54]

Pater was living at a time when modern notions of sexuality were just beginning to be defined. Indeed we might see him as one of the pioneers of that distinctively modern preoccupation with the formative role of sexual desire in the constitution of the self, which was later taken up in psychoanalytic theory. Pater identified with Winckelmann as a man who was still able to fabricate a compelling image of erotic manhood, and do it, in his view, largely unselfconsciously. Pater could not publicly speak his own 'homosexual' desire except by way of what he saw as the as yet 'unsexualized' image of youthful 'Greek' masculinity he discovered in Winckelmann. But he was also acutely aware that the apparent undisturbed calm of this image blocked the definition of his own desire in all its complex (in)sufficiency.[55]

The limits Pater identified in Winckelmann's Hellenism also have to do with a politics of gender. His Greek ideal presents an exclusively masculine world where a whole male self is in effect constituted through the exclusion of any resonant suggestions of femininity. According to Pater, Winckelmann's world is one 'represented by that group of brilliant youths in *Lysis*'.[56] The Greek ideal, 'purged from the angry, bloodlike stains of action and passion, reveals, not what is accidental in *man*, but the tranquil godship in him . . . [it] records the first naïve, unperplexed recognition of *man* by himself (Plate 44).'[57] In this passage there is an insistence on man that carries with it an accent of 'not woman' absent in Winckelmann. A further passage hints at something more explicit in this connection. When Pater talks about the limited range of states of mind and attitude in Greek art, his evidence is that 'there is no Greek Madonna; the goddesses are always childless.'[58]

These relatively marginal comments on the absence of femininity in the Greek ideal take on a different cast when read in conjunction with what Pater says in his contemporary essay on Leonardo. Leonardo functioned for him as the embodiment of a resonantly modern subjectivity. A rather more richly articulated male identity is projected in this context through identification with the feminine;[59] the painting of Mona Lisa makes manifest the depth and range of Leonardo's rich sense of self, and also exposes a major absence in the Hellenic ideal:

> It [the figure of Mona Lisa] is a beauty wrought out from within upon the flesh, the deposit, little cell by cell, of strange thoughts and fantastic reveries and exquisite passions. Set it for a moment beside one of those white Greek goddesses or beautiful women of antiquity, and how would they be troubled by this beauty, into which the soul with all its maladies has passed.[60]

Mona Lisa is gendered in this passage as 'it' rather than 'she', not so much a woman, but a figure that suggests those resonances and antinomies of (male)

desire which, in the context of nineteenth-century European culture, were so often projected through the image of the female body. The subjectivity intimated by the *Mona Lisa*, and with which we as readers are invited to identify, is the 'embodiment' of 'an idea of humanity . . . wrought upon by, and summing up in itself, all modes of thought and life . . . the symbol of the modern idea'. For Pater, what is missing in Winckelmann's image of the (male) self is such a (feminine) supplement. Leonardo's all-encompassing sense of self contrasts with Winckelmann's purified and simplified image of 'man'. Pater's identifying this lack in the ideal image of masculinity offered by Winckelmann is all the more forceful because it is informed by a vivid awareness of such an image's compulsive fascination for a male viewer, whether gay or heterosexual.

When Pater elaborates on the distinctive qualities of the purest Greek ideal, he follows Winckelmann very closely. His evocation of 'This colourless, unclassified purity of life'[61] in Greek sculpture picks up directly on imagery used by Winckelmann, as in the passage describing the attenuated forms of the most ideal beauty as analogous to the pure tasteless water from a spring.[62] The echoes of Winckelmann are at times very close indeed:

> Greek sculpture deals almost exclusively with youth, where the moulding of the bodily organs is still as if suspended between growth and completion, indicated but not emphasized; where the transition from curve to curve is so delicate and elusive, that Winckelmann compares it to a quiet sea, which, although we understand it to be in motion, we nevertheless regard as an image of repose.[63]

If we look at the corresponding passage in Winckelmann, however, there is an important difference:

> A beautiful youthful physique is made up of such forms [forms unified by an imperceptible flowing of one into the other], like the unified flat expanses of the sea, that from a distance appears smooth and still, like a mirror, though it is in incessant movement, and rolls in waves. [*Ein schönes jugendliches Gewächs aus solcher Formen gebildet ist, wie die Einheit der Fläche des Meers, welche in einiger Weite eben und stille, wie ein Spiegel, erscheinet, ob es gleich allezeit in Bewegung ist, und Wogen wälzet.*][64]

Pater's rhetoric produces a liminal space where the dynamic of life is simultaneously intimated and suspended. With Winckelmann, the purifying of potential disturbance is effected in a prose that is not itself so immaculately modulated. Rather it shifts constantly between an apparent affirmation and a denial of sensuous immediacy and vitality. If we consider the overall picture of the Greek ideal that Pater extracts from Winckelmann, we see echoed something of the effect of stilled vitality evident in the passage by him quoted here.

Pater focuses quite exclusively on one particular part of Winckelmann's *History*, namely the theoretical discussion of ideal beauty, and precisely on those sections of it concerned with expunging traces of identity and feeling

that might disturb the perfect youthful ideal of self-sufficient oneness. Winckelmann's analysis is both taken at its word and at the same time given a very different inflection, not just through the purifying presentation of the more rarefied aspects of Winckelmann's Greek ideal, but through the systematic exclusion from the domain of Greek art of any potential disturbance to this ideal. In Pater, the supplement to the Greek ideal's absolute serenity, namely the stains of passion, the darker complexities of desire, are systematically drained off from the Greek world and projected onto the modern.[65] In Winckelmann, in contrast, the disturbances expunged from the highest model of the Greek ideal are played out elsewhere in his presentation of Greek art and culture—in the struggles and conflicts marking out the material history of Greek art, and more vividly in the 'unconscious' eruptions of violence and struggle in his reading of statues such as the Laocoön. Greek art in the end encompasses both narcissistic solipsism and its other, violent sado-masochistic confrontation and struggle. In Pater's reading of the Greek ideal, this 'unconscious' is more systematically repressed, but its effects are insistently there in the acute intimations of death suffusing his images of 'untroubled' Greek youth.

In Pater, much more evidently and disturbingly than in Winckelmann, the image of ideal youth is split between an affirmation and a negation of the self. 'Everywhere there is the effect of an awakening, of a child's sleep just disturbed,' Pater writes of the Greek ideal.[66] But the intimations of life awakening are drained away as 'the supreme and colourless abstraction' of the Greek ideal, 'the secret of their (the Olympian gods') repose', is taken to its logical conclusion. 'That high indifference to the outward, that impassivity, has already a touch of the corpse in it.'[67] The expunging of signs of 'anger, or desire, or surprise' produces an 'impassivity' that borders on 'insipidity'—that is, the antithesis of the grotesque expression of those deformed by the 'sharp impress of one absorbing motive, from which it is said death sets their features free'.[68] With Pater, the ultimate logic of the Greek ideal, the Nirvana it seems to promise, comes very close to Freud's conception of 'the death instincts, whose aim is to conduct the restlessness of life into the stability of the inorganic state'.[69]

It is striking how, in Pater, the question of passion and its denial becomes a focus of intense anxiety in a way which it was not in Winckelmann. This anxiety centres on the image of blood. Blood, its redness, is the embodiment of bodily vitality that is drained from the Greek ideal.[70] Equally it is a stain, a sign of some disavowed horror. The Greek ideal, according to Pater, has to be 'purged from the angry, bloodlike stains of action and passion'. The connotations attaching to blood as both life-giving warmth and trace of violence and pain resonate in the word 'stain' used to describe Winckelmann's 'romantic, fervent friendships with young men . . . friendships, bringing him into contact with the pride of human form, and staining the thoughts with its bloom.' Blood too stains the image of Winckelmann's death, the murder whose terrifying and gratuitous violence Pater both registers and seeks to evade. If Pater follows

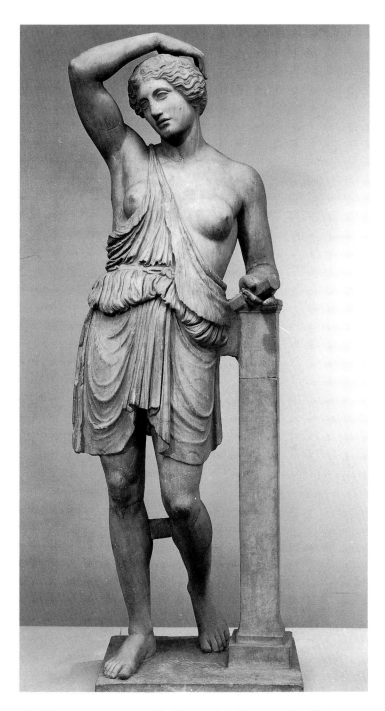

45. Wounded Amazon, marble, Metropolitan Museum, New York.

46. Wounded Amazon, detail of torso.

Goethe in seeing it as 'a death which, for its swiftness and its opportunity, he [Winckelmann] might well have desired', it is too disturbing to be fully rationalized in this way. In the abrupt space of two sentences, Pater moves from the image of a blood-soaked Winckelmann 'dangerously wounded', to that of him in the memory of posterity 'eternally able and strong'. Winckelmann's death is made to repeat the duality of deadly fatality and utopian self-realization that troubled and fascinated Pater in the Greek ideal.[71]

The stain of blood, then, is both a supplement that sustains the bloodless Greek ideal, but equally a source of anxiety from which it must be purged. The white light that Pater sees as the essence of the Greek ideal, which bleaches out both the vitality of blood-redness and the 'stain' of angry passion, is, like the contour in Winckelmann's account, the visual emblem of the fetishistic aspect of the Greek ideal. But it is more immediately evocative of psychic anxiety because of the way Pater associates it with the highly charged image of blood. In a later essay on the athletic ideal, the one embodiment of 'exquisite pain, alike of body and soul' Pater identifies in Greek art is a statue of 'the would-be virile Amazon' (Plates 45, 46). The Wounded Amazon[72] is an exceptional image in which blood literally erupts onto the 'white' surface of the marble Roman copy. It is hardly surprising, given the gendered stereotypes available to Pater, that a female figure should be enlisted to suggest the confluence of bodily pain and vital warmth he associates with blood; nor that it should be the figure of a woman—the potential source of menstrual blood—where vital bodily fluids appear that the Greek ideal usually expunged, thereby allaying the disturbing fascination and disgust excited by these in male fantasy. But equally femininity is conjured up by Pater here to make up for a lack within available images of masculinity. A female figure is needed to supplement a purified masculine ideal, which in Pater's world was prohibited from being desired too warmly, and only able to realize a mirage of integrity and serenity by repressing the richer resonances of male anxiety and desire.

For Pater, a kind of deathliness pervades the Greek ideal. Indeed he quite explicitly characterizes the modern fascination with it as having something of a fascination with death. The modern imagination dwells on the antique world so insistently partly because it 'has passed away . . . What sharpness and reality it has is the sharpness and reality of suddenly arrested life.'[73] It is in their death that the clarity of these ideal youthful forms comes into focus, and the intense pleasure that they give is the pleasure of (re)discovering that 'ideal of youth still red with life in the grave'. Here a certain unavowed sadism emerges that we might see as, among other things, an internalization of the largely unspoken 'homophobia' in Victorian culture, from whose violent prohibitions the Greek ideal might seem to be but could not fully offer an escape.

To sum up, then, the smoothing out and purifying of the Greek ideal is taken by Pater to the point where, in contrast with Winckelmann, it cannot but be seen as registering a lack and an unease. Pater took the fetishizing logic of the Greek ideal further than Winckelmann, and in doing so also registered more

explicitly the psychic disavowals its image of undisturbed plenitude entailed. In his account, the Greek ideal could only function as a relatively 'safe' focus of male fantasy if it visibly blocked the more complex resonances of male desire.[74]

Pater also registers a self-consciousness over the limits framing the Greek ideal at another quite different level, which had to do with the material form it took as a sculptural object. It is striking how in Winckelmann, the materiality of the antique nude seems to have so little to do with its materiality as a work of art. The physical sensuous aspect of a sculpture is defined almost exclusively in terms of the body it represents, rather than the literal substance of the sculptural object itself, even though the formal representational nature of the ideal figure is clearly registered in his conception of contour.

With Pater something else enters in. The objectness of sculpture becomes a problem, and a troubling disparity opens up between the reified thing-like quality of the sculpture as material object and the living ideal it supposedly embodies. This could not have been a problem for Winckelmann in the same way. A self-consciousness about the reifying effects of the art object was not yet an issue in eighteenth-century artistic culture. Signs of it begin to occur in some discussions of sculpture later in the eighteenth century, and are certainly there in Hegel, on whom Pater draws quite extensively. But it is only towards the middle of the nineteenth century that the idea takes hold in discussion of the visual arts that a truly modern living art should not present itself to the spectator too insistently as a static object or thing. It is at this moment that the materiality of the object of representation becomes a problem within modern artistic culture, as art is called upon to figure forth some alternative to reification, to the reduction of culture to a system of exchangeable commodities.[75]

When Pater defined the Greek ideal as trapped within the confines of a sculptural mode of representation, he was in part following a Romantic tradition of defining different art forms as appropriate to different phases in the historical development of human culture. Sculpture was the art of the ideal childhood of humanity realized by the ancient Greeks, when a full human subjectivity could still convincingly be embodied in the sensuous forms of a beautiful figure. Modern subjectivity, in contrast, had expanded beyond these confines to the point where an image of the body could only be an inadequate expression of inner being. Modern sensibility manifested itself pre-eminently in art forms that were allusive and not so insistently bound up with their literal materiality as sculpture, namely in painting and above all in poetry and music. These art forms, according to Pater, 'through their gradations of shade, their exquisite intervals . . . project in an external form that which is most inward in passion or sentiment'.[76]

The lack or limit involved in the Greek sculptural ideal is made more acute in Pater than in earlier Romantic aesthetics. It is not merely that the sculptural ideal could only embody a subjectivity that had not yet developed its richest and more troubling potential. Fashioning a human figure in the form of a solid object itself came to be seen as inherently problematic. For Pater, the formal

exigencies of sculpture required a reification of the human subjectivity being represented or, to put it more in his terms, a presentation of the figure from which all obvious traces of feeling were removed, those passing states of consciousness central to the constitution of the modern self. A sculpture could only be convincing if it were a simplified image of the human self, an embodiment of its original but relatively empty essence, which did not attempt to render the nuances of human feeling that were the province of other more dematerialized art forms.

As Pater said:

> at first sight sculpture, with its solidity of form, seems a thing more real and full than the faint abstract world of poetry or painting. Still the fact is the reverse. Discourse and action show man as he is, more directly than the play of muscles and the moulding of the flesh; and over these poetry has command. Painting, by the flushing of colour in the face and dilation of light in the eye—music, by its subtle range of tones—can refine most delicately upon a single moment of passion, unravelling its subtlest threads.[77]

Sculpture, confined within the limits of pure form, purges out the vivid richness of sensuous life associated with colour and tone, those aspects of the body that we most readily read as intimations of expression and feeling.[78] At one level there is oneness and simplicity: 'the art of sculpture records the first naïve, unperplexed recognition of man by himself.' At another this sculptural ideal represents a denial of the living signs of selfhood.

The obdurate materiality of sculpture, as Pater explains more fully in a slightly later essay on Luca della Robbia, completed in 1872,[79] is a limitation it must confront by way of radical contradiction. Greek art could only achieve its aims by, on the one hand, reducing the human figure to pure form, and yet on the other seeking to block recognition of this reduction, by creating an image that would not invite comparison between a living feeling self and 'the hardness and unspirituality of pure form' inherent in the positivity of sculpture. A sculpture must not directly echo the vital forms of a body in nature, but instead conjure up an abstract structure, purged of individuality and expression, which if fixed would expose the sculptural object as the dead and lifeless thing it was. The sculptural body, if it is not to appear rigidly unlifelike, has to present itself as purged of life: 'In this way their [the Greeks'] works came to be like some subtle extract or essence, or almost like pure thoughts or ideas: and hence the breadth of humanity in them.'[80] We could recast Pater's analysis here to say that this sculptural form is a little like the commodity—just a thing on one hand, but on the other existing as an element within the dematerializing system of exchange values that provide the framework for modern apprehensions of the material object, something totally immaterial and abstract. At the very least we have in Pater a theorist working within a new cultural formation for which object and thing in their raw materiality had become problematic in ways that they were not before.

There is one further important issue that Pater raises when he seeks to define

the limits of Winckelmann's Greek ideal. It too concerns definitions of identity, but this time more political than psychic in nature. In a crucial passage where he distances himself from the ideological configuration of Winckelmann's world, Pater defines the modernity separating him from Winckelmann as producing, not just a richer contemplative self-consciousness, but also a dissolution of the self as effective agent within the 'real' world:

> That naïve, rough sense of freedom, which supposes man's will to be limited, if at all, only by a will stronger than his, he can never have again . . . For us necessity is not, as of old, a sort of mythological personage without us, with whom we can do warfare. It is rather a magic web woven through and through us, like that magnetic system of which modern science speaks, penetrating us with a network, subtler than our subtlest nerves, yet bearing in it the central forces of the world.[81]

Or, to take another passage from the conclusion to the *Renaissance*:

> That clear perpetual outline of face and limb is but an image of ours, under which we group them (the forces of physical life that flow through us from the world outside)—a design in a web, the actual thread of which passes out beyond it.[82]

In getting at the sense of these passages, we are perhaps hampered by an all too ready recognition of echoes of post-modern ideas on the death of the traditional centred subject. We could easily draw out a web of analogies with such orthodoxies of present-day critical theory as the Lacanian notion of identity being constituted in lack and fragmentation. We should not be wrong to do so. Now we have post-modernism, it pervades our sense of what it means to be modern. Certainly we would be justified in recognizing elements of a distinctively 'post-modern' anxiety about the self in the 'modern' culture of the late nineteenth century, above all about the self as a psychic entity constituted through desire and fantasy. Much could be gained no doubt by examining Pater from this perspective, if only to remind ourselves that fantasies about the dissolution of the self are often bound up with reifying fantasies about the individual self as a substantive self-sufficient entity. Pater comes to his 'post-modern' conclusion at the end of a long essay analysing his fascination with the emblem *par excellence* of centred human subjectivity, the ideal classical nude, which he deconstructs in the very act of purifying its claims to represent a deproblematized integrity of self.

If we are to understand what is at stake in Pater's distancing from Winckelmann, it is not just the dissolution of the self as such. Pater's projection of an ideal modern subjectivity, no less or more than Winckelmann's 'archaic' ideal of subjective serenity, was bound up with fantasies and fears of self-annihilation. Also at issue is Pater's attempt to render redundant the more violent contradictions inherent in Winckelmann's notion of a free sovereign subjectivity. Pater seeks a definition of individual consciousness that effaces

any suggestion of confrontation between it and the world around it. It is only here, where he is so explicit about the ideological discrepancy between his and Winckelmann's constitution of self, that it seems possible for him to signal the conflicts so powerfully articulated at moments within Winckelmann's account of the Greek ideal. When Pater talks of Winckelmann's sense of 'freedom' as realized in a 'warfare' between ourselves and 'a sort of mythological personage without us', we have one of the few places in the essay where, for example, the conflicts acted out by the struggling Laocoön or the annihilated Niobe come to mind.

Pater's conception of individual consciousness negotiates a powerful anxiety concerning the threats anathematizing sexualized relations between men in the society he inhabited—threats that had become a more pressing issue in Victorian Britain than they could have been for Winckelmann.[83] But the fantasy of abolishing the self as any kind of active force in the 'real' world also had other political reverberations. In constituting a new identity that precluded any possibility of confrontation with the larger material forces moulding it, Pater categorically rejected as archaic or naïvely unselfconscious the idea of self as political agent.

Pater's appropriation of Winckelmann's Greek ideal focuses on the image of a solipsistic enjoyment of self, a self existing in a narcissistic limbo where there is no disturbance of desire, and whose 'ineffectual wholeness of nature' Pater seeks to move beyond, but cannot quite.[84] The supplement to this in Winckelmann, the active subject in violent confrontation with the world around it, and its historical echo in struggles against tyranny and oppression, which according to Winckelmann activated the spirit of freedom integral to the Greek ideal, is insistently repressed in Pater. But this repression brings into focus precisely what makes Winckelmann such an unusually fascinating and politically resonant figure—his desire to fuse a voluptuary aestheticism with the 'naïve, rough sense of freedom' which so disturbed Pater.

FREQUENTLY CITED SOURCES

The texts listed below are cited in the notes in the abbreviated form indicated in square brackets.

Caylus, A.-C.-P. de Tubières, comte de, *Recueil d'Antiquités*, Paris, Vol. I, 1752, Vol. II, 1756, Vol. III, 1759, Vol. IV, 1761, Vol. V, 1762, Vol. VI, 1764 [Caylus, *Recueil*]

Dilly, H., *Kunstgeschichte als Institution*, Frankfurt-am-Main, 1979 [Dilly, *Kunstgeschichte als Institution*]

Freud, S., *Penguin Freud Library*, Harmondsworth, Vol. 1, *Introductory Lectures on Psycho-Analysis*, 1973; Vol. 7, *On Sexuality*, 1977; Vol. 11, *On Metapsychology*, 1984; Vol. 12, *Civilization, Society and Religion*, 1985; Vol. 13, *The Origins of Religion*, 1985 [Freud, *Freud Library*]

Greenberg, D. F., *The Construction of Homosexuality*, Chicago and London, 1988 [Greenberg, *Homosexuality*]

Haskell, F. and Penny, N., *Taste and the Antique*, New Haven and London, 1981 [Haskell and Penny, *Taste and the Antique*]

Jenkins, G. K., *Ancient Greek Coins*, London, 1972 [Jenkins, *Ancient Greek Coins*]

Justi, K., *Winckelmann und seine Zeitgenossen*, 3 vols, Leipzig, 1932 [Justi]

Musée Calvet, Avignon, *La Mort de Bara*, Avignon, 1989 [*La Mort de Bara*]

Pater, W., *The Renaissance: Studies in Art and Poetry*, London and Glasgow, 1961, ed. K. Clark; first published 1873 [Pater, *Renaissance*]

Pliny, *The Elder Pliny's Chapters on the History of Art*, translated by K. Jex-Blake, Chicago, 1968 [Pliny, *Natural History*]

Potts, A. D., 'Political Attitudes and the Rise of Historicism in Art Theory', *Art History*, I, 1978, pp. 191–213 [Potts, 'Political Attitudes']

—— 'Greek Sculpture and Roman Copies I: Anton Raphael Mengs and the Eighteenth Century', *Journal of the Warburg and Courtauld Institutes*, XLIII, 1980, pp. 150–73 [Potts, 'Greek Sculpture and Roman Copies']

—— 'Winckelmann's Construction of History', *Art History*, 5, 1982, pp. 377–407 [Potts, 'Winckelmann's Construction of History']

Winckelmann, J. J., *Geschichte der Kunst des Alterthums* (*History of the Art of Antiquity*), Dresden, 1764 [*Geschichte*]

—— *Geschichte der Kunst des Alterthums*, Vienna, 1776 [*Geschichte*, Vienna 1776]

—— *Versuch einer Allegorie, besonders für die Kunst* (*Attempt at an Allegory, Particularly for Art*), Dresden, 1766 [*Allegorie*]

—— *Anmerkungen über die Geschichte der Kunst des Alterthums* (*Remarks on the History of Art of Antiquity*), Dresden, 1767 [*Anmerkungen*]

—— *Monumenti Antichi Inediti* (*Unpublished Antique Monuments*), Rome, 1767 [*Monumenti Inediti*]

—— *Kleine Schriften. Vorreden. Entwürfe*, Berlin, 1968 [*Kleine Schriften*]

Winterbottom, M. and Russell, D. A. (eds), *Ancient Literary Criticism*, Oxford, 1972 [Winterbottom, *Ancient Literary Criticism*]

NOTES

INTRODUCTION

1 Quoted in T. W. Adorno, *Philosophy of Modern Music* (London, 1973), p. 3.

2 The famous quotation comes from the early essay Winckelmann published in 1755, *Thoughts on the Imitation of Greek Works* (*Kleine Schriften*, p. 43 and also p. 45). When the word 'still' crops up later in his *History of the Art of Antiquity* (*Geschichte*, pp. 153, 167), the idea of an almost inanimate stillness tends to takes precedence over the suggestions of an emotional or moral calm found in the earlier essay.

3 In the passage in *Thoughts on the Imitation of Greek Works*, 'Just as the depths of the sea always remain calm (*ruhig*), however much the surface might rage' (*Kleine Schriften*, p. 43), the image of the sea functions to evoke the idea of still depths that remain unmoved by even the wildest disturbance of the surface. The resonances of the image change in *The History of the Art of Antiquity* (*Geschichte*, pp. 156, 163), even if there are moments when the notion of an essential underlying calm is still to the fore (p. 167). In the *History*, Winckelmann's most resonant images of the sea evoke the idea of an apparently smooth surface modulated imperceptibly by a powerful, gently surging swell. For a somewhat different analysis of the tensions implicit in Winckelmann's image of 'still grandeur', see S. Richter, *Laocoon's Body and the Aesthetics of Pain* (Detroit, 1992, particularly pp. 43–8). Images of water and the sea in Winckelmann are discussed in B. M. Stafford, 'Beauty of the Invisible: Winckelmann and the Aesthetics of Imperceptibility', *Zeitschrift für Kunstgeschichte*, 43, 1980, pp. 65–78.

4 'the primary purpose of this history turns upon the art of the Greeks' (*Geschichte*, p. XXII).

5 *Geschichte*, pp. L (No. 14), 127. The passage in Plutarch's life of Theseus is quoted from Scott-Kilvert's translation (*Plutarch. The Rise and Fall of Athens* (Harmondsworth, 1960), p. 19. Later archaeologists inclined to the view that this gem represented Achilles and Penthesilea (see A. Furtwängler, *Antike Gemmen* (Berlin, 1900), vol. II, p. 179; No. XXXVII, 34).

6 *Geschichte*, pp. 170, 226–7.

7 Winckelmann was simply following established precedent when he categorized as essentially Greek the most admired surviving antique statues of heroic or mythological figures, such as the Apollo Belvedere, which we today consider to be comparatively 'imperfect' Graeco-Roman copies or imitations of earlier Greek work. See Chapter I, note 23 below.

8 *Geschichte*, p. 349. For further discussion see pp. 138–42.

9 *Anmerkungen*, P. XV. Winckelmann is referring here to the translation by Gottfried Sell published in Paris in 1766 (*Kleine Schriften*, p. 502).

CHAPTER I

INVENTING A HISTORY OF ART

1 *Geschichte*, p. IX. Winckelmann's point about the larger meaning that history had in the Greek language makes reference to a well-known passage in Cicero. See Chapter II, note 5 below.

2 See VII, 1764, part 1, pp. 64–83, and part 3, pp. 76–91; VIII, part 1, pp. 54–83 and part 2, pp. 97–122. This was more a digest of the contents of the book than a review in the modern sense.

3 H. A. Stoll, *Winckelmann, seine Verleger und seine Drücker* (Berlin, 1960), p. 10.

4 The most widely circulated of these new scholarly editions was the three-volume French translation by H. J. Jansen, *L'Histoire de l'art chez les anciens*, published in Paris in 1790–4. Also particularly important was the Italian edition, *Storia delle Arti del disegno presso gli antichi*, with substantial notes and additions by the antiquarian Carlo Fea, which came out in Rome in 1783–4. Two major new editions appeared in German in the early nineteenth century as part of collections of Winckelmann's writings, one published by Fernow and Meyer in Dresden (1808–25), and one by Eiselein in Donaueschingen (1825–9). An edition in English only came out much later, published in Boston in the United States (*The History of Ancient Art*, translated by G. H. Lodge,

vol. 1, Little Brown & Co., 1856, vol. 2, J. Monroe & Co., 1849, vols 3–4, J. R. Osgood & Co., 1872–3).

5 L. Cicognara, *Storia della scultura del suo risorgimento in Italia fino al secolo di Napoleone, per servire di continuazione dalle opere di Winckelmann et di d'Agincourt* (Cicognara was referring to Seroux d'Agincourt's *L'Histoire de l'art par les monumens, depuis sa décadence au IVe siècle jusqu'à son renouvellement au XVIe siècle* that began to appear in 1811), vol. I (Venezia, 1813), p. 9. See also L. Lanzi, *Storia Pittorica della Italia*, vol. I (Bassano, 1795), pp. vi–vii, and J. D. Fiorillo, *Geschichte der zeichnenden Künste von ihrer Aufhebung bis auf die neuesten Zeiten*, vol. I (Göttingen, 1798).

6 Quatremère de Quincy, *Éloge Historique de M. Visconti* (Paris, 1820), pp. 430–1. Quatremère envisaged an ideal history of art that, though based on Winckelmann's, would transcend the residual empiricism of the latter and truly be 'simultaneously chronological, historical, theoretical and didactic' in character—see S. Lavin *Quatremère de Quincy and the Invention of a Modern Language of Architecture* (Cambridge, Mass. and London, 1992), pp. 98–9.

7 J. W. von Goethe (ed.), *Winckelmann und sein Jahrhundert* (Tübingen, 1805), p. 448.

8 See pp. 30–31.

9 F. Thiersch, *Über die Epochen der Bildenden Kunst unter den Griechen* (München, 1929; first edition 1825), pp. 4–5.

10 On the issue of Graeco-Roman copies, see Chapter I, notes 40 and 41. Winckelmann's periodizing of the history of Greek art (archaic, early classic, late classic, and the epoch of imitation and decline, or what is now called Hellenistic) still structures standard modern textbooks on Greek sculpture, even though the works now used to exemplify this history are quite different from those cited by Winckelmann (see, for example, G. M. Richter, *The Sculpture and Sculptors of the Greeks* (New Haven, 1970)).

11 Throughout most of the nineteenth century, the entry on art history in Brockhaus's *Real-Enzyklopädie* defined it as a study concerned with 'the representation of the origin, development, rise and decline of the fine arts' (quoted in Dilly, *Kunstgeschichte als Institution*, p. 80).

12 See Haskell and Penny, *Taste and the Antique*, pp. xiii–xv.

13 See A. Tibal, *Inventaire des Manuscrits de Winckelmann* (Paris, 1911).

14 It played an important role, for example, in Walter Pater's famous essay on Winckelmann (see p. 246). Winckelmann's tomb in Trieste became quite a point of pilgrimage in the nineteenth century.

15 C. Pagnani and H. A. Stoll, *Mordakte Winckelmann* (Berlin, 1965).

16 Pater, *Renaissance*, p. 205.

17 G. W. F. Hegel, *Vorlesungen über die Ästhetik* (Frankfurt-am-Main, 1970), vol. I, p. 92.

18 See J. Ruskin, *The Stones of Venice*, vol. 3 (London, 1898), pp. 8 ff. ('The Fall', chapter I). On the 'realism' that characterized the 'classic' phase of historical writing in the nineteenth century, see Hayden White, *Metahistory: The Historical Imagination in Nineteenth-Century Europe* (Baltimore and London, 1973), particularly pp. 39 ff. For a categorically sceptical view of that fusion between the study of individual artifacts and a larger understanding of history promised by systematic art historical enquiry as it emerged in the nineteenth century, see D. Preziosi, *Rethinking Art History* (New Haven and London, 1989).

19 For the classic historicist characterization of Winckelmann as a transitional figure, see Friedrich Meinecke, *Die Entstehung des Historismus* (Munich und Berlin, 1936) vol. II, pp. 313 ff. For a sophisticated formulation of the traditional art-historical view, see E. Heidrich, *Beiträge zur Geschichte und Methode der Kunstgeschichte* (Basel, 1917), pp. 27 ff. The valuable reassessment of Winckelmann by H. R. Jauss ('Geschichte der Kunst und Historie', in R. Koselleck and W. D. Stempel (eds), *Geschichte Ereignis und Erzählung* (Munich, 1973); translated in Jauss, *Toward an Aesthetic of Reception* (Minneapolis, 1982)), while framed as a critical analysis of historicism and the disavowed aesthetic basis of its use of historical narrative, nevertheless retains a conventional historicizing of Winckelmann's work as part of a larger development towards modern modes of historical writing which emerged in the nineteenth century. H. C. Seeba's important revaluation of Winckelmann's historical aesthetics, 'Zwischen Reichshistorik und Kunstgeschichte. Zur Geschichte eines Paradigmawechsels in der Geschichtesschreibung' (in H. E. Bödeker and others, eds., *Aufklärung und Geschichte* (Göttingen, 1986), pp. 299 ff.) usefully highlights the more speculative aspects of his conceptualizing of history, though here again Winckelmann is presented as prefiguring later tendencies, this time the anti-positivist strain in Herder's historical hermeneutic. H. Dilly (*Kunstgeschichte als Institution*, particularly pp. 95 ff.) convincingly argues that Winckelmann's politically engaged Enlightenment perspective needs to be distinguished more clearly than it has been from the outlook of early nineteenth-century writers or art such as Rumohr.

My own understanding of the ambivalent and potentially disruptive position of Winckelmann's writing in relation to nineteenth-century historicism owes a lot to discussions with Wolfgang Ernst (see for example his 'J. J. Winckelmann im Vor(be)griff des Historicismus', in H. W. Blanke and J. Rüsen, eds., *Von der Aufklärung zum Historismus* (Padeborn, 1984), pp. 255 ff.).

20 See particularly *Geschichte*, pp. 127–8. For a valuable discussion of the significant tensions inherent in Winckelmann's injunction to imitate the Greek ideal in his earlier writing, see Michael Fried 'Antiquity Now', *October*, no. 37, Summer 1986, pp. 87–97.

21 For the classic analysis of such a rupture in conceptions of history, see M. Foucault, *The Order of Things* (London, 1970), chapter 7, section I 'The Age of History'.

22 M. Fontius, 'Winckelmann und die französische Aufklärung', *Sitzungsbericht der Deutschen Akademie der Wissenschaften zu Berlin, Klasse für Sprachen, Literatur und Kunst*, 1968, Nr. 1, and H. Dilly, *Kunstgeschichte als Institution* (note 19).

23 See Potts, 'Greek Sculpture and Roman Copies', particularly pp. 156 ff., 'Winckelmann's Construction of History', pp. 380–1, 385, and P. Sénéchal, 'Originale e copia. Lo studio comparato delle statue antiche nel pensiero degli antiquari fina al 1770', in *Memoria dell'antica nell'arte italiana*, vol. III, *Dalla tradizione all'archeologia* (Turin, 1986), pp. 151 ff.

24 Paradigm is meant here in the technical sense used by Thomas Kuhn in *The Structure of Scientific Revolutions* (Chicago, 1962). The most important recent rethinking of Winckelmann's significance as a historian that has emerged from literary studies (see Seeba and Jauss in note 2), while usefully illuminating the ideological parameters of his project through a critique of traditional positivist assumptions informing earlier writing on the subject, turns something of a blind eye to this scientific dimension of Winckelmann's work. As a result, the tension between theoretical construct and an obsessive attention to empirical detail which lies at the core of Winckelmann's analysis tends to be overlooked. Kuhn's notion of a paradigm or Foucault's of an 'episteme' are directly applicable to Winckelmann's conceptualizing of the history of Greek art precisely because Winckelmann envisaged the elaboration of his 'system' so explicitly as a scientific problem-solving exercise.

25 It is not only in Berenson-like accounts of the stylistic formation and dissolution of a tradition that this model has continued to play a central in role in modern art-historical studies, but also in the work of more sophisticated art historians such as Panofsky.

26 *Geschichte*, p. 248.

27 On the ideological inflection of the divergent attitudes towards the revival of Greek art that emerged in the late eighteenth century and the period of the French Revolution, see Potts, 'Political Attitudes' and T. Namowicz, *Die aufklärerische Utopie. Rezeption der Griechenauffassung J. J. Winckelmanns um 1800 in Deutschland und Polen* (Warsaw, 1978).

28 Goethe is a particularly interesting figure in this connection because he so self-consciously appealed to Winckelmannn's Greek ideal as an antidote both to the excesses of radical Greek revivalism (on which see pp. 225–6) and to what we would view as a Romantic or proto-Romantic search for alternatives to classical models. See T. Namowicz, *Die aufklärerische Utopie* (note 27).

29 On the pervasive tension between ideas of progress and cultural decline in Enlightenment thought, see H. Vyverberg, *Historical Pessimism in the French Enlightenment* (Cambridge, Mass.), 1958; P. Burke, 'Tradition and Experience: the idea of decline from Bruni to Gibbon', in G. M. Bowersock and others (eds), *Edward Gibbon and the Decline and Fall of the Roman Empire* (Cambridge, Mass.), 1977, pp. 93 ff.; and J. G. A. Pocock, *Politics, Langage and Time* (New York, 1971), pp. 102 ff.

30 Two of the most important histories written in the period were on the decline of the Roman Empire, Gibbon's *The History of the Decline and Fall of the Roman Empire* (1776–88; on which see F. Haskell, 'Edward Gibbon and the Decline and Fall of the Roman Empire', *Daedalus*, Summer 1976, pp. 217–29) and Montesquieu's *Considérations sur les Causes de la grandeur des romains et de leur décadence* (1734). The larger logic of history was usually envisaged at the time as a cyclical rise and decline framing a few chosen 'great centuries', such as the age of Leo X or what we would call the High Renaissance (see Chapter I, note 66).

31 For an account of the initial reception of Winckelmann, which concentrates on his advocacy of the Greek ideal rather than on his reconceptualization of the history of art, see H. C. Hatfield, *Winckelmann and his German Critics 1755–1781* (New York, 1943). A detailed analysis of early reponses to and appropriations of his new systematic history of Greek art is to be found in sections 3.1 and 4.1 of my unpublished dissertation *Winckelmann's Interpretation of the History of Ancient Art in its Eighteenth-Century Context* (London University, Warburg Intstitute, 1978).

32 C. G. Heyne's 'Lobschrift auf Winckelmann' was published in French in 1779 and reprinted in the

1790–4 French edition of his *History of Art*. It appeared in German in 1785 (*Litterarische Chronik*, vol. I). Heyne published a much fuller and more scholarly critique of Winckelmann's *History of Art*, prompted by the posthumous Vienna edition of 1776, in *Sammlung Antiquarischer Aufsätze* (2 vols., Leipzig, 1778–9). For a more detailed account of Heyne's and Herder's critiques of Winckelmann's scholarly writing on the history of ancient art, see Potts, *Winckelmann's History* (note 31), sections 3.3 and 3.4.

33 The essay was first published under the title *Denkmal Johann Winckelmanns* in 1882 and then in a fully annotated critical edition in Herder's *Sämmtliche Werke* (Berlin, 1877–99), vol. 8, pp. 466 ff. Herder published a much modified, and somewhat less searchingly critical commentary on Winckelmann in 1781 (*Werke*, vol. 15, pp. 45 ff.). He had already aired his scepticism about the systematic aspect of Winckelmann's history of art in his *Kritische Wälder* (Riga, 1769): see particulary vol. I, pp. 12 ff. On the larger conceptions of history at issue in Herder's response to Winckelmann, see H. C. Seeba, 'Geschichte als Dichtung. Herders Beitrag zur Ästhetisisierung der Geschichtsschreibung', *Storia della Storiografia / History of Historiography*, 8, 1985, pp. 50–72.

34 Heyne, *Sammlung*, vol. I, p. 174 ff., vol. II, p. 32. One of the first to raise this issue was Lessing, who challenged Winckelmann's hypothetical dating of the Laocoön to the classic period of Greek art and argued that it could have originated much later, in early Roman Imperial times (*Laokoön*, Stuttgart, 1964, pp. 190–1; first published 1766).

35 See particularly *Sammlung*, vol. I, pp. 166–7. As Heyne was a classical philologist, the weight of his critique fell on shortcomings in Winckelmann's use of literary sources. On Heyne's involvement with archaelogical studies as a professor of classics teaching at Göttingen, see Bräunig-Oktavio, *Christian Gottlob Heynes Vorlesungen über die Kunst der Antike . . .* (Darmstadt, 1971).

36 Herder, *Werke*, vol. 8, pp. 466–9, 478, vol. 15, pp. 45–6.

37 Herder, *Werke*, vol. 8, pp. 476–8.

38 Herder, *Werke*, vol. 15, pp. 49–50. On eighteenth-century discussion of the problems of reviving earlier forms of art and culture, which focused on poetry, see R. Wellek, *A History of Modern Criticism 1750–1950* (London, 1955), vol. I, pp. 128 ff., 181 ff. On the emergence of a new perspective of the visual arts in the very late eighteenth century, which envisaged the revival of the antique as inherently problematic, see Potts, 'Political Attitudes', pp. 195 ff.

39 A very early instance of such an outlook being formulated explicitly with reference to the visual arts comes in the writings of Johann Georg Forster, one of the few German intellectuals of the period to be directly involved in French Revolutionary politics (*Ansichten von Niederrhein . . . im April, Mai und Junius 1790* (Berlin, 1791), vol. I, pp. 207–11, vol. II, pp. 65–8, vol. III, pp. 116–17. Such intimations of a 'modern' aesthetic remained relatively fragmentary and sporadic until the controversies over Realism in the mid-nineteenth century. On historicism and anti-historicism in debate about the Greek ideal in the years just after the French Revolution, see Potts, 'Political Attitudes', pp. 200 ff.

40 See Potts, 'Greek Sculpture and Roman Copies', pp. 170 ff.

41 On the controversies that broke out in the early nineteenth century over the relative status of 'original Greek' and later 'Graeco-Roman' sculpture sparked off by the arrival in London of sculpture taken from the Parthenon, see J. Rothenberg, *'Descensus ad Terram': The Acquisition and Reception of the Elgin Marbles* (New York and London, 1977). On the museum of antiquities in the Louvre in the Napoleonic period, see Haskell and Penny, *Taste and the Antique*, pp. 108–15.

42 E. Q. Visconti, *Musée Pie-Clementin* (Milan 1818–22), vol. VI, pp. 93–4. Earlier he sought to counter Mengs's argument by claiming that the finest surviving masterpieces were early Greek in origin (vol. I, pp. 139–142; originally published in 1782), but eventually he came to accept that the evidence clearly pointed to their being Graeco-Roman (vol. I, p. 154; addition made in 1807 supplement).

43 T. B. Eméric-David and E. Q. Visconti, *Musée Français*, vol. II (Paris, 1805), pp. 89 ff. This theory was further elaborated in Eméric-David's *Recherches sur l'Art statuaire* (Paris, 1805); see particularly pp. 8–15, 129. On these debates concerning the antique ideal in French art theory of the period, see F. Benoit, *L'Art français sous la Révolution et l'Empire: les doctrines, les idées, les genres* (Paris, 1897), pp. 80 ff., 104 ff.

44 Other French proponents of Eméric-David's view of the history of ancient art included J. G. Schweigerhaeuser (*Les Monumens Antiques du Musée Napoléon* (Paris, 1804–6), vol. I, particularly pp. 44–5) and J. B. de Saint-Victor (*Musée des Antiques* (Paris, [1822]), particularly p. 5). Quatremère de Quincy, the most insistently historicizing of French writers on the antique in the period, had opposed the removal to Paris of masterpieces of antique sculpture from their original

context in Italy or Greece (*Lettres sur l'Enlèvement des ouvrages de l'art antique à Athènes et à Rome* (Paris, 1796), on which see E. Pommier, *L'Art de la Liberté: doctrines et débats de la Révolution française* (Paris, 1991), pp. 415 ff.). In Germany, the one significant scholarly publication on ancient art to take up Eméric-David's 'revisionist' view of the history of Greek art was F. Thiersch, *Über die Epochen der bildenden Kunst unter den Griechen* (Munich, 1829; first published 1825). In a review published in 1826–7, the young K. O. Müller, who was to become the leading German authority on ancient Greek art, saw Thiersch's 'anti-historical' conception of the history of ancient art and the strictly Winckelmannian view of its rise and decline propounded by Goethe and Heinrich Meyer as the two main paradigms current in archaeological studies in the 1820s (*Jahrbücher der Literatur*, 31, 1826, pp. 170 ff., 37, 1827, pp. 258 ff., and 39, 1827, pp. 136 ff.). Fuller details can be found in Potts, *Winckelmann's History of Ancient Art*, Sections 4.2 and 4.3.

45 K. O. Müller (*Handbuch der Archäologie der Kunst* (Breslau, 1835), pp. 23 ff., 112 ff.) may have been critical of too literal an application of a Winckelmannian model of rise and decline. But he nevertheless assumed, as did his contemporaries, that any artistic tradition was subject to a general pattern of development in which an austere or archaic phase led to a classic period, when art achieved its fullest realization of naturalism and beauty, and that this was followed inevitably by a phase of mannerism and decline (see also *Jahrbücher der Literatur*, 31, 1826, p. 191 and 37, 1827, p. 143).

46 K. O. Müller, *Jahrbücher*, 1826, p. 170.

47 *Geschichte*, p. IX.

48 One of the most sophisticated apologias for a system of this kind can be found in Vico's *New Science*. For an illuminating analysis of Enlightenment notions of system as applied to the study of culture, see L. Pompa, *Vico: A Study of the 'New Science'* (London, 1975), particarly pp. 93 ff. and 121 ff. While there is no clear evidence that Winckelmann was directly acquainted with Vico's writing, the underlying concepts were pervasive in Enlightenment thought—see, for example, E. B. Condillac, 'Traité des Systèmes' (1749; *Oeuvres* (Paris, 1947), pp. 216 ff.). The distinctive combination of theoretical and empirical analysis involved had close affinities with models current in the study of natural history, a subject in which Winckelmann had taken a strong interest early in his career (W. Lepenies, 'Kunst und Naturgeschichte im 18. Jahrhundert', in T. W. G. Gaehtgens (ed.), *Winckelmann 1717–1768* (Hamburg, 1986), pp. 227 ff.).

49 Roman art for Winckelmann did not constitute an independent category because he saw it as essentially imitative in character. In its earliest phases it was in his view imitative of Etruscan art, and in its later ones a mere offshoot of the Greek tradition (*Geschichte*, pp. 293 ff.).

50 Winckelmann took extensive notes from Montesquieu's *De l'Esprit des lois* (A. Tibal, *Inventaire des Manuscrits de Winckelmann* (Paris, 1911), LXX and LXXII). On Montesquieu's system, see L. Althusser, 'Montesquieu: Politics and History', in *Montesquieu, Rousseau, Marx*, transl. B. Brewster (London, 1972), and S. Gearhart, *The Open Boundary of History and Fiction: A Critical Approach to the French Enlightenment* (Princeton, 1984), particularly pp. 152 ff.

51 Winckelmann's analysis of the material circmstances conditioning non-Greek ancient traditions focused on factors that blocked the fully realized development of their art. This perspective is particularly explicit in an introductory passage to the *Anmerkungen* (pp. 1–2).

52 E. B. Condillac, *Essai sur l'Origine des connaissances humaines* (1746) and J.-J. Rousseau *Essai sur l'Origine des langues* (probably written in the 1750s and first published posthumously in 1781).

53 See pp. 76 ff.

54 There is a larger historical logic inscribed in Montesquieu's *De l'Esprit des lois*, in so far as the republican system of government, for example, is seen as necessarily prior to the monarchical one. However, Montesquieu's typologies are not designed to explain the historical development of systems of law, but rather their inner logic as generic types. Typologies of non-archaic cultural formations in Enlightenment thought often took the form of dualities, such as that between the sublime and the beautiful in Burke's aesthetic.

55 *Kleine Schriften*, p. 21. On this early unpublished essay, see H. C. Seeba, 'Zwischen Reichshistorik und Kunstgeschichte', in H. E. Bödeker and others, *Aufklärung und Geschichte* (Göttingen, 1986), pp. 299 ff.

56 Voltaire, 'Essai sur les Moeurs', *Oeuvres complètes* ([Kehl], 1785), vol. 19, pp. 363, 370.

57 *Oeuvres*, vol. 19, p. 349. See S. Gearhart, *The Open Boundary of History and Fiction* (Princeton, 1984), pp. 85 ff., and Hayden White, *The Historical Imagination in Nineteenth-Century Europe* (Baltimore and London), 1973, pp. 48 ff., who defines this systematic disjunction in Voltaire in rhetorical terms as an ironic troping of history.

58 *Geschichte*, p. X.
59 See pp. 54 ff.
60 Antiquarian scholarship was divided between the 'philological', that is, compilations of and com-
 mentary on ancient Greek and Roman texts referring to the visual arts (the standard reference work
 on the subject, to which Winckelmann was deeply indebted, was F. Junius, *The Painting of the
 Ancients* (London, 1638)), and the 'archaeological', that is compendia and catalogues, almost
 exclusively concerned with iconographical problems, of extant antiquities (the most comprehensive
 being Bernard de Montfaucon's *L'Antiquité expliquée et representée en figures*, 5 vols (Paris, 1719);
 supplement, 5 vols (Paris, 1724)). See Potts, 'Winckelmann's Construction of History', pp. 377 ff.
 On early antiquarian scholarship, see A. Momigliano, 'Ancient History and the Antiquarian', in
 Contributo all Storia degli Studi Classici, I, 1955, and C. B. Stark, *Systematik und Geschichte der
 Archäologie der Kunst* (Leipzig, 1880).
61 In the Anglo-Saxon world, such an approach has enjoyed particular prominence as a result of the
 work of Rhys Carpenter (see his *Greek Sculpture: A Critical Review* (Chicago, 1960)).
62 Even this connection was not any great help for a historical reconstruction of Greek art of the kind
 being attempted by Winckelmann. The sculptors of the Laocoön were not among the known
 personalities of the early history of Greek art, and were not assigned by Pliny to a particular period
 (*Natural History*, XXXVI, 37).
63 Comte de Caylus, 'Rélexions sur quelques chapitres. . . . de Pline', *Histoire de l'Académie Royale des
 Inscriptions et Belles-Lettres*, 25, 1759, pp. 332 ff. Like Winckelmann, Caylus was seeking to define
 a history of ancient art that would be traced out in terms of extant monuments, and would not be
 based exclusively on the interpretation of textual sources, as had been the norm before (see, for
 example, G. Turnbull, *A Treatise on Ancient Painting containing observations on the Rise, Progress and
 Decline of that Art among the Greeks and Romans* (London, 1740)).
64 Pliny XXXIV, 52. Modern interpreters of Pliny usually take this to refer, not to a decline, but to
 a 'period of stagnation'. This comment in Pliny may simply have marked the point where his main
 Greek authority broke off (see *The Elder Pliny's Chapters on the History of Art*, ed. K. Jex-Blake and
 E. Sellers, 1968, pp. 40–1). For Winckelmann's commentary, see *Geschichte*, p. 356, *Monumenti
 Inediti*, p. LXXXI.
65 For details, see pp. 73–4.
66 On the great century theory, see P. Burke, 'Tradition and Experience: the idea of decline from
 Bruni to Gibbon', in G. M. Bowersock and others, *Edward Gibbon and the Decline and Fall of the
 Roman Empire* (Cambridge, Mass., 1977), p. 96, and Potts, 'Winckelmann's Construction of
 History', p. 384. The most influential exponents of this theory (Dubos, *Réflexions critiques sur la
 poésie et sur la peinture* (Dresden, 1760), vol. II, pp. 131 ff., and Voltaire, *Le Siècle de Louis XIV*, in
 Oeuvres, vol. 20 ([Kehl], 1785), pp. 189 ff.) tended to envisage these 'great centuries' as isolated
 periods of cultural efflorescence, and not, like Winckelmann, as phases in some larger and all-
 embracing process of historical development.
67 Vasari discusses the decline of ancient art in the later Roman Empire in the preface to part one of
 his *Lives of the Artists*, while his account of the progress of Greek art from archaic origins to classic
 perfection is set out in the preface to part two. For further details, see Potts, 'Winckelmann's
 Construction of History', p. 382.
68 Accounts of modern art in the seventeenth and eighteenth centuries centuries usually took the form
 of collections of lives of artists. Though accounts of individual artists were often arranged roughly
 chronologically by school, these were not set in some larger schema of historical development
 comparable to Vasari's. Bellori and Félibien, two of the more important classical theorists of the
 seventeenth century, did identify a phase of decline afer the High Renaissance, and then a revival
 under the Carracci (J. von Schlosser, *Die Kunstliteratur* (Vienna, 1924), pp. 453 ff., and E. van der
 Grinten, *Enquiries into the History of Art-Historical Writing* (Amsterdam, 1952), pp. 47–9), but
 traces of this larger historical pattern were much attenuated in collections of lives of the artists
 published in the eighteenth century. These usually took Roger de Piles' ahistorical *Abrégé de la vie
 des peintres* (1699) as their model (Potts, 'Winckelmann's Construction of History', 1982, p. 383).
 Bellori's purist classical view of the history of modern art was very important for Winckelmann (G.
 Heres, 'Winckelmann, Bernini, Bellori. Betrachtungen zur Nachahmung der Alten', *Forschungen
 und Berichte*, 19, 1979, pp. 9 ff.) in that Winckelmann envisaged the supposed corruption of art in
 the period after the High Renaissance as a model for conceptualizing the degeneration of taste in
 ancient Greek art in the wake of the classic period (*Geschichte*, p. 359, and also more implicitly
 p. 235; on this see E. H. Gombrich, *Ideas of Progress and their Impact on Art* (New York, 1971)).

69 *Geschichte*, p. XXIV. While he was in Germany, Winckelmann took a strong interest in the natural sciences and scientific method, reading widely in the most up-to-date scholarly literature on the subject. See J. Wiesner, 'Winckelmann und Hippokrates. Zu Winckelmann's naturwissen-schaftlich-medizinischen Studien', *Gymnasium*, 60, 1953, pp. 149–67, and also Lepenies, 'Kunst und Naturgeschichte' (note 2). After completing *The History of Art*, he contemplated returning to the natural sciences (*Briefe*, vol. II, p. 366, and vol. III, p. 32; letters dating from Dec. 1763 and April 1764).

70 On the epistemology of this Enlightenment notion of system, see the references in note 2.

71 Montesquieu, *Oeuvres*, vol. I (Paris, 1950), pp. lix, lxii.

72 *Geschichte*, pp. X–XX.

73 Winckelmann makes this quite explicit in the conclusion to the *History of Art*. See pp. 48–50.

74 *Geschichte*, pp. 185–6.

75 *Geschichte*, pp. IX–X.

76 On the theoretical complexities of Rousseau's histories of social inequality and of language, see P. de Man, *Allegories of Reading* (New Haven, 1979), pp. 136ff., 154ff., and 'The Rhetoric of Blindness: Jacques Derrida's Reading of Rousseau' in *Blindness and Insight* (Minneapolis, 1983), pp. 114ff.; and also S. Gearhart, *The Open Boundary of History and Fiction* (Princeton, 1984), pp. 280ff. I am grateful to Michael Podro for drawing my attention to the importance of Rousseau's *Discourse on Inequality* for the structuring of Winckelmann's *History of Art*.

77 J.-J. Rousseau, *Discours sur les sciences et les arts. Discours sur l'Origine de l'inégalité* (Paris, 1971), p. 204. The succession of negatives in the last sentence make this passage quite difficult to interpret on first reading: 'les conséquences que je veux déduire des miennes [i.e. de mes conjectures] ne seront point pour cela conjecturales, puisque, sur les principes que je viens d'établir, on ne saurait former aucun autre système qui ne me fournisse les mêmes résultats, et dont je ne puisse tirer les mêmes conclusions.'

78 Rousseau, *Discours*, p. 204. A very similar point was made later by Schiller, though he took a less incisively sceptical view of the disparity between the historical facts and the necessarily speculative narratives of a general history that seek to bridge the gaps between them (S. M. Martinson, 'Filling in the Gaps: "The Problem of World-Order" in Friedrich Schiller's essay on Universal History', *Eighteenth Century Studies*, 22, no. 1, 1988, pp. 37, 40).

79 Rousseau, *Discours*, p. 204.

80 How, Rousseau would ask (*Discours*, pp. 183ff.), could standard 'functionalist' explanations of the emergence of the institutions of civil society work? As people would have had to subject themselves to the disciplines and constraints these institutions imposed well before experiencing their benefits, they could not have been motivated to submit to such a radical curtailment of their freedom by an awareness of the compensatory benefits it would bring. On Rousseau's radical critique of contemporary explanations of the origin of language, see de Man, 'The Rhetoric of Blindness' (note 30).

81 Rousseau, *Discours*, p. 204.

82 On Winckelmann's conceptualizing the history of ancient traditions other than the Greek one as incomplete, see note 51. The history of modern art too was seen by him as an imperfect or stunted version of the ideal history realized by the ancient Greeks (*Geschichte*, pp. 247–8). On Winckelmann's 'ideal' constitution of the history of ancient Greek art, see A. Vidler, 'The hut and the body', *Lotus International*, 33, 1972, p. 107.

83 See S. Gearhart, *The Open Boundary* (note 76), p. 280.

CHAPTER II

FACT AND FANTASY

1 From our particular present-day perspective, Enlightenment thinkers can often seem to have a greater awareness of the conceptual framing of history than the supposedly more historically conscious writers of the nineteenth century. On this critical dimension to eighteenth-century ideas of history see, for example, S. Gearhart, *The Open Boundary of History and Fiction: A Critical Approach to the French Enlightenment* (Princeton, 1984), and Paul de Man's studies of Rousseau (Chapter I, note 76), to which the analysis offered in this chapter owes a good deal.

2 Winckelmann, *Geschichte*, pp. 430–1. An earlier version of the analysis offered here appeared as

'Vie et mort de l'art antique' in *Winckelmann: la naissance de l'histoire de l'art à l'époque des lumières* (Paris, 1991), published by the Service culturel du Musée du Louvre at La documentation française under the direction of Édouard Pommier.

3 Imagination in Enlightenment thought is seen simultaneously as the driving force activating mental processes, and as a potentially uncontrollable creative energy that can readily spill over into madness—see, for example, E. B. Condillac, *Essai sur l'origine des connaissances humaines* (Auvers-sur-Oise, 1973; first published 1746), p. 127.

4 A paper by Whitney Davis given London in 1991, 'Mourning . . . The Death of Art History', first drew my attention to the significance of this gendering.

5 Winckelmann here makes reference to a passage in Cicero (*Orator* 51– 4; quoted in Winterbottom, *Ancient Literary Criticism*, p. 255) which distinguishes 'history the way the Greeks wrote it' from 'merely the compiling of annals'. The idea of 'history the way the Greeks wrote it', however, is not understood by Cicero in the same way as it is by Winckelmann. Cicero is referring to forms of historical writing that exploit the full resources of rhetoric, and hence make more of an impact on their audience than unadorned compilations of historical fact. There is no suggestion that a larger conceptual understanding of history is involved of the kind Winckelmann envisages. At the same time, Winckelmann does consider history 'taken in the broader sense' to be integrally bound up with the rhetorical devices of story telling (see p. 51).

6 *Geschichte*, pp. IX–X.

7 See, for example, J. Derrida, *Of Grammatology* (Baltimore, 1976), pp. 12–14. If we take radical scepticism to the point where the coherence of historical narrative becomes entirely a function of language, (de Man, *Blindness and Insight* (Minneapolis, 1983), p. 135), and we regard any correspondence between 'a historical system of periodization' and theoretical or 'hermeneutic' categories as merely the product of our desire for 'seamlessly articulated' aesthetic totalities (de Man, *The Resistance to Theory* (Manchester, 1986), p. 67), then the very possibility of systematically defining a cultural formation existing at a particular point or epoch in history is thrown into question, just as much as any narrative of its appearance and disappearance. A synchronic structural approach to cultural history can no more evade the antinomies involved than a diachronic narrative one.

8 Karl Marx, *Werke. Ergänzungsband. Schriften Manuskripte Briefe bis 1844*, vol. I (Berlin, 1968), pp. 286–7.

9 *Geschichte*, pp. 213–14.

10 Aristotle, *Poetics*, 23, quoted from Winterbottom, *Ancient Literary Criticism*, p. 123.

11 Aristotle, *Poetics*, 9, quoted from Winterbottom, p. 102.

12 *Geschichte*, pp. 3– 4.

13 On cyclical theories of history in the eighteenth century involving processes of evolution from the necessary to the superfluous, and on the preoccupation with the possibility of cultural decline these articulate, see L. Pompa, *Vico: A Study of the 'New Science'* (London, 1975), pp. 124 ff., 37 ff. (the relevant passages in Vico's *Scienza Nuova* are sections 238– 44 and 348–9); J. G. A. Pocock, *The Machiavellian Moment* (Princeton, 1975), pp. 76 ff., and *Politics Language and Time* (New York, 1971), pp. 95 ff., 76 ff.; and P. Burke, 'Tradition and Experience: The Idea of Decline from Bruni to Gibbon', in G. W. Bowersock and others (eds), *Edward Gibbon and the Decline and Fall of the Roman Empire* (Cambridge, Mass., 1977), pp. 93 ff. Winckelmann conceived the history of architecture in very similar terms as evolving from a crude simplicity dictated by necessity to the non-functional variety of the beautiful, and beyond this to the excesses of superfluous decoration (*Anmerkungen über die Baukunst der Alten* (Leipzig, 1762), p. 50 ff.). One of Winckelmann's main sources of information on ancient art, F. Junius *The Painting of the Ancients* (London, 1638, p. 118) quoted Pliny as saying 'Such is always the condition of our minds, that the workes begun with necessary things, end most commonly with the superfluous.' On the major role a preoccupation with decline played in structuring Winckelmann's understanding of history, see E. H. Gombrich, *Ideas of Progress and their Impact on Art* (New York, 1971), particularly p. 22.

14 The classic account of such a history of language was Condillac's *Essai sur l'Origine des connaissances humaines* (Auvers-sur-Oise, 1973; first published 1746); see particularly pp. 229–31, 259. Winckelmann's analysis of the origins and early formation of art very much keeps to this paradigm of the earlier Enlightenment, which gives priority to the epistemological as distinct from the expressive function of systems of signs and representations.

15 *Geschichte*, pp. X, 213.

16 *Geschichte*, p. 27.

17 There was a certain amount of debate in the period over whether climate or physical 'causes' took

precedence over moral, or what we might call political or social factors; see, for example, George Turnbull's critique of the climactic determinism associated with Dubos and Montesquieu and his arguments, largely based on Shaftesbury, for the primacy of political freedom as the main stimulus of artistic excellence (*A Treatise on Ancient Painting* (London, 1740), pp. 107 ff.).

18 *Geschichte*, p. 132. See also pp. 130 ff., 324 ff.
19 *Geschichte* (Vienna, 1776), p. 234.
20 *Geschichte*, p. 26.
21 *Geschichte*, pp. 130, 135.
22 On positive and negative conceptions of liberty, see Quentin Skinner, 'The republican ideal of political liberty', in G. Bock, Q. Skinner and M. Virilio, eds., *Machiavelli and Republicanism* (Cambridge, 1990), pp. 293–309, and R. G. Pfeffer, *Marxism, Morality and Social Justice* (Princeton, 1990), pp. 122 ff. This distinction first became a major issue of political debate in the aftermath of the French Revolution.
23 See pp. 225–6. On the distinction that nevertheless needs to be made between Winckelmann's traditional understanding of the relation between art and freedom and that found in later German idealist thought, see M. Podro, *The Critical Historians of Art* (New Haven and London, 1982), p. 8.
24 See for example *Observations sur les Arts et sur quelques morceaux de peinture et de sculpture, exposés au Louvre en 1748* (Leiden, 1748), pp. 9–10, and [O. de Guasco], *De l'Usage des statues chez les anciens: essai historique* (Brussels, 1768) particularly pp. 425 ff. Winckelmann's quasi-sociological analysis of the political circumstances affecting art still links him, however, with French Enlightenment thought (see Chapter I, note 22). What is completely absent in Winckelmann is that new consciousness of the socio-economic determinants of culture emerging in British thinking of the period, which was already having a significant impact on art theory—see John Barrell, *The Political Theory of Painting from Reynolds to Hazlitt* (London and New Haven, 1986).
25 On the great century theory, see Chapter I, note 66.
26 *Geschichte*, p. 407.
27 The idea that freedom had been a crucial factor in the flowering of the arts in ancient Greece might easily be patrician, and not just radical or proto-republican in tenor. The Comte de Caylus was as insistent as Winckelmann that freedom explained the superiority of Greek over Roman art (*Recueil*, vol. I, 1752, p. 159, vol. IV, 1761, pp. 136–7, vol. VI, 1764, p. 118). Freedom would often represent something enjoyed by a small elite—among whom artists could be included—and refer to the freedom of the independent aristocrat or man of means from political or economic interference by central government.
28 *Geschichte*, Vienna, 1776, pp. 711–12, and 722; see also pp. 691–2.
29 On the eighteenth-century concern with the apparent incompatibility between the refinements of culture and the 'primitive' virtues of a truly free society, see J. G. A. Pocock, *Politics, Language and Time* (New York, 1971), pp. 95 ff. and 498 ff. Rousseau was haunted by the vision of an ideal fusion of virtue and desire that was blocked by the corrupting divisions and inequalities of modern society (see C. Bloom, *Rousseau and the Republic of Virtue: The Language of Politics in the French Revolution* (Ithaca, 1986), particularly pp. 106 ff., 64 ff.).
30 *Geschichte*, pp. 25–8.
31 *Geschichte*, p. 224.
32 *Geschichte*, p. 345.
33 *Geschichte* (Vienna, 1776), pp. 691–2.
34 *Geschichte*, p. 369.
35 *Geschichte*, p. 409.
36 See p. 38 and Potts, 'Greek Sculpture and Roman Copies'.
37 *Geschichte*, p. 392.
38 Winckelmann, *Geschichte*, pp. 170, 226, 233. See pp. 82–3 for further details. Both the Niobe and the Laocoön are now believed to derive from Hellenistic prototypes. The Niobe is thought to be a rather mediocre copy of an early Hellenistic work, and the Laocoön a free reinterpretation of a much later Hellenistic creation (Martin Robertson, *A History of Greek Art* (Cambridge, 1975), pp. 461, 541 ff.). Of the other 'masterpieces' of antique sculpture particularly singled out by Winckelmann, the Belvedere Torso is now categorized in similar terms to the Laocoön as late Hellenistic in conception, though possibly a very high-quality copy rather than a free reworking of an earlier model (Robertson, p. 543). The Apollo Belvedere and the Belvedere Antinous, like the Niobe, are now thought to be Graeco-Roman copies of earlier Greek creations. On the reputation these 'masterpieces' enjoyed prior to their devaluation in the nineteenth century as inferior to

'pure' Greek work, see Haskell and Penny, *Taste and the Antique*, Nos 8, 52, 66 and 80. For a recent analysis arguing that such statues are better seen as free imitations or pastiches characterized by their own distinctive aesthetic preoccupations, rather than mere mechanical replicas, see P. Zanker, *Klassizistische Statuen* (Mainz, 1974).

39 *Geschichte*, pp. 371, 368–9. Winckelmann used a rather questionable epigraphical argument based on the form of the lettering on the signature inscribed on the statue to date the Torso as early as he did.

40 *Geschichte*, p. 392. Winckelmann made the point that the Belvedere Torso (p. 370), which according to him well postdated the classic period, was 'nearer to a higher period of art than even the Apollo (Belvedere)'.

41 Robertson, *History* (note 38), p. 460 ff.

42 *Geschichte*, p. 407.

43 *Geschichte*, pp. 409–10. The statue later came to be identified as a Hermes. Winckelmann maintained that Roman portraits, as distinct from free-standing ideal nudes, could still be of very fine quality. On occasion he would be very eloquent about the beauty of Hadrianic portraits of Antinous, particularly the relief (Plate 5) in the Villa Albani (*Anmerkungen*, p. 123).

44 R. Barthes, *Camera Lucida* (New York, 1981), transl. R. Howard p. 65.

45 *Geschichte*, pp. 430–1.

CHAPTER III

STYLE

1 The latter two sections of this chapter were published in somewhat different form in my article 'The verbal and visual in Winckelmann's analysis of style', *Word & Image* (Taylor and Francis, London, New York and Philadelphia), 6, 1990, pp. 226–40.

2 *Geschichte*, p. X.

3 For a discussion of the issues involved, see Barthes' essay 'The Rhetoric of the Image' (1964, published in English in *Image Music Text*, New York, 1977) and also Y.-A. Bois, *Painting as Model* (Cambridge, Mass and London, 1990), pp. xvii–xxiv. Among the many recent theoretical reformulations of rhetorical theory, Paul de Man's (*The Rhetoric of Romanticism* (New York, 1984), and *The Resistance to Theory* (Manchester, 1986)) has been particularly important for the analysis offered in this chapter.

4 *Geschichte*, pp. 222–3, 225.

5 *Geschichte*, pp. 229–33.

6 For a particularly dematerialized definition of ideal beauty in art, see Ten Kate, 'Discours préliminaire sur le beau idéal' in J. Richardson (père et fils), *Traité de la peinture et de la sculpture*, vol. III (Amsterdam, 1728).

7 The turn to systematic stylistic analysis in German and Austrian art-historical scholarship of the later nineteenth century that culminated in the work of Wölfflin and Riegl (on whom see M. Podro, *The Critical Historians of Art* (New Haven and London, 1982), pp. 55 ff.) coincided with a major revival of interest in Winckelmann. Justi's three-volume intellectual biography *Winckelmann und seine Zeitgenossen* first came out in 1867–72.

8 On modern art-historical notions of style see E. H. Gombrich, *Art and Illusion* (London, 1960) introduction, M. Schapiro, 'Style' in A. L. Kroeber (ed.), *Anthropology Today* (Chicago, 1953), reprinted in M. H. Philipson (ed.), *Aesthetics Today* (Cleveland, 1961), pp. 81–113, and Nelson Goodman, 'The Status of Style', *Critical Inquiry*, I, 1975, pp. 799–801.

9 Dilly, *Kunstgeschichte als Institution*, p. 86. The passage comes from an article by Burckhardt on the history of art published in an encyclopaedia in 1843.

10 E. Panofsky, 'Über das Verhältnis der Kunstgeschichte zur Kunsttheorie', in *Aufsätze zu Grundfragen der Kunstwissenschaft* (Berlin, 1964); first published in 1925. Wölfflin's famous distinction between the linear and the painterly in his *Principles of Art History* (New York, 1950; first German edition 1915) might at first sight seem to be somewhat at odds with the opposition being set up here between the idea-like and the literal or object-like. It is important to appreciate that Wölfflin's theory is, in contrast with Winckelmann's, first and foremost a theory of style in painting, not sculpture. In Wölfflin's scheme of things, drawing is associated with plasticity, and in the context of painted representations, this plasticity is ostensive, not literal. The pure optical effect

of colour privileged in the painterly mode constitutes the more immediate phenomenal aspect of painted representation. Wölfflin's formal theory of style was closely bound up with debates around naturalism and Impressionism in the later nineteenth century, in which drawing was envisaged as defining structure or essence and colour as rendering visual appearance, or atmosphere and texture. In Wölfflin, as in Winckelmann, the linear or 'high' term of the polarity is designated as historically prior to the painterly or 'beautiful' one, with the former geared more to the determinate articulation of meaning, and the latter more to fullness of sensual effect.

11 See for example P. Leider, 'Literalism and Abstraction', *Artforum*, June 1970, pp. 44 ff., and M. Fried, 'Art and Objecthood', *Artforum*, June 1967.

12 The two best-known analogies between the historical development of artistic and literary style in ancient rhetorical theory are found in Quintilian, *Institutio Oratoria*, XII, x, 1–10, and Cicero, *Brutus*, 70 (see J. J. Pollitt, *The Art of Greece 1400–31* B.C. (Englewood Cliffs, NJ, 1965), pp. 219–21).

13 Pliny, *Natural History*, XXXIV, 52 and XXXIV, 65.

14 Caylus, 'Réflexions sur quelques chapitres du XXXIVe Livre de Pline', *Mémoires de l'Académie des Inscriptions et des Belles-Lettres*, 25, 1759, pp. 338–9.

15 *Geschichte*, pp. 222, 227.

16 *Geschichte*, p. 224.

17 *Geschichte*, p. 228.

18 See for example, Caylus, 1759 (note 14), p. 345 and E. Falconet, *Traduction des XXXIV, XXXV et XXXVI livres de Pline l'Ancien* (Amsterdam, 1773), vol. I, p. 92.

19 *Geschichte*, p. 227.

20 *Geschichte*, p. 248.

21 G. Vasari, *The Lives of the Artists* (Harmondsworth, 1965), transl. and ed. G. Bull, based on the second Italian edition of 1568, pp. 85 (preface to Part II), 249–51 (preface to Part III).

22 Vasari, *Lives*, pp. 251–2.

23 Caylus, *Recueil*, vol. I, p. vii. On Caylus, see S. Rocheblave, *Essai sur le Comte de Caylus* (Paris, 1889), and F. Haskell, *History and its Images: Art and the Interpretation of the Past* (New Haven and London, 1993), pp. 180–8.

24 Caylus, *Recueil*, vol. I, p. ix.

25 Caylus, *Recueil*, vol. I, p. iii.

26 G. L. L. de Buffon, *Histoire naturelle*, vol. I (Paris, 1749), pp. 11 ff. On Buffon's method, see C. Roger, *Les Sciences de la vie dans la pensée française* (Paris, 1963), pp. 527 ff.

27 Caylus, *Recueil*, vol. III, p. 400.

28 Caylus, *Recueil*, vol. V, p. 92.

29 Caylus, *Recueil*, vol. I, pp. v–vi.

30 Caylus, *Recueil*, vol. II, p. i.

31 J. J. Barthélemy, 'Essai d'une Paléographie Numismatique', *Mémoires de l'Académie des Inscriptions et Belles-Lettres*, 24, 1757, pp. 30 ff., and 'Remarques sur Quelques Médailles publiées par différents Auteurs', *Mémoires*, 26, 1759, pp. 535 ff.

32 Caylus, *Recueil*, vol. V, pp. 91–2.

33 Caylus, *Recueil*, vol. II, pp. 53–5.

34 See particularly *Geschichte*, p. 217.

35 Barthélemy (1759 (note 31), pp. 534–5, 540–1) rejected several early datings of coins on the grounds that the style of the image and inscription did not have the archaic form one would expect of work from the period concerned.

36 Caylus, *Recueil*, vol. I, 284, vol. III, p. 41, vol. IV, pp. 57–8.

37 Caylus favoured a cautiously empirical approach, expressing, for example, strong scepticism about reconstructing a history of Greek art on the basis of literary evidence in the absence of specific examples of the works described by ancient writers (1759, note 14, p. 334). There are indications that he might have objected to Winckelmann's more systematic and speculative method (S. Rocheblave, *Essai sur le Comte de Caylus* (Paris, 1889), p. 331.

38 Caylus, *Recueil*, vol. V, p. vi.

39 Caylus, *Recueil*, vol. V, p. 127.

40 Caylus, *Recueil*, vol. I, p. 158.

41 Caylus, *Recueil*, vol. I, p. 159, vol. II, p. 317 ('Le beau travail et les idées du grand').

42 For Winckelmann the finest qualities of the archaic style were to be valued in the final analysis as preconditions for the emergence of a fully developed classic style (*Geschichte*, pp. 222–3). If

Caylus's characterization of Egyptian art came much closer than anything in Winckelmann to attributing an autonomous value to archaic-looking work, he never in so many words challenged the accepted view that classic Greek art represented a peak of achievement in relation to which all earlier forms of art were somewhat imperfectly realized preludes. He enthusiastically celebrated the 'grandeur' and 'simplicity' of Egyptian work (*Recueil*, vol. I, 119, and vol. IV, p. 57), but at the same time made clear that Greek art not only had a beauty and elegance lacking in Egyptian art, but 'grandeur' as well (*Recueil*, vol. I, p. ix and vol. IV, pp. 136–7).

43 *Geschichte*, pp. 232–3. On these statues, see Chapter II, note 38.

44 *Geschichte*, p. 226. On the identification of this Athena as the so-called Athena Farnese in Naples, see P. Preyes, 'Athena Hope und Pallas Athena—"Farnese"', *Jahrbuch des Kaiserl. Archäologischen Instituts*, XXVI, 1912 (and also XXVII, 1915). For a detailed analysis of this supposedly fifth-century BC Athena type, see A. Furtwängler, *Masterpieces of Greek Sculpture* (London, 1895), pp. 73 ff.

45 *Monumenti Inediti*, p. LV ; see also *Geschichte*, p. 228. On Morelli and Winckelmann, see J. J. Spector, 'The Method of Morelli and its Relation to Freudian Psychoanalysis', *Diogenes*, 66, 1969, pp. 69–71 (my thanks to Jaynie Anderson for this reference).

46 *Geschichte*, p. 217.

47 *Geschichte*, p. 350. For examples of such coins, see Jenkins, *Ancient Greek Coins* (London, 1972), Nos 278–9, 235, 237. Around 1760 Winckelmann wrote a short treatise in Latin on ancient Greek coinage, which he never published. There he elaborated a number of ideas about the early development of Greek art that he later incorporated in his *History* (see K. P. Goethert, *Johann Joachim Winckelmann 'De ratione delineandi Graecorum artificium primi artium seculi ex nummis antiquissimus dignoscenda'* (Akademie der Wissenschaften und der Literatur, Abhandlungen der Geistes-und Sozialwissenschaftlichen Klasse, Mainz, 1974).

48 There are odd very isolated instances of pre-Hellenistic coins carrying the name of a ruling monarch, such as those issued by Alexander I of Macedon. See Jenkins, *Ancient Greek Coins*, p. 63.

49 *Geschichte*, p. 216; see also *Anmerkungen*, p. III.

50 *Kleine Schriften*, p. 154. See also the passage (*Geschichte*, p. l66) where he makes a more general point about how the images on coins and engraved gems give one an idea of the high conception of early Greek representations of the heads of the gods. For examples of these Syracuse coins, see Jenkins, *Ancient Greek Coins*, Nos 371, 392, 396. Many are illustrated in the standard eighteenth-century reference book on ancient coinage, L. Beger, *Thesaurus Brandenburgus Selectus* (Brandbenburg, 1696).

51 *Geschichte*, p. 166.

52 *Geschichte*, p. 327, *Anmerkungen*, pp. 31, 87. On these coins, see C. T. Seltmann, *Greek Coins* (London, 1960), LX No. 15 and p. 248. J. J. Barthélemy, 'Remarques sur quelques médailles . . .', *Mémoires de l'Académie des Inscriptions et Belles-Lettres*, 26, 1759, p. 534. The coin illustrated here (Plate 11) is close in type to the one cited by Winckelmann. It was issued by Gelon II's successor, Hieron II, who similarly had a namesake among the earlier tyrants of Syracuse who ruled in the fifth century BC.

53 See note 44.

54 Pliny, *Natural History*, XXXVI, 28.

55 Pliny, *Natural History*, XXXIV, 49.

56 *Geschichte*, p. 227.

57 On the controversies surrounding the dating of the Laocoön, see M. Robertson, *A History of Greek Art* (Cambridge, 1975), pp. 541 ff.

58 Pliny XXXVI, 37.

59 *Geschichte*, p. 243; *Monumenti Inediti*, p. lxxv, and No. 40. Initially, Winckelmann thought that a marble version then in the Borghese collection, and now in the Louvre, might be an original work by Praxiteles. Later, he noticed (*Geschichte*, Vienna, 1776, pp. 678–80) that the statue was cited by Pliny in his chapter on bronze sculpture (*Natural History*, XXXIV 70), and he identified a small bronze in the Albani Collection as a possible original. On this prototype, see M. Robertson, *A History of Greek Sculpture* (Cambridge, 1975), pp. 388–9, and Haskell and Penny, *Taste and the Antique*, No. 9.

60 The literary evidence Winckelmann cited for Praxiteles' work being distinguished by a particular gracefulness of style (*Geschichte*, p. 228; Lucian, *Eikones*, 6, in *Lucian* (Loeb Classical Library), vol. VI, 1969, pp. 266–9) devolves on a highly eccentric interpretation of the relevant passage in Lucian.

61 E. Q. Visconti, whose elaborately argued and documented identifications of copies of statues

mentioned in ancient literary sources arguably did more to initiate a modern approach than Winckelmann's rather *ad hoc* and intuitive style of analysis, tended to focus on types that could be ascribed to Praxiteles (see for example *Musée Pie-Clementin* (Milan, 1818–20), vol. I, pp. 112–13 and vol. II, pp. 217–19; first published 1782–4). Both Canova (think of his various versions of the genius of death, and his statue of Paris) and even more so Thorwaldsen (particularly his Mercury and Shepherd Boy) showed an interest in a graceful 'Praxitelean' image of the nubile male youth.

62 *Geschichte*, p. 235.
63 He described the head of the Antinous as softly graceful in contrast with the more austere head of the Apollo Belvedere (*Geschichte*, p. 409). His analysis of the beautiful style cites a number of Graeco-Roman renderings of the graceful childish type he believed to have been invented in the beautiful period, though he does not unequivocally assign these to the late classic period (*Geschichte*, pp. 233–4).
64 *Anmerkungen*, p. VI.
65 *Anmerkungen*, p. 87. The statue is now identified as a figure of Apollo carrying a lyre. Adolf Furtwängler, (*Masterpieces of Greek Sculpture* (London, 1895), p. 88) thought it a copy of a relatively 'austere' fifth century BC creation, but scholarly opinion now inclines to the view that it derives from a later prototype of the fourth century BC (see D. Ohly, *Glyptothek München* (Munich, 1977), p. 100).
66 *Geschichte*, p. L.
67 *Geschichte*, p. 109, illustrated on p. 127. Later opinion is of the view that the gem is a Roman work dating from the first century BC or the Augustan period (see Preface, note 5).
68 A technical understanding of rhetorical theory played a similarly crucial role in the formulation of theories of visual style in the Renaissance (M. Baxandall, *Giotto and the Orators* (Oxford, 1947)).
69 Conceptualist and Minimalist tendencies in the visual art of the 1960s highlighted a structural disjunction between the visual or material constitution of a work and its possible 'immaterial' or verbal meanings well before the influence of French structuralist and post-structuralist theory made it fashionable to criticize the illusions of a symbolic fusion between form and meaning. See for example the commentary by Carl André dating from the early 1960s (quoted in C. André and H. Frampton, *Twelve Dialogues 1962–3* (Halifax, Nova Scotia, 1980), p. 5) and that published by Robert Smithson in 1968 (reprinted in *The Writings of Robert Smithson* (New York, 1975), pp. 67, 87).
70 Pliny, *Natural History*, p. 227. Athenagoras was a Greek writing in the later second century AD. See W. J. T. Mitchell *Iconology. Image, Text, Ideology* (Chicago and London, 1986) for a discussion of modern western ideas on the relative reliability of image and language as forms of representation.
71 *Allegorie*, p. 2.
72 Winckelmann was quite explicit that the ideal figures of Greek art were not what we would call symbolic figures in which meaning and sensuous form somehow fuse together. On the contrary, they were visual allegories whose meaning had to be constituted through the mediation of language. It was in the writings of the poets that equivalences had first been set up between the idea of a god and a particular conception of that god's bodily form (*Allegorie*, p. 22).
73 On the distinction between the symbolic and the allegorical, see P. de Man, 'The Rhetoric of Temporality', in *Blindness and Insight* (London, 1983), pp. 187 ff.
74 A systematically historical distinction of the kind Winckelmann was making between the high and beautiful styles only begins to occur in discussions of style in literature (see for example F. Schiller 'Über Anmut und Würde', in *Über Kunst und Wirklichkeit: Schriften und Briefe zur Ästhetik* (Leipzig, 1975), p. 189) towards the end of the eighteenth century.
75 See note 12. On the importance of comparisons between rhetoric and art for Winckelmann's definition of the style of early Greek sculpture, see E. H. Gombrich, *Ideas of Progress and their Impact on Art* (New York, 1971), p. 16.
76 *Geschichte*, pp. 232, 346.
77 *Monumenti Inediti*, p. LXXVI.
78 Two main kinds of systematic stylistic distinction were made in ancient rhetorical theory, a binary one between disconnected and period forms of word arrangement, and a tripartite one between a grand, a middle or ornate, and a plain style. In each case, one style was understood to have evolved earliest, namely the disconnected style and the grand style. The two schema were not integrated with one another, however. Thus grandeur of effect was not necessarily associated with a disconnected form of word arrangement. Nor were the styles mapped in any systematically chronological way. No exact precedent can be found for Winckelmann's idea of a change from a more discon-

nected and grand to a more flowing and refined style of writing in the classic period. Demosthenes, a 'late' figure from the time of the Macedonian invasion, was conventionally seen to mark the high point of the ancient Greek rhetorical tradition and was considered the supreme master of all styles, including the disconnected one and the grand one. Indeed, his oratory was deemed particularly notable for its grandeur of effect. On style in ancient rhetorical theory see G. M. A. Gruber, *The Greek and Roman Critics* (Toronto, 1965), J. W. H. Atkins, *Literary Criticism in Antiquity* (Cambridge), 1934, and E. H. Gombrich, 'The Debate on Primitivism in Ancient Rhetoric', *Journal of the Warburg and Courtauld Institutes*, 29, 1966.

79 The closest precedent for such a patterning comes in Caylus's *Recueil d'Antiquités* (vol. I, p. ix) where he outlined his general 'history of the arts' in the ancient world: 'You see them formed in Egypt with all the character of grandeur, from there pass to Etruria, where they acquired parts of detail, but at the expense of this same grandeur; then transported to Greece, where knowledge joined to the most noble elegance, led them to their greatest perfection.' See p. 78–9.

80 *Anmerkungen*, 1767, p. 32.

81 Demetrius, *On Style*, 14–15 (quoted in Winterbottom, *Ancient Literary Criticism*, p. 176). Compare also Dionysus of Halikarnassus, *On the Arrangement of Words*, 21–23, and Aristotle, *Rhetoric* 3, 1409 (both quoted in Winterbottom, pp. 147–8 and 338–9).

82 *Geschichte*, pp. 224–5, 227–8.

83 See the distinction made between the disconnected and periodic styles of word arrangement in Demetrius *On Style* (translated by W. Rhys Roberts (Cambridge, 1902); particularly sections 13–15) and between an austere (disconnected) and smooth (periodic) style in Dionysus of Halikarnassus *On Literary Composition* (translated by W. Rhys Roberts (London, 1910); particularly sections 22–4).

84 *Geschichte*, pp. 222–3. See also *Anmerkungen*, p. 32. The point about a clear and emphatic distinction between parts in the earlier phases of the development of a system of representation features centrally in Condillac's classic history of language (*Essai sur l'Origine des connaissances humaines* (Auvers-sur-Oise, 1973), see particularly chapter II, pp. 200–1; first published in 1746).

85 The idea that beauty of style does not enhance or improve on the clear articulation of the forms of the human body achieved in a developed archaic style, but rather involves a refinement of effect, underlies Winckelmann's general outline of the history of art (*Geschichte*, pp. 3–4; see also p. 52). Condillac, following the British historian of language William Warburton, envisaged the cultivation of beauty as an embellishment of linguistic form that became possible once all the resources needed for a full and clear representation of knowledge had been evolved (*Essai*, 1973, p. 255).

86 *Geschichte*, pp. 228–9; Longinus, *On Sublimity*, 12.3–5 (quoted in Winterbottom, *Ancient Literary Criticism*, p. 475; the attribution of this text to Longinus, common in the eighteenth century, is now generally rejected).

87 *Geschichte*, 226–7, 232–3. The two statues (see also note 28) were among the more famous sights of Rome in Winckelmann's time (the Niobe was subsequently moved from the Villa Medici in Rome to the Uffizi). On the story represented by the Laocoön, see J. B. Onians, *Art and Thought in the Hellenistic Age* (London, 1979), pp. 90–1, and S. Richter, *Laocoön's Body and the Aesthetics of Pain* (Detroit, 1992), pp. 24–5.

88 *Geschichte*, pp. 232, 233, 349.

89 *Geschichte*, pp. 230–l. The allegory makes reference to a conventional idea of the dual character of Venus in her heavenly and earthly guises inherited from antiquity, the classic formulations of which are in Plato's *Symposium* (181, see *The Dialogues of Plato*, vol. 2, *The Symposium and other Dialogues*, translated by B. Jowett (Falmouth, 1970), pp. 194–5; Winckelmann does not specifically cite Plato in this context) and Xenophon's *The Banquet* (VIII, 6ff., see *Anabasis IV–VII. Symposium and Apology*, translated C. L. Brownson and O. J. Todd (London, 1947)).

90 On this tendency as manifested in Winckelmann's *Treatise on the Capacity for the Feeling for Beauty* (1763), see pp. 205–6.

91 Plato, *Parmenides, Theastetos, Sophist, Statesman*, translated J. Warrington (London and New York, 1961), p. 243.

92 See pp. 157–8.

93 See Stephen Bungay, *Beauty and Truth: A Study of Hegel's Aesthetics* (Oxford, 1987), and also P. de Man, 'Sign and Symbol in Hegel's *Aesthetics*', *Critical Inquiry*, Summer 1982, pp. 761 ff.

94 *Geschichte*, pp. 226–7.

95 *Geschichte*, p. 232.

96 *Geschichte*, p. 346.

97 This duality was codified systematically in seventeenth-century academic art theory. On the debates over the relative priority of drawing and colour in the French Academy, see B. Teyssèdre, *Roger de Piles et les débats sur le coloris au siècle de Louis XIV* (Paris and Lausanne, 1965). Earlier, during the Renaissance, the distinction between vivid imitation of nature and a conceptually informed mastery of drawing or *disegno* was not seen to be so problematic (E. Panofsky, *Idea: A Concept in Art Theory* (New York, 1968)).

98 In the new systematic distinction between the verbal and the visual being formulated in Winckelmann's time, there was a tendency to envisage the 'disembodied' medium of language as more effective for conveying the sublime or the powerfully emotive than the visual arts' more material or sensuous form of representation—consider, for example, Burke's *A Philosophical Enquiry into the Origin of our Ideas of the Sublime and Beautiful* (Oxford, 1987), Part V, pp. 163 ff.; see also W. J. T. Mitchell, *Iconology. Image Text Ideology* (Chicago, 1986), pp. 125 ff. and Lessing's *Laokoön* (Stuttgart, 1964), particularly section II, pp. 17 ff.

CHAPTER IV

BEAUTY AND SUBLIMITY

1 On eighteenth-century theories of the sublime, see H. Monk, *The Sublime: A Study of Critical Theories in Eighteenth-Century England* (New York, 1935), and T. Eagleton, *The Ideology of the Aesthetic* (Oxford, 1990), pp. 53 ff., 83 ff. For a discussion of the gendering of the category of the sublime, see W. J. T. Mitchell, 'Eye and Ear. Edmund Burke and the Politics of Sensibility', in *Iconology. Image Text Ideology* (Chicago, 1986), and Paul Mattick, 'Beautiful and Sublime. Gender Totemism in the Constitution of Art', *Journal of Aesthetics and Art Criticism*, 48, no. 4, 1990, pp. 293–303.

2 At that time sodomy was still officially a capital offence in most European countries. Recent studies have tended to highlight the ways in which it can be misleading to use the word homosexuality for contexts prior to the moment when it first came into use in the later nineteenth century, mainly because of its association with distinctively modern conceptions of identity as being constituted through sexual desire. On these debates, which have centred on Foucault's historicizing of modern notions of sexuality, see, for example, D. Halperin, *One Hundred Years of Homosexuality and other Essays on Greek Love* (New York and London, 1990), pp. 15–53, and more specifically, with reference to eighteenth-century Europe, G. Rousseau, 'The Pursuit of Homosexuality in the Eighteenth Century: "Utterly Confined Category" and/or Rich Repository', in *Perilous Enlightenment. Pre- and Post-Modern Discourses* (Manchester and New York, 1991), pp. 32 ff. For a general historical account of what we necessarily anachronistically call homosexuality in the eighteenth century, see Greenberg, *Homosexuality*, pp. 312–52.

3 See for example J. Kristeva, *Powers of Horror. An Essay on Abjection* (New York, 1982).

4 Where the post-modern condition in art is seen as having some existential weight to it, it is under the rubric of the sublime rather than the beautiful that this claim is usually staked out; see, for example, J. F. Lyotard, 'What is the Postmodern' (1982) in *The Postmodern Condition: A Report on Knowledge* (Manchester, 1984), pp. 71–82.

5 For Barnett Newman's celebration of the sublime and his critique of the beautiful as a category of aesthetic experience that is now no longer viable, see 'The Sublime is Now'(1948) in *Barnett Newman: Selected Writings* (Berkeley and Los Angeles, 1990), pp. 170–3.

6 Adorno (*Aesthetic Theory* (London and New York, 1984), pp. 280 ff.) has argued that the sublime in the rigorous sense as defined by Kant can hardly be used to define a particular kind of art designed to produce a 'sublime' aesthetic affect. The sublime being by definition incommensurable, any such attempt to co-opt it within dominant culture as a definable and hence manageable category of experience would be by definition a travesty.

7 E. Burke, *A Philosophical Enquiry into the Origins of our Ideas of the Sublime and Beautiful*, ed. J. T. Boulton (Oxford, 1987), p. 42.

8 The accepted English translation of Freud's term *Besetzung* is the misleadingly technical word 'cathexis'.

9 E. Burke, *Philosophical Enquiry*; see particularly pp. 135 ff.

10 This complex dialectic was further developed by Kant, and it is Kant's formulation that the idea of the sublime has been most influential in later aesthetic theory. Kant's sublime is divested of the

echoes it had in Burke of a male warrior ethic. The power involved is entirely mental—the power the rational mind discovers is that of grappling with the incommensurable. In Kant, there are no typologies of sublime objects, there is only a sublime attitude of mind. Even so, the rational subject with the strength of mind to experience the sublime, to master what makes understanding falter, is still pre-eminently masculine, if not in any so overt a way as in Burke. See references in note 1.

11 E. Burke, *Philosophical Enquiry*, p. 113.

12 Burke, *Philosophical Enquiry*, p. 111.

13 E. Burke, *Philosophical Enquiry*, p. 106.

14 E. Burke, *Philosophical Enquiry*, p. 124.

15 On this see Adorno, *Aesthetic Theory* (note 6).

16 The beautiful, for example, is 'smooth, light and delicate' (Burke, p. 124). There may be something of a Freudian slip in Burke's saying that 'beauty should shun the right line, yet deviate from it insensibly; the great [i.e. the sublime] in many cases loves the right line, and when it deviates, it often makes a strong deviation.'

17 This is not so say that the figure of Venus was entirely unproblematic, for it raised questions about the part played by desire in responses to the nude that might disrupt its status as an embodiment of 'ideal' beauty. See J. Barrell, ' "The Dangerous Goddess". Masculinity, Prestige, and the Aesthetic in Early Eighteenth-Century Britain', *Cultural Critique*, No. 12, 1989, pp. 101–31.

18 *Geschichte*, p. 392.

19 In singling out the Apollo Belvedere in the way he did, Winckelmann was very much in tune with the taste of his time, except that it was customary to enthuse with equal, if not greater intensity about the Venus de' Medici. The Apollo and the Venus were generally assumed to represent the very finest models of an ideal male and female beauty. After the publication of Winckelmann's *History*, writers on the antique usually drew directly on Winckelmann for their celebrations of the Apollo, but had to construct their own hymns to the female beauty of the Venus; see, for example, C. Dupaty, *Lettres sur l'Italie en 1785* (Paris, 1788), vol. I, pp. 146ff., vol. II, pp. 17ff. Dupaty described the Apollo Belvedere as 'le corps le plus noble, le plus harmonieux, le corps le moins viril et le moins adolescent tout-à-la-fois'.

20 The passage continues—and can 'claim the preference . . . of the best remains of all antiquity', Joseph Spence, *Polymetis* (London, 1747), p. 83.

21 J. Thomson, *The Castle of Indolence and Other Poems*, edited by A. D. McKillop (Lawrence, 1961), p. 94 (from the poem 'Liberty'). I am indebted to John Barrell's article on eighteenth-century responses to the Venus de' Medici (note 17) for drawing my attention to a number of the British sources cited here.

22 [Raguenet], *Les Monumens de Rome ou Description des plus beaux ouvrages de peinture, de sculpture et d'architecture qui se voient à Rome* (Amsterdam, 1701), pp. 235–8.

23 *Geschichte*, p. 393.

24 G. G. Byron, *The Works of Lord Byron*, edited by T. Moore, vol. VII (London, 1832), pp. 258–9 (from Canto IV of 'Childe Harold's Pilgrimage', first published in 1818). On Byron, see L. Crompton, *Byron and Greek Love: Homophobia in Nineteenth-Century England* (London, 1985).

25 Hazlitt's squib against the Apollo Belvedere, though first published anonymously ('Notes of a Journey through France and Italy', *Morning Chronicle*, 26 July 1825), struck enough of a chord in the culture of the time to be picked up by Hegel in his lectures on aesthetic theory (*Vorlesungen über die Ästhetik* (Frankfurt-am-Main, 1970), vol. II, p. 431). The reaction against the Apollo's attenuated gracefulness was not in any way inherently heterosexual. Oscar Wilde considered its 'slim, dandy-like, elegant' physique inferior to the male beauty embodied in earlier Greek art (*Letters of Oscar Wilde*, (New York, 1962), letter dated 22 April 1900).

26 See for example the physician Charles Bell's (*Letters of Charles Bell* (London, 1970), pp. 115–16; Nov. 1807) vivid response to the male nudes from the Parthenon. The so-called Ilissus gradually came to displace the Apollo Belvedere as the classical paradigm of ideal male beauty.

27 While in many European countries, the early nineteenth century saw the abolition of laws that had made sodomy a capital offence, there was if anything an increase of public expressions of moral panic over the practice of sex between men (see for example Greenberg, *Homosexuality*, pp. 350ff.). It is now customary to identify a pattern of increasingly explicit homophobia emerging in nineteenth-century society, particularly in England, but the phenomenon is a deeply contradictory one. A growing self-consciousness about what we call 'homosexuality' accompanied this 'homophobia', and in turn stimulated a new and more explicitly avowed awareness of gay identity. See Jeffrey

Weeks, *Sex, Politics and Society in Victorian England: The Regulation of Sexuality since 1800* (London, 1981).
28 G. Deleuze and L. von Sacher-Masoch, *Masochism* (New York, 1991), p. 246.
29 *Geschichte*, p. 393.
30 When he ends his description by presenting it as an offering to the god, Winckelmann is making it quite explicit that his image of the statue is one created by him, not some mirror or reflection of it.
31 On how a 'masochist' controls his or her fantasies of self-abasement by staging them, see Deleuze's essay 'Coldnes and Cruelty' in *Masochism* (note 28).
32 In Sacher-Masoch's novel, the encounter with the man who eventually physically humiliates the hero marks a decisive turning-point. Earlier the scenes of masochistic debasement are largely onanistic rituals staged by the hero, in which the woman plays the parts he devises for her. Only in his encounter with the man does he confront a sexually charged power that originates outside himself, and in a sense consummates—traumatically—his masochistic desires. Inevitably the novel occludes too overt a suggestion that such male masochistic fantasy might involve the desire to be violated by a man.
33 For further discussion, see p. 208.
34 See in particular his analysis of the Antinous and the Belvedere Torso discussed on pp. 151 and 179.
35 *Geschichte*, p. 409. For a fuller discussion of this point, see pp. 146 ff.
36 *Geschichte*, p. 164.
37 *Kleine Schriften*, p. 216. In the *History of Art*, Winckelmann's discussion of 'beauty in female gods' is very summary in comparison with his analysis of the various beauties of the male gods, and occurs almost as an afterthought (*Geschichte*, pp. 164 ff.). In this respect Winckelmann was echoing the ethos of early classical Greek culture more closely than the standard discourses on beauty from his period, which focused on the female figure.
38 For a close reading of Freud that convincingly undoes the tendency within psychoanalytic literature—hardly absent in Freud himself—to project a male incapacity to overcome the fear of castration evoked by the female body as somehow a particularly homosexual problem, see Whitney Davis, 'HomoVision: A Reading of Freud's "Fetishism"', *Genders*, no. 15, 1992, p. 86 ff., and 'Sigmund Freud's Drawing of the Dream of Wolves', *Oxford Art Journal*, 15, no. 2, 1992, pp. 70 ff. It makes more sense in terms of the internal logic of psychoanalytic theory itself to define the 'problem' involved as one that has to do with a narcissism and anxiety over sexual difference fundamental to all male psychic identity, and not to take at face value Freud's more contingent and unreflectively ideological 'explanations' of homosexuality.
39 James Baldwin, *Another Country* (Harmondsworth, 1990; first published 1963), p. 324.
40 This is not done in a theoretically systematic way. That the works Winckelmann singled out as being in the high mode are female might seem at first sight to be a contingent result of the statues that simply happened to be available to him. Given that he had no dated examples of early classic Greek sculpture to work from, however, these identifications could hardly be purely empirical. They had to be based on his idea of what a truly sublime or elevated style might look like, and thus were in a very literal sense ideological.
41 *Geschichte*, p. 165.
42 *Geschichte*, pp. 166–7.
43 Lynn Hunt, *Politics, Culture, and Class in the French Revolution* (London, 1986), pp. 98–114.
44 Examples include the British sculptor Flaxman's plans for a gigantic statue of Britannia on Greenwich Hill outside London, Schwanthaler's monumental statue of Bavaria in a park on the outskirts of Munich, and later, Bartholdi's famous Statue of Liberty on Bedoes Island at the entrance to the harbour in New York.
45 M. Warner, *Monuments and Maidens: The Allegory of the Female Form* (London, 1985), pp. 47–9, 104–26.
46 G. E. Lessing, *Laokoön* (Stuttgart, 1964), particularly p. 20. On Lessing's larger misgivings about Winckelmann's analysis of Greek art, see E. H. Gombrich, 'The Place of the *Laocoön* in the Life and Work of G. E. Lessing (1729–1781)' in *Tributes* (Oxford, 1984), pp. 28–40.
47 See p. 108.
48 *Geschichte*, p. 170. The passage occurs in a discussion of how ancient artists managed to represent intense feelings in a way that did not seriously distort the beautiful bodily forms of a figure.
49 This passage refers in the first instance to the statues of the daughters of Niobe, part of the group to which the Niobe belonged. Winckelmann makes it clear in the subsequent sentence that what he says also applies to the Niobe.

50 *Geschichte*, pp. 348–9.
51 *Kleine Schriften*, p. 43. For further discussion of the early description, see p. 1, 4. The complexities of Winckelmann's conception of the statue have been explored in several recent studies. But these have been concerned almost exclusively with his better-known, though less richly articulated account of the statue in *On the Imitation of the Greeks* (P. Brandt, '. . . ist endlich eine edle Einfalt und eine stille Grösse', in T. W. Gaehtgens (ed.), *Johann Joachim Winckelmann 1717–1768* (Hamburg, 1986), pp. 48 ff. and S. Richter, *Laocoon's Body and the Aesthetics of Pain* (Detroit, 1992), pp. 43 ff.).
52 *Geschichte*, pp. 348–9.
53 S. Freud, 'On Fetishism' (1927), *Freud Library*, vol. 7, pp. 351–7 and 'The Splitting of the Ego in the Interests of Defence' (1940), *Freud Library*, vol. 11, pp. 461–4. Recent discussions of the simultaneous disavowal and acknowledgement of a threat to the self involved in fetishism that I have found particularly relevant for the present study include L. Mulvey, 'A Phantasmagoria of the Female Body: the Work of Cindy Sherman', *New Left Review*, no. 188, 1991, pp. 136–50, and J. Baudrillard, 'Fetishism and Ideology' (1970), in *For a Critique of the Political Economy of the Sign* (St Louis, 1981), pp. 88–101. What concerns me here is not the clinical phenomenon of fetishism as such, but rather a form of fantasy that can fruitfully be called fetishistic because it involves a distinctively split fixation on objects of a kind dramatized so cogently in Freud's essay on fetishism. For a cautionary note on the often unthinking homophobia that tends to accompany the diffuse understanding of fetishism common in present-day cultural analysis, see Whitney Davis's 'HomoVision' (note 38).
54 For a suggestive psychoanalytically based discussion of masochistic male fantasies of self-debasement and self-annihilation, see K. Silverman, 'Masochism and Male Subjectivity', in *Male Subjectivity at the Margins* (London and New York, 1992), pp. 185 ff.
55 The ways in which Winckelmann's writing and self-definition would have been inflected by the internalized effects of such prohibitions are discussed in more detail on pp. 206–8, 212–4. For a historical survey of the effects of the legal prohibition on sodomitical practices in eighteenth-century Europe, see Greenberg, *Hosexuality*, pp. 312 ff. I found R. Dellamora's *Masculine Desire. The Sexual Politics of Victorian Aestheticism* (Chapel Hill and London, 1990; see above all chapter 9) particularly helpful for its approach to drawing out the possible cultural reverberations of a 'homophobic' bar on sexual desire between men.

CHAPTER V

IDEAL BODIES

1 *Geschichte*, pp. 147–86. This analysis of the ideal nude, where the male figure plays much the most dominant role, is followed by a short note on the representations of animals (pp. 186–9), and then quite an extended appendix on drapery and adornment (pp. 190–212), which Winckelmann discusses exclusively in terms of the female figure. The male figure is presented as naked essence, the female figure as subsidiary masquerade.
2 See for example J. Laplanche, *Life and Death in Psychoanalysis* (Baltimore and London, 1985), chapter 4.
3 On the ideological tensions inherent in the fantasy of a free sovereign subjectivity (at one with itself and the external world) as it emerges in eighteenth-century 'bourgeois' aesthetics, see T. Eagleton, *The Ideology of the Aesthetic*, pp. 19 ff.
4 J. Laplanche and J. B. Pontalis, 'Ideal Ego', *The Language of Psychoanalysis* (London, 1988), pp. 201–2.
5 *Geschichte*, p. 409.
6 Perhaps the most powerful formulation of this myth of the self in the eighteenth century comes from Rousseau, the more so in that, in his famous *Discourse on the Origins and Foundations of Inequality among Men*, he represented such an ideal oneness of being as impossible to locate historically. It had to represent a state prior to the divisions and inequalities of civil society, but subsequent to a state of nature in which the sense of self—and of its freedom—had not yet been defined. In contrast, in the Winckelmannian Graecomania of the later eighteenth century, represented most eloquently by Herder, ancient Greece emerged as the historically reified—and hence also inaccessible—happy childhood of the human race, a uniquely privileged moment when the self

was no longer subject to nature but was not yet blighted by a self-consciousness alienating it from the world around it.

7 Laplanche and Pontalis, *Language* (note 4), p. 202.

8 S. Freud, 'Totem and Taboo' (1913), *Freud Library*, vol. 13, p. 147; J. Lacan, 'The mirror stage as formative of the I as revealed in psychoanalytic experience' (1949), in *Ecrits: A Selection* (New York and London, 1977), transl. A. Sheridan, pp. 1–7.

9 On the boyish youth as an 'ideal'—and at the same time highly problematized—object of love in ancient Greece, see M. Foucault, *The History of Sexuality*, vol. 2, *The Uses of Pleasure* (Harmondsworth, 1987; published French in 1984, transl. R. Hurley), pp. 187 ff., and the commentary on Foucault's analysis in D. Halperin, *One Hundred Years of Homosexuality and Other Essays on Greek Love* (New York and London, 1990), pp. 130–7.

10 On Freud's drift in his later writing to an ever more regressive definition of the state of 'primary narcissism', see Laplanche and Pontalis, *Language* (note 4), pp. 337–8.

11 S. Freud, 'Group Psychology' (1915), *Freud Library*, vol. 12, p. 163.

12 S. Freud, 'On Narcissism' (1914), *Freud Library*, vol. 11, pp. 82–3.

13 On this see D. Warner, 'Homo-Narcissism; or Heterosexuality', in J. A. Boone and M. Cadden (eds.), *Engendering Men* (New York and London, 1990), pp. 190–206.

14 See pp. 210–11, 214–5.

15 *Geschichte*, p. 150.

16 On Winckelmann's indebtedness to traditional theories of ideal beauty in art as formulated by seventeenth-century classicists such as Bellori, see G. Baumecker, *Winckelmann in seiner Dresdner Schriften* (Berlin, 1933), and G. Heres, 'Winckelmann, Bernini, Bellori. Betrachtungen zur Nachahmung der Alten', *Forschungen und Berichte*, 19, 1979, pp. 9 ff. My discussion of this tradition is strongly indebted to Panofsky's still classic study (E. Panofsky, *Idea: A Concept in Art Theory* (New York, 1968), first published 1924).

17 *Geschichte*, pp. 142, 148.

18 *Geschichte*, p. 148.

19 On the shift to empirical and psychological analysis of the feeling for beauty in eighteenth-century art theory, see R. Wittkower, *Architectural Principles in the Age of Humanism* (London, 1962), pp. 150–4, and E. Cassirer, *The Philosophy of the Enlightenment* (Princeton, 1951), pp. 278 ff. For a discussion of how the metaphysical basis of Winckelmann's view of art differs from more thoroughgoing materialist tendencies in eighteenth-century thought, see B. M. Stafford, 'Les idées "innées": la conception Winckelmannienne de la création', in E. Pommier (ed.), *Winckelmann: la naissance de l'histoire de l'art à l'époque des lumières* (Paris, 1991), pp. 137–59.

20 See S. Hampshire, *Spinoza* (Harmondsworth, 1951), pp. 39–48.

21 This point is reiterated in somewhat condensed form in the *Anmerkungen* (p. 35).

22 The essay was first published in 1672 as the introduction to Bellori's *Lives of the Modern Painters, Sculptors and Architects*. On Bellori, see references in note 16, and D. Mahon, *Studies in Seicento Art and Theory* (London, 1947).

23 E. Panofksy, *Idea: A Concept in Art Theory* (New York, 1968), pp. 105–9.

24 *Geschichte*, pp. 177–84.

25 *Geschichte*, p. 144.

26 Compare also *Kleine Schriften*, p. 213.

27 For a particularly explicit representation of the supposedly 'natural' divide between the 'common people' and the educated classes, see J. B. Basedow's influential progressive educational primer, *Das Elementarwerk. Ein geordneter Vorrath aller nöthigen Erkenntnis* (Altona, 1774), vol. I, p. 391, and the commentary to Pl. XIX.

28 On theories of racial difference in Enlightenment thought, see L. Poliakov, *The Aryan Myth* (London, 1974), pp. 158 ff., N. Stepan, 'Biological Degeneration', in J. E. Chamberlain and S. L. Gilman (eds), *Degeneration: The Dark Side of Progress* (New York, 1985), pp. 97 ff., and S. L. Gilman, *On Blackness without Blacks: Essays on the Image of the Black in Germany* (Boston, 1982), chapters 2, 3, and 4. On the impact of increasingly systematic theories of white supremacy on the scholarly study of the ancient Greeks, as evidenced in arguments for the autonomy of Greek culture from that of the Egyptians, see M. Bernal, *Black Athena: The Afroasiatic Roots of Classical Civilization*, vol. I (London, 1987), particularly pp. 197 ff., 219 ff.

29 *Geschichte*, pp. 19 ff., 128–9.

30 There is a particularly full compendium of this literature in G. L. L. de Buffon's *Histoire naturelle*, vol. III (Paris, 1749), pp. 371 ff.

31 For details, see references in note 28.
32 *Geschichte*, p. 146.
33 *Geschichte*, p. 145.
34 *Geschichte*, p. 148.
35 *Anmerkungen*, p. 35.
36 *Anmerkungen*, p. 35.
37 *Geschichte*, p. 147.
38 *Geschichte*, p. 147.
39 When Martin Bernal (*Black Athena* (note 14)) traces aspects of nineteenth-century classical schol-ars' racist attitudes back to the romantic Hellenism of the Enlightenment period, he is careful not to equate the two. Ideas about the supremacy of the Greeks over the Egyptians, which gained ground in the Enlightenment, took on a different cast once they combined with the full-blown racism that often accompanied nineteenth-century scientific positivism.
40 S. Freud, 'Group Psychology (1921)', vol. 12, p. 163; 'Introductory Lectures on Psycho-Analysis' (1915–17), *Freud Library*, vol. 1, p. 466.
41 *Geschichte*, pp. 167–8.
42 *Geschichte*, p. 151.
43 See *Geschichte*, p. 162.
44 *Geschichte*, p. 162.
45 *Geschichte*, p. 149.
46 *Geschichte*, pp. 150–1.
47 See note 9.
48 Sensuous images of naked boys or youths were common in mid-eighteenth-century art, usually representing mythological figures such as Cupid. Bouchardon's statue of Cupid making a bow out of Hercules' club (Louvre, Paris) was considered one of the most important modern sculptures of the period. In these works, intimations of male 'pederastic' desire were partly occluded by the supposedly 'innocent' narcissism of the figure, and Cupid anyway was conventionally associated with heterosexual sex.
49 *Geschichte*, pp. 157–62.
50 *Geschichte*, pp. 160–1, *Anmerkungen*, pp. 36–8.
51 *Geschichte*, p. 157. The analysis of Winckelmann's image of the castrato in S. Richter's *Laocoon's Body and the Aesthetics of Pain* (Detroit, 1992, pp. 49–61) almost wilfully ignores his equally erotic and rather more richly articulated responses to 'virile' male physiques, such as the Belvedere Torso.
52 *Geschichte*, p. 159. On the so-called Borghese Eros, see G. Lippold, *Die Griechische Plastik*, *Handbuch der Archäologie*, vol. III, 1 (Munich, 1950), p. 240 and W. Klein, *Praxiteles* (Leipzig, 1938), pp. 236–7. To modern eyes, the statue looks a rather unexceptional Roman copy.
53 *Geschichte*, p. 156. On the erotic imagery of the German Pietists, see P. C. Erb (ed.), *Pietists. Selected Writings* (Toronto, 1983) introduction, and pp. 173 ff., 225–6. Such a voluptuary tendency within expressions of Christian piety was pervasive enough to be ridiculed in the *Encyclopédie* (vol. XV, Neuchâtel, 1765, p. 460).
54 *Geschichte*, p. 150. For an alternative view of Winckelmann's conception of ideal contour relating it to Neo-Platonic thought, see B. M. Stafford, *Body Criticism. Imaging the Unseen in Enlightenment Art and Medicine* (Cambridge, Mass., 1991), pp. 249–52.
55 *Geschichte*, pp. 152–3.
56 *Geschichte*, p. 152.
57 Freud, 'Totem and Taboo' (1913), *Freud Library*, vol. 13, p. 146.
58 On academic theories of ideal beauty, see note 16. For a very suggestive analysis of the disjunction operating in pornographic descriptions of the body beautiful as they oscillate between an image of the whole body as simple abstract cipher and discrete images of individual bodily parts, see Roland Barthes's essay 'Le corps éclairé' in *Sade, Fourier, Loyola* (Paris, 1971), pp. 131–4.
59 *Geschichte*, pp. 177–84.
60 W. Hogarth, *The Analysis of Beauty* (London, 1753). When he seeks to exemplify the line of beauty, Hogarth either has to isolate the overall stance of a figure or the shape of an individual part of the body. This focus on contour as the locus of the beautiful also plays an important in Diderot's writing on art (*Salon de 1767* (Oxford, 1963), pp. 57 ff.).
61 *Geschichte*, p. 163.
62 *Geschichte*, p. 153.
63 *Geschichte*, p. 156.

64 See references in Chapter IV, note 53.

65 The term splitting here is intended to have Freudian connotations (S. Freud, 'The Splitting of the Ego in the Interests of Defence' (1940). *Freud Library*, vol. 11, pp. 461–4; see also J. Laplanche and J. B. Pontalis, *The Language of Psychoanalysis* (London, 1988), pp. 427–9). The disjunctive mechanism involved is analogous to that operating in political ideologies allowing a subject to hold two incompatible beliefs.

66 See particularly *Anmerkungen*, pp. 1–2, *Geschichte*, pp. 25 ff. For a fuller discussion of Winckelmann's ideas on climate, see pp. 57–8.

67 See p. 59.

68 The description (*Geschichte*, pp. 368–70) cited here differs considerably from the earlier, longer, and rather less richly resonant one first published in the *Bibliothek der Schönen Wissenschaften und der Freien Künste* in 1759 (*Kleine Schriften*, pp. 169–73). For the later description see *Allegorie*, pp. 155–8.

69 *Geschichte*, pp. 392–3.

70 *Geschichte*, p. 369.

71 *Geschichte*, p. 370.

72 This analysis is much indebted to Simone de Beauvoir's essay 'Faut-il brûler Sade' (see De Sade, *The One Hundred and Twenty Days of Sodom and other writings* (New York, 1966), particularly pp. 63–4).

73 Among the discussions of such structural contradictions embedded in Enlightenment ideals that I have found particularly helpful are T. W. Adorno and W. Horckheimer, *Dialectic of Enlightenment* (London, 1979); P. de Man, 'Aesthetic Formalization: Kleist's *Über das Marionettentheater*', in *The Rhetoric of Romanticism* (New York, 1984), pp. 263–90; and D. Outram, *The Body and the French Revolution: Sex, Class and Political Culture* (New Haven and London, 1989).

74 One of the peculiar paradoxes of the Hellenism of writers such as Herder, Goethe, and Hegel is that they conceived of the Greek ideal, projected via a 'misreading' of Winckelmann's analysis of Greek art, as the model of an unselfconscious and unalienated oneness of being, a kind of unproblematic happy childhood of human subjectivity, and at the same time were responsive to the darker complexities of Greek tragedy.

75 D. Diderot, *Salon de 1765* (Oxford, 1960), pp. 206–7. On Rousseau see J. Starobinski, *Jean-Jacques Rousseau. Transparency and Obstruction* (Chicago and London, 1988), pp. 25 ff., 296 ff., and P. de Man, *Allegories of Reading* (New York and London, 1979), particularly pp. 131–40 where he discusses the structural incompatibility in Rousseau between the active self-determination involved in realizing freedom and a state of harmonious tranquillity.

CHAPTER VI

FREEDOM AND DESIRE

1 The fullest sources of biographical information on Winckelmann are Rehm's and Diepolder's richly annotated four-volume edition of Winckelmann's letters (here cited as *Briefe*) and K. Justi's intellectual biography, *Winckelmann und seine Zeitgenossen*, 3 vols (Leipzig, 1923), here cited as Justi. There is a somewhat inadequate biography by W. Leppmann (*Winckelmann*, New York, 1970) that has been published in English. Goethe's essay ('Winckelmann und sein Jarhundert', 1805, reprinted in *Schriften zur Kunst*, vol. I (Munich, 1962)) is deservedly something of a classic and has set the tenor for most subsequent portraits of Winckelmann as scholar and man. Information on Winckelmann was already widely available in the later eighteenth century, both through the biographical essays that prefaced the fuller editions of *The History of the Art of Antiquity*, and through collections of letters published in German and then also in French from the 1770s onwards. I wish to thank August Wiedmann for helping me with some of the trickier translations from Winckelmann's letters in this chapter. Any inadequacies remain entirely my responsibility.

2 In the eighteenth century ancient Greek culture, particularly as personified by the figure of Socrates, provided an important arena for representing not only intense erotically charged friendships but also sexual relations between men in something like positive terms. Historical distance and the aura surrounding classical antiquity made the issues involved less immediately subversive of dominant social norms. Even so, most writers still felt obliged to qualify their discussion of 'Greek friendship' with ritual condemnations of 'sodomitical' sexual practices. On the complex

ambivalences at work in Enlightenment discussions of 'Socratic love', see Gert Herkma, 'Sodomites, Platonic Lovers, Contrary Lovers: the backgrounds of the modern homosexual', in K. Gerard and G. Hekma (eds), *The Pursuit of Sodomy: Male Homosexuality in Renaissance and Enlightenment Europe* (New York and London, 1989), pp. 433–56. Of particular interest in this connection is J. G. Hamann's highly elliptical, but still to some extent negatively framed, apologia for Socrates' love affairs with young men (*Sokratische Denkwürdigkeiten* (Amsterdam, 1759), pp. 67–8; reprinted with an English translation and commentary by J. C. O'Flaherty, 1967).

3 On homosociality and same-sex relations between men in Enlightenment circles of the kind in which Winckelmann moved, see G. Rousseau, '"In the House of Van der Tasse, on the Long Bridge": A Homosocial University Club in Early Modern Europe', *The Pursuit of Sodomy* (note 2), pp. 311–48, and D. M. Sweet, 'The Personal, the Political and the Aesthetic: Johann Joachim Winckelmann's German Enlightenment Life', in the same volume, pp. 145–62. Recent research on 'homosexual' subcultures in the period (see for example R. Trumbach, 'Sodomitical Subcultures, Sodomitical Roles, and the Gender Revolution of the Eighteenth Century. The Recent Historiography' in R. P. Maccubin (ed.), *'Tis Nature's Fault'. Unauthorized Sexuality during the Enlightenment* (Cambridge, 1987), pp. 109 ff., G. S. Rousseau, 'The Pursuit of Homosexuality in the Eighteenth Century', in the same volume, pp. 140 ff., and Greenberg, *Homosexuality*, pp. 312 ff.) has focused on metropolitan Britain and France where there is clear evidence of distinctively modern social patterns—and formations of homophobia—emerging, rather than on the socially more traditional German and Italian contexts in which Winckelmann lived.

4 *Briefe*, vol. I, p. 65. The passage comes from the draft of a letter Winckelmann wrote in September 1746 addressed to a close early friend, Berendis, whom he had got to know at the university of Halle.

5 *ungebundener Mensch*. To Berendis 1 July 1767, *Briefe*, vol. III, p. 281.

6 Goethe, *Schriften zur Kunst* (Munich, 1962), vol. I, p. 288.

7 Goethe had some very acute comments to make on this score, see *Schriften zur Kunst*, vol. I, pp. 285–6.

8 17 Sept. 1754, *Briefe*, vol. I, pp. 147–50.

9 Goethe, *Schriften zur Kunst*, vol. I, p. 258.

10 *Briefe*, vol. I, p. 150.

11 *Briefe*, vol. I, p. 148. The gist of the latter part of this passage is repeated in a letter to Berendis, dated 17 Sept. 1754 (*Briefe*, vol. I, p. 151).

12 To C. Füssli, 27 July 1758, *Briefe*, vol. I, p. 399.

13 To Berendis (the same friend to whom he had intended to confide his despair over his separation from Lamprecht; see note 4), July 1755, *Briefe*, vol. I, p. 180.

14 To Stosch, 17 Nov. 1766, *Briefe*, vol. III, p. 220. Winckelmann here is making reference to the problems he encountered in his dealings with the Prince of Braunschweig.

15 He received an annual pension of 200 taler. The stipend was paid irregularly until 1761, with a gap in 1756 during the first year of the Seven Years War, and a long delay in 1758 at a crucial moment when he was having to negotiate a new position with Cardinal Albani after his first patron, Cardinal Archinto, had died. On Winckelmann's unease over being seen to have been a pensioner of the Saxon court, see below, note 17.

16 To Berendis, 29 Jan. 1757, *Briefe*, vol, I. p. 265.

17 In his introduction to the *Anmerkungen* (p. II), he sought to represent himself as always having worked independent of any obligation to a court, though in letters to close friends (such as the one addressed to Marpurg, 8 Dec. 1762, *Briefe*, vol. II, p. 275) he did not deny that he received a stipend from the Saxon court.

18 January 1757, *Briefe*, vol. IV, p. 119.

19 19 Jan. 1757, *Briefe*, vol. I, p. 266. Compare also his comment to Bünau reporting what Cardinal Passionei had said to him (12 May 1757, *Briefe*, vol. I, p. 280).

20 The claims he made as to the new freedom he enjoyed in his social relations with superiors in Rome were commented on by Goethe, who argued that Winckelmann was partly deceived on this score. Goethe maintained that the familiarity with which Italian grandees treated their underlings had something of the oriental relation of master to slave to it, while the more formalized relations that prevailed in Northern Europe at least entailed a recognition of obligation on the part of the upper classes toward those under them (*Schriften zur Kunst*, vol. I, pp. 285–6).

21 *Briefe*, vol. IV, p. 249. Compare also his comment in a letter to Volkmann (1 Dec. 1758, *Briefe*, vol. I, p. 439) that Albani had offered him *einen kleinen Gehalt* as well as residence. See also p. 191 for

a revealing comment by the architect Erdmannsdorf as to Winckelmann's meagre income.

22 *Briefe*, vol. II, p. 275.
23 To Friedrich Wilhelm Marpurg, an old friend whom he had got to know at university in Halle, 8 Dec. 1762, *Briefe*, vol. II, p. 275.
24 To Berendis, 12 Dec. 1759, *Briefe*, vol. II, p. 58.
25 Later on, as a result of an incident in which he was felt to have been unduly critical of the Catholic church, he was temporarily banned from eating with Albani. See p. 199.
26 *Briefe*, vol. II, p. 110 (1761) and vol. III, p. 134 (1765). See also vol. III, p. 180. It was only later in the eighteenth century, some time after Winckelmann's death, that the book and periodical market in the German-speaking world expanded to the point where a small group of intellectuals and writers were beginning to be able to support themselves independently of the traditional network of patronage provided by Church and Court. Even then most intellectuals still operated within positions of quasi-feudal dependence (see F. Schneider, *Aufklärung und Politik. Studien zur Politisierung der deutschen Spätaufklärung* (Wiesbaden, 1978), particularly pp. 16 ff., 29 ff.).
27 To Riedesel, 31 July 1765, *Briefe*, vol. III, p. 115.
28 Winckelmann would often complain that he made nowhere enough from *The History of the Art of Antiquity* to remunerate him for the work he had put into it, and claimed that Walther, his bookseller-publisher, had swindled him out of his share of the profits. Even so the rate he received page for page was quite generous by the standards of the time. Despite its reputation, the original German edition of the *History* did not sell very well, and several hundred copies remained in Walther's hands at the time of Winckelmann's death; see H. A. Stoll, *Winckelmann, seine Verleger und seine Drücker* (Berlin, 1960), pp. 78 ff.). In order to try and ensure that he would not again lose money to intermediaries, Winckelmann planned to publish the new edition on which he was working just before his death at his own expense (see the letter to Stosch, 25 July 1767, *Briefe*, vol. III, p. 296).
29 *Ich bin mir selbst Magd, Diener, Schreiber und Böthe*. To L. Usteri 27 Sept. 1766, *Briefe*, vol. III, p. 210. Compare his comments to Stosch, 18 Feb. 1767, *Briefe*, vol. III, p. 234.
30 *Briefe*, vol. IV, p. 249.
31 6 Nov. 1765, *Briefe*, vol. III, p. 134.
32 *Spero che questo matrimonio restera senza motivie di disgusto*. To Bianconi, 16 Nov. 1758, *Briefe*, vol. I, p. 437. Compare also his comments to Volkmann, *Briefe*, vol. I, p. 440.
33 To Genzmer, 19 March 1766, *Briefe*, vol. III, p. 169.
34 1 May 1762, *Briefe*, vol. II, p. 226.
35 To Genzmer 10 March 1766, *Briefe*, vol. III, p. 169. Compare also *Briefe*, vol. III, p. 317 (to the Hanoverian minister Münchhausen, 15 Aug. 1767) and vol. III, p. 210 (to L. Usteri 27 Sept. 1766) where he talks about how, in moments he had to himself in the morning, he would sing 'songs from the Lutheran hymn book as they come into my head, and at these moments I am more contented than the great Mogul'.
36 *Theologischen Kram . . . welchem ich völlig, (Gott sey gedankt) bis auf den wahren Glaugen entsagt habe*. To Genzmer, 27 Nov. 1765, *Briefe*, vol. III, p. 138.
37 In the draft of an advertisement he prepared in 1763, the year of his two appointments at the papal court, and published in the journal *Bibliothek der schönen Wissenschaften und der freyen Künste* in 1764, Winckelmann described himself as 'Sovrintendente alla conservazione delle Antichità' di Roma e Bibliotecario' of Cardinal Albani, pointedly leaving out his appointment as 'Scrittore' at the Vatican (*Briefe*, vol. IV, p. 43).
38 To Wiedewelt, 3 June 1767, *Briefe*, vol. III, p. 269.
39 To L. Usteri, 6 August 1763, *Briefe*, vol. II, p. 333.
40 To Mechel, 21 Jan. 1767, *Briefe*, vol. III, p. 229. Compare his comment to Stosch, 18 Feb. 1767, vol. III, p. 234.
41 To Schlabbrendorf, 10 Dec. 1766, *Briefe*, vol. III, p. 222.
42 *Briefe*, vol. III, p. 478.
43 To Stosch, 18 April 1767, *Briefe*, vol. III, p. 254.
44 To Stosch, 12 May 1765, *Briefe*, vol. III, p. 99.
45 To Heyne, 22 Dec. 1764, *Briefe*, vol. III, p. 71. Compare also the letter dated 20 March 1765 (vol. III, pp. 88, 91).
46 To Reiske, Dec. 1767, *Briefe*, vol. III, p. 334.
47 3 Feb. 1768, *Briefe*, vol. III, pp. 363–4.
48 On this see particularly *Briefe*, vol. III, pp. 120–1, 127, 135, 137.

49 To Francke 6 Feb. 1768, *Briefe*, vol. III, p. 367. A year before he had been involved in negotiations for a post as President of the Berlin Academy of Sciences (see the letter to Stosch, 18 Feb. 1767, *Briefe*, vol. III, p. 234).

50 12 Aug 1767, *Briefe*, vol. III, p. 304.

51 To Barthélemey, 13 Sept. 1760, *Briefe*, vol. II, p. 99.

52 To L. Usteri, 27 Nov. 1762, *Briefe*, vol. II, p. 273.

53 Again to Usteri, 20 Feb. 176, *Briefe*, vol. II, p. 295. To Stosch he did admit to a sneaking admiration, as well as hatred, for Frederick the Great (10 April, 1761, vol. II, p. 133).

54 19 Jan. 1763, *Briefe*, vol. III, p. 413.

55 To H. R. Füssli, 18 Feb. 1764, *Briefe*, vol. III, p. 21. See note 84.

56 To C. Füssli, 20 Jan. 1764, *Briefe*, vol. III, pp. 9–10. Winckelmann uses the word *Kenner* that I have translated here as 'art expert'. The word connoisseur might also apply, though its connotations would be rather too narrow.

57 To the engraver Mechel, 14 Dec. 1766, *Briefe*, vol. III, p. 225.

58 *Briefe*, vol. IV, pp. 19–20. On the extent to which the peculiarly bleak picture Winckelmann presented of his days as a schoolmaster in Seehausen might be seen as a retrospective mythologization, see J. Kleiner, 'Joh. Joachim Winckelmann—Konrektor in Seehausen', in *Festschrift der Johann-Joachim-Winckelmann-Schule Seehausen/Altmark 1865–1990* (Seehausen, 1990), pp. 7–9.

59 *Hier ist kein Professor=und Magister=Neid. Der Hof entscheidet über das Verdienst der Gelehrten.* To Genzmer, 10 March 1766, *Briefe*, vol. III, p. 168.

60 To Walther, 22 Dec. 1764, *Briefe*, vol. III, p. 72.

61 *Bey Fürsten sind insgemein Gelehrte und Pedanta Synonomygma, welche beyde einerley Geruch an Weltlichen Höfen geben. Briefe*, vol. IV, pp. 18–19.

62 To Wiedewelt, 24 May 1764, *Briefe*, vol. III, p. 41.

63 To Stosch, 17 Nov. 1766, *Briefe*, vol. III, p. 220; see also vol. III, p. 230 (24 Jan. 1767).

64 To Stosch, Feb. 1768, *Briefe*, vol. III, p. 371. See also vol. III, p. 356 (23 Jan. 1768).

65 To Stosch, 18 March 1768, *Briefe*, vol. III, pp. 375–6.

66 *Briefe*, vol. III, p. 221.

67 To Stosch, 23 March 1768, *Briefe*, vol. III, p. 377.

68 To Stosch, 13 Jan. 1768, *Briefe*, vol. III, p. 354.

69 To P. Usteri, 14 Dec. 1766, *Briefe*, vol. III, pp. 224–5.

70 To Volkmann, 19 Sept. 1766, *Briefe*, vol. III, p. 209.

71 Possibly to Hagedorn, 1759, *Briefe*, vol. IV, p. 13.

72 22 July 1767, *Briefe*, vol. III, p. 289.

73 To L. Usteri 22 July 1767, *Briefe*, vol. III, p. 291; to Stosch, 9 Sept. 1767, vol. III, p. 312; to Münchhausen, 15 Aug. 1767, vol. III, p. 317.

74 To Stosch, 18 July 1767, *Briefe*, vol. III, p. 287.

75 To Riedesel, 8 Aug 1767, *Briefe*, vol. III, p. 302 (concerning a planned trip to Naples); to Stosch, 19 Dec. 1767, vol. III, p. 341 (concerning plans for his trip to Germany).

76 To Stosch, 26 Feb. 1768, *Briefe*, vol. III, p. 371; to Francke, 6 Feb. 1768, vol. III, p. 365.

77 To Münchhausen, 15 August 1767. *Briefe*, vol. III, p. 307.

78 To Francke, 15 Nov. 1765. *Briefe*, vol. III, p. 137.

79 *Briefe*, vol. IV, p. 236.

80 *Briefe*, vol. IV, pp. 243–4.

81 To Wilkes, 13 May 1767, *Briefe*, vol. III, p. 261. Wilkes' *Letter*, published in Paris in 1767, denounced the then Prime Minister and Lord Chatham for their failure to intervene to lift the sentence of outlwary passed on him. Wilkes' appeal to the ideal of friendship would no doubt have resonated with Winckelmann—'Friendship is too pure a pleasure for a mind cankered with ambition, or the lust of power and grandeur' (quoted in H. Blackley, *The Life of John Wilkes* (London, 1917), p. 179)—but Winckelmann seems to have been taken aback by the violence of Wilkes' polemic (*Briefe*, vol. III, p. 257).

82 At one point Winckelmann contemplated changing the dedication to Emperor Joseph II (*Kleine Schriften*, p. 477). He also dedicated the small treatise *Remarks on Architecture* to the crown prince.

83 *Geschichte*, p. xxvi.

84 Quote in Justi, vol. III, p. 61. Compare his letter to the father, H. R. Füssli, (18 Feb. 1764), *Briefe*, vol. III, p. 21. See also pp. 195–6.

85 Justi, vol. III, p. 63.

86 To Stosch, Feb. 1765, *Briefe*, vol. III, p. 80.

87 *Anmerkungen*, dedication (no pagination). See also *Kleine Schriften*, p. 247.
88 To Wille, April 1758, *Briefe*, vol. I, p. 349. See also the letter to Berendis (15 May 1758), vol. I, p. 368.
89 *Kleine Schriften*, p. 212.
90 See also *Kleine Schriften*, p. 233.
91 *J. W.'s Briefe an einen Freund in Liefland*, edited by J. F. Voigt (Coburg, 1784).
92 On the importance of the emotionally charged rhetoric of Rousseau's *Nouvelle Héloïse* as a model for self-representation in the period, see R. Darnton, 'Readers respond to Rousseau; The Fabrication of Romantic Sensitivity', in *The Great Cat Massacre and Other Episodes in French Cultural History* (London, 1984), pp. 215–56, and C. Bloom, *Rousseau and the Republic of Virtue* (Ithaca, 1986), pp. 64 ff.
93 3 Nov. 1762, *Briefe*, vol. II, pp. 268–9.
94 19 Jan. 1763, *Briefe*, vol. III, p. 413.
95 1 Feb. 1764, *Briefe*, vol. III, p. 17.
96 20 May 1767, *Briefe*, vol. III, p. 263.
97 To Stosch, 12 May 1765, *Briefe*, vol. III, p. 99.
98 See letter to Marpurg, 13 April 1765 (*Briefe*, vol. III, p. 95) and to Schalbbrendorf, 26 Oct. 1765 (vol. III, p. 130).
99 Berg's family was minor nobility, Lamprecht's reasonably monied upper-middle class. Lamprecht's father was high bailiff (*Oberamtmann*) of the cathedral chapter at Magdeburg (Justi, vol. I, pp. 118, 141 ff.). Lamprecht went on to hold relatively minor if respectable government posts in Prussia (such as Secretary to the Lieutenant of Potsdam). He and Winckelmann had roomed together for a time when he followed Winckelmann, who had been his private tutor, to Seehausen.
100 *Ewig geweihter Freund und gehorsamster Diener*. 10 Feb. 1764, *Briefe*, vol. III, p. 18.
101 To L. Usteri, 12 Nov. 1763, *Briefe*, vol. II, p. 354.
102 *Kleine Schriften*, p. 233.
103 *Kleine Schriften*, p. 233.
104 The essay was first published as a separate book in 1763. It is reprinted in *Kleine Schriften*, and there is an English translation in *Winckelmann, Writings on Art*, ed., D. Irwin (London, 1972).
105 *Kleine Schriften*, pp. 213, 220.
106 To L. Usteri, 6 August 1763, *Briefe*, vol. II, p. 333. The essay on beauty was originally conceived as one of a series of letters written to friends from Rome. In the event, only it was worked up for publication, as its scope grew with the intensification of Winckelmann's feelings for Berg. Compare also the letter to Weisse (4 Jan. 1764, vol. III, p. 4). Usteri was one of Winckelmann's Swiss correspondents to whom he was particularly eloquent about his loves (see also the letters cited in notes 101 and 111). The two had met in Rome in 1761 when Usteri was twenty. Later Winckelmann became very much attracted to his younger brother, P. Usteri (14 Dec. 1766, *Briefe*, vol. II, pp. 224–5).
107 To Riedesel, 12 Oct. 1763, *Briefe*, vol. II, p. 349.
108 For evidence that Winckelmann believed the real intensity of his passion for Berg could not be divined by the reading public, see his comment quoted earlier, p. 204. On ideas of Socratic friendship in the period, see Chapter VI, note 2. The 'safe' reading of Plato that prevailed in classical scholarly studies at the time was that the love between men he celebrated was a spiritual love (*Seelenliebe*), in which a beautiful body was appreciated not on its own account, but as the sign of a beautiful soul; and that the practice of sex among men in ancient Greece was a degeneration from this 'high' ideal. For one of the fullest discussions of the subject in German from the period, see C. Meiners, 'Betrachtungen über die Männerliebe der Griechen, nebst einem Auszuge aus dem Gastmahle des Plato', *Vermischte Philosophische Schriften. Erster Theil* (Leipzig, 1775), pp. 65 ff., 80 ff. A major driving force behind Winckelmann's conception of the Greek ideal was precisely the refusal of such a separation between the physical sensual charge of the Greek ideal and its ethical significance.
109 See *Kleine Schriften*, p. 451.
110 *Kleine Schriften*, p. 212. See earlier p. 203.
111 *Keine Neigung war so rein als diese*. To L. Usteri, 14 Sept. 1763, *Briefe*, vol. II, pp. 343–5.
112 *Kleine Schriften*, p. 454.
113 To Riedesel, 19 Dec. 1764, *Briefe*, vol. II, p. 68. The colleague in question was called Paalzow. His life of Winckelmann was published in 1764. The imputation of 'loathing and condemning women' features centrally in the condemnation of sodomitical practices in John Cleland's *Memoirs of a Woman of Pleasure* (1749; Harmondsworth, 1985, p. 196). See also La Mettrie's particular sensitiv-

ity on this issue (note 53). In the eighteenth century the sodomite came increasingly to be defined, not just in terms of the sexual acts he might perform, but as a type of man who had no interest in women, and whose sexual preferences for men set him apart from other men; see Greenberg, *Homosexuality*, p. 337, and R. Trumbach, 'Modern prostitution and gender in *Fanny Hill*: libertine and domesticated phantasy', in G. Rousseau and R. Porter (eds), *Sexual Underworlds in the Enlightenment* (Manchester, 1987), p. 74.

114 *Briefe*, vol. IV, p. 188.
115 To Francke, 18 Jan. 1766, *Briefe*, vol. III, p. 156.
116 To Stosch, 7 Dec. 1764, *Briefe*, vol. III, p. 63.
117 24 July 1765, *Briefe*, vol. III, p. 112.
118 To Volkmann, *Briefe*, vol. I, p. 440.
119 *Vertraulichkeit, . . . die den letzten Genuss ausgenommmen, nicht grösser seyn [konnte]*. To Stosch, Feb. 1765, *Briefe*, vol. III, pp. 79–80. Mengs, according to Winckelmann, had played a curiously voyeuristic role in the affair. The painter, who was living in Madrid at the time, had apparently arranged that his wife—who was Roman by origin and wanted to return there for a time because she was homesick—could turn to Winckelmann if her 'voluptuous impulses [*Blut*] should become overpowering'. Though deeply perturbed once he heard she had fallen in love, Mengs, after he discovered Winckelmann was the man involved, encouraged his wife to write love letters to Winckelmann. According to Winckelmann, Mengs went on to suggest that 'he [Mengs] might share with me his most secret lusts' if they ever got together again in Rome.
120 *. . . piegarmi la testa e à soggetarmi à un atto omogeneo della B . . . [buggerato* or *bestialita?]* March 1759, *Briefe*, vol. I, p. 454. See also the draft of a letter to another Italian correspondent dating from a few months earlier where he expresses unease about being reminded of a sexual encounter with someone of much lower social class than himself (vol. I, p. 413).
121 To Berendis, 29 Jan. 1757, *Briefe*, vol. I, p. 266; to L. Usteri, 3 Oct. 1761, vol. II, p. 183.
122 28 Sept. 1761, *Briefe*, vol. II, p. 176.
123 To Genzmer, *Briefe*, vol. III, p. 170.
124 12 Oct 1763, *Briefe*, vol. II, p. 349.
125 To Stosch, 7 Dec. 1764, *Briefe*, vol. III, p. 63.
126 *Briefe*, vol. III, p. 287.
127 See earlier p. 199.
128 See, for example, L. Crompton, *Byron and Greek Love: Homophobia in nineteenth-century England* (London, 1985), pp. 45, 54, 56, D. A. de Sade, *Oeuvres*, vol. IX (Paris, 1963), pp. 32–3, and R. Lely, *Vie du Marquis de Sade* (Paris, 1982), p. 383. One major force fuelling this paradigm was the popular prejudice prevalent in Britain and France that sodomy was a corrupt foreign import from Italy (see Greenberg, *Homosexuality*, p. 329).
129 J. Casanova de Seingalt, *Histoire de ma vie* (Wiesbaden and Paris, 1960–2), ed. F. A. Brockhaus, vol. VIII, p. 198.
130 Dec. 1765, *Briefe*, vol. III, 147.
131 10 Nov. 1758, *Briefe*, vol. I, 430.
132 12 July 1754, *Briefe*, vol. I, p. 147.
133 To Francke, 1 Jan. 1759, *Briefe*, vol. I, pp. 443–4. Winckelmann was working in the Stosch library on the catalogue of Philip von Stosch's collection of engraved gems. See also vol. I, p. 439. On the prosodomitical dialogue 'Alciabiade Fanciullo', first published in 1652, see Greenberg, *Homosexuality*, p. 323.
134 John Cleland, *Memoirs of a Woman of Pleasure* (Harmondsworth, 1985), pp. 72, 81–2, 109; first published 1749.
135 R. Trumbach, 'Modern prostitution and gender in *Fanny Hill*: libertine and domesticated phantasy' (note 113), pp. 69 ff.
136 J. O. de La Mettrie, 'L'Art de Jouir' (first published in 1753), in *Oeuvres philosophiques*, vol. III (Amsterdam, 1774), pp. 321–2.
137 La Mettrie, *Oeuvres*, vol. III, pp. 321–2.
138 Some of the negative inflections attaching to 'pederasty', as it was called then, may come from Casanova rather than Winckelmann. There are isolated references in Casanova's diaries to his own participation in acts of 'pederasty', but these emerge as bisexual escapades in a context where sex is pretty exclusively heterosexual (see John Masters, *Casanova* (London, 1968), pp. 155–6). The discussion in a talk by Whitney Davis, 'Winckelmann's "Homosexual" Teleologies' (University College, London, 1993), helped me to clarify some of my ideas on the issues raised by this text.

139 J. Casanova de Seingalt, *Histoire de ma Vie* (Wiesbaden and Paris, 1960–2), vol. VII, pp. 197–8. An article by Denis Sweet (see note 3) drew my attention to the significance of this passage, which had been expurgated from earlier published editions of Casanova's memoirs.

140 See note 108.

141 To L. Usteri, Sept. 1763, *Briefe*, vol. II, pp. 343–5.

142 To Riedesel, end April 1763, *Briefe*, vol. II, pp. 311–12. On Castellani, see also the letters to Stosch, 5 Jan. 1760, vol. II, p. 68 and to Riedesel, 18 March 1763, vol. II, p. 296.

143 To Schlabbrendorf, 19 Oct. 1965, *Briefe*, vol. III, p. 127 (*mein Ganymedes, den ich ohne Aergerniss nel cospetto di tutti i Santi küssen kann*). See also vol. III, pp. 309–10 (6 April 1763). The so-called faun's head (or head of Pann), a Roman copy with horns added by a modern restorer, is now in the Glyptothek, Munich (D. Ohly, *Glyptothek München* (Munich, 1977), p. 36).

144 *Kleine Schriften*, p. 216. See also the letter to P. Usteri (the younger brother), 27 June, 1767, *Briefe*, vol. III, p. 277.

145 8 June 1763, *Briefe*, vol. II, p. 281.

146 On the libertine and often homoerotic culture surrounding antiquarian studies in the later eighteenth century, see G. S. Rousseau, 'The Sorrows of Priapus: anticlericalism, homosocial desire, and Richard Payne Knight', in Rousseau and R. Porter (eds), *Sexual Underworlds of the Enlightenment* (Manchester, 1987), pp. 102 ff. (compare also F. Haskell, 'The Baron d'Hancarville. An Adventurer and Art Historian in Eighteenth-Century Europe', in *Past and Present in Art and Taste* (New Haven and London, 1987)). Caylus, who was active as a writer and promoter of pornographic literature as well as an antiquarian and art theorist (see S. Rocheblave, *Essai sur le Comte de Caylus* (Paris, 1889), pp. 45 ff.), gave little evidence of his libertine interests in his generally rather dry commentary on antique sculpture. On one occasin, however, he did wax lyrical on the voluptuousness of a small hermaphrodite in his collection, which he celebrated for being a perfect fusion of the sensuous beauties dispersed between the male and female body (*Recueil*, vol. III, pp. 114–21).

147 To Marpurg, 8 Dec. 1762, *Briefe*, vol. II, p. 274.

148 They were only together over a period of at most eight days in Rome; see Justi, vol. III, p. 317.

149 22 Feb. 1765, *Briefe*, vol. III, pp. 81–2. The immediate occasion for this letter was in all likelihood Wilkes's commemoration of his late friend Charles Churchill, inscribed on a vase given him by Winckelmann as a token of friendship.

150 Writing to Riedesel in 1763 (*Briefe*, vol. II, pp. 319–20), two years after Mengs had departed for Spain, Winckelmann explained how he no longer felt up to cultivating his friendship with the painter. Mengs, he claimed, was overly prone to fabricating personal difficulties, and incessantly demanded assurances of Winckelmann's commitment to him. Several years later, however, in a letter to Stosch, Winckelmann described Mengs as once having provided something of the calm and stability he now had from his friendship with Stosch (11 Oct. 1766, vol. III, p. 215). On the complex story surrounding Mengs's fake antique painting of Jupiter and Ganymede, which Winckelmann unwittingly published in his *History*, see S. Röttgen, 'Storia die un falso: il Ganimede di Mengs', *Arte Illustrata*, VI, 1972, pp. 256–70 (the account in English by T. Pelzel, 'Winckelmann, Mengs and Casanova: a reappraisal of a famous eighteenth-century forgery', *Art Bulletin*, 1972, 54, pp. 300–15 is quite misleading). Mengs' forgery, which Winckelmann apparently never uncovered, does not seem to have played a role in the cooling of relations between the two men.

151 7 Dec. 1764, *Briefe*, vol. III, p. 63. In both the letters to Berg and to Stosch, Winckelmann uses the formal *Sie*, as distinct from the *du* he sometimes uses to friends he made during his early years in Germany; see also p. 204.

152 *Anmerkungen*, dedication to Heinrich Wilhelm Muzel Stosch (unpaginated). See also *Kleine Schriften*, pp. 247–8.

153 The point is reiterated in a letter to Stosch dated 16 Sept. 1766 (*Briefe*, vol. III, pp. 206–7).

154 27 May 1767, *Briefe*, vol. III, p. 266. Winckelmann met Schlabbrendorf in 1764.

155 To Walther, 26 Sept. 1758, *Briefe*, vol. I, pp. 416–17.

156 To Riedesel, 17 June 1767, *Briefe*, vol. III, p. 274.

157 *Briefe*, vol. III, pp. 388–9. The letters concerned, dated May 1768, were sent from Vienna.

158 To Stosch from Vienna, 14 May 1768, *Briefe*, vol. III, p. 389.

159 6 Feb. 1768, *Briefe*, vol. III, p. 366.

160 23 Jan. 1768, *Briefe*, vol. III, p. 357.

161 He hoped that a French translation of the new edition of the *History* he was preparing would furnish him with the income that *Unpublished Antique Monuments* had failed to provide (to Stosch,

26 Feb. 1768, *Briefe*, vol. III, pp. 370–1, and the later letter to him dated 6 April). See also p. ••.
162 2 April 1767, *Briefe*, vol. III, p. 244.
163 Goethe (*Schriften zur Kunst* (Munich, 1962), vol. I, p. 285) identified a striking tension between certainty and vagueness of self-definition in Winckelmann, if in rather different terms, when he talked about Winckelmann's 'antique disposition' as involving 'the certainty of the goal that one wants to achieve, as well as the obscurity and imperfection of conduct as soon as one gains any great breadth of possibility' (*antike Anlage: die Sicherheit des Zieles, wohin man gelangen will, sowie die Unvollständigkeit und Unvollkommenheit der Behandlung, sobald sie eine ansehnliche Breite gewinnt*).

CHAPTER VII

AFTERLIFE

1 J. Laplanche and J. B. Pontalis, *The Language of Psycho-Analysis* (London, 1988), pp. 111–14.
2 This section is a considerably revised version of a paper, 'De Winckelmann à David: la figuration visuelle des idéaux politiques', given at a symposium *David contre David* in Paris in 1989 and published in *History Workshop Journal* (Oxford University Press), no. 30, 1990, pp. 1–21, under the title 'Beautiful Bodies and Dying Heroes'.
3 On the political resonances of 'high' art supposedly informed by the values of the antique in late eighteenth-century France see T. E. Crow, *Painters and Public Life in Eighteenth-Century France* (New Haven and London, 1985), and R. Michel, 'L'Art des Salons', in P. Bordes and R. Michel, *Aux armes et aux arts: les arts de la Révolution 1789–1799* (Paris, 1988).
4 E. J. Delécluze, *Louis David: son école et son temps* (Paris, 1855), pp. 120, 218 ff.; and also M. Fried, 'Thomas Couture and the Theatricalization of Action in Nineteenth Century French Painting', *Artforum*, June 1970, p. 41. Discussions of the aesthetic and political resonances of the new more sensuous and 'beautiful' conception of the male nude in Davidian painting of the 1790s that I found particularly helpful when elaborating this analysis were R. Michel, 'Bara: Du Martyr à l'Ephèbe', in *La Mort de Bara*, pp. 67ff., W. Olander, *Pour Transmettre à la Postérité: French Painting and Revolution* (Ph.D. thesis, New York University, 1983), particularly pp. 295ff., and a lecture by T. Crow given in London in 1988, a version of which was published under the title 'Revolutionary Activism and the Cult of Male Beauty in the Studio of David' in B. Ford (ed.), *Fictions of the French Revolution* (Chicago, 1991). There now exists a considerable body of work on homoeroticism in French Neoclassical painting of the 1790s and early 1800s; see W. Davis, 'Homoeroticism and Revolutionary Reason in Girodet's *Endymion*' (lecture, 1993), A. Solomon-Godeau, 'Male Trouble: a Crisis in Representation', *Art History*, 16, 1993, pp. 286–312, and C. Ockman, 'Profiling Homoeroticism: Ingres' Achilles Receiving the Ambassadors of Agamemnon, *Art Bulletin*, 75, 1993, pp. 259–74.
5 A. Détournelle, *Aux armes et aux arts: peinture, sculpture, architecture, gravure: Journal de la Société Populaire et Républicaine des Arts* (Paris [1794]), p. 169; the journal records the proceedings of the Société between February and May 1794. The celebration of Winckelmann occurs in a report drawn up by Détournelle on a private collection of casts of famous antique statues that the Société was negotiating to make available to young artists in order to encourage study of the antique. The quote on *contours mâles* comes from the announcement for a competition for a monument to the French people on the Isle de Paris. The Société Populaire, which described itself as made up of 'free men who have made an oath . . . only to exercise their genius to celebrate republican virtues' (Détournelle, p. 3), had been established as a radical republican alternative to the recently abolished French Royal Academy.
6 On the reception of Winckelmann's writings in France, see E. Pommier, 'Winckelmann et la vision de l'Antiquité classique dans la France des Lumières et de la Révolution', *Revue de l'Art*, 83, 1989, pp. 9ff., and also Potts, 'Political Attitudes', pp. 200ff.
7 *Geschichte*, p. 316. On Winckelmann's conception of Greek freedom, see pp. 54ff.
8 In the early years of the Revolution, it was widely claimed that political freedom would of itself spontaneously give rise to a rejuvenated public art without the need for state intervention; see, for example, the pamphlet by H. J. Jansen, Winckelmann's translator, *Projet tendant à conserver les arts en France, en immortalisant les événemens patriotiques et les citoyens illustres* (Paris, 1791). Such libertarianism soon gave way to a renewed concern with propagating a 'correct' artistic doctrine. Particularly after Thermidor, the view began to take a hold that official government intervention

would be required to encourage the arts (see E. Pommier, *L'Art et la Liberté: doctrines et débats de la Révolution* (Paris, 1990), pp. 250 ff.).

9 A. Détournelle, *Aux armes et aux arts* (Paris [1794]), particularly pp. 158–79.

10 On the competition, see F. Benoit, *L'Art français sous la Révolution et l'Empire* (Paris, 1897), p. 104. Eméric-David's prize-winning essay was published under the title *Recherches sur l'art statuaire considéré chez les anciens et chez les modernes* (Paris, 1805).

11 Where Détournelle does not rely on a paraphrase of Winckelmann, he tends simply to place side by side passages celebrating the antique in austerely republican terms, and erotically charged descriptions of the sensuous beauties of famous statues, without negotiating a transition between the two (see, for example, *Aux armes . . .* (note 4), pp. 158 and 161).

12 See Chapter IV, note 19.

13 Vivant Denon, *Discours sur les monuments d'antiquité arrivés d'Italie prononcé le 8 vendémaire an XII à la séance publique de la classe des beaux arts de l'Institut National* (Paris [1804]), pp. 19–20. The passage in quotes paraphrases a passage from Winckelmann's description of the Apollo Belvedere (*Geschichte*, p. 393).

14 When the tide turned in the years around 1800 towards a more academic view of the 'ideal beauty' of antique statuary, Winckelmann's highly charged celebrations of the Greek ideal were often criticized for their excessive enthusiasm (see, for example, N. Ponce, *Mémoire sur cette question proposée par l'Institut National: quelles ont été les causes de la perfection de la sculpture antique, et quels seroient les moyens d'y atteindre?* (Paris, an IX (1801)), pp. 40 ff., and T. B. Eméric-David, *Recherches sur l'art statuaire . . .* (Paris, 1805), p. 278. These attacks on Winckelmann were ostensibly directed against the implication that the finest ancient art represented an almost unattainable ideal. It also seems, however, that his vivid evocations of antique beauty brought to the fore desires and fantasies deemed inappropriate to the professional scholarly discourse then coming into fashion.

15 P. Chaussard, *Sur le tableau des Sabines par David* (Paris, 1800), pp. 7–8.

16 *Geschichte*, pp. 167–8.

17 For a discussion of the emphatically male gendering of the ideal subject during the years of the French Revolution, see Dorinda Outram's *The Body and the French Revolution: Sex, Class and Political Culture* (New Haven and London, 1989). Outram's book (see particulary pp. 48 ff., 81 ff., 94 ff.), as well as Carol Duncan's important article on the vicissitudes and eventual revival of the heroic male in French painting of the later eighteenth century ('Fallen Fathers: Images of Authority in Pre-Revolutionary French Art', *Art History*, 4, June 1981, particularly pp. 198 ff.), played a major part in the genesis of the ideas developed here.

18 Chaussard, *Sabines*, p. 17.

19 See references in note 22.

20 For references see note 25.

21 J. L. David, 'Rapport sur la Fête Héroique pour les honneurs du Panthéon à décerner aux jeunes Bara et Viala' (11 July 1794), in *La Mort de Bara*, p. 160.

22 For the most fully argued case that the naked figure of Bara was conceived, not as an erotic image, but as an abstract representation of heroic virtue—that in other words its nudity makes it into a Neoclassical allegory conveying an 'ideal' political message—see R. Michel, 'Bara' in *La Mort de Bara*, pp. 66 ff. In contrast, the late William Olander's fine analysis of the painting in his unpublished dissertation *Pour transmettre à la postérité* (note 4, pp. 295–302) takes a view similar to that developed in this study, namely that the sexuality of the figure works to heighten its pathos as a mythic image of uncorrupted revolutionary man sacrificed in the highest cause. The painting was one that must have had a particular significance for David. According to his pupil Delécluze (*Louis David*, 1855, pp. 19–20; see also *La Mort de Bara*, p. 18), it was prominently displayed in the painter's studio in the late 1790s along with the *Oath of the Horatii* and *Brutus*. The erotic charge of the dying youth, as Olander has pointed out, was underlined in an interesting way by David's early biographer, Alexandre Lenoir, who saw it as echoing the figure of the beautiful boy and lover of Apollo, Hyacinth, killed accidentally by a quoit thrown by the god ('Mémoires, David, Souvenirs Historiques', *Journal de l'Institut Historique*, III, 1835, p. 6).

23 See pp. 179 ff.

24 *La Mort de Bara*, 1989 (note 3), p. 175.

25 Quoted in *La Mort de Bara*, 1989, p. 143. See W. Olander (note 22, pp. 295 ff.) for a discussion of how the distinctive symbolic charge of David's image of the boy hero Bara tied in with the exigencies of Jacobin political ideology at this moment during the Terror.

26 Desmarres reported how Bara died refusing to give up the two horses that were in his charge.

Robespierre's dramatizing of Bara's dying words occurred in a speech made to the Convention on 28 December 1793. General Desmarres's letter was read out to the Convention Nationale on 10 January 1794 (See *La Mort de Bara*, pp. 142–3). On the invention of the cult of the boy hero Bara, see Jean-Clément Martin, 'Bara: de l'imaginaire révolutionnaire à la mémoire nationale' (in *La Mort de Bara*), and also J. C. Sloane's pioneering article, 'David, Robespierre and the Death of Bara', *Gazette des Beaux Arts*, LXXIV, 1969, pp. 143 ff.

27 The passage comes from Robespierre's speech to the Convention Nationale on 7 May 1794 (*La Mort de Bara*, p. 148). For a recent discussion of Jacques-René Hébert and the abrasively populist rhetoric of his famous revolutionary paper *Le Père Duchesne*, see E. Colwill, 'Just Another *Citoyenne?* Marie-Antoinette on Trial, 1790–1793', *History Workshop Journal*, 28, Autumn 1989, pp. 63 ff.

28 The passage occurs in David's famous speech to the Convention Nationale (11 July 1794) in which he set out plans for a festival (that never took place) according the boy heroes Bara and Viala the honours of the Pantheon (*La Mort de Bara*, p. 161).

29 On the larger politics involved, see D. Outram, 'The French Revolution, Modernity and the Body Politic' (note 17, pp. 153 ff.). For an alternative analysis of the sexual politics of the 'ideal' male nude in early nineteenth-century French art, see A. Solomon-Godeau, 'Male Trouble' (note 4).

30 Oscar Wilde, 'The Ballad of Reading Gaol' (first published in 1898), Section I, in *Plays Prose Writings and Poems* (London, 1975), p. 404.

31 It was first published in 1867, and then reprinted in slightly modified form in his famous study of the Renaissance that came out in 1873. It is the latter version, as re-edited in a modern reprint of the 1910 text of *The Renaissance*, that is cited here. On the text of Pater's *Renaissance*, see the introduction to *The Renaissance: Studies in Art and Poetry*, ed. D. L. Hill, Berkeley, Los Angeles and London, 1980. This section is a much revised and considerably extended version of an article 'Walter Pater's Winckelmann' published in *Zeitschrift für Kunstgeschichte*, 46, 1993, pp. 67–73.

32 Pater, *Renaissance*, pp. 210–11. My reading of Pater's 'Imaginary Portrait' of Winckelmann owes a lot to Richard Dellamora's *Masculine Desire: The Sexual Politics of Victorian Aestheticism* (Chapel Hill and London, 1990). Partly inspired by Dellamora's insistence on the ambivalences of Pater's projections of male desire, however, I interpret the essay on Winckelmann as offering an inherently more problematized view of the pagan sensuality of Greek art than he does (see his chapter 5, 'Arnold, Winckelmann and Pater'). Other studies of Pater I found helpful in coming to terms with him include J. Hillis Miller, 'Walter Pater: A partial Portrait', in H. Bloom (ed.), *Walter Pater* (New York, 1985), and W. Iser, *Walter Pater: The Aesthetic Moment* (Cambridge, 1987).

33 On this nostalgic reading of the epithet 'Et in Arcadia ego', see E. Panofsky, '*Et in Arcadia Ego*: Poussin and the Elegiac Tradition', in *Meaning in the Visual Arts* (Harmondsworth, 1970), pp. 340–1.

34 Pater, *Renaissance*, p. 211.

35 Pater, *Renaissance*, p. 209.

36 Pater, *Renaissance*, pp. 211–12.

37 Pater, *Renaissance*, pp. 209, 213.

38 J. W. Goethe, 'Winckelmann und sein Jahrhundert', in *Schriften zu Kunst*, vol. I (Munich, 1962), pp. 254–89. The essay was first published in 1805 in a book that included Winckelmann's letters to his friend Berendis, which are among his more explicitly homoerotic.

39 Pater (*Renaissance*, p. 188), quoting Madame de Staël.

40 See H. Dilly, *Kunstgeschichte als Institution*, pp. 237 ff.

41 C. Justi, *Winckelmann und seine Zeitgenossen*, first published in two volumes in 1866–72.

42 See Chapter I, note 4.

43 On the cult of Goethe in Victorian Britain, see Rosemary Ashton, *The German Idea: Four English Writers and the Reception of German Thought 1800–1860* (Cambridge, 1980).

44 Pater's identification with Winckelmann would have been the stronger because of the Socratic educative role (on the importance of this 'Platonic' paradigm for male same-sex relations, see Chapter VI, note 2.) the latter played out in relation to some of the younger men to whom he addressed his more homoerotically charged letters. On the sexual politics of Pater's milieu, see R. Dellamora, *Masculine Desire* (note 32).

45 Dellamora, *Masculine Desire* (note 32), p. 18.

46 Pater, *Renaissance*, p. 189.

47 Pater, *Renaissance*, p. 191.

48 Pater, *Renaissance*, p. 210.

49 See Chapter V, note 65.
50 Pater, *Renaissance*, pp. 183–4.
51 Pater, *Renaissance*, pp. 211–12.
52 Pater, *Renaissance*, p. 184.
53 Pater, *Renaissance*, p. 212.
54 Pater, *Renaissance*, p. 202.
55 On the contradictory dynamic at work in the definition and new self-consciousness about homo-sexuality in the late nineteenth century, see Chapter IV, note 27.
56 Pater, *Renaissance*, p. 182. I am grateful to Caroline Arscott's comments for help in clarifying this analysis.
57 Pater, *Renaissance*, p. 205 (my underlining). The statue illustrated in Plate 44 is a Roman copy based on a classic Greek prototype of about 440 BC. It was acquired by the British Museum in 1857.
58 Pater, *Renaissance*, p. 208.
59 See Dellamora, *Masculine Desire* (note 32), pp. 144–6.
60 Pater, *Renaissance*, pp. 122–3.
61 Pater, *Renaissance*, p. 209.
62 *Geschichte*, p. 151.
63 Pater, *Renaissance*, pp. 208–9.
64 *Geschichte*, pp. 152–3.
65 Pater (*Renaissance*, p. 212) does indicate that there is some suggestion of this in Greek tragedy, and even in pastoral poetry. Like most historians and theorists of culture in the nineteenth century, following in the wake of Hegel (see also Chapter V, note 74), Pater envisaged Greek sculpture as the essence of the Greek ideal in its most purified form.
66 Pater, *Renaissance*, p. 209.
67 Pater, *Renaissance*, p. 209.
68 Pater, *Renaissance*, p. 207.
69 Freud, 'The Economic Problem of Masochism' (1924), *Freud Library*, vol. 11, p. 414. This was a recurrent motif in Pater. Thus, in his imaginary portrait of a man who sought to find a measure of serenity in complete self-sufficient isolation, he wrote 'one's wisdom, therefore consists in hasten-ing, so far as may be, the action of those forces which tend to the restoration of equilibrium, to the calm surface of the absolute, untroubled mind, to *tabula rasa*, by the extinction in one's self of all that is but the correlative to the finite illusion—by suppression of ourselves' (*Imaginary Portraits* (London, 1887), p. 123).
70 See, for example, the passage quoted earlier, note 57.
71 Pater, *Renaissance*, p. 193.
72 W. Pater, 'The Age of Athletic Prizemen' (1894), in *Greek Studies: a series of essays* (London, 1899), p. 316. The Roman copy illustrated in plates 45–6, that derives from the early classical so-called 'Sciarra' type (see M. Robertson, *A History of Greek Art* (Cambridge, 1975), pp. 335 ff.), is one where the wound is particularly in evidence. The famous Dying Gaul in the Capitoline Museum is among the very few surviving 'Greek' male nudes displaying an obvious wound, and significantly it does not represent a hero or an athlete but a defeated barbarian.
73 Pater, *Renaissance*, p. 202.
74 John Addington Symonds's much more explicit discussion of homosexual desire in Greek culture (*A Problem in Greek Ethics* (London, 1908)), written in 1873, could not be published in the normal way, and only appeared in a very limited private edition in 1883. Any attempt on our part to represent the complex structures of disavowal and affirmation of homosexual desire in a writer such as Pater is well described by Jonathan Dollimore's comment (*Sexual Dissidence: Augustine to Wilde, Freud to Foucault* (London, 1991), p. 31) about how, in declaring 'either the absence of homosexu-ality *or* its (repressed) presence, plausible arguement proceeds inseparably from questionable disavowal, inheriting the history of homosexuality's paradoxical, incoherent construction. Put another way, the disavowals are now as much a part of the history of homsexuality's actual absence as well of its presence, overt or repressed.'
75 For further discussion see Potts, 'Male Phantasy and Modern Sculpture', *Oxford Art Journal*, 15, no. 2, 1992, pp. 39, 44–5.
76 Pater, *Renaissance*, p. 203.
77 Pater, *Renaissance*, p. 204.
78 Pater, *Renaissance*, pp. 204–5.

79 This essay was included with the one on Winckelmann in *Studies in the Renaissance*. See Pater, *Renaissance*, pp. 79–81.

80 This quasi-modernist focus on the physical fabric of artistic representation, as distinct from a more traditional concern with the sensuous qualities associated with the motif being represented, involved conceptualizing a work of art so that it would both be true to and at the same time overcome the limits of its literal materiality. Such concerns first properly took shape in the later nineteenth century, and clearly separate Pater's analysis of Greek sculpture from Winckelmann's. On the specific problems these changes raised for sculptural aesthetics, see A. Potts, 'Male Phantasy' (note 75).

81 Pater, *Renaissance*, p. 218.

82 *Renaissance*, pp. 220–1. That this conclusion was left out of the second edition of 1877 would indicate that Pater was sensitive as to the controversial constructions that might be put on his aestheticism. But it is not at all clear that the problems had to do with any too overt suggestions of homoerotic desire. If this had been the case, the Winckelmann essay would probably have been the section to cut. For a fuller discussion, see Dellamora (note 32), chapter 8.

83 See earlier notes 44 and 74.

84 A slightly different perspective on Pater's conception of the Greek ideal in art is developed in my later article 'Walter Pater's unsettling of the Apollonian ideal in M. Biddiss and M. Wyke (eds.), *The Uses and Abuses of Antiquity* (Bern, 1999), pp. 107–26.

PHOTOGRAPHIC CREDITS

Archivi Alinari, Florence, 15, 17, 26, 27.
Deutsches Archäologisches Institut, Rome, 4, 21, 22, 28, 29, 30, 32, 33.
The Getty Center for the History of Art and the Humanities, Resource Collections, George Stone Collection, 16, 18, 20, 25, 31.
Hirmer Verlag, Munich, 7, 8, 9, 10, 11.
Istituto Centrale per il Catalogo e la Documentazione, Rome, 19, 23, 36, 37, 38, 39.
Metropolitian Museum of Art, New York, 1, 45, 46.
Musée Calvet, Avignon, 42.
Réunion des Musées Nationaux, Paris, 12, 34, 41, 43.
Staatliche Antikensammlungen und Glyptothek, Munich, 14.
Trustees of the British Museum, London, 24, 44.
The Warburg Institute, London, 2, 3, 5, 6, 13, 35, 40.

INDEX